Re NOV08

OS MAY 2009
WK DEC 2011
OS NOV 2014
OS Apr 2C

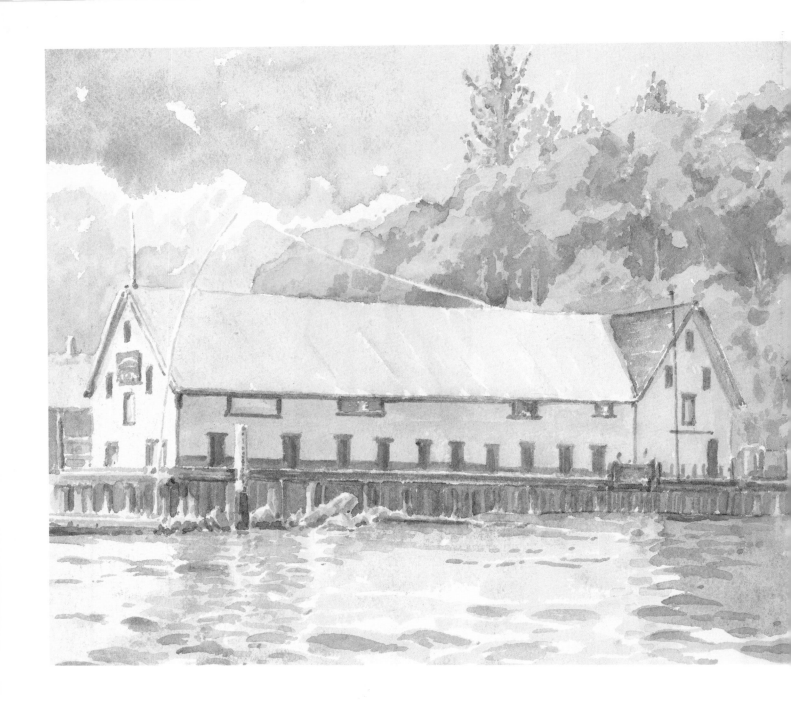

vanishing BRITISH COLUMBIA

MICHAEL KLUCKNER

UBC PRESS / VANCOUVER AND TORONTO
UNIVERSITY OF WASHINGTON PRESS / SEATTLE

15 14 13 12 11 10 09 08 07 06 05 5 4 3 2

Printed in Canada on acid-free paper

Library and Archives Canada Cataloguing in Publication

Kluckner, Michael
 Vanishing British Columbia / Michael Kluckner.

Includes bibliographical references and index.
ISBN 0-7748-1125-0

 1. Historic buildings – British Columbia – Pictorial works.
2. British Columbia – History. I. Title.

FC3812.K58 2005 917.1104'5 C2004-904809-0

Library of Congress Cataloging-in-Publication Data

Kluckner, Michael.
 Vanishing British Columbia / Michael Kluckner.
 p. cm.

 Includes bibliographical references and index.
 ISBN 0-295-98493-7 (hardcover: alk. paper)

 1. Historic sites – British Columbia – Pictorial works. 2. Historic buildings – British Columbia – Pictorial works.
3. Cities and towns – British Columbia - Pictorial works. 4. Watercolor painting – British Columbia. 5. British Columbia –
History, Local – Pictorial works. 6. British Columbia – History, Local. I. Title.

F1087.8.K58 2005 971.1'04'0222-dc22 2004023543

UBC Press gratefully acknowledges the financial support for our publishing program of the Government of Canada through the Book Publishing Industry Development Program (BPIDP), and of the Canada Council for the Arts, and the British Columbia Arts Council.

UBC Press
The University of British Columbia
2029 West Mall
Vancouver, BC V6T 1Z2
604-822-5959 / Fax: 604-822-6083
www.ubcpress.ca

University of Washington Press
PO Box 50096
Seattle, WA 98145-5096, USA
www.washington.edu/uwpress

HALF TITLE *Beekeepers' cottage (page 86), a Doukhobor building near Grand Forks.*
FRONTISPIECE *The BC Packers complex on the Alert Bay waterfront, the year before its demolition in the spring of 2003 (page 158). While negotiating the abandonment of these buildings, BC Packers was also engaged in re-developing its lands on the Steveston waterfront at the mouth of the Fraser River, replacing its "Cannery Row" packing plants and wharves with condominums and interpretive plaques.*

FACING PAGE *The abandoned St. Nicholas Catholic Church, built about 1890 at Spahomin, the Indian village on the west side of Douglas Lake in the arid grasslands east of Merritt. Missionary Father Jean-Marie Raphael LeJeune, its designer, is more often remembered for the Kamloops Wawa, a newsletter he published between 1891 and 1923 for his Native audience in English, French, and a Chinook jargon he developed himself. LeJeune wrote about national and international events of Native concern, eventually circulating about 2,000 copies to readers as far away as Quebec and France.*

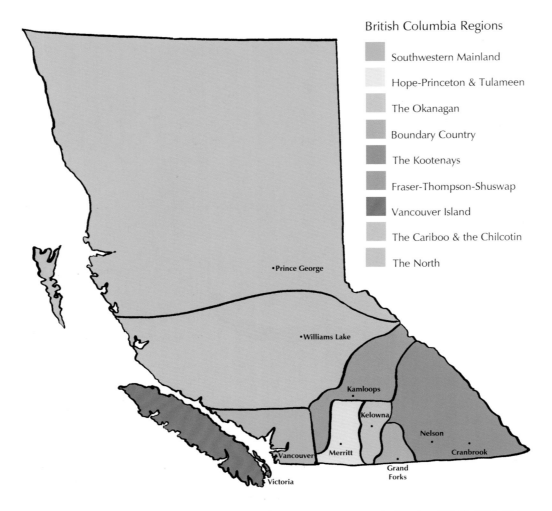

British Columbia Regions

- Southwestern Mainland
- Hope-Princeton & Tulameen
- The Okanagan
- Boundary Country
- The Kootenays
- Fraser-Thompson-Shuswap
- Vancouver Island
- The Cariboo & the Chilcotin
- The North

•Prince George

•Williams Lake

Kamloops

Kelowna

Nelson

Vancouver

Merritt

Cranbrook

Victoria

Grand Forks

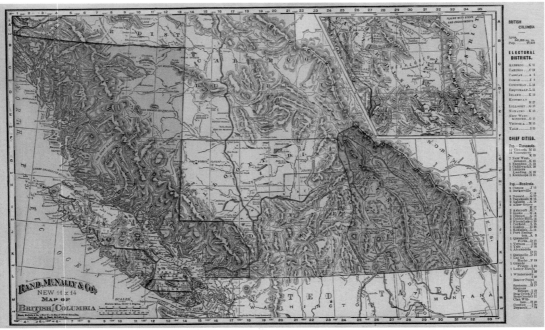

British Columbia at the turn of the twentieth century, showing the Electoral and Land districts that reflect the development of the province's regions.

NEIL ROUGHLEY

CONTENTS

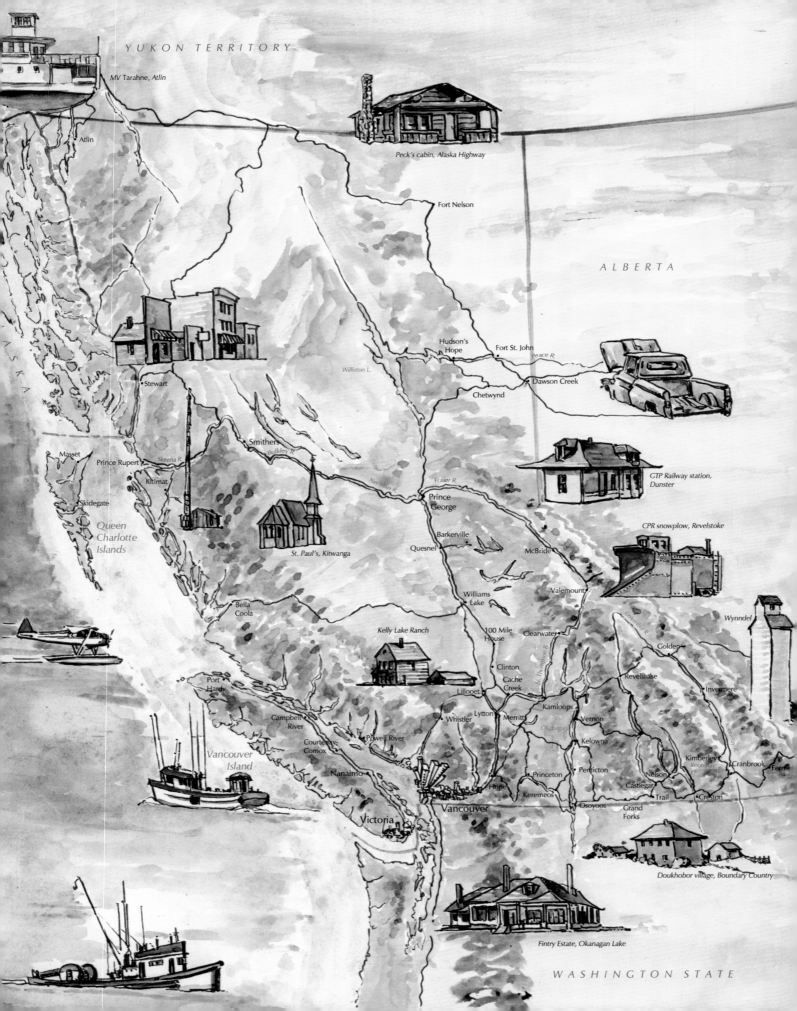

YUKON TERRITORY

MV Tarahne, *Atlin*

Atlin

Peck's cabin, Alaska Highway

ALASKA

Fort Nelson

ALBERTA

Hudson's
Hope

Fort St. John

Peace R.

Williston L.

Dawson Creek

Chetwynd

Stewart

GTP Railway station,
Dunster

Masset

Prince Rupert

Skeena R.

Smithers

Bulkley R.

Kitimat

Nechako R.

Fraser R.

Prince
George

CPR snowplow, Revelstoke

Skidegate

Queen
Charlotte
Islands

St. Paul's, Kitwanga

Barkerville

Quesnel

McBride

Valemount

Columbia R.

Wynndel

Golden

Bella
Coola

Williams
Lake

Clearwater

Revelstoke

Invermere

Kelly Lake Ranch

100 Mile
House

N. Thompson R.

Port
Hardy

Clinton

Cache
Creek

Kamloops

Kimberley

Cranbrook

Fernie

Lillooet

Campbell
River

Whistler

Lytton

Merritt

Vernon

Vancouver
Island

Courtenay-
Comox

Powell River

Kelowna

Nelson

Castlegar

Nanaimo

Princeton

Penticton

Trail

Creston

Hope

Keremeos

Grand
Forks

Osoyoos

Vancouver

Victoria

Doukhobor village, Boundary Country

Fintry Estate, Okanagan Lake

WASHINGTON STATE

Introduction

. .

"My mother-in-law wishes to know why you have come to our village."

"I want to make some pictures of the totem poles."

"What do you want our totem poles for?"

"Because they are beautiful. They are getting old now, and your people make very few new ones. The young people do not value the poles as the old ones did. By and by there will be no more poles. I want to make pictures of them, so that your young people as well as the white people will see how fine your totem poles used to be."

—Emily Carr, *Klee Wyck*[1]

I n the four or five decades that I've spent travelling in British Columbia, I've developed a sort of mental map of it, including images of the province's well-known natural splendours. But many dots on my map are landmarks from earlier generations of human settlement – a kind of "roadside memory" that helps make my province and my country my home.

In a casual way, on holidays a dozen years ago, I began to paint them in my

Abandoned orchard near Spences Bridge in the fall of 2002. The colossal rugged landscape along the Thompson River – the dryness, remoteness, summer heat and winter cold – dwarfs and dooms puny men's attempts at settlement.

1 Kitwancool chapter (1971 edition, p. 101).

1 For example, Doris Shadbolt, *Emily Carr*, pp. 83-145.

2 For example, E.J. Hart, *The Selling of Canada*, pp. 31-41.

3 Numerous printed references, including J. Russell Harper, *Paul Kane 1810-1871*.

4 www.goodallartists.ca, the website maintained by the family.

5 For example, 158 of Dangelmaier's watercolours and drawings of pioneer buildings form part of the Langley Centennial Museum collection.

6 Page 13.

7 Clemson's *Old Wooden Buildings* is still in print.

sketchbook. At first I was content just to do the pictures, but eventually my curiosity got the better of me. So little of the history of these places has been recorded in museums and archives and most of it, I believed, would likely disappear "within a heartbeat" as families dispersed and memories dimmed. But how could I find this oral history and, with luck, the family photo albums and letters that would document it?

The Internet provided the solution. In 1999, after I put a few of the travel sketches onto my website, I began to get responses from browsers who were using search engines to seek information on specific places. With the help of CBC radio's *BC Almanac* program and its host Mark Forsythe, I was soon developing a network of correspondents, some of whom "knew people who knew people," others whose families had once owned the places on my roadside map. Thus, *Vanishing British Columbia* was born on-line.

The watercolours fit into the long Canadian tradition of documentary art, practised by Emily Carr with her Indian village paintings,[1] "CPR artists" such as F.M. Bell-Smith,[2] and the wandering watercolourist Paul Kane.[3] To me there is urgency to the task, for my "trail markers" are often abandoned and may soon be razed, or buried beneath acres of concrete, cul-de-sacs and chain stores. Perhaps like most artists, I find my own simplified and slightly abstracted watercolours more real, or at least more atmospheric and evocative, than photographs could be.

One theme tying the places together is cultural change. In human terms, seaports have always provided this, but *all* cities are crucibles of evolution, in the main a positive force. However, in the countryside, notably in western North America, change is often a synonym for depopulation and abandonment. This book is about that kind of change, and thus pays little attention to the province's cities; an earlier book, *Vanishing Vancouver* (1990), focused on change due to development.

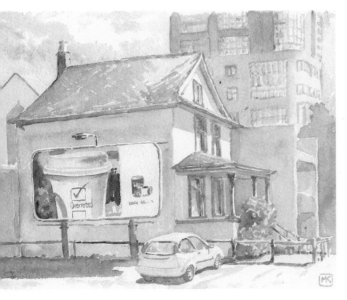

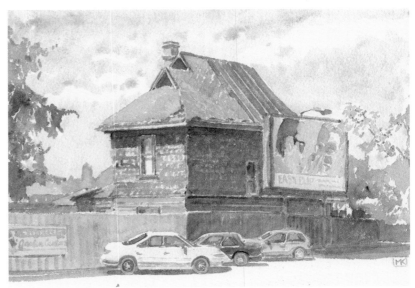

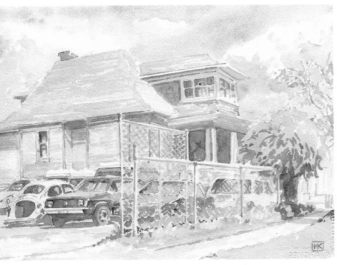

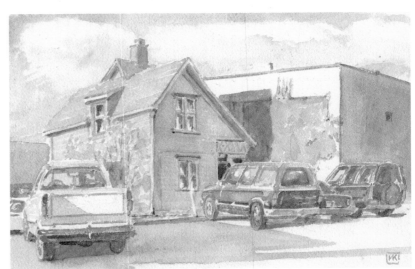

In most of BC's cities, enlightened heritage policies save and reuse valuable old buildings. The ones awaiting demolition in transitional areas have a certain aesthetic appeal (at least to me and artists such as Raymond Chow)[1] due to the blacktop, billboards and beaters crowding them.

TOP LEFT *815 Drake Street in downtown Vancouver, a 1907 stucco rowboat with a billboard sail adrift in a concrete sea.*

TOP RIGHT *The house that for half a century stood next to the David Hunter Garden Centre on West Broadway between Maple and Arbutus in Vancouver. Dairyman Samuel Swann Fearn (1860-1931) built it in 1907. Fearn emigrated from Brassington, Derby, when he was about 20, settling first in Saskatchewan where he fought to squelch the Riel Rebellion. He had a family of seven children, with one daughter born in the house in 1911 when he was 51, and probably worked at the Jersey Farms dairy two blocks to the west, or at Associated Dairies at 2134 to 2156 West Twelfth Avenue.[2] Next door, in the mid-1940s, Harry and Helen Derewenko built a coffee shop with the enticing name Midget Lunch, which continued in op-*

eration until about 1955. Subsequently, the David Hunter Garden Shop opened on the site.[3] Fearn's house was demolished in 2003.

BOTTOM LEFT *Victoria, which lacks billboards, nevertheless creates aesthetic synergy in a handful of houses marooned in the transitional areas between the downtown and the industrial and apartment districts to the north and east. 632 Hillside occupies the lot next to Beetle Parts & Repairs, its upper windows looking south over the flat roofs of a light industrial area toward the Upper Harbour.*

BOTTOM RIGHT *Growing towns and cities sometimes retain "buried" houses, such as the one behind a row of stores, including a barber and a beauty shop, at 451 Lawrence in downtown Kelowna.*

1 *Vancouver As It Was,* (500 copy limited edition), Cobblestone Press, 1983.
2 Correspondence from grandson John Lofquist and great-grandson Steve Darvell.
3 Information from water records and city directories in Vancouver City Archives.

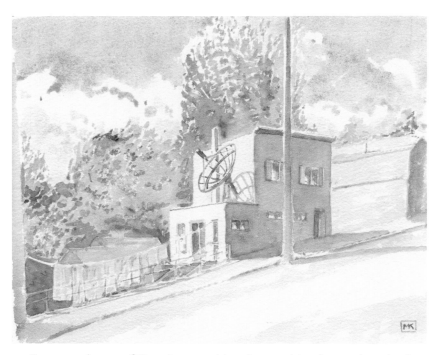

A house on Washington Street in Rossland in 2000, fitted picturesquely onto one of the town's steep downtown streets and demonstrating the combination of technological savvy (the dish) and environmentalism (the laundry line) typical of British Columbia. The erection of flat-roofed buildings in the snow belt shows, to a certain degree, the triumph of fashion over common sense, a foible more often identified with modern condominiums in Vancouver. In the southern Interior, flat and low-pitched shed roofs were once common only on downtown commercial buildings which were constantly heated, keeping the roofs relatively free of snow. With the advent of insulation, a few buildings in Rossland and Revelstoke began to suffer structural problems and needed reinforcing, as their roofs had not been built with adequate strength to carry snow loads.[1]

1 Correspondence from Robert Inwood, Mainstreet Consulting, Winlaw, 2004.

Some rural parts of Canada are making the transition from culture back to nature. In the more drought-prone areas of southern Saskatchewan, for example, marginal farmland is being turned back to native grassland – an admirable aim in that vast monoculture of wheat farms, but nonetheless astonishing given that in the 150 years since it was in its natural state an entire culture of farms, families, schools, grain elevators and little towns has been born, matured and cast away like so much chaff on the prairie winds. Perhaps British Columbia's rusty Atlantis will go the same way – the collapse of the homesteads and the disappearance of the fencelines heralding a return to nature. It is a romantic thought: the settlers were foolish, their lives an insignificant blip in the march of humanity, they never should have gone to all those infertile valleys and windswept hills, and only the Natives were in tune with the real world. Nevertheless, these old places are the last tangible link with a significant part of our history and culture. I fail to see how BC's story will be well told once all this roadside memory has disappeared.

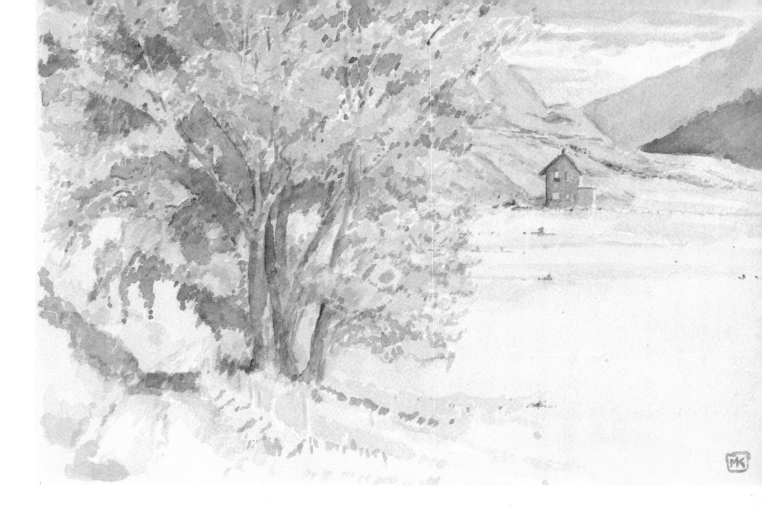

Themes & Variations

"If some countries have too much history, we have too much geography."
 –William Lyon Mackenzie King[1]

British Columbians define themselves regionally, perhaps more so than other Canadians, largely due to the tremendous diversity of geographic zones and the relative isolation they create. While today the political and economic traffic, like spokes on a bicycle's wheel, converges at the province's southwestern corner, people still identify themselves strongly with the Kootenays, or the Cariboo, or the Peace. Within each of the regions relatively distinct cultures and types of buildings emerged.

Like the early electoral districts, the province's original land districts (see map facing the contents page) evolved with reference to this complex geography and coincide roughly with our modern conception of the province's regions: the sections into which the balance of this book is divided.

1. Southwestern Mainland comprises the populated part of the New Westminster Land District.
2. Hope-Princeton & Tulameen is essentially the Nicola Division of the Yale Land District.
3. The Okanagan is the parts of the Nicola and Osoyoos divisions of the Yale Land District adjoining Okanagan Lake.

The Elton home is a forlorn relic from 1910 on the east side of Highway 3 south of the little community of Cawston. Ralph Elton was born in India where his father was a colonel in the British army. He moved to England as a child, and subsequently immigrated to Canada. On his little farm he had apple trees, chickens and horses, but his main source of income was work on the roads. His daughter married into the McCurdy family, settlers in the valley since 1878, whose 1895 house still stands across the road, its squared-log sides hidden behind modern cladding.[2]

1 Speech on Canada as an international power, June 18, 1936.
2 Interview with Don McCurdy.

4. Boundary Country is essentially the Osoyoos Division of the Yale Land District.
5. The Kootenays correspond with the Kootenay Land District.
6. Fraser-Thompson-Shuswap is the Yale and Kamloops divisions of the Yale Land District.
7. Vancouver Island combines the old Esquimalt, Cowichan, Nanaimo, Alberni and Comox land districts, and includes the Gulf Islands.
8. The Cariboo & the Chilcotin is the Lillooet and Cariboo land districts, all to the west of the continental divide.
9. The North is essentially the Cassiar Land District, the old Cariboo Land District corridor through which the Grand Trunk Pacific Railway ran, plus the Peace River Block and the Queen Charlotte Islands.

The former prime minister's quip about history and geography seems apropos for modern Canada, although it does not jibe with my understanding of Aboriginal tradition where history is tied to specific places and the "geography" is encoded with both sacred and utilitarian sites. The recently published *Stó:lō Coast Salish Historical Atlas,* for example, describes a myriad of historic places in Stó:lō traditional territory throughout the Lower Mainland and Fraser Canyon.

The saga of X̱á:ytem – *aka* the Hatzic Rock on the Lougheed Highway a few miles east of Mission – illustrated the contrast between Aboriginal values and those of the white culture which had overwhelmed them. X̱á:ytem, like Siwash Rock in Vancouver's Stanley Park, was created by the X̱exá:ls, the transformers[2]; the developer who bought the land was going to break the rock apart and remove it in preparation for building a housing subdivision. Stó:lō anthropologist Gordon Mohs discovered archaeological remains in the soil

History has been preserved in situ in the set of publicly owned heritage sites in the province, most notably Barkerville in the Cariboo. The upsurge in interest in the province's past, resulting from the 1958 centennial celebrations of the crown colony of British Columbia prompted the provincial government to begin the town's restoration. This Traveltime postcard from the late 1950s, by an unknown photographer, shows Barkerville's main street and St. Saviour's Anglican Church, built "almost singlehandedly" by the Reverend Reynard in 1870.[1]

1 Downs, *Sacred Places,* p. 118.
2 Keith Thor Carlson, ed., *Stó:lō Coast Salish Historical Atlas,* p. 6.

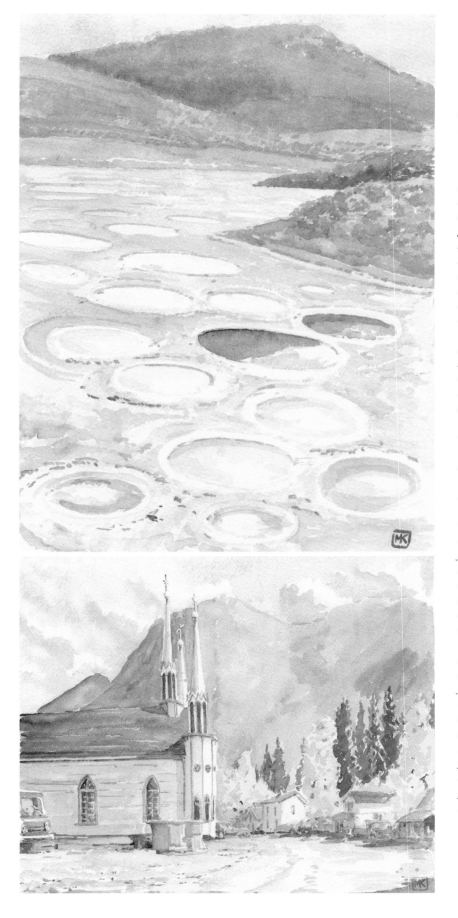

Two significant Native places:

TOP *Spotted Lake is a natural site with cultural meaning. Easily visible from Highway 3 about nine kilometres west of Osoyoos in the desert country of southern BC, it is a rare phenomenon covering about 15 hectares and containing extremely high concentrations of minerals, so much so that as the summer progresses and the lake dries out its mud forms into white, pale yellow, green and blue circles. Although a sacred site to the local Natives, it lay on privately held ranchland. During perhaps the 1940s and 1950s a small resort developed: on the lakeshore today, surrounded by sagebrush and wild roses, there is a ruined wooden building on which a painted sign advertises "Information - Gifts - Souvenirs." Salt-encrusted pilings extend into the lake from several points. Beginning in 1979, despite opposition from Native leaders, the owners tried to develop a spa, then stripmine the lake's mineral-rich mud for shipping to the USA. Finally, after a protracted controversy, the federal government and the Okanagan Nation Alliance purchased the lake in October 2001.*

BOTTOM *On the Lillooet River north of Harrison Lake, the Holy Cross Catholic Church dominates Skookumchuck Village, which occupies a narrow strip of land below the road along the river. An equally fascinating cemetery covers the bench between the road and the church. In the fall the air has the sharp crispness of the BC Interior, needing only a little moisture added to the hard air to produce snow. Built in 1905, the church has been described as "a masterpiece of hand-crafted folk art," and "the culmination of a well-tutored folk art tradition in the area."[1] Correspondence from Sharon Syrette: "A group of mostly First Nations people, descendants of the original builders of the church, have formed a not-for-profit society called Ama Liisaos Heritage Trust Society. The primary purpose is restoration and maintenance of the Church of the Holy Cross, along with preserving the history, memories, photos, traditions, etc."*

1 Downs, p. 96. See also Veillette and White, *Early Indian Village Churches*, and *Lillooet-Fraser Heritage Resource Study*, vol. 1, Heritage Conservation Branch, Province of BC, 1980, p. 65.

removed by the bulldozers from near the rock. In 1991, Mohs excavated the site for the Stó:lō Nation, with the financial assistance of the provincial government. It gained a level of meaning to many non-Aboriginals when archaeologists uncovered the adjoining c. 4,000-year-old pit house.[1]

In post-contact culture in the countryside, where human additions to the landscape are so spread out and abandoned places quickly return to the soil, historians have had difficulty creating such a cultural geography. For example, the site of Fort St. John near the modern town is unrecognizable, with only Old Fort Road, which leads to the riverbank, offering a clue. Indeed, much non-Aboriginal historical writing is decidedly vague about the specific locations of homesteads and properties.[2]

Even the federal agency for historical commemoration, the Historic Sites and Monuments Board of Canada, can miss the boat, as witnessed by its monument to anthropologist James Teit at Spences Bridge. Teit's publications were well-documented, but no connection was made either in the research publications or in the placement of the cairn with his long-time home in the area – a historic building in its own right, a property on which the family cemetery still exists – or the home of his aunt, "Widow Smith," which still stands in the centre of Spences Bridge near the Chief Whistemnitsa Community Complex (page 130). The cairn ended up on the Five Nations Campground a few kilometres away – a lost opportunity to tie a historical figure together with a specific site.

SHELTER FROM THE STORM

Wherever possible, I have drawn floor plans of houses to provide some clues about social habits, as well as the available technology (and budget) of the occupants. Some of the more interesting plans show evidence of communal dining, such as the Lawless ranch house (page 76), or especially efficient use of space (Highline Houses, page 126).

ABORIGINAL For most of the pre-contact era, Natives lived in pit houses such as the aforementioned Xá:ytem; later, along the coast in the immediate pre-contact period, they built sophisticated plank-sided houses and longhouses with post-and-beam frames.[3] In the Interior for more than 5,000 years, most lived in pit houses, although on the Interior plateaus some built mat houses – pole lodges covered with mats made of rushes or bark – while the Kutenai in the southeastern corner of the province used tipis like the Plains Indians.[4] Post-contact reserve houses are referred to below.

LOG CABINS The classic western log cabin is a single-room structure, perhaps partitioned inside, made of round horizontal logs saddle-notched at the corners, with a chimney at one end; this was the style introduced into North America by Swedes who settled along the Delaware River in 1638.[5] Although until the beginning of the eighteenth century only central and northern Europeans built the log cabin, over the next hundred years it became the standard frontier dwelling in North America. Modified only to the extent of metal chimneys and stoves replacing the earlier mud-and-stick chimneys and stone fireplaces, the log cabin was the typical British Columbia prospector's or trapper's abode.[6] Although usually in ruins, it is still relatively common in the province, especially in areas where dry climate slows its rot-rate. Camp Defi-

1 www.xaytem.museum.bc.ca, and Carlson, pp. 40-1.
2 For example, Margaret Ormsby's *A Pioneer Gentlewoman in British Columbia* gave little information about the actual locations of Susan Allison's homes in Hope, Princeton and Westbank.
3 Carlson, p. 42, and Kalman, *A History of Canadian Architecture*, vol. 1, pp. 365-70.
4 Kalman, vol. 1, pp. 371-2.
5 Walker, *American Shelter*, p. 50.
6 Kalman, vol. 1, p. 406.

ance on the Hope-Princeton Highway (page 55) and Dudley Shaw's cabin at Hudson's Hope (page 202) are two classic examples.

Squared-log cabins with dovetailed corners are most common in the Cariboo, such as 137 Mile House (page 179). According to a former owner, the Lawless house on Anarchist Mountain (pages 31 and 76) is squared tamarack beneath its board siding.

In more recent years, some of the most beautiful architect-designed houses in BC have been built of logs. The McMaster house on Savary Island (page 52) is one such; Eaglecrest at Qualicum Beach has burned down, although its servants' compound survives (page 156). One of the bright spots on BC's current rural building scene is the renaissance in log building, with many elaborate and beautiful homes now dotting the countryside; they differ from the pioneer cabins in their scale, of course, but also because they are generally prefabricated in construction yards and trucked to the site. One such enterprise, Eagle's Nest Log Industries near Merritt, is a joint venture of the Coldwater, Cook's Ferry, Nooaitch and Siska Indian bands.

FRAME HOUSES The earliest frame buildings in British Columbia (including the oldest surviving building, the 1840 storehouse at Fort Langley) were fur-trading posts of the Hudson's Bay Company which were predominantly constructed of Red River frame, a technique also called *poteaux en coulisse* (grooved posts). It came west with the Québécois carpenters and axemen employed by the company.[1]

The vista along the Peace River, seen from the cliff at the south end of Fort St. John's 100th Street, is almost unchanged from fur-trading days when, about 1860, the Hudson's Bay Company re-established its fort on the flat on the far bank of the river. The original Rocky Mountain Fort, founded just upstream in 1793, probably by Alexander Mackenzie, was the first permanent non-Native settlement on the BC mainland. Factor Frank Beaton moved the fort to the flat on the near side of the river in 1872, where it remained until 1925.[2] A very large neo–Greek Revival house sits on the fort site itself, and wrecked cars, pushed off the cliff over previous decades, dot the hillside.

1 Kalman, vol. 1, p. 339.
2 Fort St. John museum records.

A classic frame house: 308 Sixth Street, Revelstoke. The elaborate, stick-built starburst in the gable was not unusual in houses built about 1900, but the closed-in front porch and boot room are adaptations to the cold and snow missing from otherwise identical houses of that era in, say, the Strathcona area in Vancouver.

Frame houses of sawn lumber pinned together with wire nails (the mass-produced and incredibly cheap successors to the hand-forged nails of the fur-trade era) came north into BC rather than west. Balloon framing, developed about 1845, involved the use of what is now called dimensional lumber – usually 2 x 4s – to create a skeleton of continuous light wooden timbers. (Balloon-framed houses have their vertical studs running all the way to the roofline, with the floors attached to them, whereas the preferred twentieth-century method, called platform framing, involves building walls in units, tilting them up, then laying a floor or rafters atop them.) Cottages, in styles called Carpenter Gothic, Steamboat Gothic, Swiss Chalet, Queen Anne and a myriad others, popped up on gridiron townsites throughout the American west[1] and, subsequently, in British Columbia. Nelson and Grand Forks, for example, have excellent collections of these houses, as do such Vancouver Island communities as Victoria and Ladysmith. Boomtown or false-fronted buildings were usually commercial, as in the stores at Dewdney (page 40) and on Denman Island (page 163).

Most of the ranch houses and cabins illustrated in this book are a true vernacular architecture, impossible to classify as belonging to any style and representing a quick response to a harsh climate and a limited budget. Of the very modest buildings, the Aho cottage near Sointula (page 162) shows some cultural decoration – just enough woodwork and paint to be reminiscent of Finland. Somewhat more elaborate, St. Andrew's Lodge at Qualicum Beach (page 155) is a "remembered" English building created by an engineer with a talent for house design.

Unique to British Columbia in all of North America and reflecting the arrival here of English expatriates, many of them remittance men, are the Anglo-Indian bungalows built in the few places where such individuals congregated. Walhachin (page 132), mainly built by Bert Footner, is one; other surviving buildings in that style are Lord and Lady Aberdeen's Guisachan (page 68), now a restaurant in Kelowna, and J.C. Dun Waters's manorhouse at Fintry. Houses with pyramid roofs were a part of Spanish/Portuguese tradition,[2] but the antecedents of the BC examples are clearly the Bengali *Chauyari* (literally "four sides") and *banggolo*.[3] This style of house became quite popular in England and South Africa and is ubiquitous in rural Australia but never caught on in British Columbia – at least, it could never compete with the more vertical, multi-storeyed ranchers with gables and carved fretwork that were popular across the western United States.

Due to costs and fashions, few builders used stone for houses; there were, regardless, few good quarries. Similarly, there were few brickmakers, the Doukhobors (page 82) being a notable exception. British Columbia, however, had excellent sources of limestone for making Portland cement (leading to fortunes including the Butcharts' in Saanich, where the old quarries became the famous garden) and concrete was commonly used for foundations. Before the First World War, its use in houses spread upwards, as concrete-block houses were built in many communities. In East Vancouver, contractors Cotton and Parker built several homes using a hand-operated block machine;[4] the Chilliwack Heritage Inventory[5] lists four concrete-block houses; there are surviving examples in Revelstoke, one on the western outskirts of Keremeos,

1 Walker, pp. 122-37.
2 Walker, pp. 40-1.
3 Anthony D. King, *The Bungalow: The Production of a Global Culture*, p. 24 ff.
4 Houses by them in the Vancouver heritage inventory include 2035 East Second, 2630 Turner and 2168 Parker Street.
5 Foundation Group Designs, 1991.

and at least two houses built of "Ideal" concrete blocks by E.A. Walkley in Kamloops (page 23). Two examples of commercially available concrete-block machines were the "Jarvis," developed in Toronto around 1900 and equipped with several different "rusticated" face moulds, and the Huennekes System for manufacturing "sand-bricks."[1]

GOVERNMENT-BUILT HOUSES There are a few examples of colonization or returned servicemen's cottages designed by provincial government architects or sponsored by provincial departments from the period just after the First World War. The venerable style can be traced back to provincial Supervising Architect Henry Whittaker's Dutch Colonial design for the provincial Department of Lands to use in a Soldiers' Housing Scheme in then-rural South Vancouver;[2] he apparently adapted the design for use by the Provincial Police and other government departments. Gambrel-roofed buildings are still the most common design for forest service and ambulance outposts in the BC Interior. The Yahk lock-up (page 111) is another provincial government design from those years.

With the passage of the Dominion Housing Act in 1935, a response to the decline in living conditions during the Great Depression, followed by the National Housing Act of 1938, the federal government entered the housing business. Both acts empowered the minister of finance to loan a portion of mortgages to prospective homeowners. The Second World War prompted the federal government to become directly involved in building through Wartime Housing Ltd., a crown corporation. The typical Victory House measured 25 x 32 feet, with four to six rooms on a single floor, a tiny front stoop and a simple side-gabled roof. Some government planners considered them to be harbingers of truly manufactured, or factory prefabricated, housing that would become the norm in post-war Canada.[3] Due to the proximity of the North Vancouver shipyards, the federal government in 1941 hired the architectural firm McCarter & Nairne to build 752 of them, 2 of which survive more or less unaltered at 240 St. Patricks and 402 East Third.[4] Better known is the

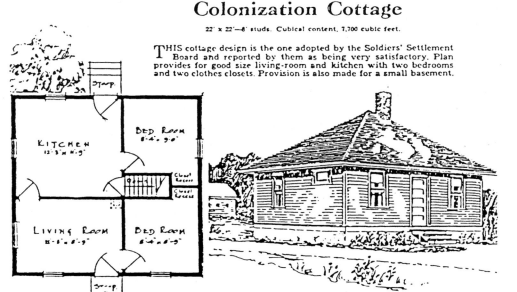

Colonization Cottage

22' x 22'—8' studs. Cubical content, 7,700 cubic feet.

THIS cottage design is the one adopted by the Soldiers' Settlement Board and reported by them as being very satisfactory. Plan provides for good size living-room and kitchen with two bedrooms and two clothes closets. Provision is also made for a small basement.

Provincial government housing styles after the First World War included this hipped-roof cottage plan for returned soldiers' orchard lots in Oliver and Osoyoos, adopted by the Southern Okanagan Lands Project in 1919.[5] With the addition of a full-width front porch, with carved brackets on the porch posts, the little cottage would have looked like the colonial bungalows in English expatriate communities like Walhachin.

1 John R. Stuart, "Observations on the Retaining Wall attendant to the Hotel North Vancouver (1902)," research paper, 1987.
2 Kalman et al., *Exploring Vancouver 3*, p. 203; Donald Luxton, ed., *Building the West*, pp. 428-30.
3 Denhez, *The Canadian Home*, pp. 75-81.
4 Foundation Group Designs, *City of North Vancouver Heritage Inventory*, p. 170; *Vancouver News-Herald*, November 5, 1941.
5 Robert Hobson and Associates, *Okanagan-Similkameen Heritage Resources Inventory*, 1986.

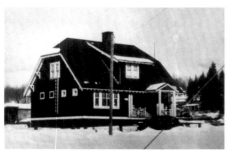

More provincial government buildings:
ABOVE LEFT *6288 Windsor Street, Vancouver, a bungalow designed by provincial architect Henry Whittaker in 1919 for a returned soldiers' settlement, shortly before its renovation in the spring of 2003.*[1]
ABOVE RIGHT *The "DOT site" next to Ashcroft Manor on the Trans Canada Highway: the gambrel-roofed bungalows probably date from a provincial government forestry camp; other buildings were part of a radio-range facility for the Department of Transport, built about 1944, later phased out and converted into a weather station in the 1960s.*[2] *The site is now abandoned.*
BELOW LEFT *The building at 23 Third Avenue, Burns Lake, now the offices of the* Lakes District News, *reveals its parentage as a provincial government building by its gambrel roof and off-centre front stoop. Originally called the Burns Lake lock-up, it was built for the Provincial Police in 1926.*[3] *The rear two of the small windows visible on the side wall probably illuminated cells. Pete Anderson took the photograph about 1952.*[4]

community of Burkeville on Sea Island near Vancouver International Airport, built for the workers at the nearby Boeing airplane plant.[5] Although it bears a strong resemblance, internment camp housing (page 102) was even more modest, and a provincial responsibility.

As part of post-war reconstruction, the federal government on January 1, 1946, created Central Mortgage and Housing Corporation to administer mortgages and to endorse simple house designs that would work anywhere in the country. For a time, CMHC eradicated regional housing styles for popular housing.[6] The modernist post-and-beam "west-coast" custom homes of 1950s Greater Vancouver, perhaps inspiring the ubiquitous Vancouver Special, are a notable exception.

The Victory House's simple, modular design is also similar to Indian reserve housing of the interwar period. Similarly, the National House Builders Association "Mark" houses of the 1950s and 1960s reflect the evolution of housing styles on reserves. The surveyor Samuel Bray designed and built Indian reserve houses in the 1880s, but by around 1900-10 an Indian Affairs standard plan emerged, probably by architect Denis Chené.[7] Over the succeeding decades it remained unaltered in any significant way, with only minor decorative changes from time to time. Typically, it had about four rooms on the main floor with the addition of a bathroom depending on the availability

1 Kalman et al., p. 203.
2 Correspondence from Vashti Fisk, whose grandmother, a Cornwall, was raised at Ashcroft Manor, 2003.
3 BC Archives, Department of Public Works Records GR-0071, box 6, file 103.
4 Photograph courtesy Laura Blackwell, publisher.
5 Kluckner, *Vanishing Vancouver*, pp. 186-7.
6 Denhez, p. 94.
7 Dana H. Johnson correspondence.

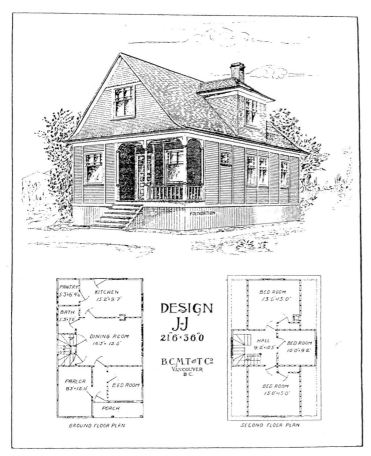

For price, etc., see over.

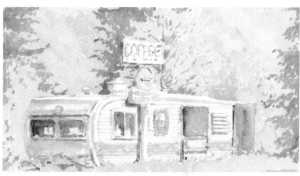

of a septic or sewer system. After 1950, Indian Affairs tended to utilize new standard plans produced by other agencies of the federal government, notably CMHC.[1] Clearly, the houses dictated that Natives would live in nuclear families rather than communally.

Arguably there was an additional assimilative message in the typical reserve house: the lack of open-planned spaces to support traditional family and community gathering and interaction. As well, the small dwellings "sent a message of diminished social status to the broader population."[2] There is the counter-argument that the government had only limited resources, and when they built anything for the broader population they built modest houses, too.

PREFABRICATED OR MANUFACTURED HOMES Travel trailers can trace their ancestry back at least to the gypsies, with the current designs of "fifth wheels" being evolutions of the tent trailers of the 1920s. What is now the familiar form of trailer (as in the buildings in a trailer park), also known as mobile home or Singlewide, had emerged by the late 1950s in models such as the Prairie Schooner and the Arrow in the USA. The Doublewide, touted as "a new concept in space" and being effectively two units designed to be butted together and finished on site, was introduced to the North American market in 1968. With the increasing popularity of mobile homes, governments began to intervene in the 1970s to ensure quality standards and in 1980 the US Congress endorsed the name switch to "manufactured home" – the industry's preferred appellation. A large part of their appeal is that they are "typically half the price compared with custom building," according to the on-line Atlas Mobile Home Directory.[3]

LEFT *From the 1904 BC Mills, Timber & Trading Company catalogue, the Model "J-J," one of the range of prefabricated house styles created by the New Westminster company. They featured modular, insulated wall panels with battens covering the joins – the easiest way to spot an unrenovated one. Two "J-J"s stand side-by-side on the Union Bay waterfront – greatly modified, they are known locally as the "Aladdin houses," a mistaken reference to an American prefabricated-house company that competed with Montgomery-Ward and Sears, Roebuck ("Honor-Bilt" brand) in the early decades of the twentieth century.[4]*
RIGHT ABOVE *A "General" model mobile home, manufactured in Hensall, Ontario, with a shed built onto it, in Hudson's Hope.*
RIGHT BELOW *A travel trailer converted into a coffee shop on the Yellowhead Highway at Avola.*

1 Dana H. Johnson correspondence.
2 Carlson, p. 44.
3 www.allmanufacturedhomes.com.
4 BCMT&T and Aladdin Homes catalogues in the Heritage Branch library, Victoria; Kluckner, *Vanishing*, p. 19; Luxton, p. 166.

British Columbians have bought many prefabricated houses, notably the BC Mills, Timber & Trading Company Ltd. models of the first decade of the twentieth century. Today's manufactured housing market is worth more than $110 million per year. There were about 75,000 manufactured or mobile homes registered in British Columbia in 2002, of which about three-quarters were Singlewides, the balance Doublewides. A typical Singlewide is 14 x 66 feet, fitting more or less into a highway lane. It is often found in trailer parks, *aka* mobile home parks, of which there are almost 600 in BC, about 5 percent of them located on First Nations reserve land. Seventy percent of mobile home owners are 55 or older.[2]

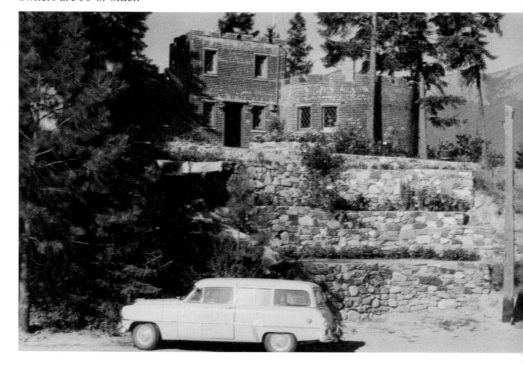

Probably the rarest houses are those built of bottles. There is one across the Island Highway from Wippletree Junction near Duncan, and this one at Sanca, a "six room fully modern residence, constructed entirely of sixty-one thousand 16 ounce glass bottles (30 tons) situated on #3 highway, midway between Creston, B.C. and the Kootenay Bay Ferry enroute to Nelson, B.C." Mortician Dave Brown built it in 1952, using the large supply of formaldehyde bottles he had used in his trade. The caption above is from a postcard published about 1960 by Donaldson's Studio of Cranbrook. Photographer Robert Donaldson bought the Nelson Studio in Cranbrook about 1947 and operated a studio there until 1964. Subsequently, he retailed camera products. This image is one of about 40 of his Ektachromes that were published as postcards.[1]

HIGH-STYLE BUILDINGS Of the buildings illustrated in this book, only a handful are "pure" enough to be classified as belonging to any style. The earliest is the house in the Second Empire style built by Caspar Phair in Lillooet and now known as the Miyazaki house (page 170). Mansard roofs became popular during France's Second Empire (1852-70), and Parisian expositions in 1855 and 1867 spread the style to England and abroad.[3] By the time it arrived in Lillooet in the early 1890s, it was out-of-date in urban Canada. Other surviving examples, possibly the only ones in the province, are the Jones house at 1124 Fort Street, built in 1886, and the Jacobson house at 507 Head Street, built in 1893, in Victoria; and, surprisingly, the Hillcrest Motel in Pouce Coupe, built in the 1920s (page 33).

By comparison, Balcomo Lodge in Summerland (page 64), influenced by the Arts and Crafts style, was still fashionable when it was built in 1906. Blaylock, near Nelson on Kootenay Lake (page 93), is a lavishly built rural estate in the Tudor style. The three ranch houses built by Malcolm Gordon of Penticton, near Bridesville (page 75), are an example of an urban style, the Craftsman, making it into the countryside.

1 Interview with son George Donaldson.
2 Source: Hanam Canada Corporation, a market reports and sales research company, at www.hanamcanada.com.
3 McAlester and McAlester, *A Field Guide to American Houses*, p. 242.

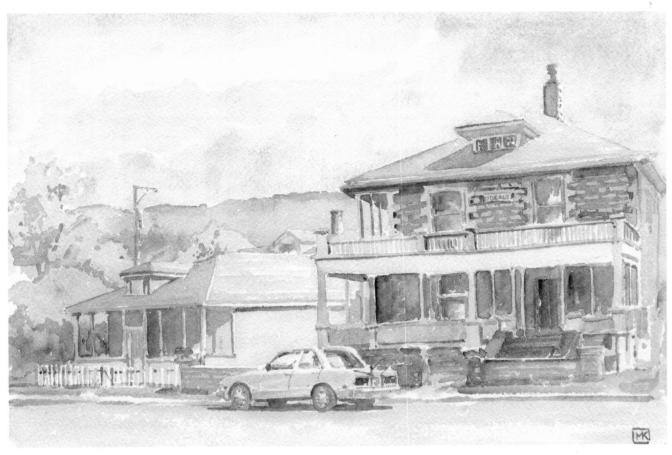

In the neighbourhood southeast of downtown Kamloops, 673 Battle Street is distinctive, being made of concrete blocks with a small plaque, visible on the wall between the two upper-floor windows, reading IDEAL. *E.A. Walkley manufactured "Ideal" concrete blocks in a long shed located at the back of the next door lot. In 1911, the year before he built this house, he had purchased the Small and Dobson Cement Plant in BC Fruitlands. The second all-block home he built is 467 St. Paul Street, a bungalow now used as a Women's Shelter. He sold the Battle Street properties in 1923 to William and Aida Snowden of North Bend, who allowed him to continue making his blocks in his shed; following Aida Snowden's death in 1982, the Ideal was sold and became a rooming house. However, the Snowdens' grandchildren, the Nickels, bought it back in 2002 and are restoring it.[1] It likely will be one of the handful of survivors from that era, as the neighbourhood has been recently rezoned, with many nearby properties for sale behind billboards breathlessly touting their development potential.*

PLACES OF EXILE AND UTOPIA

There is a fine line between exile and utopia, unless you happen to have been a Japanese Canadian in the early 1940s and were ordered away from the coast. From its earliest days, British Columbia's complex geography attracted misfits, who could have been exiles, utopians, or both. The remittance men of upper-class England, such as the nephew of Cecil Rhodes sent to Walhachin to manage his family's investments after an attempt to start a revolution in Costa Rica, often fled or were pushed to distant colonies to escape their past indiscretions.[2]

When the province made it into literature, it was often as a place where people could go and start again, where nobody knew them and their past was left behind. (In D.H. Lawrence's *Lady Chatterley's Lover*, Constance Chatterley implores the gamekeeper to escape with her from their impending disgrace. "Why should we not just disappear, separately, to British Columbia, and have no scandal?") Dudley Shaw's cabin at Hudson's Hope (page 202) became a dreamscape, as it were, due to the writings of Bradford and Vena Angier.

1 Correspondence from Arlana Nickel, quoting information from the Kamloops City Archives.
2 Riis, "The Walhachin Myth: A Study in Settlement Abandonment," *BC Studies*, 17, p. 18.

A prime destination during its mining and internment-camp eras, New Denver also attracted hippies, war resisters aka draft dodgers and other potential communalists in the late 1960s and early 1970s. Evidence of that third wave survives today in the strong environmentalism of the societies devoted to the nearby Valhalla wilderness, the hair and clothes in the town, and some whimsical architecture, like this house on Bellevue Street built by Glenn Jordan.[1] "Hobbit-house" buildings like this are seen elsewhere in the province on a few of the Gulf Islands, on Denman and (especially) Hornby islands, and at Tlell on the Queen Charlottes.

1 Interview with Gary Wright, mayor of New Denver.

Some mining communities merit a utopian definition. A utopia to the prospectors was a place with lots of money and few rules. There was Barkerville in the 1860s with its boomtown wooden architecture, narrow streets and shanties; Sandon, destroyed twice by fire and flood (page 105); and Zeballos (page 166), seemingly made up as it went along, evolving from beach shacks to hotels in a few years. Many mine sites, like Phoenix near Greenwood (page 80) or Discovery near Atlin (page 200), became the archetypal ghost towns, the fodder for numerous nostalgic forays by "history buffs." Like that of Atlantis, their legends remain, but being modern tales they were documented photographically.

The misfits included religious exiles, also utopians, most notably the Doukhobors whose exodus from the Canadian prairies to the Boundary and Kootenay districts came after the federal government denied them an exemption from the individual-ownership provisions of the Homesteading Act (page 82). Among the cultural misfits, Finns sought enough of an exile to ensure them the opportunity to develop their own utopia – "Kaleva" at Sointula on Malcolm Island (page 161). Ironically, another surviving Finnish community, the aptly named Finn Slough on the south arm of the Fraser River near Steveston (page 37), has become a sort of utopia a century later. And then there were the racial "misfits," primarily the Chinese, who lived apart from whites from the earliest days of the gold rush and railway construction; almost all the historic Chinatowns except the two big ones, in Victoria and Vancouver, survive only in photographs. A generation of Chinese Canadians ran grocery stores such as Wong's Market (page 38). *Vanishing British Columbia* documents the 1942 exile of Japanese Canadians from the coast, following them from Vancouver and Mayne Island (pages 38 and 150) to the Kootenays, the Shuswap and Lillooet (pages 99, 135 and 170), as well as, post-war, to Spuzzum (page 116).

A recent group of exiles and utopians were the "back to the landers" who fled the cities for the Kootenays and the Gulf Islands in the 1960s and early 1970s, creating some interesting communities with architecture as diverse as vans, geodesic domes and Arts-and-Crafts quality "hobbit houses." Dr. Donald Branigan's holistic healing centre in Atlin (page 199) sprang from the same fertile ground. For more conventional cottagers, the Gulf Islands (pages 145 ff) and the "Gulf Coast," once served by the Union Steamships Company (page 50), remain a utopia to this day.

CORRIDORS

Some of the most successful heritage efforts of the past generation have been toward trail preservation, including the "rails to trails" movement for abandoned railway lines, much of which has come together into the Trans Canada Trail network. When Alexander Mackenzie became the first white man to traverse North America, arriving at tidewater near Bella Coola in 1793, he used Aboriginal trading trails and guides to get to his destination. Other historic corridors were rivers, none more famous than the Fraser, to the mouth of which its namesake canoed in 1808.

The most significant corridor of the post-contact era is the Cariboo Road,

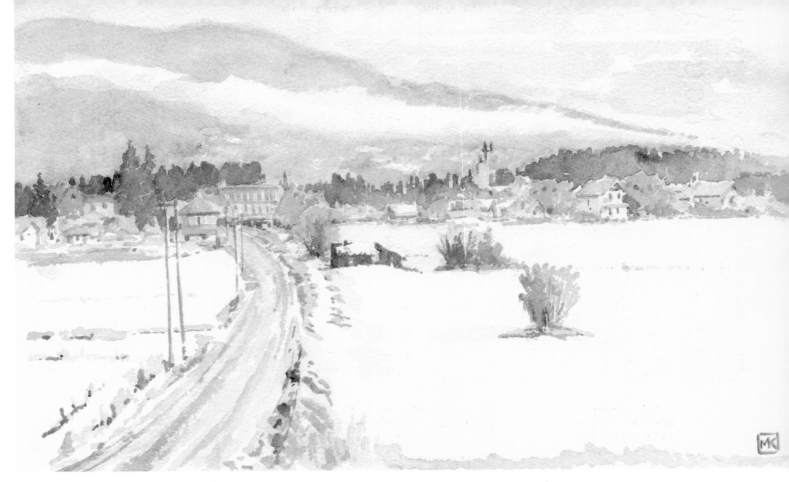

The remains of one of BC's historic Chinatowns:

ABOVE *Because of a dispute between the Shuswap & Okanagan Railway and a landowner a mile to the north, Armstrong became established on the "Island," the sandbank in the middle distance with swamps and sloughs on both sides. The railway line and the town's main buildings were established on this high ground along today's Pleasant Valley Road. Once the swamps in the foreground and on the far side of the "Island" were drained, Chinese farmers took them over, turning "the flats" into neatly cultivated vegetable fields and earning Armstrong its nickname Celery City. The dark brown wooden cabins along the road (Okanagan Street) midway across the flats, painted in January 2004, are the last survivors of a group that provided accommodation during the growing season for the field workers.*

BELOW *In the wintertime, the workers lived in a bunkhouse arrangement on the upper floor of the Lee Bak Bong Building which stands, together with another similar but altered one, on Okanagan Street on the edge of the flats on the far side of the "Island." The main floor was a grocery store and vegetable distribution centre. Built by Mah Yick using the last of the output from the Armstrong brickyard, the building was erected in 1922 following a fire that destroyed much of the original Chinatown. The painted sign of the Kwong Wing On & Co., which rented the building from Mah Yick for a few years until the Lee family bought it, is still faintly visible on the brick facade. After living in Victoria for a few years, Lee Bak Bong returned to China in 1910 to marry, then moved to Armstrong; 10 years later, he was able to pay the $500 head tax to get his wife into Canada, and because of the passage of the Chinese Immigration Act in 1923 Mrs. Lee was for decades the only Chinese woman in Armstrong. Their vegetable wholesale operation was called Wing Quong & Co., after the two eldest sons of the Lee family. The survivors of the Lees' seven sons and four daughters, including Ben Lee of Kelowna, now own the building which has been vacant for nearly 30 years. The flats have grown up in sedge and weeds.*

(See Johnny Serra, "Armstrong Packing Houses," Okanagan Historical Society, 28th report, 1964; Peter Critchley, The Chinese in Armstrong, OHS, 63rd report, 1999; Armstrong Heritage Inventory, 2001. Thanks to Lisa Mori, curator, Armstrong-Spallumcheen Museum-Archives.)

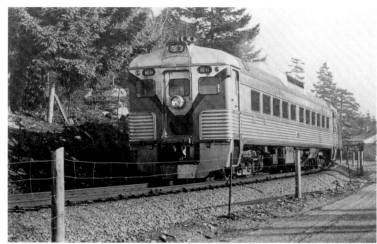

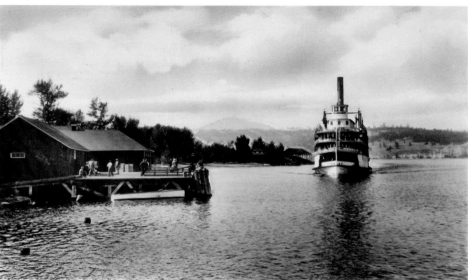

ABOVE LEFT *"Early BC Stage at 100 Mile House, British Columbia," a promotional card by an unknown photographer published by the Pacific Great Eastern Railway (BC Rail). The coach now occupies a shed in front of a modern hotel.*
ABOVE RIGHT *A PGE self-propelled Budd car – a 1950s promotional card by an unknown photographer. The "Cariboo Dayliner" service ended in the fall of 2002, cancelled by the provincial government, but may be revised as a tourist route under the railway's new CN owners.*
RIGHT *The SS* Sicamous *paddlewheeler approaching the Kelowna wharf about 1925. Like the* Moyie *at Kaslo, the* Hazelton *at Hazelton and the* Tarahne *at Atlin, the* Sicamous *is beached (at Penticton), relic of an era of picturesque, gracious transportation on the province's lakes and rivers. The postcard, a hand-coloured photograph, was published by the Camera Products Company owned by photographer Joseph Spalding, a former partner in the prolific Gowen-Sutton firm of Vancouver.*[1]

1 Thirkell and Scullion, *Frank Gowen's Vancouver, 1914-1931*, p. 10.
2 *Lillooet-Fraser Heritage Resource Study.*

connecting the head of navigation at Yale with the Cariboo goldfields in the 1860s; it and restored Barkerville are the legacy of the events that led to the creation of the colony of British Columbia. As the Cariboo *Highway*, opened in 1926 as a section of the Trans Canada Highway and what is now called Highway 97, it ushered in an era of truck transport and automobile travel (page 114). In the Cariboo, the old mileposts – the names of communities like 70 Mile House and roadhouses like 137 Mile House (page 179) – keep the memories alive.

An earlier corridor now all but forgotten is the Harrison Lake-Lillooet route used by miners heading to the Cariboo. It provided the initial access to the goldfields and was the most highly developed path to the Interior from 1858 to 1863.[2] The Indian village of Skookumchuck, with its splendid 1905 church (page 15), is a significant stop along the way.

Along the 49th parallel, defined as the international boundary in 1846, the Dewdney Trail was constructed to forestall American incursion into southern British Columbia (page 54). It still survives, in the broad sense, as the route of the Southern Transprovincial Highway.

The railways brought profound change to the province, beginning with the Canadian Pacific Railway in the 1880s, whose Fraser Canyon section effectively wiped out the 20-year-old Cariboo Road; North Bend (page 123) is the

surviving hamlet from that era. The other transcontinental lines from a century ago – the Canadian Northern Pacific and the Grand Trunk Pacific – continue their role for freight and the handful of remaining Canadian train passengers, their stations still landmarks across the province's midriff (pages 186 ff). On Vancouver Island, the beleaguered Esquimalt & Nanaimo Railway – a federal government bauble to spur BC's embrace of Confederation in 1871 – continues to operate a passenger service in a haphazard way (page 142). The mainland equivalent is the old Pacific Great Eastern, in recent decades called BC Rail, a lifeline for freight between the north and the Lower Mainland but a money-loser on the passenger side (operated by CN since 2004). Another line, still-born due to economic woes and war, was the Canadian Northeastern, with Stewart as its terminus (page 195).

The most railway-interlaced part of BC in the 1890s, the Kootenay/Boundary country, has lost most of its tracks, although much of the Kettle Valley Railway right-of-way is now part of the Trans Canada Trail (the majority of the Myra Canyon trestles were destroyed in the forest fires of the summer of 2003). Some railway hamlets like Coalmont (page 58) all but disappeared but may be reborn due to "trail tourism." The right-of-way of the famous Kaslo & Sandon narrow-gauge line to Payne Bluffs is now maintained as a path (page 107).

Two long-vanished CPR hotels:
LEFT *The Sicamous Hotel, designed by Edward Maxwell and opened in May 1900, had 60 guest rooms (5 with private bath). It closed in 1956 and was demolished in 1965.[1] Postcard by the Gowen-Sutton Co. Ltd., photograph c. 1925. On the back of the card, tourist Jessie Acorn wrote: "This is where Jean and I spent the night waiting for the train to Kelowna. There are plenty of mosquitoes."*
RIGHT *On the E&NR, the Strathcona Hotel served day trippers and travellers. Postcard by Valentine & Sons, c. 1915.*

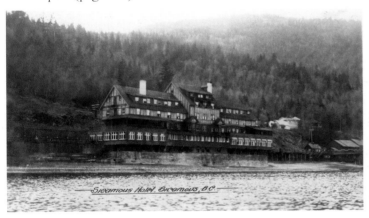

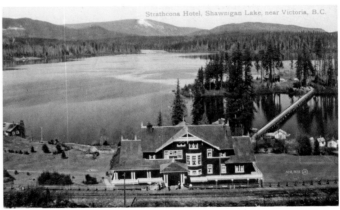

It is quite difficult to trace some old routes, especially those that were linked with the main lines by paddlewheelers. The flooding of the Arrow Lakes in the late 1960s drowned many communities and eliminated pathways and landmarks. Some corridors ended up being reused, like the Great Northern Railway line between the Cawston area and Princeton which became the roadbed for the Southern Transprovincial Highway – one railway bridge survives across the Similkameen River (page 56). However, sections of the GN line which looped into the USA, such as the one near Bridesville (page 77), are very hard to locate today.

All the railways built beautiful stations, whether for whistlestops or divisional points. Uniting their designs, regardless of the line, are their spreading, "bellcast" rooflines and the oversized brackets between the eaves and the walls. A handful of them remain on their original sites, the oldest being the Columbia & Western (CPR) station in Grand Forks, now converted into a pub/restaurant. The station at Salmo recalls the Nelson & Fort Sheppard

1 Jo-Anne Colby, CPR Archives, Montreal.

ABOVE *Third Avenue, Prince George, in the 1950s. An up-to-the-minute Royal Bank building shares the street with prewar woodframed commercial architecture. Photographer unknown.*

BELOW *Built in Lower Town, quite a distance from the commercial downtown, and now sitting in the middle of a grassy sward surrounded by modest houses, the Revelstoke courthouse is a curious landmark from a time when governments and landowners were feuding over where the town centre ought to be. Designed by Thomas Hooper and built in 1912 by the local construction firm of Foote and Pradolini,[1] it is one of the surviving set of grand provincial public buildings from the time of the Richard McBride administration, when Thomas Taylor, the MLA from Revelstoke, was the minister of public works. Like Fernie and Grand Forks before it, Revelstoke purchased its courthouse from the provincial government on June 1, 2003, for a reported $350,000. Although it was one of 16 courthouses sold by the government following a consolidation of court services, it will continue to host a circuit court.*

Railway (page 92). Fort Langley and Boston Bar have their Canadian Northern Pacific stations, both moved from their original locations. Brookmere has the last surviving water tower from the CPR's Kettle Valley Railway (page 59), and Midway's station is now the town museum. Unfortunately, the beautiful CPR resort hotels in the mountain sections of the province and on Vancouver Island have all been demolished.

GOVERNMENTS AND OTHER INSTITUTIONS

The federal government once had a splendid record of building high-quality public architecture that was lauded as helping to "form the public taste" and becoming "an influence for good."[2] In recent years, government agencies such as Canada Post have usually tended to build small, rather mean outlets, abandoning their earlier edifices. Greenwood's turreted post office (page 81) is a notable exception.

The province, especially during the prosperous first decade of the twentieth century when Sir Richard McBride led a stable Conservative government, also anchored many BC communities with magnificent public buildings, such as the courthouses in Rossland, Greenwood (page 80), Fernie and Revelstoke. In Atlin (page 198), a more modest courthouse from that era continues to be

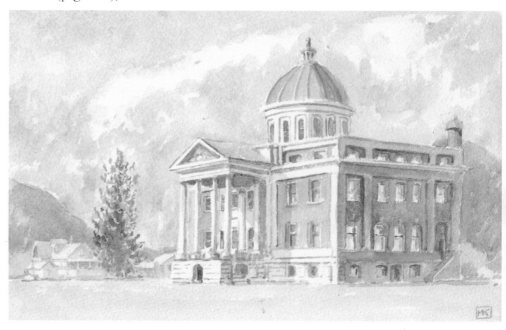

1 Ruby Nobbs, *Revelstoke Architectural Heritage Walking Tour* brochure.
2 Quoted in Kalman, *A History of Canadian Architecture,* vol. 2, p. 546.

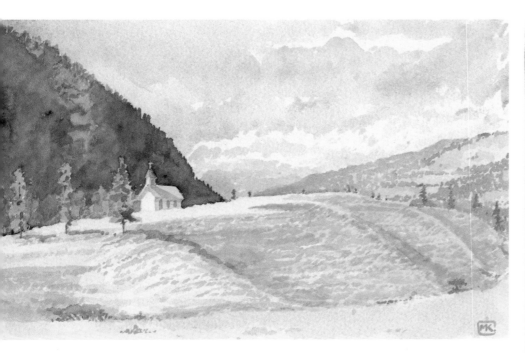

used for circuit court. Even the small Provincial Police buildings in villages like Yahk (page 111) and Burns Lake show design and construction merit that still command attention, although some are in ruins. It is hard to imagine, given the anti-public-sector rhetoric of recent years, what an object of civic pride government buildings once were. School buildings have fared better: cities like Kelowna and Vernon still have their magnificent public schools from the early years of the twentieth century.

As with reserve housing, the Department of Indian Affairs reinforced the government policy of assimilating Native peoples into Canadian culture with their residential schools (pages 112 and 159), most of which in the nineteenth century were designed by private architects. After 1900, most plans were the work of department architect Robert M. Ogilvie and used his standard format (indeed, like the standard-plan schools erected for the broader population). His successors, Denis Chené and R.G. Orr, continued the practice through the 1920s.[1]

Canada's banks erected dour, substantial edifices along many a main street, then abandoned them in the 1960s and 1970s seeking a more up-to-date, modern look. In small communities in the early years, banks often looked to the BC Mills, Timber & Trading Company for prefabricated designs, two of which (in Steveston and Mission) survive as museums. A design exclusive to the Canadian Imperial Bank of Commerce was erected on Seventh Avenue in Keremeos; it is now used by an insurance company; another BCMT&T prefabricated bank building at 2420 Douglas Street in Victoria is now used by an insurance agency.

As elsewhere in the country, churches are threatened as fewer Christian Canadians attend religious services. The Indian reserve churches are a special case: in spite of their association with residential schools, many Anglican and Roman Catholic ones are treasured by their parishioners. Small churches, some in Indian villages such as at Gitsegukla near New Hazelton (page 192) or at Skookumchuck north of Harrison Lake (page 15), dot the roadsides of the province. None is more dramatically sited than St. Aidan's at Pokhaist Village on the Thompson River (page 128).

Two Indian village churches: LEFT *St. Ann's Catholic at Chuchuwayha near Hedley, erected in 1910-1, is a sparkling white dot on the golden fields.* RIGHT *The Anglican St. Michael and All Angels — for travellers heading east on the Trans Canada Highway, it has always signalled their arrival at Spences Bridge — sits on the edge of the Cook's Ferry Indian Band village. With its brown dome and slumped shoulders it has a demoralized look. Apparently it was built around 1905, replacing an earlier church destroyed in the horrific landslide that also wiped out the Indian village on the other side of the river.*[2]

1 Dana H. Johnson, "Indian Affairs 1887-1962," in Luxton, ed., *Building the West*, p. 73.
2 The best overview is Veillette and White, *Early Indian Village Churches*.

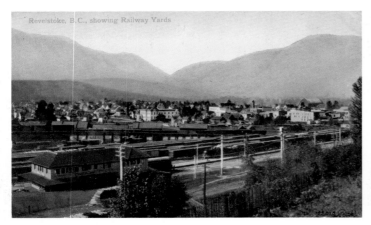

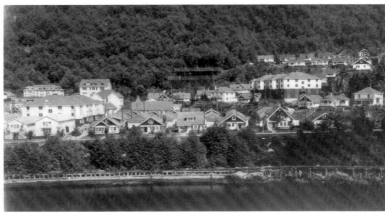

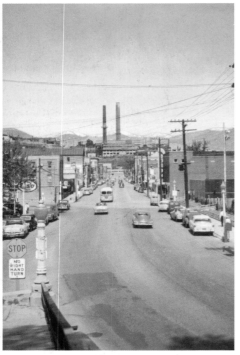

Three company towns:
LEFT ABOVE *Revelstoke c. 1910,*
a Valentine & Sons postcard.
RIGHT *Part of the residential area*
of Ocean Falls showing Apart-
ments 4 and 5, with the tennis
court structures built into the
hillside visible in the middle; a
Gowen-Sutton Company
photograph.
BELOW *Trail in the 1950s,*
looking toward the Cominco
smelter; photographer unknown,
postcard distributed by Hammitt
Company, Kelowna.

1 T.W. Paterson and Garnett Basque (Sunfire, 1989).

COMPANY TOWNS

BC's two biggest industries, forestry and mining, created many of the company or resource towns dotting the province. The fishing industry also created a myriad of outports, many of which have completely disappeared, with the fish-packing heritage of the coast now preserved in cannery museums at Port Edward and Steveston. The BC Packers complex at Alert Bay (frontispiece) was demolished in 2003.

I found the former coal-mining communities on Vancouver Island the hardest to "read." The pitheads and works have largely disappeared, and the rows of identical miners' houses that made for dramatic historic photographs have been altered or infilled. Cumberland is most reminiscent of the years when its employer, James Dunsmuir (like the Crich family in D.H. Lawrence's *Women in Love*), controlled every aspect of life. Nanaimo's Southend at the pithead of the Number 1 Esplanade Mine still looks like a workers' town, its rows of small houses interspersed by inexpensive hotels with taverns, with the interesting Evergreen Auto Court still standing on the edge of the railyards (page 153). South Wellington, another Dunsmuir coal community, is a hodgepodge of little buildings around Scotchtown Road at the point where it crosses the E&N Railway line, but I could not find a scene to paint that was either well-restored or pleasingly deteriorated. Union Bay has assembled some of its historic buildings along the waterfront, where the ruins of the wharves testify to the scale of industry once there. This mining history is probably best appreciated now in museum displays and rollicking history books such as *Ghost Towns and Mining Camps of Vancouver Island.*[1]

Trail, child of the Cominco smelter, is dominated by its enormous smelter (page 93; only Powell River, page 46, compares). Bralorne (page 172), the company town for a gold mine developed in the 1930s by a syndicate of Vancouver capitalists, is attempting to reinvent itself as a recreational area while the mine awaits higher gold prices. Britannia Beach is another former company town standing in the shadow of its copper smelter (page 48). These towns, once controlled by a single company, make an interesting comparison with Wells (page 182), whose owners made a sincere attempt to create a town that could survive its mine closing, and with freewheeling Zeballos (page 166). With the aid of old photographs, stories and the few surviving buildings, North Bend (page 123) comes alive in the imagination as a railway company town. Revelstoke, much bigger and with a more diversified economy, is still dominated by railyards.

The first big post-war company town, Alcan's Kitimat, relied on American

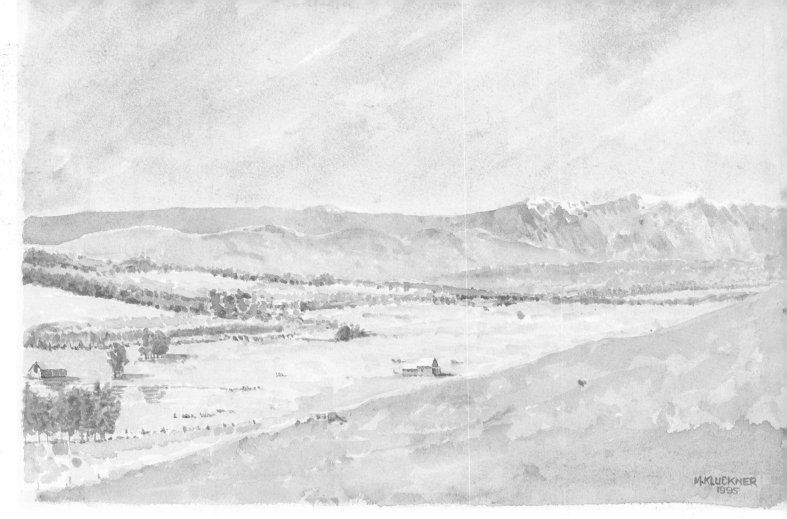

planners and reflects Garden City or Greenbelt City concepts popular around the time it began construction in 1952. According to Harold Kalman, it is "the most successful example of a comprehensively planned resource town" in Canada.[1]

FOLKLORIC LANDSCAPES

In the province's folklore, individuals survived the rugged environment while following their dreams – perhaps mining, but more often some aspect of food production like ranching or fishing. Such rugged individualists were probably always in the minority, and much of the development of the province, even in its earliest days, was due to well-organized and administered foreign capital. Whether one refers to the British colonial administration constructing the Cariboo Road, eastern Canadian and federal government capital building the CPR, or the Anglo-British Columbia Packing Company consolidating small canneries and developing its own fishing fleets, British Columbia quickly became a society of the employers and the employed, with only scattered instances where a yeomanry developed. Later, the capital was locally amassed: the Woodward department-store family established Douglas Lake Ranch east of Merritt, for example, or Vancouver industrialist Austin Taylor developed Bralorne.

Nevertheless, folkloric BC *images* easily come to mind: cattle ranches in the Cariboo or the dry Boundary Country, where the golden bunchgrass hills, dotted with Ponderosa pines, sweep up to skies of astonishing translucent

The Lawless ranch from Anarchist Summit, looking west to the Cathedral Mountains on a spring day in 1995 – the sort of "folkloric" scene of wide-open spaces and boundless opportunities synonymous with the idea of "the West" promoted in magazines like Westward Ho!, Man to Man *and* British Columbia *in the first decade of the twentieth century.*

1 Kalman, *A History of Canadian Architecture,* vol. 2, pp. 672-3.

azure (pages 74 ff); coastal fishing villages such as Sointula (page 161), some accessible only by sea, with a jumble of pilings and wharves, grey, unpainted boathouses and netlofts with rusting metal roofs and a cluster of brightly painted wooden seiners, the sky leaden and threatening rain, a few shingled cottages clustered near the shore with a backdrop of moody cedars; the trapper's or prospector's shack like Camp Defiance (page 55), a cleared patch where a dreamer tried to push back against the siege of Mother Nature.

The Cree-Met Drive-Inn in Pouce Coupe is a rare survivor from the era before burger chains roamed the land, gobbling up everything in their path, an era when a man with a grill, a deepfryer, a soft ice cream machine and a jukebox could erect a sign saying, perhaps, "Tastee-Freez," and the townsfolk would beat a path to his door. "It was run by a man named Pete, who had a top secret soft icecream recipe that brought people from miles around. It could be purchased in cardboard pint containers as well as cones. We always stopped there each year after our big Saskatoon berry picking excursions."[1]

1 Correspondence from Brenda Anderson, with recollections from Jill Wonnacott (former mayor).
2 An expression apparently coined by essayist Reyner Banham, "the historian of our immediate future."

THE ARCHITECTURE OF MOBILITY[2]

Gas stations, motels and drive-ins are the ultimate roadside memory. The quirkiness of early gas stations was captured by movie-set designers in the Gas for Less station on page 34, and survives in the service station at Union Bay (page 153). Just as gas is now pumped at national chains with a corporate image, burgers and shakes are now consumed at the McDonald's and Wendy's that dot the province like cloves on the fat of a Christmas ham. "Highway-commercial" architecture – Canadian Tire, Petrocan, Wal-Mart – the same modular design anywhere throughout the corporate empire, dominates the outskirts of modern BC towns, whether in Langley or Cranbrook, Prince George or Kelowna.

The holiday "experience" has in effect come full circle in the past century. From the railway-developed destination hotels of a century ago in the mountains and on the lakeshores, to the motels and auto courts that began to spring up in the 1920s (Evergreen Auto Court, page 153; Alexandra Lodge, page 117; Siska Lodge, page 122), to modern resorts such as the Lake City Casino at Penticton or the Naramata Hotel (page 66), leisure accommodation has gone from the exclusive to the democratic and back to the exclusive, or from "destination" to "wanderer" and back again. Any time spent in motels – so fashionable in the 1950s and 1960s – now has a downmarket cast to it, and many small-town hotels, like Coalmont's (page 58) or Beaverdell's (page 72), survive on the proceeds of their beer parlours. A handful of others, like the Windsor Hotel (page 96) and Springwater Lodge on Mayne Island (page

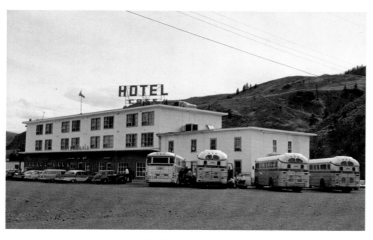

The evolution of vacation accommodation, a contrast with resorts from the railway era of a lifetime ago (such as the hotels on page 27) and the modern destination resorts like the Naramata Hotel (page 66).

LEFT ABOVE *The Hotel Oasis in Cache Creek, c. 1965: "A modern, completely air-conditioned 32-room Hotel and Coffee Shop, at the Sportsman's Crossways – Junction of the Trans-Canada and Cariboo Highways." A Traveltime card, photographer unknown.*
LEFT BELOW *The Crown Motel: "21 De Luxe Units – including a new and just completed 'Double-Decker.' On beautiful Okanagan Lake, Lakeshore Drive, Penticton."*
PHOTOGRAPH © HUGO REDIVO
RIGHT ABOVE *The Hillcrest Motel, with "Kitchenettes & Plug-Ins," in Pouce Coupe. It is a classic auto court: one side of the property occupied by four duplex bungalows set in a semicircle, the other side occupied by the owner's house (surprisingly mansard-roofed – a very retro style) and garage. The house was an RCMP-Provincial Police outpost in the 1920s and 1930s, when Pouce Coupe was the government service centre for the newly opened Peace District, and is actually a log structure covered now by siding. The walls are nearly two feet thick, creating a window seat. The upstairs floor of the house was the barracks and the main floor was the police station.*[1]
RIGHT BELOW *A Garbage Gobbler; icon of the 1958 BC centennial, in front of Ashcroft Manor.*

1 Correspondence from Brenda Anderson quoting Everett Beaulne, who lived there from 1959 to 1968 and still runs the Hillcrest General Store.

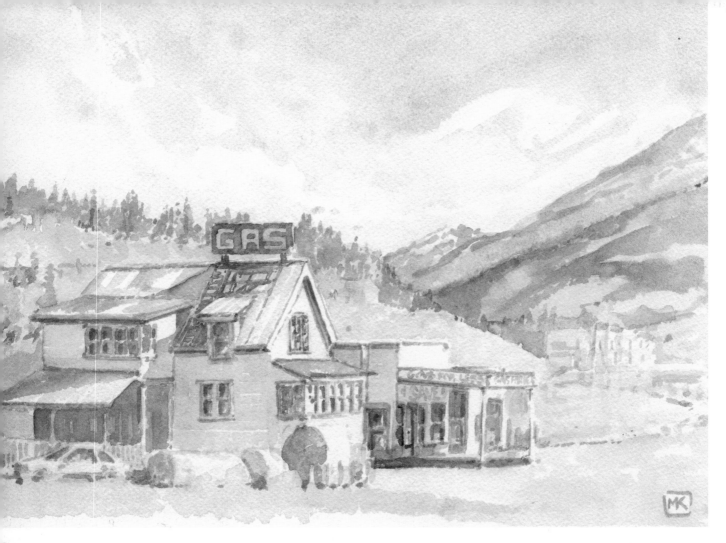

Gas for Less on the outskirts of Lytton looked so much like the independent service stations from a generation ago that I pulled into a shady spot on a blazingly hot day in August 2001 and spent a pleasant hour putting it into the sketchbook, then moved on without investigating further. Perhaps the heat made me careless. Some months later, I saw it in an American movie, The Pledge, *and commented on my website how pleased I was that filmmakers were seeking old buildings. Soon, I learned from a bemused reader, Catherine Schulmann in Lillooet, that my subject was "Hollywood magic" — a movie set built from scratch a few years earlier!*

149), still provide good accommodation without any modern "spa" frills. St. Eugene's Mission (page 112), a former residential school now the centrepiece for a golfing resort, completes the circle.

Along the highways roadside attractions sprang up, usually at a scale that could be appreciated by a motorist passing at high speed. Drive-in theatres once dotted the sagebrush fringes of dusty Interior towns and former orchards on city edges, while fantasy attractions like the ersatz historic towns of Wippletree Junction near Duncan and Three Valley Gap east of Sicamous, and Dusty's Dinotown at Popkum near Rosedale, competed for the dollars of tourists who usually had a backseatful of bored, hostile children. These sorts of places in the USA are documented and interpreted by the Society for Commercial Archaeology. Established in 1977, the SCA is the oldest national organization devoted to the buildings, artifacts, structures, signs and symbols of the twentieth-century commercial landscape. Regrettably, there is no parallel organization in Canada.

Southwestern Mainland

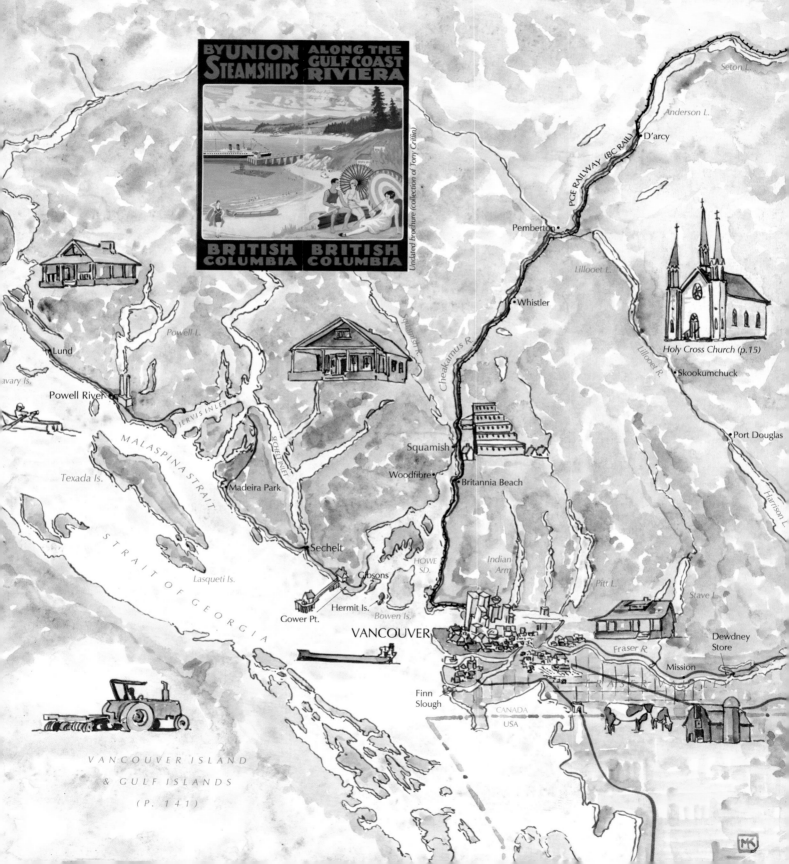

BY UNION STEAMSHIPS ALONG THE GULF COAST RIVIERA

BRITISH COLUMBIA BRITISH COLUMBIA

Undated brochure (collection of Tony Crilfin)

Seton L.

Anderson L.

D'arcy

PGE RAILWAY (BC RAIL)

Pemberton

Lillooet L.

Whistler

Holy Cross Church (p.15)

Lillooet R.

Skookumchuck

Port Douglas

Powell L.

Lund

Cavary Is.

Powell River

Squamish R.

Cheakamus R.

MALASPINA STRAIT

JERVIS INLET

SECHELT INLET

Squamish

Woodfibre

Britannia Beach

Texada Is.

Madeira Park

Harrison L.

STRAIT OF GEORGIA

Lasqueti Is.

Sechelt

HOWE SD.

Indian Arm

Pitt L.

Stave L.

Gibsons

Gower Pt.

Hermit Is.

Bowen Is.

VANCOUVER

Fraser R.

Dewdney Store

Mission

Finn Slough

CANADA
USA

FRASER VALLEY

VANCOUVER ISLAND
& GULF ISLANDS

(P. 141)

The Lower Mainland

In Vancouver's lower Mount Pleasant district, a few isolated houses from a century ago, so different in form and texture, so mellow in the pale April sunshine, stand up above the smooth, flat-roofed buildings south of False Creek and look toward the shiny towers of the post-Expo city: writer Douglas Coupland's City of Glass. [1] *Carpenter Duncan McLennan built this house at 1919 Quebec, and its two long-vanished neighbours to the north, in 1907, keeping it for himself.* [2] *This area, together with its Strathcona, Fairview and Kitsilano neighbours, was zoned in the Harland Bartholomew plan of 1930 for light industry, providing a transition between the "satanic mills" of False Creek and proposed apartment areas beyond.* [3] *That transition remains incomplete even today.*

1 Douglas and McIntyre, 2000.
2 Water permits, City of Vancouver Archives.
3 See Wynn and Oke, *Vancouver and Its Region*, p. 128.

Change in cities is often callous, dismissive of history, and disruptive to the lives of the people already there – especially the poor. But it *is* inevitable, and one of the marks of maturity of modern cities is their ability to manage it.

The most successful, livable cities change incrementally. They evolve. Their layers of history remain visible, unlike the clearcuts – to use a logging analogy – of planners and architects who believe that the future can exist in a single crystalline vision, like Le Corbusier's Radiant City of the 1920s.

After a brief flirtation with urban renewal and downtown freeways in the 1960s, Vancouver set itself on an incrementalist path, absorbing enormous growth by finding new uses for abandoned industrial land. In its neighbourhoods, there slowly arose in the late 1980s and 1990s a recognition that historic wooden houses, mature trees and established gardens were a distinctive, valuable part of urban life. The city has muddled along in a very west-coast way, most notably retaining the Lions Gate Bridge even though it is not really adequate for the twenty-first century. Even the few wild-eyed romantics who thought it should be saved because it was a beautiful heritage object, a universally recognized icon, were sneered at only a little.

Other Lower Mainland cities have struggled to maintain their historic layers. New Westminster is a stable, gracious city rather like Victoria. Burnaby has focused its preservation efforts around the enclave of Edwardian mansions at Deer Lake. Isolated farmhouses have become the centrepieces of regional parks in Coquitlam, Surrey and Langley. However, the old town centres have been swallowed up by suburban growth and fight a losing battle against malls and big-box retailers. Only the Agricultural Land Reserve, established in 1972, constituting 70 percent of the Township of Langley, for example, has cinched a tight greenbelt around the expanding suburban girth. That fateful year, 1972, also saw the cancellation of the waterfront freeway system that was to raze Gastown and Chinatown, and slowed the Lower Mainland's slide down the greased ramp toward becoming another L.A.

ABOVE *Two that got away: the bungalows built in 1913 by James Quiney at the corner of Second and Waterloo in Kitsilano, demolished in 2001 and replaced with two large neo-Craftsman houses that more accurately reflect Vancouver's stratospheric real-estate values. Architecturally, they were among the best colonial bungalows in the city, with breezy open verandahs, board-and-batten siding and low-pitched roofs – the near one hipped (his home), the other with side gables. Historically, they recalled the family whose earlier house (long-since demolished) at the corner of Fourth and Dunbar was the first in that part of Kitsilano.[1] Quiney's camera documented his family's life, including their pet bear, leaving an excellent set of photographs in the Vancouver archives. About 1910 he was working for R.D. Rorison selling real estate: the blocks now filled with splendid Craftsman homes northwest of Fourth and Blenheim that have set the fashion for modern infill in the neighbourhood.*

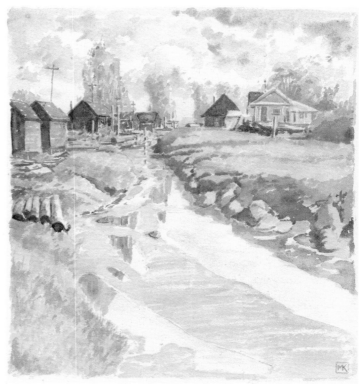

RIGHT *Significant as a relic of the way of life of an early immigrant community, picturesque Finn Slough (painted at low tide, 2002) occupies a tidal channel of the south arm of the Fraser River near the foot of Number 4 Road in Richmond. The community dates from the settlement nearby of seven Finnish families in the 1890s. With their floathouses secured onto pilings above the high-tide mark and their fishboats moored safely in the slough, they could keep their independence and avoid working on the company-owned boats. Their quest for utopia led other BC Finns to Malcolm Island early in the 20th century (page 161). As for Finn Slough, its existence has been threatened for decades in battles over taxes, building codes and land ownership.[2] Nevertheless, with its boardwalks, shanties and pilings, "it is an important, rare, intact example of early settlement patterns in a slough area, and maintains an important relationship with the natural environment."[3]*

1 Kluckner, *Vancouver the Way It Was*, p. 156.
2 Interview with activist/historian David Dorrington, 2000.
3 Denise Cook, City of Richmond Heritage Inventory worksheets, 2001.

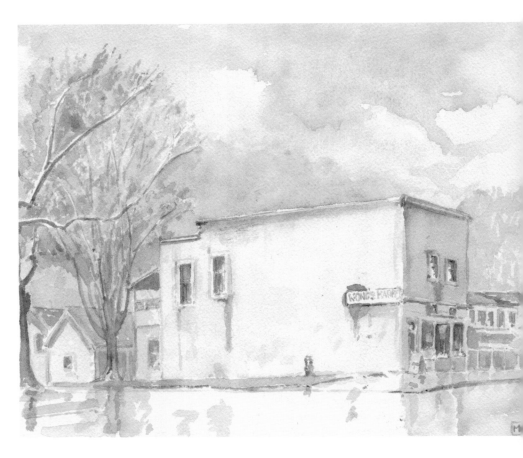

RIGHT *Wong's Market on Main Street at Forty-fourth on a rainy spring day in 2002. It was the first building on that part of Main, erected soon after the BC Electric Railway Company extended its streetcar line south from Thirty-third to Marine Drive in 1910.*

BELOW *Fumiko Fukuhara and her son Steven, walking in downtown Vancouver about 1941, captured by an anonymous street photographer.*

KATHY UPTON

Wong's Market

.

Although it did not become one of the Vancouver's ubiquitous Chinese groceries – which had nothing to do with the kind of food sold there – until nearly 20 years after the streetcars stopped running, Wong's Market is one of the survivors of a generation of grocery stores that dotted the city's streetcar routes. In 1973 when Kwok Wong became its proprietor, the city's Chinese populace no longer typically worked just in Chinatown or at the canneries at Steveston, or farmed in the Fraser Delta. Today, most of these neighbourhood grocery stores that served a local, walking trade have been replaced by the 7-Elevens and convenience stores attached to gas stations and ideal for people "on the go" in their cars.

A nondescript two-storey woodframe structure, it nevertheless towers above the Vancouver Specials and bungalows of the East End. The main floor is a surprisingly narrow store space, while upstairs provided living quarters for the proprietors. Originally called the Reeve & Harding General Store, it was soon renamed Blyth's Cash Grocery and provisioned by Kelly-Douglas and Company, owner of the Nabob brand.

Late in the 1930s a Japanese-Canadian family, the Fukuharas, bought the store. George Kisaburo Fukuhara was the son of a cabinet maker who worked in bamboo in a factory on East Hastings Street. Born in 1908 in Vancouver, he knew a lot of the city's history and according to his granddaughter Sian Reiko Upton "spent his youth recording it with a camera." In 1937, he married Fumiko Nagata, the daughter of a Mayne Island family. She was a

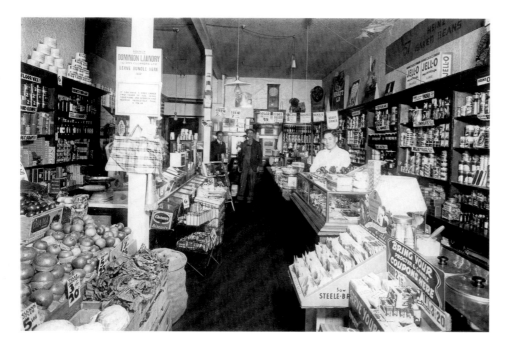

talented seamstress but apparently made clothes only part time for friends, devoting herself to raising her family. They worked hard and over the next few years paid off the mortgage. Then, in the early months of 1942, following the Japanese attack on Pearl Harbor, they lost it all.

The Fukuharas were not detained initially but were allowed, as was the case with other local Japanese Canadians, to remain in their homes under curfew.[1] However, they were soon forced into Hastings Park where they reunited with their relatives, the Nagatas and the Konishis, who had been taken from Mayne Island in April (page 150). Kumazo Nagata, the extended family's "elder" who had been in charge of the Japanese businesses on Mayne Island, made the decision that they would strike off on their own, following the example of other Japanese Canadians who went to the self-sustaining villages in the Interior. Perhaps using the sponsorship of an old associate originally from Telegraph Cove, Charlie Nakamura, who had established a railway-tie mill in Salmon Arm, they obtained permission from the BC Security Commission to set out in June for Ski-mikin, near Squilax in the Shuswap area. Their saga continued there (page 135).

In a further insult, the custodian of enemy alien property sent a letter to the Fukuharas demanding $70, claiming implausibly that the liquidation of the store contents cost more than their value. They never regained title to the store.[2]

By 1943, it had been taken over by Dean and Elizabeth Brynildsen, and continued as Blyth's Cash Grocery until a grocer and butcher who bought it in the early 1950s renamed it Hunter's Purity Market. He ran it for 20 years before selling to Kwok Wong.[3]

LEFT *The interior of Blyth's Cash Grocery about 1940, with George Fukuhara behind the counter. Photograph by George Fukuhara (using automatic timer).* BELOW *Fumiko Fukuhara, standing on Forty-fourth Avenue just west of Main, with the grocery store in the background about 1938. Photograph by George Fukuhara.*
KATHY UPTON

1 See overview on page 99. Joy Kogawa's novel *Obasan* contains evocative descriptions of the roundup at Hastings Park. Her family's home, at 1450 West Sixty-fourth Avenue in Marpole, was seized; 61 years later, its sale and possible demolition galvanized supporters to attempt its purchase for a Kogawa museum and writers' retreat.
2 Interviews and correspondence with Kathy Upton, Fumiko Fukuhara, Sian Reiko Upton and Fiko Konishi, 2002-3.
3 City directories, Vancouver City Archives.

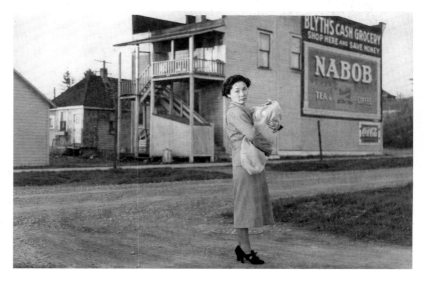

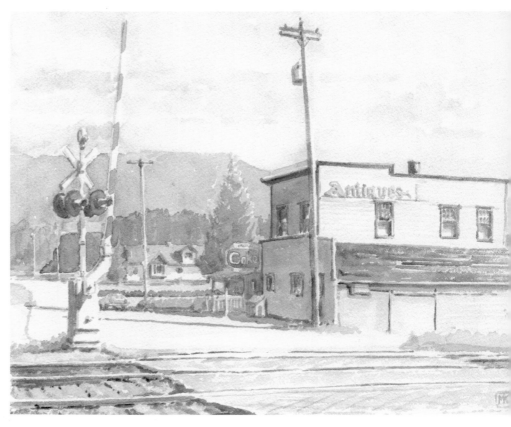

Like Wong's Market in Vancouver and country stores in Fraser Valley communities like Whonnock, Webster's Corners, Langley and Clayburn, the Dewdney store is a roadside landmark and a rare survivor from the era before motorized mobility changed the way of life in the Lower Mainland. Another survivor, the Kilby General Store at Harrison Mills, has been restored and operates as a museum.

Named for the surveyor, politician and namesake of the Dewdney Trail, Dewdney was one of the early agricultural municipalities in the Fraser Valley, settled about 1867 by N.C. Johnston and Robert Grenville McKamey. Incorporated in 1892, it was bankrupted by the stupendous 1894 floods and disincorporated itself in 1906. By that time, the riverboat era had ended and, with improved roads and the beginning of the automobile age, the store at the old Johnston's Landing closed and the business re-established about 1904 next to the Dewdney CPR station. A man named Cox bought it in 1908, selling it to the Watson family in 1911. The Watsons' store became the post office and in 1917 Ida Kate Watson became postmistress, serving in the position until shortly before her death at the age of 93 in 1948. Her son Morton, who operated the general store, then apparently took over from her.[1]

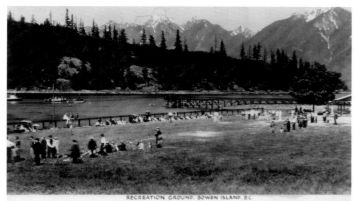

RECREATION GROUND, BOWEN ISLAND, B.C.

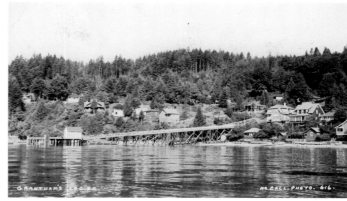

GRANTHAMS LDG. B.C. McCALL PHOTO. 616.

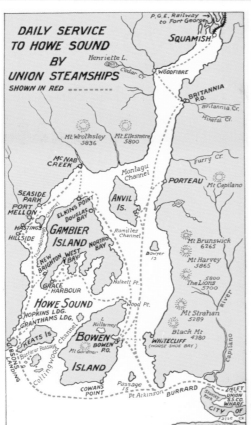

DAILY SERVICE
TO HOWE SOUND
BY
UNION STEAMSHIPS
SHOWN IN RED – – – – –

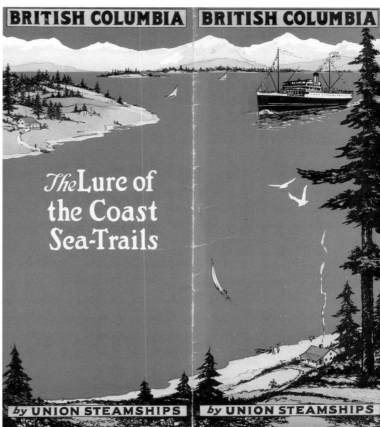

BRITISH COLUMBIA BRITISH COLUMBIA

The Lure of
the Coast
Sea-Trails

by UNION STEAMSHIPS by UNION STEAMSHIPS

The relative isolation of Bowen Island and Howe Sound had more to do with an "island pace" than with any actual difficulty of travel; in fact, during the first half of the twentieth century, daily service connected the outports to the Union Steamships Company wharf at the foot of Carrall Street in Vancouver. The map and brochure above are 1930s or 1940s vintage. Today, with paved roads and frequent ferries from Langdale and Bowen, the communities on this map are within daily commuting range of city jobs and city money and many of the summer cottages have made way for large, year-round homes, referred to by the more rustically inclined as West Vancouver houses.

CLOCKWISE FROM TOP LEFT *The Snug Cove foreshore on Bowen Island managed by Union Steamships, a 1930s postcard by the Gowen-Sutton Co.; the former general store and several of the rental cottages in the Orchard, now Crippen Regional Park, have been restored. Wooden cottages and bungalows on the hillside above the steamer dock at Grantham's Landing, a postcard by "McCall" mailed in 1940. Union Steamships Co. brochure and map.*
TONY GRIFFIN

Hermit Island

. .

Little Hermit Island, part of the archipelago off the southwest coast of Bowen Island, epitomizes the west-coast dream of a private paradise. Before it was owned, in the real-estate sense, there were Aboriginal visitors and the eponymous hermit, an old man discovered in 1925 building a boat in which he apparently drowned the following winter while rowing to Gibsons for groceries.

In the 1920s, Reginald and Isobel Tupper lived on Haro Street in Vancouver's West End and were friends with the Henry Bell-Irving family next door at the corner of Chilco. The latter's father had owned Pasley Island since 1909. One day in the summer of 1925, according to family story, Reggie and Isobel paddled a canoe from Pasley to Hermit and were skinny-dipping in a small bay when they heard the Bell-Irvings' launch approaching. They dodged into the bushes (subsequently naming the spot Dodge Bay), dressed, and began to explore the island. Enchanted, the following year they and their friends Bruce and Zulette (London) Boyd bought the island. Both families vacationed in tents for the first few years, but in 1929, flush with cash from the stock market boom, they built log houses. Local builders Pete Blad and Herb Steinbrunner felled the trees and prepared them for both cottages.

The Tupper name entered Canadian history through Sir Charles Tupper (1821-1915), a Nova Scotian "Father of Confederation" who subsequently joined Sir John A. Macdonald's government (their respective sons were law partners). As the fourth and last of a hapless group who attempted to govern in the wake of Macdonald's death, Tupper holds the dubious distinction of the shortest prime-ministerial term in Canadian history: May 1 to July 8, 1896.

One of his sons, Sir Charles Hibbert Tupper (1856-1927), became minister of fisheries in his father's cabinet; he was knighted for his work on the Bering Sea sealing treaty. Later, he applied to the BC Law Society to become a solicitor, and moved his family to Victoria, then settled in Vancouver where he and his wife, Lady Janet, built the beautiful home called Parkside near the

LEFT *Built at Anchorite Bay in 1929 by the Weingarten family, the Tuppers' log cabin occupies just over 1,000 square feet and has five rooms including an annex originally used by their Chinese cook. In the early years, the Tuppers owned small, rather unsafe boats to get back and forth from Coal Harbour to Hermit; later, they relied on Union Steamships to get to Gibsons and hired water taxis to get them to Anchorite Bay.*

RIGHT *On a meadow looking directly north up Howe Sound, the Boyds built a similar five-room cottage, recently destroyed by fire. Photos by E.W. Palmer, 1968.*

JACQUIE TUPPER

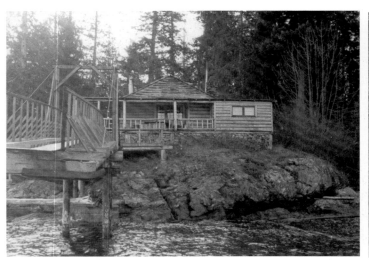

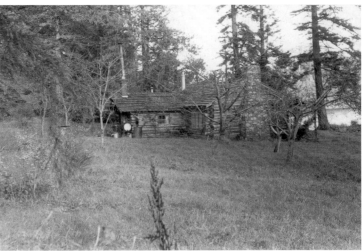

Stanley Park end of Barclay Street. He became the great "renegade Tory" of BC politics, clashing first with the McBride government in the early years of the twentieth century over railway policy, then launching a vendetta against William Bowser's government before supporting industrialist A.D. McRae's reformist Provincial Party in the 1920s.

Reginald Hibbert Tupper, born in 1893, was the sixth of his seven children. Born in Ottawa, he spent his childhood in Vancouver, took military training in England and, as a lieutenant in the 16th Battalion Canadian Scottish, was seriously wounded by shrapnel at the second Battle of Ypres. Like that of many soldiers and aviators, his recuperation left him addicted to morphine, an affliction he soon overcame. He spent the balance of the war in Vancouver as a major in command of reinforcement and depot regiments. His wife Isobel was one of three daughters of the prominent Conservative Dr. David Henry Wilson, Sir Charles's personal physician.[1] Tupper was admitted to the bar in 1917 and commenced law practice in 1919 with his father's firm; he was most prominently in the news in 1955 when he served as a one-man commission into Vancouver police force graft and corruption.

The Tuppers bought out the Boyds and continued to work on the island, increasingly in stone – a legacy of a 1930 trip to Italy. Isobel died in 1969, her husband three years later. Their son David (1921-99) had taken over the island, bought out his brother Gordon, then strata-titled it in 1968. An appraisal done at that time by E.W. Palmer of Bell-Irving Realty valued the island at $95,000. It remains in family control today.[2]

ABOVE *The Tuppers' cottage in 2000, from tiny Arbutus Island, which is connected to Hermit Island by a spit of sand at low tide.*

BELOW *Reginald Hibbert Tupper.*
JACQUIE TUPPER

1 *Who's Who and Why,* 1921 edition, p. 34.
2 Information not cited above from an unpublished manuscript by David Tupper; interviews with Charles H. Tupper and Jacquie Tupper; Kluckner, *Victoria the Way It Was,* p. 140, and from Janet and Alec Bingham.

Gower Point

U nlike much of the Sunshine Coast, the Gower Point-Bonniebrook Beach area near Gibsons Landing is a relatively flat piece of land. Bonniebrook Lodge, the fine old house that is now an inn and restaurant, is the successor of a c.1910 house called Trelawney owned by the Chaster family. James Chaster preempted about 300 acres, subdividing it and selling it, an enterprise continued by his son Harry and daughter-in-law Florence. They let rooms in the summer and maintained a few rental cottages and a store.

Harry Chaster also built cottages, including the one on page 45 owned for many years by Rev. George Wilson of St. Michael's Anglican Church, on East Broadway at Prince Edward Street in Vancouver, and his son, Alderman Halford Wilson. Built in the 1920s in the sort of rustic Craftsman style that was popular for buildings such as the original Grouse Mountain Chalet and Wigwam Inn, it had bracketing and balustrades of peeled saplings, many naturally curved to create a whimsical softness to the structure. Another, less-decorated half-log house, known as Craigowan, faces the beach just east of Camp Road.

The Wilsons acquired and moved the cottage from its original location behind the Chaster house after tearing down their original place, built of beach wood and cedar slabs. In 1915 James Chaster had made a gift to the church of an acre of land for a summer camp for the Sunday School students. After Camp Artaban opened on Gambier Island, the property was rented to summer campers, providing St. Michael's with further income; it was then sold, the proceeds applied to the church's mortgage.[1] The camp house still stands on Camp Road and has been owned since about 1935 by the Armstrong family; it was originally a single room with bunkbeds set against the walls and a porch in front, and slept about 10.[2]

The Reverend Wilson, walking over the barnacles barefoot, "had his trousers rolled up on his white chalky legs, which moved up and down like tugboat pistons ... [He] was in the habit of shingling his Gower Point house virtually every summer."[3] Every Sunday in the summer he crossed the road to "Amen Corner" – the beach in front of his house – pushing a small harmonium for his wife to play. A congregation of 20 to 30 would gather, scattered among the salal and the stumps, those furthest away continuing quiet games of crokinole. The services were timed to conclude when

One of the Chasters' old rental cabins, used as the Gower Point Store in the summer of 2001, redolent of bare feet, suntan oil, Kik Cola, wet bathing suits and sweet summer romances. The original store was the cement-finished square box at Harry Road.

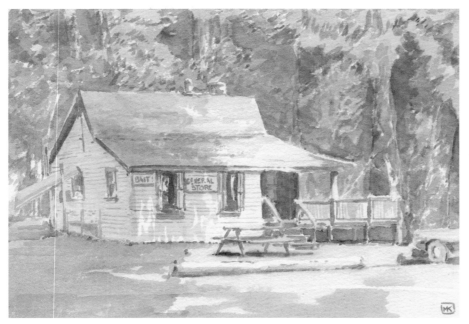

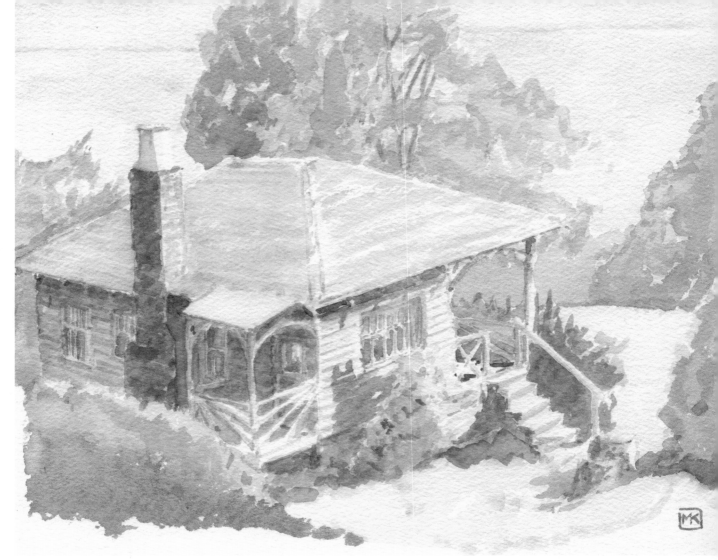

the Union Steamships boat came into view, as everyone rapidly lost interest in the deity and rowed out to meet new arrivals at the float.

When I began to get involved in Vancouver affairs in the early 1970s, Alderman Halford Wilson was one of the "dinosaurs" of the Non Partisan Association-dominated city council. Although he had earned a reputation for cautious financial scrutiny, he eagerly supported the megaprojects of the era and was among the group that bloc-voted for the Chinatown freeway and Third Crossing and the proposed Four Seasons Hotel complex at the entrance to Stanley Park during the mayoral terms of Tom Campbell from 1966-72.

He and his father both had reputations in the 1920s and 1930s for vocal anti-Orientalism. Although especially prejudiced against Japanese Canadians as the clouds of war gathered, he had no tolerance for Chinese Canadians either. In 1941, following the purchase of 5810 Highbury in Dunbar by newlyweds Tong and Geraldine Louie, he sponsored the neighbours' exclusionary petition and presented it to city council. At the time, Louie ran the H.Y. Louie Company; subsequently he developed the IGA supermarket chain and London Drugs.[4] The Wilsons also appear in the most famous novel of the Japanese-Canadian internment, Joy Kogawa's *Obasan*. "Is this a Christian country? Do you know that Alderman Wilson, the man who says such damning things about us, has a father who is an Anglican clergyman?" the character Aunt Emily writes to her sister early in 1942.[5]

The Wilson cottage at Second Street and Ocean Beach Esplanade near Gower Point, in 2001. It has since been renovated extensively, including the removal of the old brackets and balustrades.

1 Fred Cadman, Unpublished biography of Rev. George Halford Wilson, St. Michael's Church Archives, Vancouver. Thanks to Stuart Isto for locating it.
2 Interview with Doreen Armstrong, 2002.
3 Cadman.
4 E.G. Perrault, *Tong: The Story of Tong Louie, Vancouver's Quiet Titan*, p. 92.
5 Page 88.
(Material otherwise uncited from Sally Thicke, granddaughter of Harry Chaster, and from correspondence from Bevlee Wilks and Dave McDonald.)

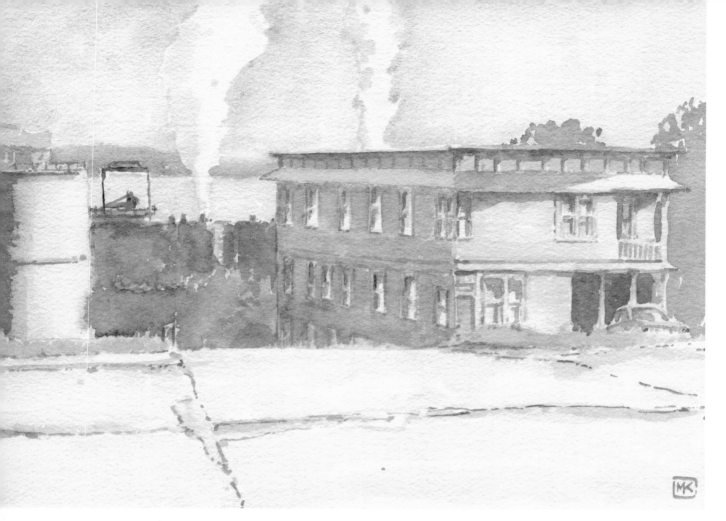

Powell River

The Kenmar Building at the corner of Walnut and Arbutus, with the steaming mill in the background, on a hot August day in 2001. The Kenmar was built for Dr. Andrew Henderson in 1913 as St. Luke's Hospital. According to the Townsite Heritage Society, Henderson was the first practising physician in Powell River and implemented the first medical plan in BC in 1910. The building is now divided into apartments.

Powell River is the largest community on the BC coast between the Lower Mainland and Prince Rupert. The Powell River Lumber Company constructed the pulp mill, dam and townsite in 1910, thereby producing the first newsprint in western Canada. Isolated save for the regular visits of coastal steamships and needing to attract a stable, skilled workforce, Powell River had to become a "complete community" in a holistic sense that modern town planners can only dream of. As the last surviving mill townsite on the coast, the original dozen square blocks on the hillside above the mill were named a National Historic District in 1995, a rare commemorative acknowledgement from the Historic Sites and Monuments Board of Canada.

This townsite is especially interesting because of its residential blocks, designed mainly by townsite manager John McIntyre in the fashionable styles of the 1910s and 1920s. The old downtown is more eclectic, with a couple of hotels, government buildings, banks and the Patricia Theatre creating a nostalgic atmosphere for anyone with enough imagination to repeople the streets and re-erect vanished shops and businesses on the many vacant lots. A few blocks away, above Marine Avenue, the Triangular Gardens and the sprawling Craftsman-style homes of the mill manager and other senior administrators look out, from a discreet distance, onto the harbour, the smokestacks and jumbled industrial works of the pulp mill.

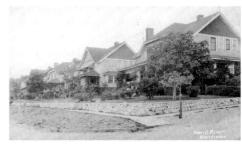

Modern mills and logging operations employ comparatively few workers, and much of Powell River's vivacity has migrated to newer, more suburban neighbourhoods to the south, leaving the old downtown quite deteriorated and depopulated. Regrettably, the National Historic District designation brings with it neither money nor statutory protection – typical of the half-hearted way the federal government has addressed heritage issues in the past 35 years – so volunteers market the townsite as a heritage attraction. The population of the area is quite stable, with new arrivals seeking a small-town lifestyle and recreational opportunities, but apparently many in the community have temporarily left their families behind for work in the "oil patch" in the Peace Country and Alberta.

1 Luxton, *Building the West*, p. 406. (Information not elsewhere cited from the Townsite Heritage Society, Powell River.)

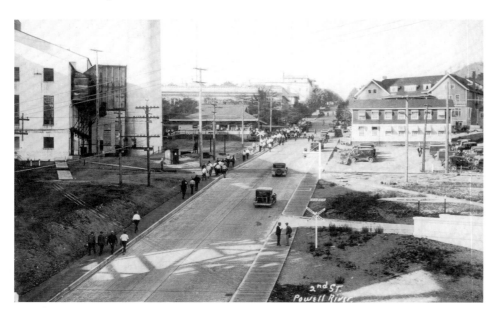

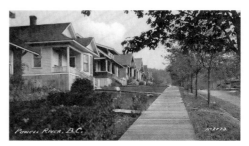

Few places in the world combine natural beauty and industrial despoliation as effectively as Howe Sound. Britannia Beach's copper smelter and compact company town evoke the past and attract tourists and the filmmakers of Hollywood North, while the acid leachate from the old mine (among the worst pollution sites in North America) is one of the province's myriad challenges for the future. The view below, from the wharf where the Union Steamships once connected the town with the outside world, looks across to the pulp mill at Woodfibre, a scene recalling politician Phil Gaglardi's quip that "pollution is the smell of money."

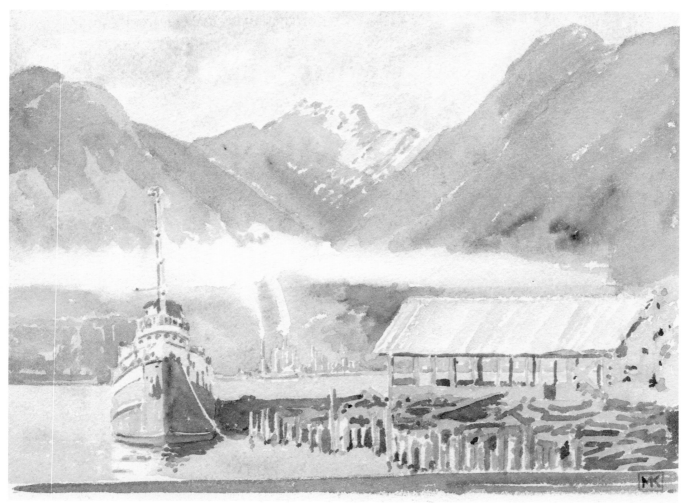

Fishboats at Lund in the setting sun — candy for the travelling watercolourist. Lund is the end of the road — the northernmost point of the highway that begins at Cabo San Lucas at the tip of Baja California. Founded in 1889 by two Swedish brothers, it has evolved into a transportation hub for boaters exploring Desolation Sound, and cottagers and visitors to Savary Island. Indeed, Lund in the summertime is a parking lot: every roadside is jammed with parked cars, with water taxis running regularly from the dock in front of the hotel to Savary Island. In the distance, the low blue profile of Hernando Island, owned by a syndicate whose only shareholders are its cottagers, provides a refuge for some former Savary Islanders who found the latter becoming overcrowded.

The Malaspina Hotel, built more than a century ago by the Thulin brothers and altered since this photograph was taken in the 1940s, still dominates the Lund waterfront (photographer unknown).

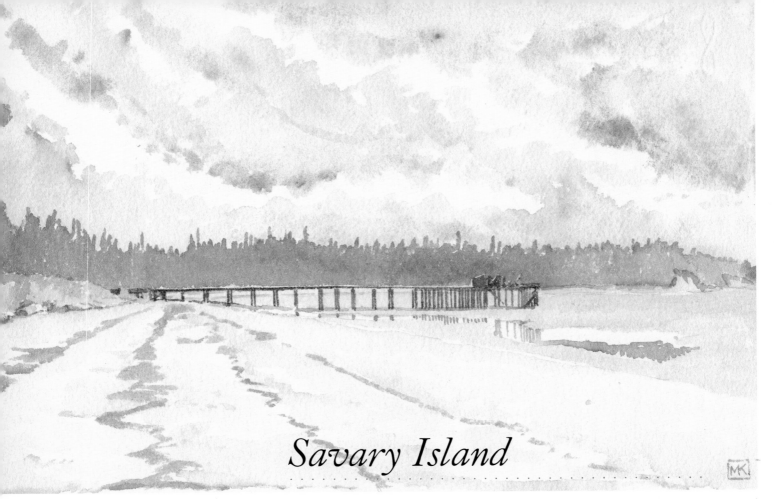

Savary Island

The old government dock, looking west on a cool May day in 2003, the high-tide zigzags of previous days marked by kelp on the beach.

A legendary refuge of old Vancouver families and summer dreams, Savary Island is a rustic, west-coast version of Ontario's Muskoka cottage country or the Hamptons of wealthy eastern seaboard families. Isolation has always helped support its cachet: neither car ferries, motorhomes, arcades nor discos distract.

The watercolours on these pages are from the same spot – the beachfront where Townley Walk meets the shore road now called Malaspina Promenade, near the east end of the island. This is the historic section of cottages from the 1920s and 1930s, and includes the McMaster house, now the Savary Lodge (the razed Royal Savary Hotel, publisher of the neo-Polynesian brochure, stood at the west end of the island – out of sight in the right distance of the beach sketch). The Savary Island Syndicate headed by Harry Keefer subdivided the island in 1911-2 into a checkerboard of city-sized lots, only some of which have ever been cleared and developed; it also developed the original Savary Inn and attempted to provide such infrastructure as a communal water supply. The latter has so far proved unnecessary; although the island is little more than a huge sandbar it has an excellent aquifer. Unlike those on many Gulf Islands, individual wells never run dry in the summer. In the 1960s and 1970s, realtors attempted to sell many of the landlocked lots at bargain prices, going so far as to rent booths at the Pacific National Exhibition for the purpose.

Sunshine and Sea~Charm

Along Holiday Shores on the GULF ROUTE, from Vancouver to Powell River and Savary Island

by UNION STEAMSHIPS

TONY GRIFFIN

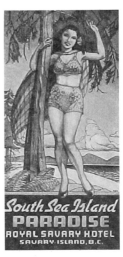

South Sea Island PARADISE
ROYAL SAVARY HOTEL
SAVARY ISLAND, B.C.

JEAN YUILE

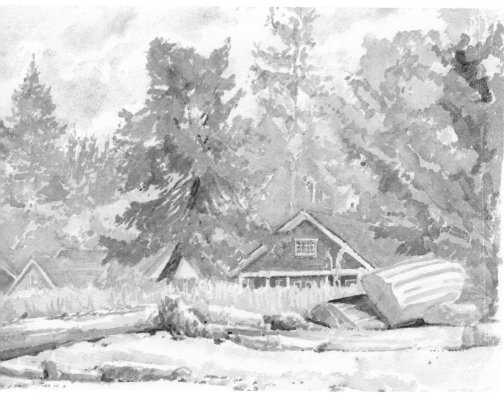

The first permanent house on the island, built about 1910 by Louis Anderson, still stands near the wharf, while the Spilsbury family's old home is located at the T of the wharf and the road.[1] An old concrete sidewalk, hand-built by the cottagers so they could more easily move their goods in wheelbarrows from the wharf, runs along the shoreline. It is now overgrown and unused, since cars have arrived on the island (landed by barge on the beach) as well as a taxi service.

Long-time Savary Islander Tony Griffin describes this part of the island as "a quintessential Martha's Vineyard sort of landscape," where people "walk up and down the street and say hello to everyone" and old rowboats and bleached driftlogs dot the grassy border between the beach and the road. The tennis courts nearby are decked with twisted old 2 x 8 boards, leading to "the Savary bounce." While its fine beach, warm water and clear skies, in the lee of Vancouver Island's high mountains, have led to the sobriquet "the Hawaii of the North," the long, indolent summers and the isolation have also earned it a Peyton Place reputation where, as one islander described it, "gossip is the most valuable currency." Most cottages have a flagpole in front, and when a flag (usually the Maple Leaf) flies, the family is in residence. There is no on-grid electricity and commerce consists of a couple of seasonal restaurants, a store and several B&Bs. Transportation is by water taxi, private boat or the "Daddy planes" chartered from Vancouver for summer weekends. So many people now covet Savary that a few of the wealthier cottagers have assembled large tracts of land with the intention of preserving them, while other cottagers organize a summertime art auction to raise money for the purchase of environmentally sensitive areas on behalf of the Savary Island Land Trust.

1 Jim Spilsbury, *Spilsbury's Album*, pp. 22-3.
2 Norman Hacking, "It Couldn't Have Been Busier," *Province*, February 12, 1955. Obituary published in *Sun*, September 13, 1965, p. 14.

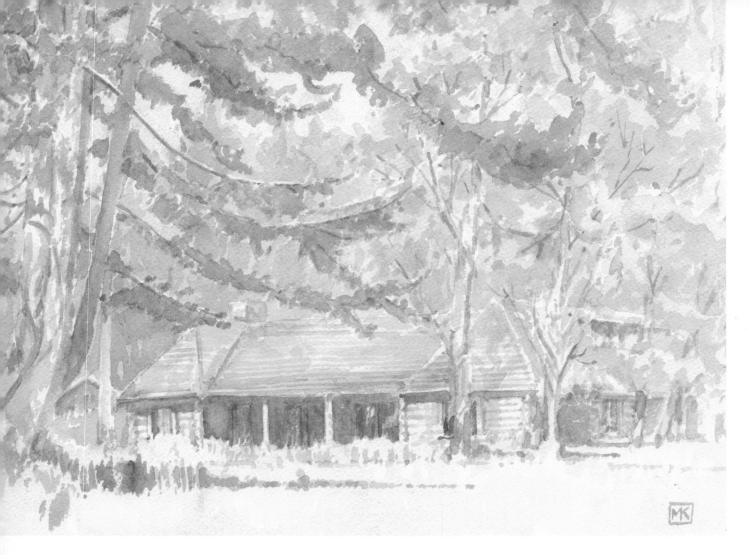

The log beach house now called Savary Lodge, on the Malaspina Promenade near Mace Point, looks out across a neatly tended lawn toward the sea, the mountains and the entrance to Desolation Sound. It is one of the few historic rustic villas left in BC, in company with the

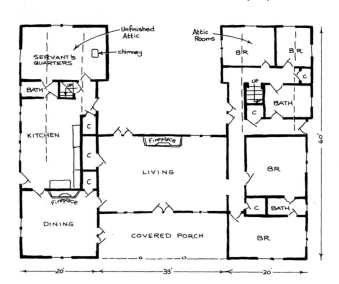

Rogers family's Fairweather on Bowen Island[1] and Eric Hamber's Minnekhada Lodge in Coquitlam.[2] A.E. McMaster hired Bill Mace to build it in about 1934 — an ideal time to obtain the best craftsmanship and materials at affordable prices! Elmer Lee, secretary of the Powell River Company, assembled the logs and had them towed to the island. George Bloomfield, "the island mason," constructed the four stone chimneys.[3] It has a very pleasing and sophisticated interior layout, with wings on either side of a living room opening onto a covered verandah, predating General McRae's much larger Eaglecrest at Qualicum Beach (page 156) designed a few years later by Vancouver architect C.B.K. Van Norman. Son Bill McMaster, during a visit to Savary Island in 2004, stated that his mother drew the plans herself.[4] Innkeeper Jean Yuile operates the lodge today.

1 Kluckner, *Vanishing Vancouver*, p. 192.
2 Luxton, *Building the West*, p. 419.
3 Ian Kennedy, *Sunny Sandy Savary*, p. 127-8.
4 Correspondence from Rick Thaddeus.

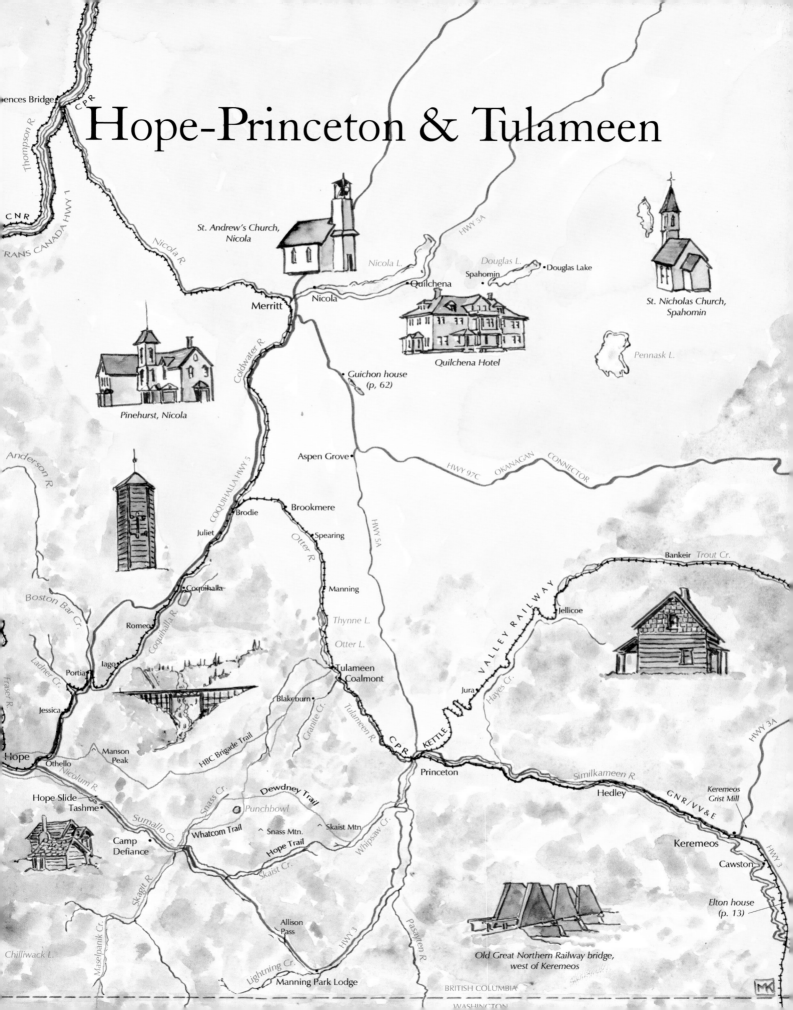

Hope-Princeton & Tulameen

St. Andrew's Church, Nicola

St. Nicholas Church, Spahomin

Quilchena Hotel

Pinehurst, Nicola

Old Great Northern Railway bridge, west of Keremeos

Elton house (p. 13)

Keremeos Grist Mill

ences Bridge

Thompson R.

TRANS CANADA HWY

CNR

CPR

Nicola R.

Nicola L.

HWY 5A

Douglas L.

Spahomin
• Douglas Lake

• Quilchena

Merritt

Nicola

Coldwater R.

• Guichon house (p, 62)

Pennask L.

Anderson R.

COQUIHALLA HWY 5

Aspen Grove •

HWY 97C OKANAGAN CONNECTOR

Brookmere

Brodie

Juliet

Otter R.

Spearing

HWY 5A

Bankeir Trout Cr.

Coquihalla

Manning

Jellicoe

Boston Bar Cr.

Romeo

Coquihalla R.

Thynne L.

Otter L.

VALLEY RAILWAY

Jura

Hayes Cr.

HWY 3A

Ladner Cr.

Iago

Portia

Tulameen
Coalmont

Jessica

Blakeburn

Granite Cr.

Tulameen R.

CPR

KETTLE

Fraser R.

Hope

Othello

Nicolum R.

Manson Peak

HBC Brigade Trail

Princeton

Similkameen R.

Hedley

GNR/VV&E

Hope Slide
Tashme •

Dewdney Trail

Snass Cr.

Punchbowl

Whatcom Trail

^ Snass Mtn.

^ Skaist Mtn

Whipsaw Cr.

Keremeos

Camp Defiance

Sumallo Cr.

Skagit R.

Hope Trail

Skaist Cr.

Cawston

HWY 3

Maselpanik Cr.

Chilliwack L.

Allison Pass

HWY 3

Lightning Cr.

Pasayten R.

Manning Park Lodge

BRITISH COLUMBIA

WASHINGTON

The Dewdney Trail

T he Hope-Princeton Highway did not open until November 2, 1949, but trails had existed across the mountains for millennia. The Dewdney Trail, just north of the 49th parallel from the expansionist Americans, was the most important and venerable of the post-contact ones. It began in the summer of 1860, when Governor James Douglas decided to have the "Queen's Trail," suitable for mules, blazed from Hope to Vermilion Forks (Princeton). Edgar Dewdney and Walter Moberly obtained the contract, with Sergeant William McColl of the Royal Engineers surveying the route.[1] Plans to upgrade it the following year were cancelled when Douglas decided instead to focus resources on a road to the Cariboo. Hope soon lost its importance to Yale, the head of navigation on the Fraser River.[2] Dewdney eventually extended the trail all the way to Fort Steele in the east Kootenays following the 1865 gold rush there, but that portion saw little use before the railway era.

The Dewdney Trail followed the Coquihalla River for a short distance east of Hope, then swung southeast along Nicolum Creek. At the headwaters of the latter, it crossed a divide (the Hope Slide and Sunshine Valley-Tashme area), then ran southeasterly beside Sumallo Creek to its confluence with the Skagit River, which it followed upstream. At that point, it joined the 1858 Whatcom Trail up Snass Creek, continuing through Paradise Valley and the pass between Granite and Skaist mountains before descending 47 Mile and Whipsaw creeks to the Similkameen River upstream from Princeton. The later Hope Trail, used for cattle drives through the 1940s, followed Skaist Creek and the Hope Pass south of Skaist Mountain before reaching Whipsaw Creek.[3]

Riding the Dewdney Trail, Douglas wrote that the journey could without exaggeration be compared to "the passage of the Alps."[4] Among the significant groups who used it were, in 1883, General William Tecumseh Sherman leading a party of 81 including a military escort of 60 men, 66 horses and 79 mules, which crossed BC in order to re-enter the US to subdue Indian uprisings in the American Northwest. Some years later, the ill-fated Archduke Franz Ferdinand of Austria led a hunting party including six gentlemen and two dozen horses.[5] More than 40 years after the initial trail was finished, in 1901, Dewdney again surveyed the area, looking for a railway route. He chose the Allison Pass, named for John and Susan Allison who used the Dewdney Trail in the 1860s and 1870s to reach their homestead near Princeton. This became the route of the Hope-Princeton Highway.

Two old cabins survive along Sumallo Creek. They belonged to a prospector named Bill Robinson, who settled there sometime around the end of the First World War and

Forest fires were a regular occurrence in the Hope-Princeton area, and bedevilled travellers on the Dewdney Trail including Susan Allison, who remarked on her narrow escape from one in her memoirs. The most notorious fire of the highway era swept through the valley below Allison Pass in the late 1950s, resulting in the erection of the "gallows," which lasted for years, and a burnt-over landscape that took more than 40 years to heal. Postcard by the Coast Publishing Company, c.1958, photographer unknown.

was known to all the packers and travellers using the Dewdney Trail. His name appears in most of the accounts of the area, including those of the search for an English nurse, Mary Warburton, who in August 1926, determined to walk from Hope to Princeton on her way to a working vacation as a fruit picker in the Okanagan. Carrying only four packets of Ryecrisps, a half pound each of bacon, butter and cheese, a pound of raisins, two ounces of almonds and some tea, she became lost for weeks in the mountains, eventually attracting attention and subsequent rescue by inadvertently burning down the Paradise Valley cabin of an old-timer named "Podunk" Davis.[6] An area of Paradise Valley near the headwaters of the Tulameen River has been named Warburton Park; Podunk Creek drains into the Tulameen River nearby.

The Reverend John C. Goodfellow met Robinson during a hike from Princeton to Hope in 1929. "We had not far to go before we came to the Skagit trail, on our left [the Whatcom Trail to Bellingham]. After a while we crossed another bridge and came to the first real signs of civilization we had met since leaving the Overland [car] at Nine Mile Bridge. This was Camp Defiance, a comfortable log home, and a garden. We walked right in, and received a royal welcome from a man named Robinson."[7]

In 1931, the renowned newspaperman Bruce Hutchinson wrote an article extolling the potential of a modern road through the Hope Mountains. "We are descending now, but still by easy grades, and soon we are down beside the green waters of Sumallo. Here, on the boiling stream's edge, is the first house we have seen all day, the big log house of Bill Robinson, whom people call the old 'Flintlock of Sumallo.'

"Bill Robinson's well-named Camp Defiance is almost the farthest thrust of civilization into these mountains. His little garden of strawberries, of lettuce and potatoes, his six petunias and eight Sweet Williams, in the narrow gorge between the mountain and the stream, are a welcome sight to those who have just come out of the wilderness. And so are the big, firm trout that Bill caught at his back door last night, and the pie made from his late-ripening strawberries."[8]

Tom Hodgson of Cranbrook, a mechanic who worked at Allison Pass from 1953 to 1961, recalled Robinson's legendary lack of success as a prospector as a regular topic of conversation along the Hope-Princeton. "I often used Bill Robinson as an example to my kids of the reality that, no matter how convinced you are or how sincere you might be, if that confidence is not based on fact you can end up investing your life and not gaining your goal."[9]

But perhaps his true goal was simply to have a contemplative, solitary life on the edge of the wilderness? Regardless, nobody seems to know what became of him. My first recollection of the cabins more than 40 years ago was of a neat homestead, perhaps only recently abandoned, but it has since been engulfed by the returning forest.

Bill Robinson's Camp Defiance, along Sumallo Creek just inside Manning Park at Mile 22 of the Hope-Princeton Highway, in the autumn of 2000. By late in November, the cabins are locked in a perpetual blue gloom, shaded by the mountains to the south.

1 Ormsby, *A Pioneer Gentlewoman*, p. xix.

2 Ormsby, p. xxi.

3 R.C. Harris, *Old Park Trails in the Proposed Cascade Wilderness*. Bob Pelley, of the Pelley Ranch on the 5-Mile near Princeton, was among those driving cattle on the Hope Trail in the 1940s.

4 James Douglas papers, *British Columbia Historical Quarterly* vol. 2, 1938, p. 81.

5 Kathleen Stuart Dewdney, "The Dewdney Trail," *Okanagan Historical Society Report* vol. 22, 1958.

6 Joan Greenwood, "The Amazing Story of Nurse Mary Warburton: Survival and Rescue in the Wilds of B.C.," *Okanagan Historical Society* vol. 46, 1982.

7 "The Old Hope Trail," *Museum and Art Notes* vol. 4, no. 2, June 1929 (Art, Historical and Scientific Association of Vancouver).

8 "To the Okanagan in a Day," *Province Sunday Magazine*, August 30, 1931, p. 10.

9 Correspondence, 2001.

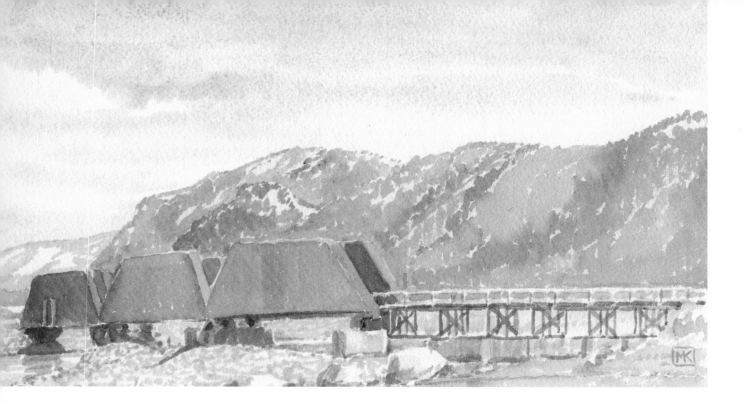

The GNR & the KVR

. .

The former Great Northern Railway bridge crossing the Similkameen River west of Keremeos, now used for road access to Cathedral Provincial Park. Train service to Princeton via Hedley began across it late in 1909. Much of the former roadbed through the Similkameen Valley is now used by Highway 3.

During 1910 and 1911, Princeton experienced a coal-mining boom, primarily as a result of the arrival of the Great Northern Railway in the shape of its Canadian shell company, the Vancouver, Victoria & Eastern Railway (VV&E). The Great Northern system, with its western hub at Spokane, had been sucking resources and trade into the US from the Boundary Country and the Kootenays since the early 1890s. The vendetta of its president, James Jerome Hill, against the directors of the Canadian Pacific Railway (CPR) dated back to failed partnerships in the early days of railroading in Manitoba.[1] The VV&E and its rival, the Kettle Valley Railway (KVR), a subsidiary of the CPR, were vying to be the first to connect Vancouver with southern BC across the Hope Mountains – south of the CPR's main line. The strategy for both was to establish a line connecting the Kootenays and Boundary Country with Princeton and thence Otter Summit (Brookmere), where the most direct route began through the Coquihalla Pass to Hope.

The KVR ran its line from the Boundary Country north along the Kettle River at Rock Creek. It then looped south through the mountains (using dramatic Myra Canyon whose trestles, having become part of the Trans Canada Trail, were tragically destroyed in the 2003 forest fire) and along Okanagan Lake to Penticton. The KVR then headed west using Trout Creek above Summerland, the valley through Osprey Lake, and Hayes Creek to reach Princeton.

The VV&E line to Princeton, completed five years before the KVR one, meandered through the Boundary Country back and forth across the international border, connecting communities like BC's Bridesville (page 77) with Washington's Molson and Oroville. Thence it came north, bypassing the mountains west of Osoyoos along the easy grade of the Similkameen River,

1 Pierre Berton's *The National Dream* is a readily available source for this story.

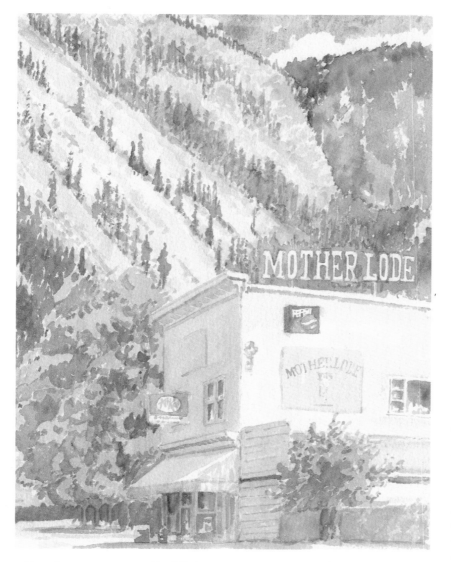

LEFT *Hedley's store is one of the historic commercial buildings that survived the vagaries of time and the fires of 1956 and 1957. Like a pint-sized Princeton, Hedley has a tight grid of streets with small cottages from its gold-mining heyday of the first decade of the twentieth century.*
BELOW *The rich gold strike on Nickel Plate Mountain above the town brought investment, most notably the 1904 Stamp Mill (photographed about 1960, probably by J.C. Walker) that is now in ruins on the hillside above the town, and the Great Northern Railway. Robert Hedley was the manager of the Hall Smelter in Nelson. Nickel Plate gold continued to flow until 1955; nearby, on an unclaimed fraction of the mountain, prospector Duncan Woods developed the Mascot Mine, whose ruined buildings perch dramatically on the cliffside high above the town. The property is today known as the Barrick Gold (Homestake) Nickel Plate Mine.*[1]

1 Information from Hedley Heritage Arts and Crafts Society.

taking the route now used by Highway 3 past Cawston and Hedley.

Eighteen kilometres west of Princeton along the VV&E's projected route to the coast, Granite Creek empties into the Tulameen River. There, in 1885, between 400 and 500 Canadians and Americans and 150 to 200 Chinese panned for gold. A community of stores, restaurants and saloons, plus the inevitable log cabins, dotted the meadows along the Tulameen; most of the population had disappeared by 1888. A century later, only the cemetery is left, but there are still gold panners and "hydraulickers" working the riverbank.

Nearby, bituminous coal deposits that had been ignored by the earlier generation of gold miners attracted the interest of the railroaders and a community, imaginatively named Coalmont, began to take shape. The VV&E finally reached it in November 1911, as the work on the five bridges crossing the Tulameen between Princeton and Coalmont had taken more time than expected (the last bridge before Coalmont, at a bend in the river, crosses one of the great swimming holes on the Tulameen). The line began for regular service in May 1912, about the time the Coalmont Hotel opened.

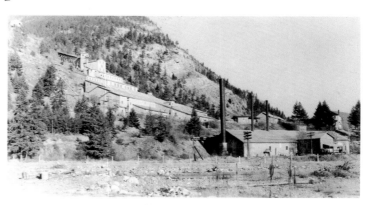

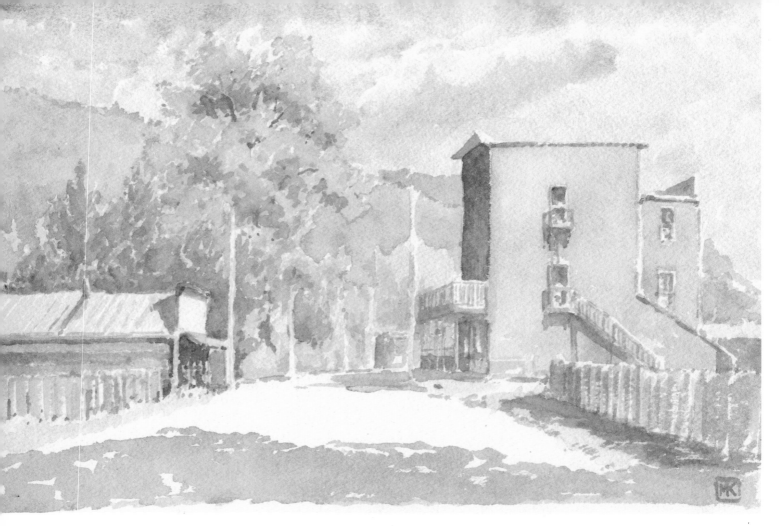

ABOVE *Coalmont in October 2001: the view from the northern (Tulameen) side, with the hotel on the right and old liquor store (later the meat market) on the left.*

BELOW *The meat market; the town's other historic commercial building is the former general store, on the left of the strip of photographs I took in 1977.*

In those years, the beer parlour was presided over by an aged character whose hat was festooned with fishing flies and lures, its clientele local prospectors, loggers, fly fishermen and the odd tenting traveller like me. The town, populated in part by BC's home-grown hillbillies, for years sported a sign urging women to beware the many local bachelors. Gradually, the populace has aged and moved on; after years of quiet deterioration, the hotel was purchased in 1995 by a group of five businessmen, according to correspondent Robert McNeney, who repainted it and advertised its "historic dining room, heritage rooms, and gold panners pub" in the "Snowmachine Capital of Canada." Since the abandonment of the railway, its roadbed has become part of the Trans Canada Trail, bringing a new influx of hikers and cyclists in the summer. The coal bunkers on the outskirts of town were still visible in the 1970s but have all but disappeared today. The fields have grassed over and the dry wind rattles the cottonwoods and aspens. Correspondence from Peter Smith, England: "my grandfather and two of his brothers were killed at Blakeburn in August, 1930 and are buried in Princeton cemetery. My grandmother returned to Scotland with her children. I am now the oldest surviving Smith. [My grandmother] was a tough lady – just imagine travelling back to eastern Canada with four children, the oldest was eight years (my father), the youngest a babe in arms. Then the boat trip back to Scotland. Hard life." Alaini Vlassopoulous wrote about Thomas Gibson, her great-grandfather, who perished in the blast at Coalmont Collieries, and her grandfather, then 16 years old and also a miner, who hadn't gone to work that day but had to continue thereafter in the mine to support his widowed mother and sisters. A provincial plaque at the cemetery lists the 45 men killed in the explosion.

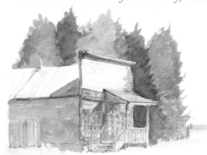

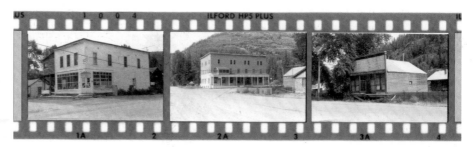

By 1911, the Columbia Coal & Coke Company had its first mine in operation, and the *Coalmont Courier* was advertising that the town was built upon "The Largest Body of Coal Yet Discovered in North America." VV&E's management believed it to be one of the finest steam coals available, and signed a contract with Columbia to provide 500 tons of coal per day to feed the Great Northern's locomotives. By comparison, Princeton coal was a light variety that had its main market in heating Vancouver houses – apparently when it was tried in locomotives the flying cinders started a number of forest fires. The CPR began to convert its locomotives from coal to oil in 1913, but had to convert back to coal during the First World War due to oil shortages.

Coalmont Collieries, which took over from the Columbia Coal & Coke Company in 1913, had its expansion stalled by the war but went into full production in 1917 at Blakeburn – named for the two principals, Blake Wilson of Vancouver and packing-house magnate Pat Burns of Calgary. Getting the coal from the Blakeburn site high on the mountain above Coalmont down to the rail line was the big problem – the grades were too steep even for specialized locomotives, and hauling trucks were in their infancy – so an aerial tramway was installed in 1921, and the mine became one of the biggest coal producers in the province. Typical production in the 1920s was 160,000 tons annually, and the railways worked hard to secure a share of the production.

ABOVE *The Manning section house with its distinctive hipped roof and tall windows, built about 1914 at Manning Creek midway between Princeton and Brookmere.* BELOW *The Brookmere water tower, the last one left on the Kettle Valley Railway line, and the old section foreman's house at Brookmere in 2000, when it was still painted "CPR Red" (as Margaret Laurence wrote, "the colour of dried blood"). It has since been painted green and modified with shutters.*

The pending showdown between the VV&E and the KVR fizzled into a sort of anticlimax in the fall of 1912 – three years before the KVR's tracks reached Princeton – when both sets of executives agreed to share the rail line planned for the Coquihalla Pass. Completed in a marathon negotiating session in the Hotel Vancouver in early April 1913, the agreement allowed the KVR to build the 54 miles of line from Hope to Otter Summit and set trackage rights and leasing rates for the VV&E. It also gave the KVR rights to use the VV&E's tracks from Otter Summit to Princeton. The KVR retained exclusive rights to its line from the "Loop" at Brodie northward to Merritt and the Nicola Valley's rich coal deposits.

According to railway historian Barry Sanford, the agreement was a major victory for the CPR and the beginning of the withdrawal by the Great Northern from southern British Columbia. Concurrent national issues reinforced Canadians' sense of their own sovereignty against the US commercial juggernaut, including, in the "reciprocity" (free trade with the US) election of 1911, the defeat of Sir Wilfrid Laurier's Liberal government – in power since 1896 – and the installation of Robert Borden's protectionist, pro-Empire Conservative government. There was, in addition, a

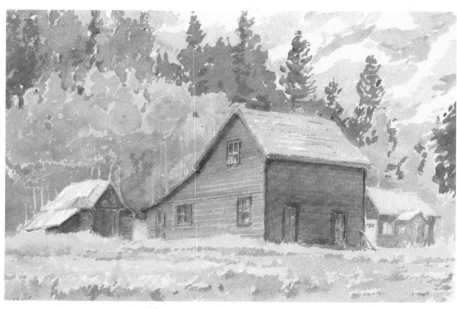

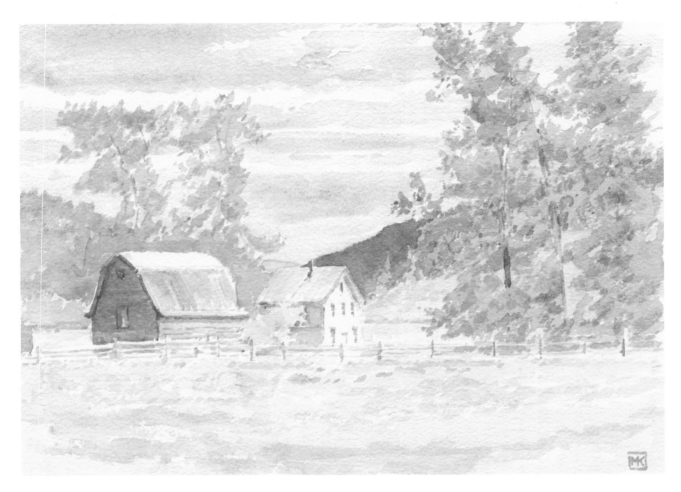

Thynne Lake Ranch, in the Otter Valley north of Tulameen, was a stopping place for stagecoaches in the years before the KVR. Jack Thynne, a Cornishman, settled on a homestead near Yorkton, Saskatchewan, and in 1887 came west to the Nicola, afterwards to Otter Valley, where he and his wife Mary, daughter of the factor at Fort Garry, ran the inn, which featured a tennis court out front. He died in 1943, she in 1957.[1]

1 Obituary in *Okanagan Historical Society,* 1957, p. 104 ; see also *Nicola Valley Historical Quarterly* vol. 4, no. 2, April 1981.

world-wide economic depression, which had begun symbolically with the loss of the *Titanic* in April 1912.

Although the two companies had agreed to share the Hope to Princeton rail lines, they intended to compete as always for traffic between Vancouver and the southern Interior. However, when J.J. Hill died in 1916, just two months before the rail line was completed through the Coquihalla Pass, the old rivalry lost its punch and the Americans began to withdraw from southern BC. The KVR established the tracks and built the roundhouse, station and other buildings at Brookmere. Following flood damage in 1934, the VV&E abandoned service between Princeton and Hedley; a decade later it forfeited its trackage rights, paying a veritable fortune to the CPR to get out of its obligations. The following year, in no position to bargain, it sold the orphaned Princeton-Brookmere line to the CPR for $1.5 million, a fraction of its cost.

Daily passenger service and the shipping of coal, lumber and fruit occupied the line in the interwar years. The Hope-Princeton Highway opened in 1949, exacerbating the diversion of fruit shipments onto trucks that was already well underway via the Cariboo (Trans Canada) Highway. Passenger traffic continued to drop and late in 1957 the company cut its branch line services throughout the area, including the trains that had run from Spences Bridge to Brookmere since 1916. In February 1958, the CPR cut passenger service from Midway to Nelson from daily to twice a week; Vancouver-Penticton remained daily, but as train schedules changed the remaining passenger traffic slipped away. The CPR abandoned the Coquihalla Pass

section of the KVR in 1960, and two years later the track was pulled up as far as Brodie. Passengers and freight for the KVR made it to Brookmere via the main line and the section from Spences Bridge to Brookmere. In 1964, the KVR ran its last passenger train.

Due to a dispute over prices, the CPR began to boycott Coalmont coal in the mid-1920s in favour of coal from its Merritt collieries; when the CPR formally took over the KVR in 1931 it switched the KVR trains to Merritt coal, earning itself the nickname Cheapie-R and causing operational problems when Merritt coal turned out to be too light for the steep grades of the Coquihalla Pass.

It is difficult to get any sense today of the scale of the railway operations in little Brookmere. The roundhouse there was destroyed in 1949 when a locomotive blew up; it was then rebuilt, then ultimately disassembled in 1970 for salvage by a Brookmere resident.[1] The right-of-way, now part of the Trans Canada Trail, seems an impossibly narrow slit through the forest. The village itself, which once boasted in addition to the railway operations a hotel and numerous commercial facilities, is now just a straggle of small buildings, many of which are mere cabins, along the roadway. There is still an unfortunate number of junkpiles and old cars, but some paint-up/fix-up activity is beginning, and hopefully new owners will restore the old places rather than build new ones so that the village retains some of its remaining historic character.

In the years between the end of passenger service in 1964 and the opening of the Coquihalla Highway (Highway 5) in 1986, Brookmere was quite remote, but is now easily accessed from the highway at the Coldwater Road exit. It is possible to see the old railway roadbed several kilometres to the south, as it makes the "Loop" – the point where the railway ended its northerly climb from Princeton and emerged from a narrow cleft in the hills, then headed southwesterly, upstream along the Coldwater River toward the Coquihalla Pass and eventually Hope.

Old log hay barn in the Otter Valley, October 2001.

1 Railway text developed largely from two excellent and detailed histories: Barry Sanford, *McCulloch's Wonder: The Story of the Kettle Valley Railway*, 1978; and Joe Smuin, *Kettle Valley Railway Mileboards: A Historical Field Guide to the KVR*, 2003. Correspondence from Joe Smuin and Neil Roughley helped to clarify the different types of railway buildings.

Apicturesque ranch house, about 15 kilometres east of Merritt at Iron Mountain Road, emerged into the general consciousness when the Okanagan Connector, following the route of the old Aspen Grove Road, opened in the late 1980s. It is a good example of a classic western homestead: the main house with side gables, a simple roof without any dormers, a front porch with a hipped roof, and a rear addition (which may indeed have been the original building) forming a T with the main house. Unusual, though, are the expensive turned porch posts and brackets, likely imported from a mill such as the ones that existed in New Westminster.

An unconfirmable story says the place was built by Guichon interests about 1900.[1] Joseph Guichon came from the Savoie region of France, was related to the Morens family of Spences Bridge (page 130) and built a vast cattle empire. He built the Quilchena Hotel, an elegant tourist destination still owned by his descendants, in the Nicola Valley in 1907-8. In the 1930s the house belonged to the Clowter family. At that time there were a number of sheep farmers in the area, including the neighbouring SX Ranch.[2]

1 An anonymous visitor told the story to Kimberley Turley, whose Sunnyhill Ranch is the current owner of the property and house.
2 Correspondence with Glynnis Tidball of Merritt, quoting her great-aunt. The latter's mother, Fanny Langstaff, played violin at the Quilchena Hotel during the First World War years.

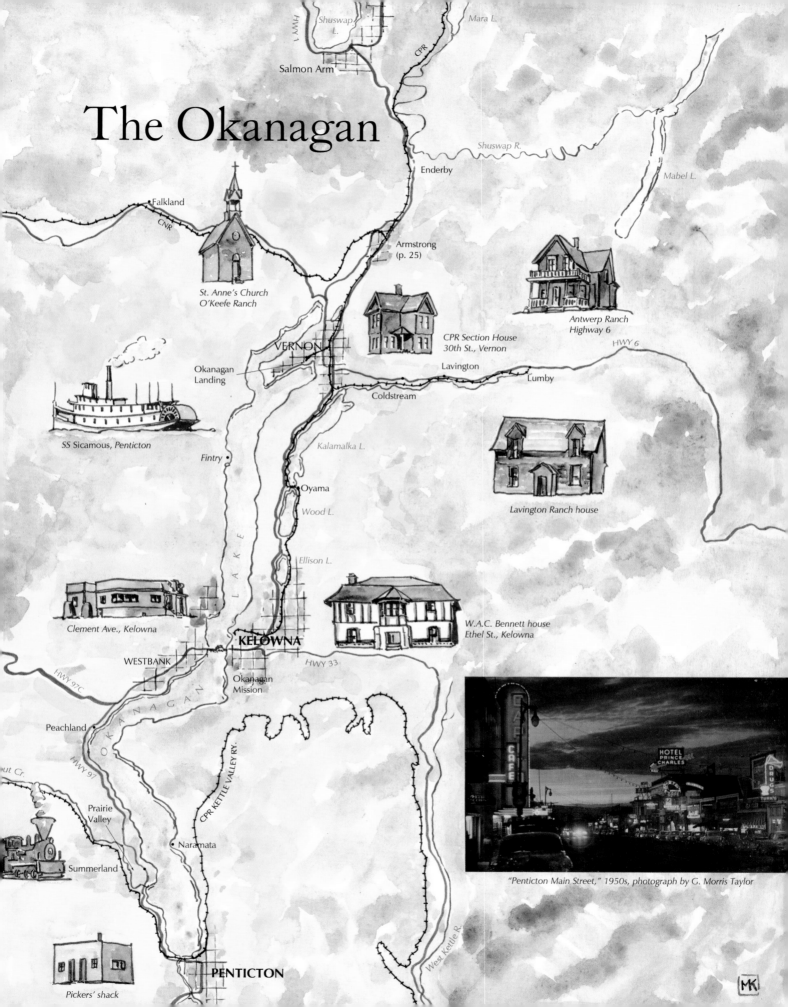

The Okanagan

Shuswap L.

Mara L.

HWY 1

CPR

Salmon Arm

Shuswap R.

Mabel L.

Enderby

Falkland

CNR

Armstrong
(p. 25)

St. Anne's Church
O'Keefe Ranch

Antwerp Ranch
Highway 6

CPR Section House
30th St., Vernon

HWY 6

VERNON

Okanagan
Landing

Lavington

Lumby

Coldstream

SS Sicamous, Penticton

Kalamalka L.

Fintry

Lavington Ranch house

Oyama

Wood L.

Ellison L.

Clement Ave., Kelowna

W.A.C. Bennett house
Ethel St., Kelowna

LAKE

KELOWNA

HWY 33

WESTBANK

Okanagan
Mission

HWY 97C

OKANAGAN

Peachland

HWY 97

out Cr.

Prairie
Valley

CPR KETTLE VALLEY RY.

Naramata

Summerland

West Kettle R.

PENTICTON

Pickers' shack

"Penticton Main Street," 1950s, photograph by G. Morris Taylor

MK

The J.M. Robinson Towns

. .

It was no mean feat for John Moore Robinson to promote the Okanagan Valley both as a "California" (the ultimate democratic Eldorado) and as a place suitable for well-born Englishmen eager to try their hand as orchardists (a suitable occupation for a gentleman, it was believed). A century after he established Peachland (1898), Summerland (1902) and Naramata (1907),[1] the three towns still represent the best of the Okanagan dream and have so far resisted the flood of suburban development inundating, among others, Kelowna and Westbank.

It is the settled quality of Summerland, especially Prairie Valley to its west, with its fine homes and orchards, its blue skies, sagebrush-dotted hills and blue-black pine forests, that makes it such a period piece. Laid out in orchard lots in 1902 by Robinson, it had its original townsite and commercial district along the lake where the ferry docked, in the area now called Lower Summerland. The community's modern town centre was originally called West Summerland. The latter has favoured mock-Tudor buildings in keeping with the style established by renowned architect Samuel Maclure's Bank of Montreal on Main Street and Bredon Hill, the home of Major E.E. Hutton, at 12045 Reynolds Avenue. Another landmark from the early years, visible from miles around, was the home on Giant's Head bought by playwright George Ryga in 1962. The former Dominion Experimental Farm, now the Pacific Agri-Food Research Centre, recalls the federal government's seminal role in the successful settlement of the agricultural areas of the country.

Robinson's Summerland Development Company was able to acquire a block of land in Prairie Valley from Barclay's Bank in England, thanks to a $75,000 loan from Sir Thomas Shaughnessy, president of the Canadian Pacific Railway. Among the eastern Canadian investors was Bank of Montreal vice-president and CPR director Richard Angus, who had an orchard bungalow erected for him on Dodwell Avenue in 1904.[2] R.H. Agur's beautiful Balcomo Lodge was erected two years later, and is "one of the Okanagan's most important architectural statements from the first half of the 20th century." It was built, probably from American plans, by John Robertson and the Nelson Brothers, in a style that owes much to the designs of M.H. Baillie-Scott and other architects of the English Arts and Crafts Movement.[3]

Balcomo Lodge, on Rutherford Avenue south of Prairie Valley Road, built for a migrant from Winnipeg with connections to the Massey-Harris farm implement company who became one of Summerland's first councillors and its second reeve. At harvest time, 2001, I found the house, slightly deteriorated, sitting in the middle of an intensively worked apple orchard.

ABOVE *Looking east along the bowl of Prairie Valley to dramatic Giant's Head, which largely blocks the view of Okanagan Lake. Summerland's town centre is to the left of Giant's Head, outside the picture frame. The view, painted in late September 2001, is too distant to capture the small grids of fruit trees, and only the rows of poplars and the other large shade trees cast major shadows. Balcomo Lodge sits almost dead-centre in the scene in a clump of trees.*

LEFT *The view along Dale Meadows Road toward Giant's Head, with an old shed and orchards in the distance.*

1 Win Shilvock, "John Moore Robinson," *British Columbia Historical News*, Spring 1990, p. 27.
2 Summerland Museum and Heritage Society and the Heritage Advisory Commission, *Summerland's Heritage*, undated pamphlet.
3 Hobson and Associates, *Okanagan-Similkameen Heritage Resource Inventory*, pp. 23-4.

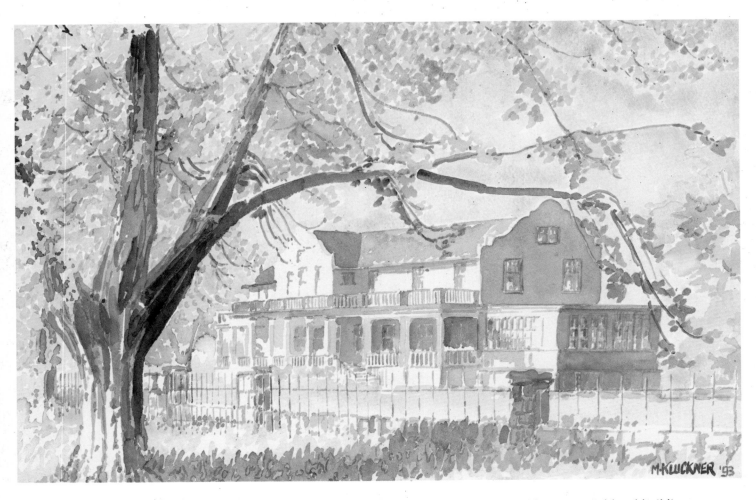

Ontarian John Moore Robinson was a particularly successful example of the boosters who flooded westward in the late nineteenth century. A newspaper reporter in Manitoba, he looked first for mining opportunities in the Kootenays before seeing more profit in the pockets of potential Okanagan settlers. (Photo: J.E. Whiteman, 1905.)

BC ARCHIVES A-02438

What I first saw in 1993 – writing "An old, unoccupied hotel building near the waterfront at Naramata on Okanagan Lake" on the back of the watercolour – has recently been restored as the Naramata Inn and Spa. The Naramata Hotel was "the pre-eminent commercial heritage building in the Okanagan-Similkameen Regional District. It was once rivalled by the now-demolished Incola Hotel [on the Penticton waterfront], but it survives as the last of the lakefront hotels, associated with boat travel on Okanagan Lake."[1]

J.M. Robinson's 1910 promotional brochure for Naramata stated, "On the triangle of land projecting into the lake is being constructed, under the supervision of a New York architect, a hotel with rest cure sanitarium annex." Features included cottages for rest cures, a bowling green, tennis courts, croquet grounds, a lacrosse field and a baseball diamond where, its exclusive clientele was reassured: "You would not wish to find yourself surrounded by garlic-eating foreign neighbours, with whom you had nothing in common socially. The class of people coming to Naramata is not of that type. They are of the very best Canadian stuff."[2]

In the early 1980s, Bill Robinson, J.M.'s nephew, occupied the hotel as a private residence. It retained its large dining room, lobby with fireplace, ballroom, conservatory, billiards room, and 17 bedrooms. The Mission Revival style was very popular for institutional buildings around the time of the First World War, another example being the former residential school at St. Eugene's Mission (page 112).

Naramata was Robinson's favourite of his three towns, to which he moved

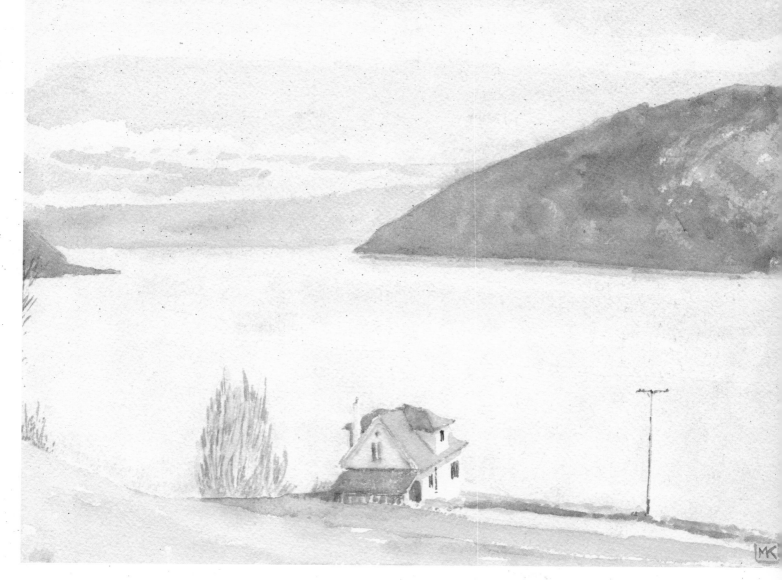

with his wife and eight children in 1907, remaining there until his death in 1943. It evidently received its name through his interest in the occult – a popular pastime. Naramata, "the Smile of Manitou," was the wife of a Sioux chief named Big Moose summoned by a settler and medium, Mrs. J.S. Gillespie, to a seance at her tent home attended by Robinson.[3]

Peachland, promoted by Robinson in 1898 with the sale of 10-acre irrigated lots, occupies the bench above Okanagan Lake about midway between Summerland and the Kelowna bridge. A number of fine houses still dot the orchards and vineyards, which are interspersed with small cul-de-sacs of houses from the 1960s and 1970s. The townsite itself is cramped on the narrow flat below the bench and along the lake; with its main street – the highway until the 1960s – small lots, cottages and graceful weeping willow trees, it is a period piece in its own right.

Robinson was by no means the first to promote fruit growing in the Okanagan, which had begun in the early 1890s largely due to the vision of the Earl and Countess of Aberdeen, who purchased the 480-acre Guisachan property near Okanagan Mission and planted 100 acres of apples and small fruits over the winter of 1890-1.[4]

One of the fine old homes remaining in Peachland, on the bench above the townsite, it was floated to the beach from Kelowna in 1904, hauled up the hill and established on a new foundation.[5] (The treetop is a poplar growing next to the octagonal former Peachland Baptist Church, now the museum, 30 metres below the house.)

1 Cited in Robert Hobson and Associates, *Okanagan-Similkameen Heritage Inventory*, p. 31.
2 Ibid.
3 Win Shilvock, "John Moore Robinson," *British Columbia Historical News*, p. 27.
4 Ursula Surtees, *Sunshine and Butterflies: A Short History of Early Fruit Ranching in Kelowna*, p. 9.
5 Correspondence from Ken Chilton.

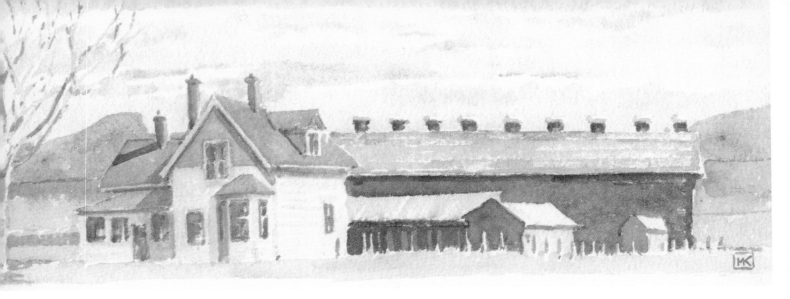

Kelowna Orchards

The McFarland farm, with its tobacco barn identifiable by the number of roof vents, at 3139 Benvoulin Road, built c. 1900.

In the Benvoulin Road/Okanagan Mission area of Kelowna, in spite of huge population growth and suburbanization, an excellent collection of historic farm buildings helps tell the early story of the community. Most significant is Okanagan Mission, established along what is now called Mission Creek in 1859-60 and preserved as a heritage site. A little ways south, the farm buildings of the John Casorso family, demonstrating the evolution from log to frame as the family settled and prospered in the 1880s, occupy both sides of busy Casorso Road, which connects new subdivisions to the south (some burnt out in the 2003 forest fire) with the City of Kelowna. The earliest settlers in the Okanagan Valley, including John Ellis in the Penticton area and Cornelius O'Keefe near Vernon, were cattlemen who in some cases grew grain. John and

LEFT *The Anthony Casorso bungalow, built about 1908 at 3350 Benvoulin Road on property his father John had bought south of the Lequime store. After managing the family's Pioneer Ranch, Tony began to farm 16 acres, became prominent in tobacco farming, kept bees, and ended up cultivating 120 acres of vegetables and fruits. He died in his garden,* aged 87, in 1967; his daughter Margaret Greening lived in the house until about 1994.[1]

RIGHT *Guisachan House at 1073 Guisachan Road, built in 1891 for Lord and Lady Aberdeen by Eustace Smith and David Lloyd-Jones.[2] It is the purest example of a British colonial bungalow in Canada. Similar but smaller bungalows still exist in the archetypal remittance-men's colony, Walhachin (page 132).*

KELOWNA MUSEUM 3412

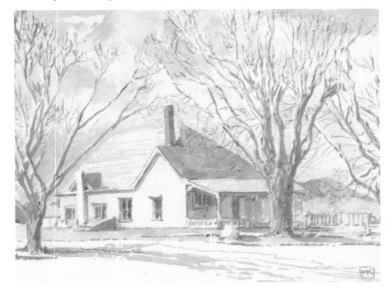

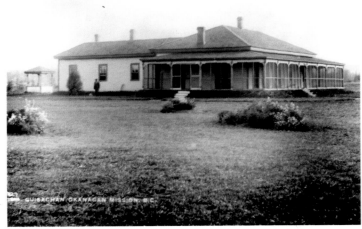

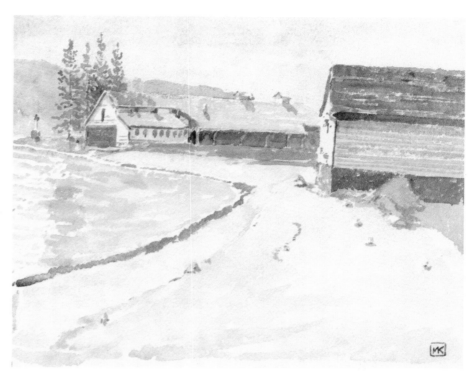

Susan Allison, who had earlier homesteaded near Princeton, lived what she described as a "perfectly ideal life" at Sunnyside (Westbank) from 1873 to 1881 in a log house that was the first European habitation built on the west side of Okanagan Lake.[3]

The next group of settlers brought capital and the desire to grow fruit, ultimately creating the venerable sundrenched quilted orchard landscape synonymous with the Okanagan of the pre-vineyard era. The Earl and Countess of Aberdeen's purchase of the Guisachan ranch in 1890, and their subsequent promotion of the valley throughout Canada and Great Britain (including in her book *Through Canada with a Kodak*, published in 1891), put a genteel stamp on the Okanagan that was still quite evident until about 30 years ago. East of Vernon, Lady Aberdeen used the capital from the sale of her London house to purchase Forbes Vernon's 13,000-acre Coldstream Ranch, still one of the finest such properties in the province with a nonpareil collection of "manorhouses," bunkhouses and barns.[4] Another wealthy Englishman, James C. Dun Waters, left Shropshire for 2,500 acres of ranchland at Shorts Point on the west side of Okanagan Lake; named Fintry after his original estate, it featured a splendid hipped-roof manorhouse quarried of local stone, with a trophy room, which is now the centrepiece of Fintry Provincial Park. Dun Waters, according to a neighbour, "refused to recognize local customs. He rode English saddle in English britches and jodphurs. He carried a hunting horn which he used to use – you'd hear this hunting horn through the hills and it was Dun Waters out for a ride."[5]

Unlike John McDougall who sold to the Aberdeens, some early pre-emptors in the Kelowna area sold out to land syndicates around the turn of the twentieth century. Evidence of two of them, the Kelowna Land and Orchard Company and the Belgo-Canadian Fruit Lands Company, remains in K.L.O. Road and Belgo Road. Many settlers were orchardists, while others grew grain and some tobacco. Tobacco growing by the Oblate Fathers of Okanagan Mission was noted by travellers as early as 1863, and had its heyday around the beginning of the twentieth century.

Kelowna lacked a direct rail connection with the outside world until 1925, when a CNR spur line arrived in the industrial area just north of the current downtown[6] and effectively spelled the end of the gracious era of travel (and fruit shipping from Kelowna) by CPR paddlewheelers plying the lake between the main line spur at Okanagan Landing and the Kettle Valley Railway connection at Penticton (page 26). A fire in the summer of 1969 destroyed the remaining wharf buildings at what was then called the Aquatic in Kelowna's pretty city park.

Packing plant at Fintry, the last one left on the Okanagan lakeshore,[7] late in the fall of 2002. Such plants were once dotted all along the west side of the lake at places like Westbank, Peachland and the Greata Ranch (now a Cedar Creek winery) south of Peachland. Some had tracks on their wharves allowing boxcars to be packed on site and then pushed onto scows for towing to the railhead.

1 Victor Casorso, *The Casorso Story*, p. 95; Okanagan Historical Society, 32nd report, 1968, pp. 44-52. Thanks to Scott Meadows and Kelowna Museum archivist Donna Johnson.
2 Kelowna Heritage Advisory Committee, *Kelowna Heritage Resource Inventory*, p. 14.
3 Margaret Ormsby, ed., *A Pioneer Gentlewoman in British Columbia*, p. 16.
4 Surtees, *Sunshine and Butterflies*, pp. 9-10; and *Kelowna Heritage Resource Inventory*, Early Settlement and Land Use Section.
5 Quoted in Paul M. Koroscil, *British Columbia: Settlement History*, p. 83.
6 The railway station, built in 1927, still exists near Ellis Street north of Clement Avenue.
7 Correspondence from Ken and Jan Weldon, Friends of Fintry Society.

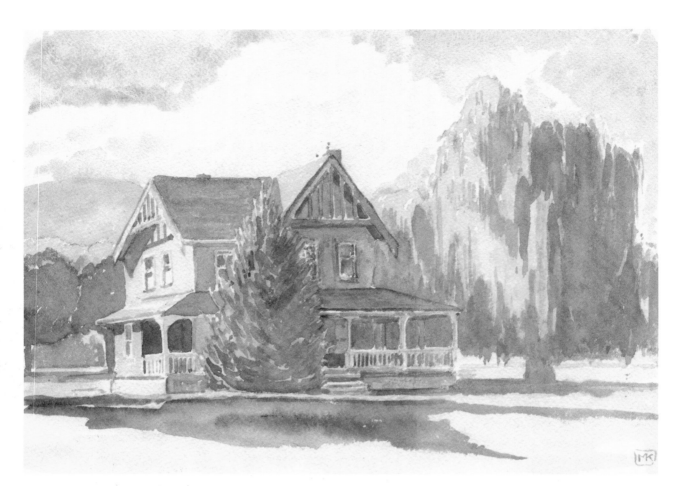

Coldstream & Lavington

The Princess Patricia Ranch at 9058 Kal Lake Road on a bright autumn morning in 2002. I stopped, imagining ghostly croquet players on the lawn, then decided to paint it as it seemed in decline, as if held for speculation. Fortunately, it has since been bought by Sherry Hudson who has restored it as a B&B called Aberdeen Manor.

The fertile valley running east from Vernon toward the Monashees was, like Summerland and Okanagan Mission, a Shangri-la for British expatriates seeking a refined country life. Along Kal Lake Road near the Coldstream Ranch, this large mock-Tudor with splendid wraparound porch and weeping willow, its orchard dotted with pickers' shacks stretching behind, evokes their model farms.

Ishbel, the countess of Aberdeen, owner of the Coldstream Ranch, was a progressive thinker who supported women's suffrage and encouraged the education of young women and their emigration from England to the colonies.[1] In 1892, she and her husband, the governor general, subdivided lands between the ranch and Kalamalka Lake into 10- to 20-acre lots, and began irrigation works and orchard plantings with the "more or less philanthropic wish to make land available for new settlers."[2]

In 1906, Lord Aberdeen formed the Coldstream Estate company, sharing control with the chairman of an English distillery company. Henceforth, until all activity ground to a halt with the outbreak of the war, the Coldstream became populated with middle- and upper-class families from Great Britain and eastern Canada. These "people of good breeding" formed a community through local private schools, the Kalamalka Country Club and the Ranchers' Club in Vernon. The Honourable Caroline Grosvenor engaged architect O.B. Hatchard[3] in 1912 to build the Princess Patricia Ranch – named for HRH

1 Jo Fraser Jones, ed., *Hobnobbing with a Countess and Other Okanagan Adventures*, contains vivid descriptions of the impact of Lady Aberdeen on the Vernon community. **2** Hobson and Associates, *Greater Vernon Heritage Resource Inventory*, 1986, p. 29. **3** See Luxton, *Building the West*, p. 377.

Princess Patricia, whose parents, the duke and duchess of Connaught, subscribed funds. It ran initially as a girls' agricultural school and boarding house under the direction of the Colonial Intelligence League.[1]

But the war changed everything, and eventually the ranch was sold at a distress price to A.T. Howe, who had a number of holdings in the area, including by the late 1930s one of the best Jersey dairies in the Interior. According to one of his grandsons, Sean Henry, Howe "was British, but originally settled in Toronto. In about 1910 he was told he had a heart condition and was not going to live very long. He had read about the Okanagan Valley being a 'garden of Eden' so he packed up and moved there in 1913 to spend his final days in pleasant surroundings. He purchased a house by Kalamalka Lake, which included a small orchard. As time went by and he remained alive, he became interested in the fruit business and began acquiring more properties. In the end he owned several thousand acres of mainly orchards and his own packing house. He finally died in 1947 at the age of 92 (in the house you have portrayed). So much for medical advice!"[2] Subsequently, "George & Myfanwy Nuyens bought the place from A.T. Howe ... in 1949 through the Veterans Lands Affairs and raised seven children there."[3] The current owner bought it after the deaths of the elder Nuyenses. Although the ranch lasted only a brief period for its intended purpose, it remains as a monument to the Colonial Intelligence League, whose "determination to find careers for women beyond the normal confines of domestic service made them a progressive group in emigration history."[4]

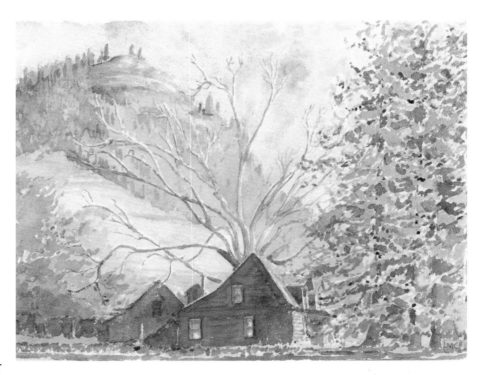

Early in the morning on a late-October day with heavy frost still on the lowland pastures but the sun already warming the south-facing hillsides, I climbed over a rather tall wire fence and sat in the thick grass with this almost unimpeded view of the Duteau house. "This may be the oldest remaining residence in the Greater Vernon Area. If not, it is at least a very rare example of surviving log construction with verifiable historical association."[5] With its two large wall dormers and its "saltbox" shape, it is easily recognizable as a very old rural building. It has been boarded up for about 20 years, somehow avoiding significant vandalism or arson.

The most significant survivor from the pre-Aberdeen era is the Duteau house, *aka* the Lavington Ranch, on Highway 6. Nelson Duteau reputedly visited the White Valley in the 1860s, during the era when Cornelius O'Keefe in Spallumcheen and Tom Ellis in Penticton were assembling their huge cattle ranches, and the Oblates' Okanagan Mission was one of the few spots of European settlement along Okanagan Lake. However, Duteau did not buy his 800 acres until 1883, building the house at some point over the next decade. Like Barrington Price near Keremeos and the Lequimes and Brents in Kelowna, Duteau built a grist mill, the first in White Valley, on a creek near his house, an essential feature of an established farming community. Reuben Swift married one of Duteau's daughters, inherited part of the property and later bought out the other family members, but around 1905 he sold the entire ranch to a man named James Buchanan, an investor in Coldstream Ranch.

1 Andrew Yarmie, "English Female Residents at the Princess Patricia Ranch," *British Journal of Canadian Studies* vol. 16, no. 1, 2003, pp. 102-25. Thanks to Jean Barman for locating the article.
2 Correspondence.
3 Correspondence from a daughter, Pat Duggan, who was born in the house.
4 Yarmie, p. 118.
5 Hobson and Associates, p. 140.

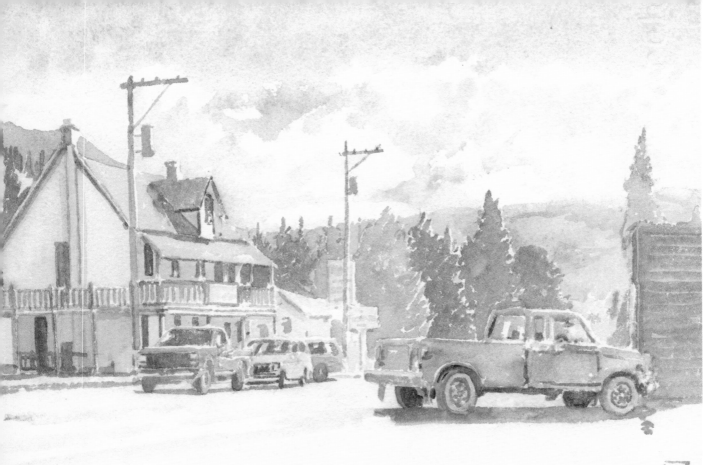

The road from Kelowna to Rock Creek provides a transition between the rather genteel Okanagan and the rougher Boundary Country. The community of Beaverdell breaks the journey, its venerable hotel being, according to its owners, the oldest continuously operating one in the province – leading, as Rosemary Neering quipped, to some very tired bartenders.[1] A silver strike on Wallace Mountain and a gold strike at Carmi a few kilometres north in the late 1890s led to settlement, the towns of Rendell and Beaverton amalgamating into Beaverdell. The legacy of the initial mineral strikes was the Highland Mine, which produced for more than 90 years and, together with logging, kept the area alive through good times and bad.

ABOVE *The Beaverdell Hotel, built c. 1900,* looks *like a roadhouse, and its fine period interior, especially in the beer parlour, is no disappointment. The lodgepole-pine forests here are dotted with tamarack which daub the hillsides with gold as autumn comes in.*

BELOW *Nearby, the town of Carmi has even more of a backwoods feel, leavened by the many cyclists coming through the area to ride the old Kettle Valley Railway line. Sadly, its fine old hotel building burned down about 2000. Photo courtesy of Dan Langford, author of* Cycling the Kettle Valley Railway.

1 Neering, *Traveller's Guide to Historic British Columbia,* 1993 edition, p. 111.

Boundary Country

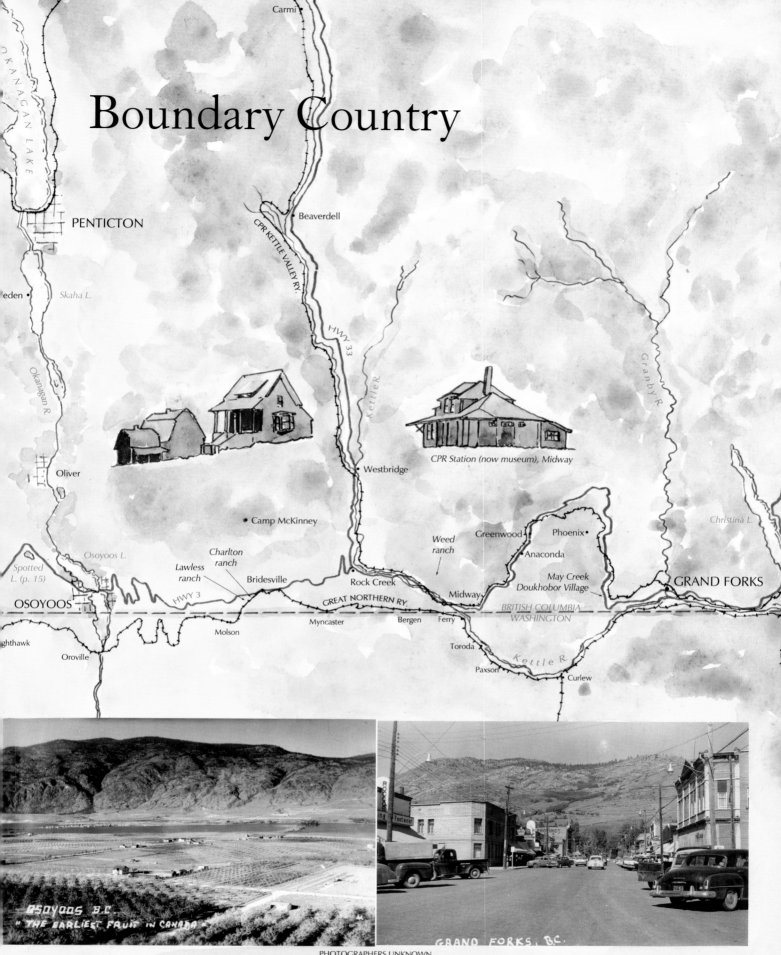

Carmi

OKANAGAN LAKE

PENTICTON

Beaverdell

CPR KETTLE VALLEY RY.

HWY 33

Kettle R.

Granby R.

eden •

Skaha L.

Okanagan R.

Oliver

Westbridge

CPR Station (now museum), Midway

Christina L.

Camp McKinney

Osoyoos L.

Greenwood

Phoenix

Spotted
L. (p. 15)

Charlton
ranch

Anaconda

Weed
ranch

Lawless
ranch

Bridesville

Rock Creek

May Creek
Doukhobor Village

GRAND FORKS

OSOYOOS

HWY 3

GREAT NORTHERN RY.

Midway

BRITISH COLUMBIA
WASHINGTON

Myncaster

Bergen

Ferry

ghthawk

Molson

Toroda

Kettle R.

Oroville

Paxson

Curlew

OSOYOOS B.C.
"THE EARLIEST FRUIT IN CANADA"

GRAND FORKS, B.C.

PHOTOGRAPHERS UNKNOWN

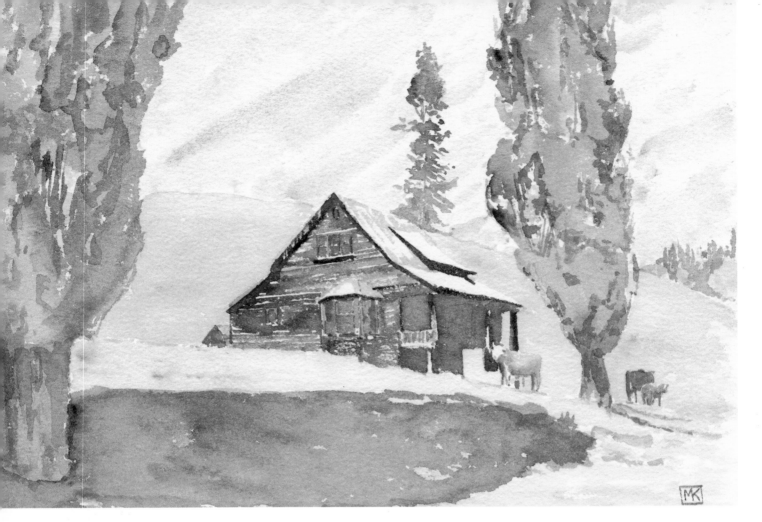

Border Ranches

Charlton's, aka *the Foster place or the Reed place, sat in a gully south of Highway 3 a kilometre east of Anarchist Summit. I noticed it in the spring of 1995 only because the tops of the poplar trees, not native to that arid area, stood up above the rolling bunchgrass hills. At the time, the abandoned farmstead included two gambrel-roofed barns, with Hereford cattle grazing nearby and using them for shade. When I returned in 2000 the house and the big barn had burned to the ground, torched by arsonists later in the year I painted the watercolours.*[1]

1 Correspondence from Penny Dell; thanks also to Norah and Arthur Harfman.

The Boundary Country between Osoyoos and Midway has superb vistas and landscapes: yellow bunchgrass, distant blue hills and mountains dotted with Ponderosa pines, and a scattering of historic ranches that, to me, epitomize the "go west young man" pastoral dream of the province's founding years. The Charlton and Lawless ranches illustrated here are within a kilometre either side of Anarchist Summit, just west of Bridesville, while the Weed ranch is on Ingram Mountain, east of Rock Creek and near the eastern end of the climate belt that produces these spectacular open ranges.

In recent years, by comparison with the era when people and goods flowed casually back and forth between communities like Bridesville and Molson east of Osoyoos Lake, the international boundary has become like a neat part in a head of hair, with everything on each side directed away from the divide. The old Rock Creek border post closed in the 1970s, and Canadian travellers wishing to go back and forth now have to use the Midway-Ferry crossing or the Osoyoos-Oroville one to enter the USA.

A hundred years ago, the Vancouver, Victoria & Eastern Railway, technically a Canadian line but in reality part of the American Great Northern system, looped back and forth across the border, entering BC at Midway and travelling west along the boundary south of modern Highway 3, through Bergen, Myers, Myncaster, Syackan, Dumont and then Bridesville; it then

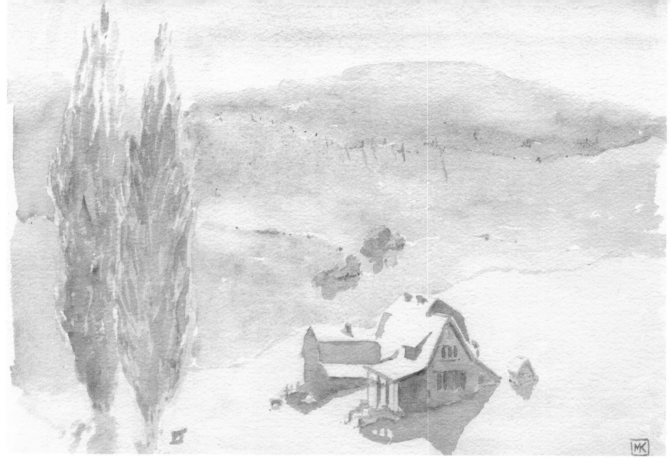

CLOCKWISE FROM ABOVE *Early June morning, 1995 – the ranch in the raking sunlight; Chester Lewis Charlton and daughter Alice, about 1918; Charlton's second house on the Sidley Mountain Road, built by Malcolm Gordon from Penticton about 1922 – a nice solid Craftsman house with exposed rafter ends and a mixture of board siding and shingling on the gables (according to Arthur Harfman, there were three houses by Gordon, two for Charlton and one called the Schorn house visible on the hillside at the east end of Bridesville); Alice Charlton with her "uncle," Allen Eddy, and one of the newly planted poplar trees, about 1919 – Eddy was the Bridesville customs officer, a position made necessary by the GNR's route; Alice and mother Helen in front of the farmhouse around 1919. Note the oval glass on the front door and the leadlights.*
BUNNY COX

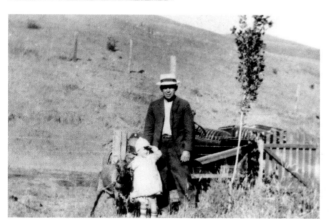

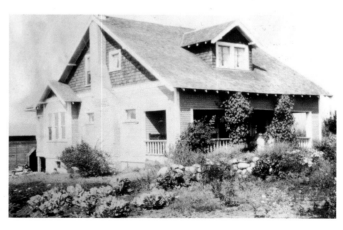

went south into Washington, to Oroville via Molson, then north across the boundary again, following the Similkameen River to Keremeos, Princeton and beyond (page 56). The section to Bridesville, originally called Maud but renamed for David McBride, a pioneer settler who granted land to the GNR on the condition that the townsite be named after him, was built in 1905. Traffic from Spokane was cut off in 1931 when the section known as the Washington & Great Northern from Curlew to Ferry was abandoned; four years later, the Canadian section from Midway to Bridesville met the same fate.[1]

Earlier, in the 1890s, it was the gold strikes at Camp McKinney that brought settlers to the region. The Dewdney Trail to Wild Horse Creek wound around the hill on the south side of Anarchist Mountain, sometimes on the Canadian side of the boundary and sometimes on the American side, depending on the grade. R.G. Sidley, the namesake of Sidley Mountain (and the dot on the map called Sidley), came from Ontario and took up a homestead in 1885 at the forks of Nine Mile Creek, almost on the 49th parallel. He gave Anarchist Mountain its name and established its first post office. The road from Bridesville to Osoyoos was not completed until 1910.[2]

Among the early settlers was Chester Charlton, who arrived in 1899 in his twenty-first year. He had left his home town of Ilderton, now a suburb of London, Ontario, as a youth and moved first to the Manitoba ranch of a cousin, John Mansfield, a producer of wheat and of Hereford cattle which he drove regularly as far as Oklahoma. Charlton eventually rode across the open plains as far as White Sulphur Springs, Montana, where he worked for the renowned A.B. Cook Ranch. His employer evidently liked him enough to promise, "If you ever get a ranch, I'll give you your first good Hereford bull."

Eventually, Charlton moved north and for a time drove stagecoach into Camp McKinney. In 1909, he purchased the Bridesville store and post office,

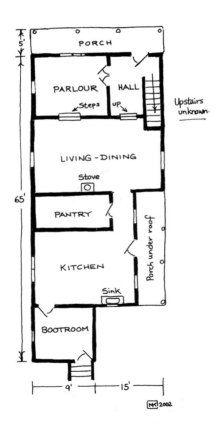

The Lawless house in September 2002. The porch post had fallen victim to its new role as a scratching post for the cattle that range freely over the property. At the time, the living-dining area was used to store some kind of rock or gravel, with the rest of the house empty, very rickety and unsafe; ergo, I drew no second-floor plan.

1 Correspondence with rail historian Neil Roughley.
2 Katie Lacey, "Anarchist Mountain Settlements," *Okanagan Historical Society* vol. 16, 1952, pp. 112-7.

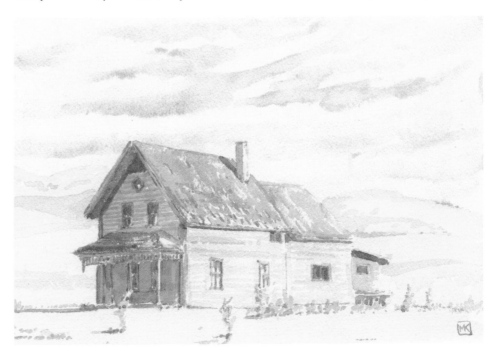

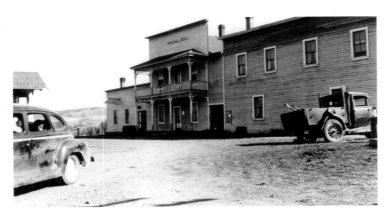

and also bought a quarter section (later doubled in size) in the rolling prairie southwest of Bridesville. According to family legend, he imported the first registered Herefords into BC from Montana. A few years later he met Helen Wellia, from Cologne, visiting Bridesville in order to see her sisters, wives of the co-owner brothers of a pole and sawmill business. They married in 1914, and Charlton soon began work on a proper ranch house, engaging builder Malcolm Gordon of Penticton. The construction, probably delayed by labour and material shortages during the war, extended through about 1917. Their first child, Alice, was born in Oroville, where there was good medical service; Bunny, christened Bernice, was a "blue baby" born in the house in 1920 with Mrs. Kingsley, the local midwife, presiding. The doctor, who had gone to Molson for the day, had been unable to make it back in time.

Charlton soon moved on, looking for better land, and sold his ranch to Pete Reed of Victoria for $20,000 – a good price at the time. Subsequently it was bought by the Fosters, so the homestead became known latterly as the Foster place. Today, at the bottom of the road below the home site, there is a series of flat pastures with a few derelict ranch buildings and modern homes; in a few spots it is just possible to pick out the old GNR grade along the hillsides.

In 1922, Charlton again engaged builder Malcolm Gordon to erect a $5,000 house on the Sidley Mountain Road – owned since 1946 by the Harfmans of the Circle 2 Ranch. He was among the first to import Rambouillet sheep into BC. Later, in another venture, he built the original log cottages at the Wagon Wheel Ranch at Sidley. He died in 1959 and is buried in the Bridesville cemetery.[1]

T he ranch just west of Anarchist Summit is known locally as the Lawless place and is one of the great folkloric landscapes of British Columbia (page 31). It was homesteaded by the Tedrow family from Kansas, who sold it to William Lucien, a man originally from Quebec who had drifted west and owned a hotel in Winthrop before coming north to Bridesville in the late 1800s. The ranch house was built by William Lucien about 1902. The ranch itself recently belonged to the Lehman brothers.[2]

Although it looks like a typical frame house, it apparently was built of squared and dovetailed tamarack and later sheathed with horizontal drop siding. The interesting question is whether it was built in sections: that is, whether the single-storey "middle" section was the original house, with the pantry added onto the back and the two-storey section added later as the rancher became more prosperous. The back half of the two-storey house is a clear span across what appears to have been a dining room, supported by a major beam parallel to the side walls; that open room, together with the large kitchen and pantry (identified as such because it is windowless) reinforces the notion of many ranchhands being fed, with the family's own quarters somewhat separate at the front and upstairs, where there are probably two bedrooms (the upstairs is only about 600 square feet).

ABOVE *A 1948 photograph of the Bridesville Hotel by Lithgoe. There are no identifiably historic buildings left today on the town's main street.*
BC ARCHIVES E-05323

BELOW *Charles and Ida Ellen Weed.*

GEORGE AND ALBERTA BUBAR

1 Interview with Bunny Cox, Greenwood, 2002.
2 Interview with Fred Lawless, Cawston, 2002.

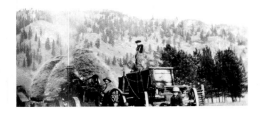

ABOVE *Threshing grain on Ingram Mountain.*
GEORGE AND ALBERTA BUBAR
BELOW *The Weed house in October 2002.*

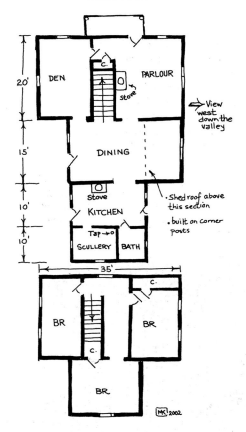

1 *Boundary Historical Society,* 7th report, 1976.

On Ingram Mountain east of Rock Creek, the treeless slopes ascend almost to heaven. A sharp-eyed traveller can pick out the Weed house silhouetted against the skyline, a kilometre above the end of the highest road, alone on the high meadows, with birds fluttering in the bushes and harvesting the seedheads, the only sound the breeze ruffling the tall grass. As I sat and painted, there were cattle in the distance, grazing among the ruins of the Weeds' barns and sheds like the goats Shelley and Byron saw when they visited Rome.

Charles Henry Weed crossed the 49th parallel into Canada during his twenties working as a freighter on the road from Myers Falls, Washington, through the Kettle Valley to Camp McKinney. Born in Iowa in 1870, he became familiar with the Boundary area in the mid-1890s, and bought ranchland high on Ingram Mountain. Perhaps only a freighter (he was also an expert harnessmaker) could have dealt with the challenge of moving supplies up and down such a steep road, but he had found a spring even further up the mountain which he tapped to provide running water for his spread.[1]

He built the house about 1900, siting it, unlike typical pioneer ranches, in a spot intended to maximize the view. In many ways it was a typical Victorian house with separate den and parlour at the front and a kitchen and scullery at the rear in a single-storey attached building where there was perhaps an indoor toilet. But the parlour and the large dining room have double windows to maximize the pleasure in the view. There is a real sense that the house was intended for a large family, and indeed Weed and his wife, Ida Ellen, had six children: Wesley (1897-1985), Charles (1902-66), George, Rena, Alica and Aletta. Wesley and Charles married Beatrice and Margery Bubar, daughters

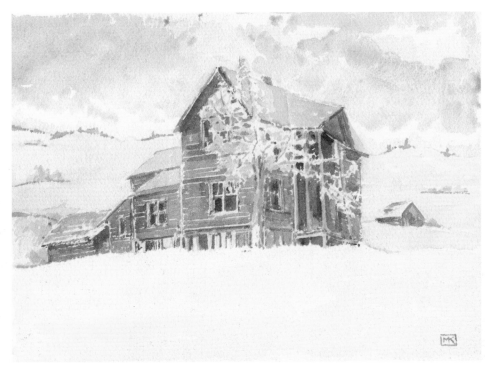

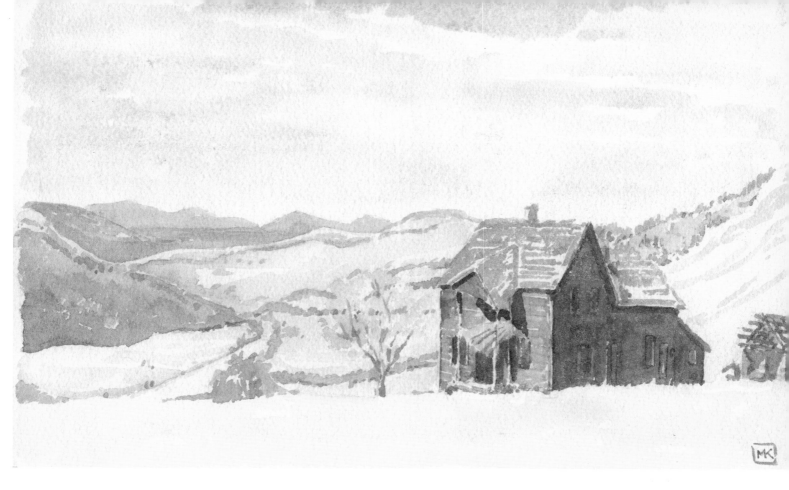

of the ranch just below the Weeds on the riverbank. Ida Weed, who, according to family story, had a telescope with which she watched the ranch below, died in Oliver in 1944; her husband outlived her by three years, having moved to Trail near the end of his life.[1]

There is no rot in this climate: buildings weaken because the boards dry out and shrink away from their nails, and eventually they shear and collapse sideways in a wind like a house of cards, rather than collapsing inward due to the failure of their structure. The Weed house was so dry and utterly free of paint, so weathered as to be almost petrified. No one can remember what colour it was painted. It apparently has been empty since the late 1940s.

ABOVE *The Weed house, looking west along the Kettle Valley.*
BELOW *The Bubar house, still extant near the north bank of the Kettle River, sits today in the midst of a ginseng farm; Stanley Livingstone Bubar, likely named for the two African explorers.*
GEORGE AND ALBERTA BUBAR

1 Interview with George and Alberta Bubar, Midway, 2003. Thanks also to Wendy and Mark Tossavainen for access through their property.

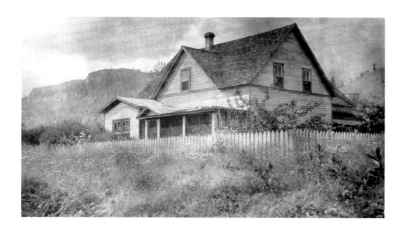

Greenwood

. .

The Kootenay district of British Columbia prospered beginning in the 1890s due to lode mining following prospectors' discoveries of silver (in the Slocan), gold (Rossland) and lead-zinc (at Trail). To the west, in the Boundary Country, copper mining and smelting supplied one of the key metals for the electrical age. Unlike placer mining, done by individuals who created quickly built and mostly vanished boomtowns like Granite Creek or Quesnel Forks, lode mining in the Boundary Country required organization and capital to extract the ore, smelt it and ship it. The scale of investment and profit was much greater, and its legacy is Greenwood, the survivor of a group of boomtowns including Phoenix, Deadwood, Boundary Falls, Eholt and Summit City. Unlike Grand Forks, which sits in a splendid agricultural valley (one of the few in BC running east-west) and whose proximity to the huge Granby smelter kept it going after the mines closed, Greenwood's compact townsite is wedged into a narrow valley.

It is easy to imagine prospectors coming through this area in the 1880s and spotting rich ore in the rocky outcroppings for, as Robert Louis Stevenson wrote of the Cevennes (in *Travels with a Donkey*), "the stony skeleton of the world was here vigorously displayed to sun and air." A good source on its glory days are the books of N.L. Barlee, better known as Bill Barlee, in the 1990s the politician responsible for BC's heritage program. As a young man, he roamed over the ghost towns of the Boundary and Kootenay areas, and has used the collection of artifacts and stories he amassed to write a number of books on mining and history. *Gold Creeks and Ghost Towns*, self-published in 1970, is the earliest one.

Greenwood, which bills itself as "The Smallest City in Canada" – its current population being 600 to 700 – was incorporated on July 12, 1897. Its founder was a promoter named Robert Wood, who built roads from the surrounding mining camps into town and quickly made it the hub for the area, eclipsing Anaconda a mile west on the flat. Fine buildings quickly followed,

1 Paul Bennett, in Luxton, ed., *Building the West*, p. 206.
2 Greenwood Heritage Society, *Greenwood Heritage Walk* brochure, 2001.

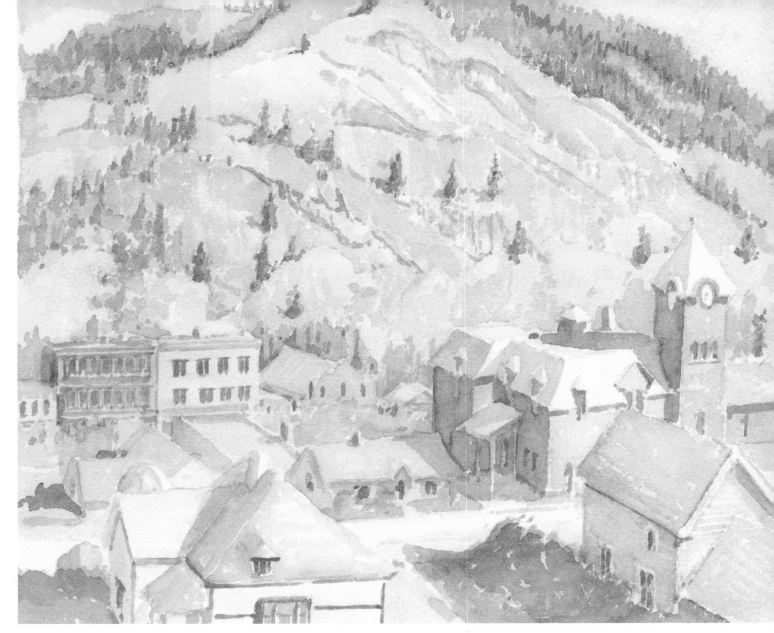

and the population peaked at about 3,000 in 1907, but when copper prices collapsed after the First World War the town went into the sort of slow decline that might have led eventually to ghost-town status.[1] However, in 1942, with its population at about 200, it became one of the first internment centres in southern BC for Japanese Canadians, with eventually 1,177 exiles residing there.[2] Some stayed after the war, and the town had a distinctively Japanese flavour as late as the 1970s. More importantly for its long-term survival, the old buildings were relatively well-maintained, and the town has had a recent rebirth with new arrivals restoring old houses and establishing new businesses. An amusing part of this rebirth was the filming there in 1998 of the town scenes for the film *Snow Falling on Cedars*, with Greenwood portraying a San Juan Islands town – the legacy is some faded signs painted on the brick side walls of the main street buildings along South Copper Street advertising fictional salmon brands and fishing supplies.

1 Greenwood Heritage Society.
2 Roy Miki and Cassandra Kobayashi, *Justice in Our Time*, p. 30.

Greenwood from the south hillside. The line of yellowed aspens defines Boundary Creek, beyond which lies the roadbed of the old Columbia & Western Railway. On the extreme left, the Guess Block, Greenwood Inn and the former Pacific Hotel (#1 Internment Building housing more than 200 Japanese Canadians during the war) sit on South Copper Street – Highway 3, in fact. The turreted brick building is the post office and federal government building, erected about 1913-5, a few years before the collapse of copper prices that closed the local mines and smelters and sent the town into a tailspin.

Doukhobor Villages

. .

Even today, a half century after their communal lands were broken up and sold to individuals, the Doukhobor villages are a significant part of the landscape of the Grand Forks area and the West Kootenays. Most noticeable are the distinctive brick houses, almost all of which are dilapidated or in ruins, which still dominate the landscape in spite of the modern ranchers and bungalows. In 1981, provincial government employee Don Tarasoff wrote that the Doukhobors faced "cultural heritage extinction: loss of communal lands, internal dissension, introduction of private ownership, prejudice, persecution, ignorance."[1] His recommendations for government intervention were never acted upon.

Map showing the Doukhobor communal villages of the Boundary/West Kootenay areas, adapted from the Tarasoff report.

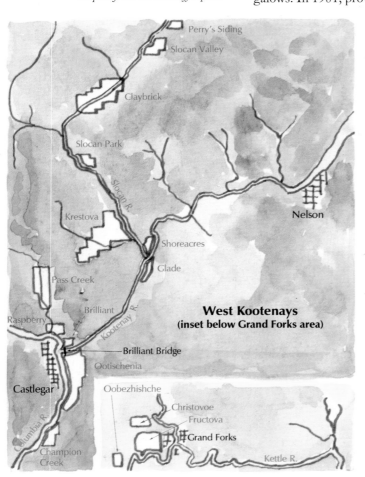

The Doukhobors came to Canada, originally settling in Saskatchewan, in 1899. A dissident religious sect believing in charismatic leadership and pacifism, they had been persecuted by the Russian government and Orthodox Church until, in the early nineteenth century, Alexander I permitted them to live communally near the Sea of Azov bordering the Crimea. Later they were exiled to the Caucasus Mountains and when, under the leadership of Peter "Lordly" Verigin, they refused military service, the Russian state increased its harassment. With the help of Leo Tolstoy and support from Quakers in North America, about 7,500 of them were allowed to emigrate. They settled on the prairies and again established a communal lifestyle, using a liberal interpretation of the "hamlet clause" in the Dominion Lands Act. When Frank Oliver replaced Clifford Sifton in 1905 as minister of the interior, Doukhobors were required to take an oath of allegiance and farm individually each quarter section of land.[2]

Peter Verigin, who had been released from Siberian exile and who arrived in Saskatchewan in 1902, led about 5,000 of his followers west in 1908 and purchased land for communal villages in the Grand Forks and West Kootenay areas. He directed them to build their villages to a standard plan (evidently by him) and organized brickworks, sawmills, packing houses and blacksmith shops which, together with farming enterprises, soon created self-contained communities. There was little livestock in the vegetarian villages, so few barns were built. As they had in Saskatchewan, Doukhobor men served in labour pools and were contracted out as

1 D.W.L. Tarasoff, *Doukhabour* [sic] *Heritage: An Inventory with recommendations for palliative care*, Heritage Conservation Branch, Victoria, 1981.
2 Kalman, *History of Canadian Architecture*, vol. 2, pp. 516-8.

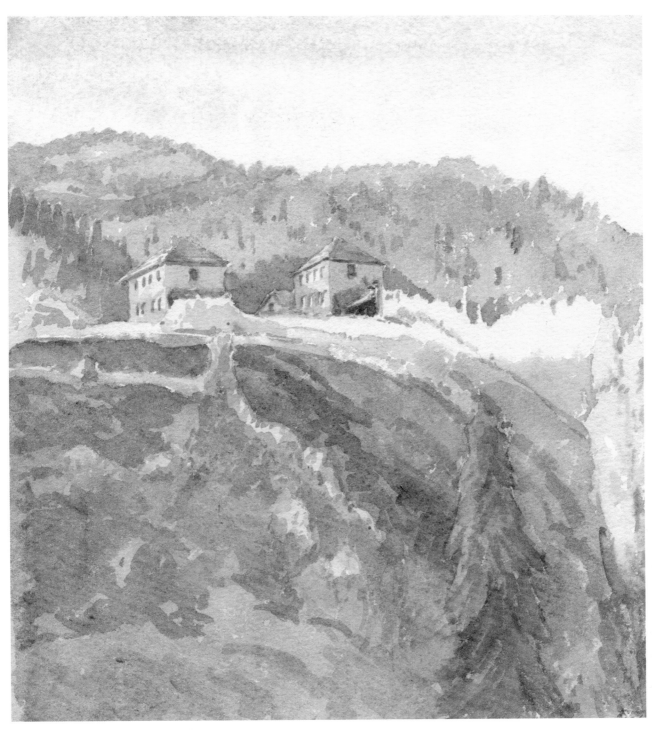

Doukhobor village on a bench on May Creek Road, within sight of Highway 3 in the hills just west of Grand Forks. Due to its isolation, it is the most picturesque and evocative of the province's surviving Doukhobor sites. The complex consists of two very plain two-storey brick houses, each 30 x 40 feet, facing each other across a courtyard with a smaller wooden building at one end forming a "U," plus the remains of some outbuildings. At the time of D.W.L. Tarasoff's 1981 study, the property's two owners were suing each other; Tarasoff recommended that the BC Heritage Trust acquire one's interest in the property for about $40,000 and thereafter encourage the other to restore the property. Alas, nothing was done. The property was for sale in the late 1990s for $329,000. The roofline of the house on the left was altered more than 20 years ago with a huge dormer, which I chose not to paint, and the property is now used for "eco-camping."

farmhands and construction workers, with their wages returned to the central authority. The villages traded back and forth amongst themselves, based on need for food, shelter, clothes and kerosene, with distribution from community warehouses like the building that became Polonicoff's Store on Donaldson Drive in the valley west of the town of Grand Forks.

The original Grand Forks area they settled was called Fructova, the Valley of Fruit. The land to the west where Danshin Village and the May Creek Road village were established was Oobezhishche, the Hideaway; the Hardy Mountain and Outlook Road villages were Christovoe, Christ's Land. Officially, the Doukhobors were the Christian Community of Universal Brotherwood, or CCUB, the largest experiment ever in communal living in British Columbia. It was strictly communal and "non-monetary" before the assassination of Peter "the Lordly" in a 1924 train bombing; subsequently, when his son Peter "Chistiakov" took control, the rules were relaxed and villages became more autonomous; the sleeping quarters of the brick houses were subdivided into rooms, and the central authority took a quota payment from each village, allowing them to sell any surplus production.

The villages kept to themselves and had as few dealings as possible with secular society. The hostility was mutual, as illustrated by the first reference to Doukhobors in the *Grand Forks Gazette* on January 30, 1909: "Peter Verigin,

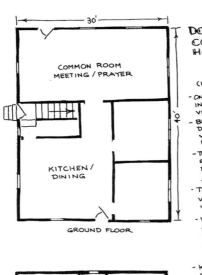

DOUKHOBOR COMMUNAL HOUSE

· c.1910

(HILLVIEW ROAD)

- ONE OF 2 MAIN HOUSES IN A TYPICAL DOUKHOBOR VILLAGE
- BRICK VENEER OVER A DIAGONALLY BRACED WOODEN PLATFORM - FRAME
- TWO MAIN HOUSES ENCLOSED ON REAR END BY A COURTYARD OF 1-STOREY WOOD HOUSES.
- TYPICALLY A VILLAGE WAS HOME TO 100 'SOULS'
- WOODEN FRETWORK & BLUE PLASTER CEILINGS WERE COMMON TO RUSSIAN VILLAGES
- KITCHEN DOMINATED BY CLAY OVEN
- UPSTAIRS, 4 BEDROOMS EACH SIDE, EACH WITH AN INDIVIDUAL WOOD HEATER.
- NO ELECTRICITY, RUNNING WATER OR INSULATION
- THERE WERE 110 LARGE COMMUNAL HOUSES IN 1951, 27 IN 1981, PERHAPS 10 IN 2002.

GROUND FLOOR

COMMON ROOM MEETING / PRAYER

KITCHEN / DINING

UPPER FLOOR

Perhaps surprisingly, given their non-materialistic beliefs and simple ways, the Doukhobors decorated their buildings with elaborate wooden fretwork or scrollwork. This example, of the Danshin Village communal house on Danshin Village Road (west of the May Creek Road village illustrated on page 83), which has since been removed, appeared in the 1986 Grand Forks Heritage Inventory. *Note also the distinctive brick, with its hollowed-out centre, always a tawny brown colour, produced at the Doukhobors' own brickworks.*

the Doukhobor leader, visited Grand Forks last week after a search for land in the Okanagan and Similkameen districts, and he immediately decided on obtaining land here. Negotiations were opened for $39,000, but the deal was not closed at the last report [it was confirmed on February 6 that Verigin had bought the Coryell ranch, which he renamed Fructova]. While this indicates the value of land here, it is not desirable that a band of these people locate here. They are a drag on progress and of no advantage to the district, as they import all their needs by wholesale. They are far from being desirable along moral lines also."[1]

Like Native Indians, Doukhobors viewed public schools as agents of assimilation; moreover, lacking a written holy book, they had no use for literacy. Following the foreclosure of the CCUB's mortgage in 1939, the community split between a group that coexisted with mainstream society and the Sons of Freedom sect, which terrorized the Kootenays with arson and explosives. A sensational and biased recounting of those times is the book by *Vancouver Sun* reporter Simma Holt, *Terror in the Name of God: The Story of the Sons of Freedom Doukhobors.*[2] In 1953, the provincial government seized 170 Doukhobor children and forced them into a boarding school in New Denver

Late fall, waiting for snow: the single remaining house of the Doukhobor village on Hardy Mountain Road, over the hill north of Grand Forks. This is a 1912 building, used for 30 years as the Mountain View Doukhobor Museum.

1 Quoted in Robert Hobson and Associates, *Grand Forks Heritage Inventory*, 1986, section 4.2.4.
2 McClelland and Stewart, 1964. See also the film *Spirit Wrestlers,* Jim Hamm Productions, 2002.

after their parents refused to allow them to attend public school. At the same time, the provincial Department of Lands and Forests inventoried the communal lands, which the government then distributed to individual Doukhobors.[1] Violence and arson emanated from the Sons of Freedom stronghold at Krestova throughout the 1960s.

As evocative as the Alexandra Bridge in the Fraser Canyon, the Brilliant Bridge is a magnificent relic, a heroic piece of construction. It spans the Kootenay River at Brilliant, just upstream from its confluence with the Columbia River not far from Castlegar. Built by Doukhobor labourers for the Christian Community of Universal Brotherhood, it was completed between the early spring and October of 1913 to provide access between the Valley of Consolation (Ootischenie) south of the modern-day Castlegar airport and the Doukhobor jam factory and CCUB administration centre at Brilliant. The provincial government contributed $19,500 to its $60,000 cost. At the time, there was no road between Thrums and Brilliant, as the terrain was considered too rough.

Plans for the suspension bridge were drawn in April 1912, by Cartwright, Matheson & Co. Engineers of Vancouver "For the Trading Store of the Doukhobor Society." According to a 1961 newspaper article by W.M. Rozinkin, probably published in the *Nelson Daily News*, J.R. Grant actually designed the bridge and A.M. Truesdale supervised its construction, with as many as 40 Doukhobor carpenters and labourers providing the muscle. The design is simple and elegantly modern: a 48-foot tower at each end, its legs tapering from four by eight feet at the base to two by four feet at the top and connected by undecorated crossmembers. The roadway was suspended a length of 331 feet between the towers, 80 feet above the river's high-water mark. The deck and the roadway cut through the rock on either side of the bridge were 16 feet wide – a single lane.

Rozinkin interviewed three of the handful of surviving workers for his 1961 article: Peter Reibin and Fred Ozeroff of Castlegar and William Makortoff of Raspberry Village near Robson, all of whom were then about 80 years old. All worked a 10-hour day. Wheelbarrows and shovels were the most-used tools, although a donkey engine was used to stretch cables and lift heavy loads and a gasoline-driven cement mixer prepared concrete in two-wheelbarrow batches for the towers. According to the article, "the bridge was actually constructed on the Brilliant side of the river in segments which were bolted together into one complete span section. After the cables were in place, the segments were moved into place and securely fastened to rods hanging from the cables."

An oft-noted feature of the bridge,

Beekeepers' cottage, Victoria Road, Grand Forks, c. 1910. Regrettably, this decorated little building is falling to pieces, its porch spindles, posts and fretwork brackets all deteriorated, and its brick skin slipping. Although it is an absolutely tiny place it is actually two separate dwelling units sharing a common chimney. It stands at the back of a field on a small farm-holding with a modern house near the road, and is used for storage. If the upstairs was used as a sleeping loft, it must have been accessed by ladder through a trapdoor.

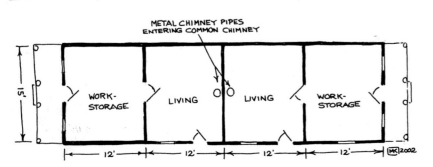

Brilliant Bridge, in the fall of 2002.

which survived until its decommissioning in 1961, was the Doukhobor sign hung on the north (Brilliant) tower, reading "Strictly Prohibited Smoking and Trespassing with Fire Arms Over This Bridge." The pacifist Doukhobors allowed no guns on their property.

Rozinkin's article suggested the old bridge was to be dismantled once the new one came into service, but for more than 40 years it has endured, its approaches ripped up to keep anyone from attempting to cross the rotting

1 Jean Barman, *The West beyond the West,* pp. 306-7.

deck. "Doomed now to become another page in the annals of West Kootenay history, the old Brilliant Bridge undoubtedly deserves a place of honor for the role it has played in the development of the area," he wrote.[1] In the 1990s, local heritage activists lobbied to have the bridge repaired and preserved, receiving the Minister's Heritage Award for their efforts. But, as was the case with the Alexandra Bridge, plans have been slow to emerge.[2]

On the hillside above the bridge is the most evocative site of all – the tomb of Peter Verigin. It is an enclosed, formally landscaped garden with the huge crypt at one end, set into the rocky hillside. Stencilled in paint onto a rockface are the following words:

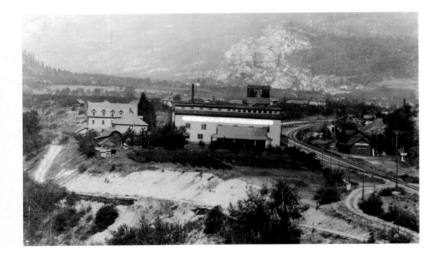

The jam factory – officially the Kootenay Columbia Preserving Works – and Christian Community of Universal Brotherhood headquarters at Brilliant, c. 1920. BC ARCHIVES D-06930

Dedicated to
Peter W. Lordly

This blessed rocky bluff
Casts its mournful sad look
On a grave sufferingly mournful, holy,
To convey people truth of a story:
Here flowed once in Doukhobor tears
A coffin with body of a leader strong, mighty
With mournful prayer of spiritual wrestlers.
Into the bowels of earth grievously lowered
His spirit – arise for memory everlasting
In many loving hearts.
He bequeathed to us in Holy Covenant
"Toil and peaceful life" with Christ.

Grand Forks has done the most with its Doukhobor Russian heritage, celebrating a number of buildings in Fructova including Polonicoff's Store, the Heritage Flour Mill on Mill Road, the old school on Spencer Road and, until recently the Mountain View Doukhobor Museum on Hardy Mountain Road. Several restaurants serve Russian food, especially borscht, and there is a strong agrarian streak in many modern residents of the valley, reflected in organic market gardening with a 1960s counterculture overlay. The former Fructova is indeed a Valley of Fruit – the finest east-west valley in southern British Columbia, with sunshine even on the shortest winter day. The Doukhobor Museum near Castlegar, featuring a model Doukhobor village, is a reconstruction. The fate of the Mountain View Doukhobor Museum, started by Peter Gritchen in 1972 and standing on 17 acres of land on Hardy Mountain Road, became uncertain following his death in 2003; the Land Conservancy of BC raised funds in 2004 to purchase the property. The village of Brilliant has lost most of its historic character – it is a collection of fairly modern bungalows on the bench above the Columbia River, with the main buildings of the co-op nearby. There is still a very good set of brick houses at Raspberry, and an excellent school building. The road to Krestova is quite nondescript, with the few remaining old sites that survived the arson badly deteriorated.

1 Thanks to Rick Goodacre, Heritage Society of BC, for the undated newspaper article, entitled "Historic Old Brilliant Bridge Soon to Disappear," and copies of the plans. Larry Ewashen of the Doukhobor Village Museum, Castlegar, also provided information. **2** The Brilliant Suspension Bridge Restoration Committee, at www.brilliant-bridge.org, has resumed the lobbying campaign. Its website references an excellent source on the bridge: a 1976 Selkirk College term paper by Cyril Ozeroff.

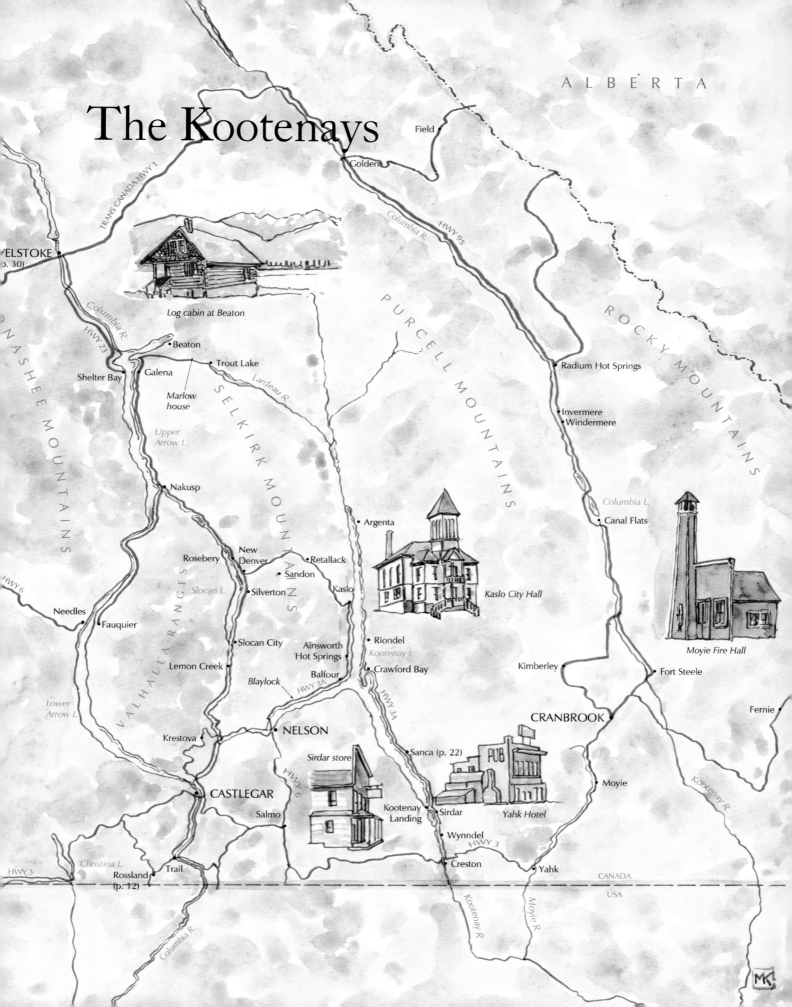

The Kootenays

ALBERTA

Field

Golden

TRANS CANADA HWY 1

REVELSTOKE
(p. 30)

Columbia R.

HWY 23

Columbia R.

HWY 95

Log cabin at Beaton

Beaton

Galena

Shelter Bay

Trout Lake

Marlow house

Lardeau R.

SELKIRK MOUNTAINS

PURCELL MOUNTAINS

ROCKY MOUNTAINS

Radium Hot Springs

Invermere
Windermere

Upper Arrow L.

ONASHEE MOUNTAINS

Nakusp

Columbia L.

Canal Flats

Argenta

HWY 6

Rosebery

New Denver

Retallack

Sandon

Kaslo

Silverton

Kaslo City Hall

VALHALLA RANGES

Slocan L.

Needles

Fauquier

Moyie Fire Hall

Slocan City

Ainsworth Hot Springs

Riondel

Kootenay L.

Lemon Creek

Balfour

Crawford Bay

Kimberley

Fort Steele

Lower Arrow L.

Blaylock

HWY 3A

HWY 3A

Krestova

NELSON

CRANBROOK

Fernie

Sirdar store

Sanca (p. 22)

PUB

Moyie

CASTLEGAR

HWY 6

Kootenay Landing

Sirdar

Yahk Hotel

Salmo

Kootenay R.

Wynndel

Christina L.

HWY 3

Trail

Rossland
(p. 12)

Creston

Yahk

HWY 3

CANADA
USA

Kootenay R.

Moyie R.

Columbia R.

MK

The Silvery Slocan

Mining fortunes often slip away from the regions where they were made and end up endowing distant cities. San Francisco's splendour from the Comstock Lode is a classic North American case; more modestly, the Klondike gold rush of 1898 paid for some fine buildings in Vancouver and Seattle, and, for example, allowed Alexander Pantages to develop his North American theatre chain. The wealth from earlier mining rushes, like Barkerville's, apparently produced few tangible results, although it spurred the creation of infrastructure including the Cariboo Road. There is little evidence of the fabulous Nickel Plate gold mine at Hedley other than a few scars on the hillside and a modest townsite; ditto for Princeton and its nearby copper mine. Coal mines on Vancouver Island built Dunsmuir palaces in Victoria, but those in, say, Coalmont, left future generations only a wooden hotel and a couple of boomtown-fronted stores. But in the Kootenays, especially around Nelson, some of the money stuck around.

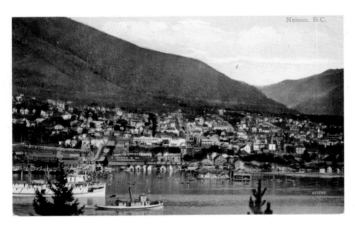

Nelson about 1910, a John Valentine & Sons postcard. The scene is not too different today, except the waterborne traffic tends to be recreational and there is a large highway bridge crossing the lake.

Post-contact history of the Kootenays can be divided into three eras: the mining boom beginning in the 1880s, which created communities ranging from settled Nelson to abandoned Sandon; the declining years of low metal prices, worked-out ore bodies and disappearing populations, creating the ghost-town landscape that was ready-made for the Japanese-Canadian internment of the Second World War years; and most recently, the birth of a sort of distinct society, seasoning the long-established stew of miners, loggers and Doukhobors with hippies, war resisters and environmentalists. A tongue-in-cheek description of millennial Nelson includes businesses with signs reading "Chainsaw Repair and Cappuccino."

The complex geography of the Kootenays can be most easily described as a set of four valleys running north-to-south. The easternmost ("fourth") one is the Rocky Mountain Trench, in which two rivers rise: the Columbia flowing north and the Kootenay flowing south. The Columbia loops over the "Big Bend," where the Trans Canada Highway ran in the pre–Rogers Pass days, then heads south through Revelstoke, widening to create the Upper and Lower Arrow lakes in the westernmost ("first") of the four valleys. The Kootenay River flows south into the United States, then loops north, passing through the Creston flats before widening to create Kootenay Lake, the "third valley"; at Nelson, the lake drains into a continuation of the Kootenay River which meets the Columbia at Brilliant. The "second" valley, just east of the Arrow Lakes and bracketed by the Valhalla and Slocan mountains, is occupied by Slocan Lake, from which the Slocan River drains into the Kootenay at

Shoreacres. A complex place indeed. Not surprisingly, east-west travel was always the most difficult and the slowest to evolve.

The "Silvery Slocan" developed rapidly due to large infusions of capital both to mine the ore and to create the infrastructure to move it. Technology had advanced to an unprecedented degree since the 1860s gold rush into the Cariboo – where miners moved on foot, horseback and by wagon, in some places building rafts to transport their goods. The initial metal strike, on Toad Mountain southwest of Nelson in August 1886, created the Silver King Mine and, soon thereafter, the City of Nelson – "the Queen City of the Kootenays," named for the province's lieutenant governor. Initially the ore had to be shipped by pack train and boat to the nearest smelter at Butte, Montana, but an influx of British capital in the early 1890s organized the Hall Mining Company and built a smelter on the edge of town.[1] Although the Silver King ore body began to run out within a dozen years, so much wealth was produced that Nelson had already grown into a gracious city, with a set of commercial buildings and homes equal to those in New Westminster and Victoria. Nelson's location, too, ultimately proved ideal, as it became the transportation hub and centre for government and educational services for the region, positioned between the silver mines of the Slocan, the gold mines at Rossland and the lead-zinc smelter at Trail. In the late 1970s, the provincial government and the Heritage Canada Foundation began a project to restore Nelson's downtown buildings, which spurred a revitalization of the entire town. A significant event was the filming in 1986 of *Roxanne*, starring Steve Martin, which restarted the city's tourism industry. In spite of the distance to the nearest airport at Castlegar and reductions in government services, it still deserves its reputation as the capital of the region.

The hot summer climate and the protection offered by deep winter snows made the lakeshores attractive for orcharding in the early years of the twentieth century, though not to the same extent as in the Okanagan. Nevertheless, fruit growing and the shipping of produce by paddlewheeler were aspects of that placid era far removed from the hurly-burly world of the miners. With better road transportation in the 1950s the paddlewheeler era ended, and when the Keenleyside (High Arrow) Dam was completed in the 1960s many of the former communities along the Arrow Lakes were drowned.

LEFT *Now beached and restored on the Kaslo waterfront, the* Moyie *(misspelled in this c. 1910 Scottish-published postcard) was the largest and most beautifully detailed of the CPR sternwheelers. Decommissioned in 1957, it narrowly missed the fate of the* Minto, *given a fiery "Viking's funeral" in the middle of Arrow Lake in 1968.[2]*
RIGHT *The end of the rails at Kootenay Landing at the south end of Kootenay Lake, not far from Wynndel and Creston (page 108) and the staging area for the CPR's sternwheelers and cargo barges. The British Columbia Southern Railway connected from here with the CPR's main line via Creston, Cranbrook and Alberta.*

1 Information from Kootenay Museum Association and Historical Society.
2 Robert D. Turner, *The SS Moyie: Memories of the Oldest Sternwheeler.*

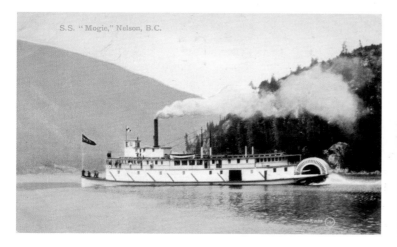

S.S. "Mogie," Nelson, B.C.

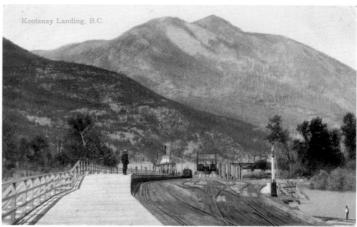

Kootenay Landing, B.C.

Salmo's Great Northern Railway station, sitting beside the abandoned right-of-way, in the summer of 2000.

One of the few railway relics in the area is the Salmo station of the Great Northern Railway subsidiary, the Nelson & Fort Sheppard Railway. This station was built in 1923, replacing the original station built by the Spokane Falls & Northern Railway when Salmo was known as Salmon Siding (*Salmo* is the scientific name for "salmon"). The 1923 station was one of the last of the old Great Northern "standard" stations in actual use by the Burlington Northern Railway. The line, built in 1893 by the Spokane Falls & Northern Railway, was the first all-rail route into the Kootenays. Conventional passenger trains to Nelson ceased in the 1920s, replaced by gas-electric "motor cars" until the ultimate service cancellation in 1941.[1]

Trail was founded in the 1890s as the supply depot for the mines operating in the mountains around Rossland, 10 kilometres to the west. In 1896, an American mining engineer named Frederick Heinze started a small smelter on a bench above the townsite to process the ores from the mines at Rossland. In 1906, this smelter, a number of the Rossland mines, and the Rossland Power Company, were amalgamated to form the Consolidated Mining & Smelting Company of Canada Ltd. (Cominco). After World War I, new techniques developed to treat zinc-laden ores, as well as gold, silver, cadmium and bismuth in ensuing years. The CM&S also expanded into the production of fertilizers using by-products of the zinc smelting process, and along the way reduced the notorious pollution which had denuded nearby hillsides and

1 Correspondence from rail historian Neil Roughley.

added lead to crops in the windplume from its smokestacks. With the enormous growth of the smelter, Trail's population tripled by 1941 to 10,000.

A key figure in the process was Quebecker Selwyn Gwillym Blaylock who, as a 20-year-old with a freshly granted B.Sc. from McGill University, moved west in 1899 and obtained work as a surveyor for the Canadian Smelting Works in Trail. Two years later, he became the company's chief chemist, but soon relocated to Nelson to become general superintendent of the Hall Mines Smelter there, then general superintendent of the St. Eugene mines. In 1908, when the Silver King Mine ore body was played out, Blaylock acted as company receiver, then moved back to Trail and joined Cominco.

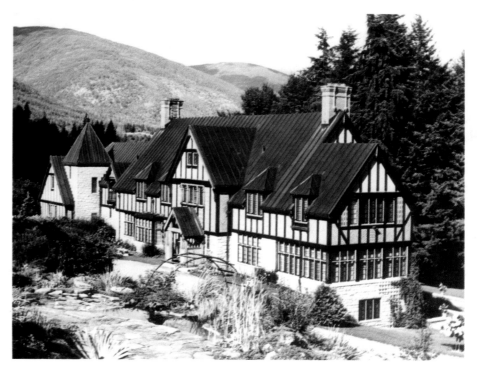

Blaylock recommended purchase of the Sullivan Mine near Kimberley and took responsibility for its development. In 1919, he became Cominco's general manager, a director in 1922, vice-president in 1927, managing director in 1938 and president in 1939. According to his biography in the Canadian Mining Hall of Fame, "in his rise to the pinnacle of Cominco, his interest in the welfare of the employees never slackened. His stated belief, '... security, comfort and welfare of workmen will be paid for in increased efficiency and good will of employees ...' became a benchmark in Canadian industrial relations circles." In part, at least, the Trail Smoke Eaters who twice carried Canada's hockey colours to a world amateur championship, were a reflection of his philosophy of human relations in a mining community; "paternalistic," a more charged word, also describes his style.

ABOVE *"Pollution is the smell of money," part two. S.G. Blaylock's estate, picture by an anonymous photographer in the 1940s.*
BC ARCHIVES D-06927
RIGHT *Selwyn Gwillym Blaylock.*
BC ARCHIVES B-04939
BELOW *The Cominco smelter at Trail early in the twentieth century, a John Valentine & Sons postcard.*

Mr. S. G. Blaylock in year 1920

However, he built the home reflecting his wealth and position near Nelson. Properly called Lakewood but known in the Nelson area as Blaylock Estate or sometimes as Sleeping Beauty's Castle, it was built to the design of

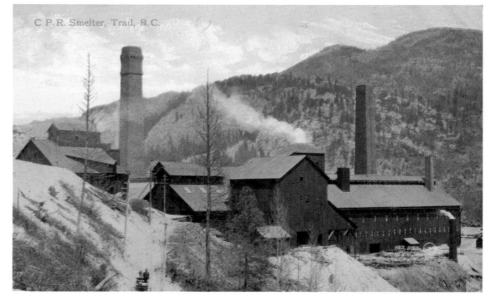

C P.R. Smelter, Trail, B.C.

Montreal architect J. Cecil McDougal. A junior in the firm, William Frederick Williams, moved from Montreal to Nelson in 1935 to supervise the construction, fell in love with the area and stayed on, having a significant impact on the introduction of Modernist architecture in Trail and Nelson, and winning the design competition for the Canadian Pavilion at the 1939 New York World's Fair. Following his death at age 43 in 1947, his wife Ilsa continued the practice until her retirement a decade later.[1]

The quality of Blaylock's massive Tudor Revival-style home, and the fact that he built it during the Depression, lend credence to the testimonials of his concern for the welfare of his employees. According to legend, Blaylock told the construction crew "it's hard times, there isn't much work, so just take your time and do a good job."[2] The head stonemason was Kuzma Golac, who died in Nelson in 1957 at the age of 70. Mike Robertson was the master carpenter and carver of the elaborate scrollwork panels. The main house is approximately 16,000 square feet and sits on 42 acres of grounds.

As seems so often the case, Blaylock had almost no time to enjoy his creation, for he died in Trail on November 19, 1945, six months after his retirement following the difficult years of keeping metal production at peak levels to aid the war effort. He was buried at Danville, Quebec. Over the ensuing decades, his widow Kathleen visited the home only occasionally, then put it up for sale in 1977. The Californian who purchased it wanted to create a deluxe resort but went bankrupt, with the property's title going to the McGauley family, whose concrete company was a major creditor. The McGauley children assumed control of the property in 2000 when their parents were killed in a car accident and operated it as a bed and breakfast. Dan McGauley has run it since as the Blaylock Resort and Health Spa, but was offering it for sale in 2003 for $2.85 million.

The corporate successor to Blaylock's company is Teck Cominco, a diversified mining and refining company, mining zinc, lead, copper, gold and metallurgical coal, as well as producing zinc, lead and a number of by-product metals and chemicals through its two refining facilities in Canada and Peru. Although its Trail smelter certainly pollutes less than it used to, the company's decades-long practice of dumping slag into the Columbia River has, according to the American Environmental Protection Agency, seriously polluted the river and Roosevelt Lake behind the Grand Coulee Dam in Washington. Resolution of the issue was pending in 2004.

Abandoned mining buildings at Retallack, on the road from Kaslo to Slocan and New Denver, in the fall of 2002, the last two of a major camp a century ago that included numerous other buildings and a concentrator. According to Bill Barlee, a man named Eaton purchased the claim from the original prospector for $200 and hit solid galena with the first thrust of his pick.[3] The near building is a classic bunkhouse – clearspan on the main floor with only a few partial privacy walls above – while the far one is a combination workshop and stable.

1 Elspeth Cowell and Donald Luxton, in Luxton, ed., *Building the West*, p. 448. Additional information from Shawn Lamb, Nelson Museum.
2 Derrick Penner, "Sharing Nelson's historic Blaylock Estate with the people," *Vancouver Sun*, February 28, 2003.
3 Barlee, *Gold Creeks and Ghost Towns*, p. 117.

Two of the minor mining camps of the Silvery Slocan that have left a modest mark on the landscape are Ainsworth and Retallack. The watercolour shows the historic buildings of Ainsworth Hot Springs, as they appear from the roadway leading up from the lakeshore and old wharf site – the first view of the townsite for people hiking up from the sternwheelers many years ago before the highway opened between Balfour and Kaslo. Mining and fruit-growing communities, linked to the railheads by sternwheelers, dotted the rugged shores of Kootenay, Slocan and the Arrow lakes. In the long run, it was the Bluebell Mine at Riondel, across the lake from this "Hot Springs Camp," which supported the local economy. Staked in 1882 by Thomas Sproule, the claim was "jumped" by Thomas Hammill, an employee of San Francisco promoter Captain George Ainsworth. Ainsworth de-

veloped the townsite at the hot springs on the west side of the lake – briefly in the late 1880s, it was the Kootenays' largest community, a status it quickly lost when the Payne Claim at Sandon was discovered in 1891. A fire in 1896 wiped out the original town; the two surviving buildings illustrated here – the Silver Ledge Hotel and the J.B. Fletcher General Store – are both privately operated museums, eking out an existence through passersby and visitors to the hot springs resort nearby. The Silver Ledge Hotel, which had hot running water from the springs, closed in 1949 and began its conversion into a museum in 1964. Henry Giegerich of Montana built the store in 1896 to replace a log building; J.B. Fletcher managed and then owned it from 1912 until it closed in the 1970s.

(Source: Ken Butler, *Silvery Slocan Heritage Tour Guidebook*, p. 16.)

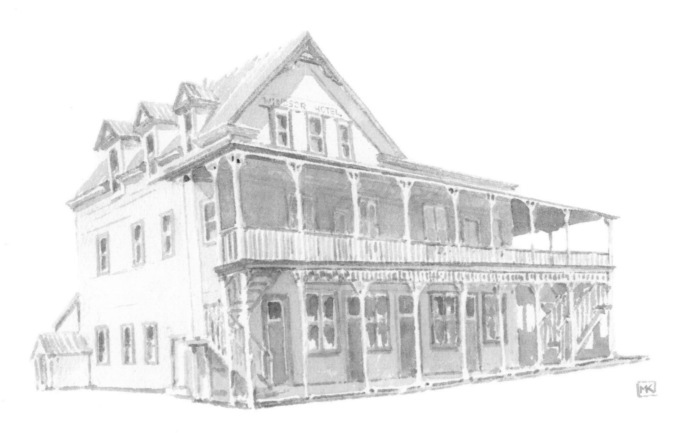

ABOVE *The fabulous Windsor Hotel, established in 1892 at Trout Lake City, the last survivor of a thriving transportation centre for the Lardeau mining area. It was kept alive for the quiet decades bracketing the Great Depression by Alice Jowett. By the time the hotel came up for sale, and new owners Keith Thomas and Krystyna Barnwell arrived on the scene in 1995, the building was crumbling, its foundations sinking and rot setting in. The owners have carefully restored it and operate it for a new generation of four-seasons vacationers.*
BELOW *The Lardeau district is remote, even by Kootenay standards. Between Trout Lake and Upper Arrow Lake, along the ancient portage route of the Sinixt First Nation, this abandoned homestead is one of the few roadside landmarks. Built by a CPR employee named Crawford who wrongly anticipated a railway line through the valley, the house became the long-time residence of the Marlow family in spite of its being "flimsily built" with "no insulation and very cold." Beaver dams along Beaton Creek have drowned the cottonwood trees along the bank, and in the winter a clammy mist rises off the rank fields into the weak sunshine.*

(Correspondence from Eleanor Delehanty Pearkes, author of *The Geography of Memory*, 2002; and from Greg Nesteroff, quoting Milton Parent, *Circle of Silver*, p. 308.)

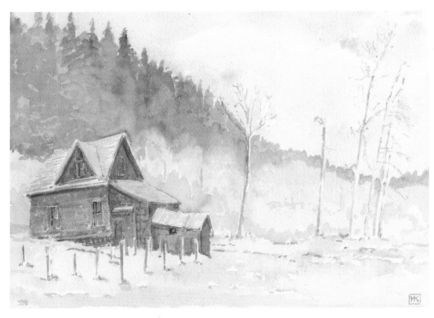

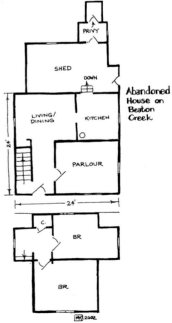

New Denver

I painted the two watercolours of New Denver, population about 600, to try to capture its distinctive visual character: old commercial buildings and houses seen across empty fields. To my mind, New Denver is the most historically picturesque town in the BC Interior. It is not alone in its thwarted dreams of greatness, nor in the fact that many old buildings have been demolished since its golden age, but it is unique in that there have been very few examples of poor-quality modern infill. The vacant lots and old established trees just add to the character.

The locals are equally distinctive: bright-eyed young backpackers, dreadlocks spilling out beneath their woollen toques – members of the "Church of the Latter Day Hippie" seeking revelation in the Valhalla wilderness area across Slocan Lake – mingling with grizzled longhairs from the 1960s, and in the "Orchard" nearby (page 102) aged Japanese Canadians taking the air, greeting each other and chatting on the streetcorners. Some of the new construction, including the house on page 24, reflects the arrival in the 1960s and 1970s of urban hippies and Americans escaping the Vietnam War

The old Bank of Montreal building and manager's residence at Sixth and Bellevue. Built in 1897, it closed in 1972 and has since been restored as the Silvery Slocan Museum. Most of the town's other commercial buildings have either flat roofs or a square false front (a boomtown front) as a facade on the end of a standard pitched roof.

The house at the corner of
Bellevue and Slocan in New
Denver, with two old commercial
buildings in the distance (on Sixth
Avenue) across some vacant fields.
This house, with its boxy, vertical
shape, tall windows, narrow
eaves and hipped roof is classic
nineteenth-century Georgian
Revival – a style more typical of
an Ontario or Nova Scotia town,
and seen elsewhere in British
Columbia only in a few old
districts in Victoria and New
Westminster. It has been owned
for years by the Angrignon family.
Ed Angrignon bought it in 1907
and rolled it up the street from its
original location near the
lakeshore.[2]

1 Historical material from Ken Butler, *Silvery
Slocan Heritage Tour Guidebook*, pp. 47-50.
2 Interviews with grandson Randy Angrignon
and Gary Wright.

draft. Indeed, Gary Wright, the mayor of New Denver since 1989, came to Canada as a war resister.

New Denver, first called Eldorado but less optimistically renamed for the American mining boomtown in Colorado, owes its existence to the silver strikes at Sandon. The easiest access turned out to be the route north along the Slocan River, then by trail or boat along Slocan Lake to the mouths of Lemon Creek or Carpenter Creek. At the latter, which flows through the town of Sandon itself, a community sprang up; today the creek splits the main townsite from the "Orchard." By the mid-1890s, government offices and supply businesses had located there, a sternwheeler service connected the town with the outside world, and a rail line – the Nakusp & Slocan – moved people and ore to the main line.[1] New Denver's two museums reflect its mining and internment history: the old Bank of Montreal building, a gracious, hipped-roof house with its main floor space designed for commercial use, interprets the earlier period, while the Nikkei Internment Memorial Centre on Josephine Street uses two shacks, one in 1942 style, the other renovated to the 1950s period, to interpret the lives of the people who stayed on after the war. A later internment in the town began in 1953, of the children of Sons of Freedom Doukhobors, resolved several years later only when parents agreed their children could receive a modern Canadian education. In the ensuing decades, most members of the Doukhobor community have entered the mainstream of Canadian society.

The Japanese-Canadian Internment

The internment of Japanese Canadians during the Second World War, paralleling American government policy in the wake of the attack on Pearl Harbor on December 7, 1941, is an especially black mark on this nation's rather soiled garment of racial tolerance and human rights. Put into the broader historical context of anti-Orientalism in the province, the internment seems inevitable, yet opportunistic. Most Japanese Canadians who lived through the period speak little of it, focusing on living the quiet, family-oriented, productive lives that were disrupted by the Second World War. For many, it is still a deep personal humiliation. As the years have passed and memories have dimmed, some of the *sensei* younger generation have kept the story alive, joined by members of the community who see modern parallels in the Orwellian jargon of "racial profiling" and the "war on terrorism."

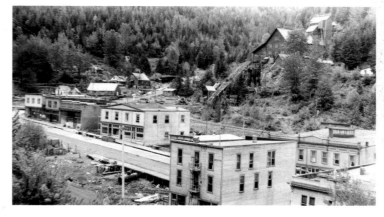

Sandon as it was in 1941, "ready-made" for the internment, the decking over Carpenter Creek clearly visible. Photograph by an anonymous provincial government employee. BC ARCHIVES C-00195

The anti-Orientalism rampant in BC at the turn of the twentieth century was mitigated slightly toward the Japanese by Japan's formal alliance with Great Britain. There were about 50 Japanese people in the province when the consulate opened in Vancouver in 1889. In March 1907, the United States government imposed restrictions on Japanese immigrants who hoped to enter the American mainland from Hawaii; in the following six months, 7,600 Japanese immigrants entered Canada.[1] To stem the tide, in 1908 Canada and Japan negotiated the Hayashi-Lemieux "Gentlemen's Agreement": instead of levying a head tax as it did with the Chinese, the Canadian government allowed an annual maximum of 400 Japanese "male labourers and domestic servants" into Canada.

But unlike most of the Chinese, who laboured to save money for their families "at home" and dreamed of an eventual return to China, the Japanese were settlers, and very successful ones. By 1919 they controlled nearly half of the fishing licences on the BC coast. The Department of Fisheries responded by reducing the number of licences issued to "other than white residents, British subjects and Canadian Indians," with the result that over the next several years more than 1,000 licences were stripped from Japanese Canadians. Many went into the logging and lumber industries, some joining the Japanese Labour Union (eventually known as the Camp and Mill Workers Union) formed in 1920 by Etsu Suzuki. In 1923 – the year Canada passed the Chinese Immigration Act – Japan and Canada amended the agreement to limit immigration to 150, changing it yet again five years later to include wives and children in the quota.[2]

No Orientals could vote in BC, although surviving Japanese-Canadian

1 Tosh Tanaka, *Hands across the Pacific: Japan in British Columbia 1889-1989*.
2 Japanese Canadian National Museum website.

The Langham in Kaslo, used as an internment building. About 965 Japanese Canadians spent the war years in that town, including Tom Shoyama, editor of the ironically named internees' newspaper, the New Canadian, *who later became a university professor and the federal deputy finance minister. The anonymous photographer in 1974 captured the crumbling building before restoration began.*

BC ARCHIVES E-02816

1 Kluckner, *Vancouver the Way It Was,* p. 30. UBC economics professor Henry Angus was among the few public figures to argue that the suspicions against Japanese Canadians were unwarranted.
2 Correspondence from Stuart Isto, St. Michael's archivist.
3 Torchy Anderson, "Big B.C. Road Plan for Japs," *Vancouver Province,* January 27, 1942.
4 *Province,* May 1, 1942, Austin Taylor reported that the BCSC had taken over 40 vacant homes in Minto.
5 *Province,* April 27, 1942, reported that 30 Japanese people had rented the Alpine Inn at Christina Lake for the duration of the war; they were "said to be persons of considerable financial means."

veterans from the First World War (146 of the 200 who volunteered, 92 of whom had been wounded in action) were enfranchised in 1931. When a delegation from the Japanese-Canadian Citizens League pleaded for extension of the franchise in Ottawa in 1936, they were rebuffed.[1]

The anti-Oriental movement through the 1920s was largely led by organized labour and focused on issues of low wages, exacerbated by outright racism, but by the 1930s it concentrated public antipathy on Japanese commercial expansion in the province and in China, where it was accompanied by brutal military adventuring by the Japanese army. Politicians including Tom Reid, MacGregor MacIntosh and Halford Wilson agitated for restrictions on Japanese businesses and settlement, while Wilson's father, pastor of St. Michael's Church in East Vancouver, preached racial purity from his pulpit.[2] Typical sentiments were expressed in an editorial in the *Vancouver Province* on April 7, 1937, decrying all BC residents of Japanese ancestry, describing them as dominant in the fishing industry, "almost a monopoly in truck gardening, gaining a hold on the hothouse industry, driving the white potato grower to despair. He runs woodyards, and is invading the confectionery and dry-cleaning business ... In the interior, he has almost a monopoly of the restaurant and hotel business."

With this atmosphere as a given, and with war imminent in the Far East, the federal government ordered all Japanese Canadians to register with the RCMP in March 1941, and made them carry identity cards with their thumbprint and photo as of August 12. The day after the attack on Pearl Harbor, December 8, the government impounded the entire fishing fleet owned by Japanese Canadians and shut down ethnic newspapers and schools. Then, early in January 1942, the government declared a "protected area" west of the Cascades/Coast Mountains and began to establish the administrative machinery to remove, initially, all Japanese-Canadian males between the ages of 18 and 45 from the coast. They were to be put to work on roadbuilding projects on the Hope-Princeton, at Blue River and in the Revelstoke-Sicamous area.[3] On February 2, Order in Council PC 1486 addressed "all persons of Japanese Racial Origin": among other restrictions, it enforced a curfew from dawn to dusk and banned possession of cars, cameras, radios and firearms. Then, on February 26, the federal government (through Orders in Council 1665 and 1666) ordered all people of Japanese race or mixed race, regardless of legal and civic status, to leave the protected area. The only equivalent forced evacuation in Canadian history is the expulsion of the Acadians from Nova Scotia in colonial times.

On March 4, the newly established British Columbia Security Commission (BCSC) ordered all Japanese Canadians to turn over their property and belongings to the custodian of enemy alien property "as a protective measure only." All during March, Japanese Canadians from the coastal communities arrived in Vancouver and were marshalled at Hastings Park – the pooling centre from which they were to be evacuated to internment camps,

many of which were abandoned mining towns in the Interior. But a number of families took matters into their own hands, as witnessed by the story in the *News-Advertiser* dated March 5, 1942: "Jap Families Leave City," read the headline, with subheads "Off to Land Where Curfew Will Not Ring" and

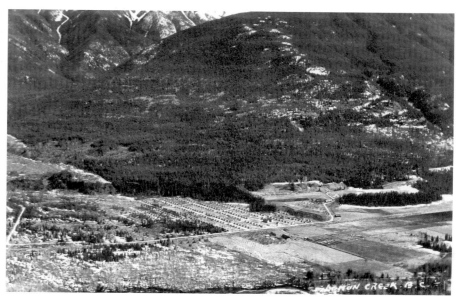

"Exiles to Begin All Over Again in Kelowna." However, their independent action was short lived – the following day, the *Province* reported, "Commission Clamps Down on Jap Exodus." Four days later, on March 10, BC newspapers published new regulations demanding that Japanese-Canadian families receive permission from the BC Security Commission before leaving the coast. There were, of course, Japanese Canadians living in the Interior before 1942; they had had to register with the RCMP, but were otherwise left alone to attempt to continue their lives while enduring the hostility of a country fighting desperately against Japan.

The first group of evacuees arrived at Greenwood on April 21; subsequently, more than 12,000 went into camps, some constructed from scratch, some using old buildings, in the Slocan Valley at Lemon Creek, Popoff, Bay Farm and Roseberry Farm, at New Denver, Sandon and Kaslo, and at Tashme (an acronym for the initials of the three BCSC commissioners Austin TAylor, John SHirras of the BC Provincial Police, and F.J. MEad of the Royal Canadian Mounted Police) at Mile 14 on the Dewdney Trail (today's Sunshine Village resort site).

Another 1,161 people, mostly families with means, went into what were described as self-supporting projects:

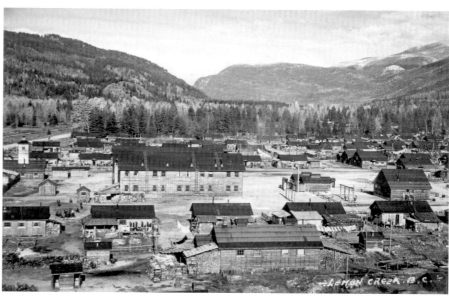

The Lemon Creek internment camp, 1944-5. The school in the centre held classes for kindergarten to Grade 12. DIANA DOMAI

at East Lillooet (page 170), Bridge River, Minto[4] and McGillivray Falls near Bralorne; and at Christina Lake in the Kootenays.[5] People who went into the self-supporting sites had to pay for their own transportation and housing materials. Sometimes they chartered trains to take more of their possessions with them – those who went into the internment camps were typically limited to 150 pounds of possessions each.

Once the Japanese Canadians were off the coast, the government moved to dispose of their property at bargain rates, without the owners' consent.

Internment housing in the
"Orchard," the floor plan drawn
by Heritage Branch staff, 1979.

ONE-FAMILY JAPANESE INTERNMENT HOUSE
UNION STREET (HWY 6)
"THE ORCHARD" NEW DENVER B.C. 1942

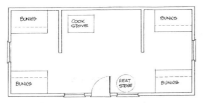

TWO FAMILY INTERNMENT HOUSE NEW DENVER, B.C.

SCALE: 0 2 4 6 IN FEET

1 Correspondence from Terry Lyster.
2 General sources: Heritage Branch, Province of BC, *Japanese Internment Houses, New Denver*, 1979; Roy Miki and Cassandra Kobayashi, *Justice in Our Time: The Japanese Canadian Redress Settlement*; Jean Barman, *The West beyond the West*, pp. 265-9; Kathy Upton, Fumiko Fukuhara and Fiko Konishi; Grace Thompson, born in Vancouver, who spent the war years in Minto; Japanese Canadian National Museum website.
3 Heritage Branch, *Japanese Internment Houses, New Denver.*
4 Gwen Suttie, "With the Nisei in New Denver," *B.C. Historical News*, February 1972, p. 17.

Included were the Blyth's Cash Grocery (page 38) and the fishboats: retired architect Bud Sakamoto finally located and bought back his father's boat more than a half century after it was seized, and occasionally goes fishing in it.[1]

Following the surrender in 1945, the government made a serious effort to "repatriate" Japanese Canadians to Japan; the only alternative for them, according to the federal policy enacted that April, was to move to eastern Canada. In January 1947, the federal cabinet repealed this forced migration/deportation, following protests from a broad cross-section of Canadian society. Japanese Canadians received the right to vote federally on June 15, 1948; the final restrictions on them, including the carrying of identity cards, ended the following April Fool's Day. The redress movement gathered force in the 1970s and 1980s, culminating in a formal apology by the federal government, given by Prime Minister Brian Mulroney on September 22, 1988. It included a compensation package for survivors who had lost their possessions, as well as their freedom, nearly half a century earlier.[2]

Remote Interior towns, especially those which had numbers of unoccupied or derelict buildings, were ready-made for the Japanese-Canadian internment. Sandon, Kaslo, Greenwood and Slocan City met that criterion, as did a few former gold-mining towns in the Bridge River area near Lillooet. Local authorities were consulted on the potential influx and in most cases showed little prejudice. During April and May of 1942, over 1,000 Japanese-Canadian carpenters, plumbers and electricians prepared existing buildings for occupation, but as spaces were created for only two-thirds of the 23,480 people who had been "pooled" in Vancouver the commission announced on June 24, 1942, its intention to build houses in the Slocan Valley – in Slocan City, Lemon Creek and Roseberry, 16 miles north of New Denver, as well as in New Denver's "Orchard," the 80-acre Harris Ranch on the edge of Slocan Lake.

During July and August, 30 Japanese-Canadian tradesmen from Slocan City arrived in the "Orchard" to construct internment houses, which were designed and built under the supervision of Philip Matsumoto (his son Sam, who witnessed the construction as a young man, went on to become president of the Matsumoto Shipyards in North Vancouver). The prototypes had been built adjacent to the Security Commission offices in Slocan City: one standard plan was a single-family unit measuring 14 x 20 feet, the other a two-family house measuring 14 x 28 feet. The New Denver skating rink became the mess hall and carpentry shop, while the workers lived initially in US army tents set up in the "Orchard." Doors and windows were shipped to the site, as were a heater, a cook stove, a wooden sink and straw mattresses for each dwelling. Studs, rafters, joists and exterior boards and battens were green hemlock, prefabricated as much as possible in the shop and erected on site. There were no ceilings or insulation, the roofs originally covered just with tarpaper, and no foundations. A Royal Commission report of 1943-4 on the actual conditions in the camps found there to be 124 two-family and 24 single-family dwellings in the "Orchard," housing 1,016 people, an average of 7 people per house. Initially, Japanese Canadians affiliated with the United Church were steered toward New Denver, with Anglicans going into Slocan City and Lemon Creek and Buddhists going to remote Sandon.

In spite of their cooperation with the authorities, internees lived in primitive conditions, the shacks being scarcely adequate for the hard Kootenay winters. The lumber was green and when the siding shrunk drafts blew through the sparsely furnished interiors, in spite of the cardboard some internees tacked onto the walls. Fuel for the small heating-cooking stoves was also green, and there were few stove pipes. At night, condensation from the breathing of the tightly packed occupants would drip from the roof boards onto the bedding. Some placed their coal oil lamps under the beds for warmth. During the first winter, the commission supplied only candles and coal oil for lanterns, a situation improved somewhat the following year with crude electrification: a 25-watt bulb for each shack! Regardless, there were regular power cuts to the "Orchard" when New Denver needed the current.[3]

According to a United Church missionary, "On an early morning visit to a family I had known well in Vancouver, I found the lady of the house sweeping up some greyish-looking stuff from the floor and putting it into a bucket. When I asked her what it was she replied: 'Oh, this is the frost we have to scrape off the walls every morning. We usually get about two buckets of it.' "[4]

After the war, the "Orchard" community languished, with some residents moving to Japan or back to the coast after travel restrictions were lifted. A 1979 report by Heritage Branch staff recommended the preservation of a few of the surviving intact internment houses which were slated for demolition to make way for a New Denver Health Care Centre. Eventually, in 1994, these buildings, a garden and interpretive materials were assembled into the Nikkei Internment Memorial Centre. Nearby, the Kohan Reflection Garden, designed by Ray Nikkel, memorializes the internees.

With a little imagination, it is easy today to see the orchard layout of ancient fruit trees and camp houses, although now modified by renovations and new construction. I was intrigued to see, on an early winter's morn, the number of aged Japanese-Canadian women walking together on the quiet streets. One was Kay Takahara, who spent 1942 to 1944 at New Denver, then was moved to Tashme in 1945. Following the war, she chose "repatriation" and went to Japan, where she lived for nine years. Then she returned to New Denver, where her parents had continued to live in their renovated house, and stayed on after their deaths, spending in total more than half a century of her life on that fated shore.

In November 2002, I went to the Lemon Creek site, an area of meadows along Slocan

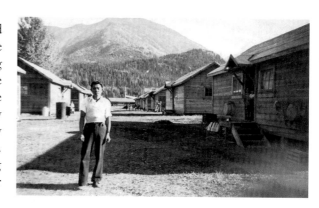

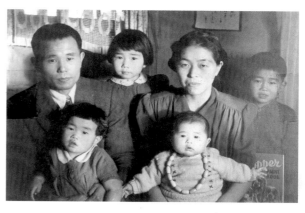

Domai family album.
ABOVE *Nobuo Domai on one of the streets of Lemon Creek, about 1945; and in November 1945, with the future uncertain: Nobuo, Toshiko, Hisae and Kyosuke (Kiyo); Hiroko (Betty) and Koji in front.*
BELOW *Post-war; the Domais left Slocan City on May 10, 1946; in Taber, Alberta, Kiyo Domai, second from the front in the far row, became part of the 1947 Grade 2 class.* DIANA DOMAI

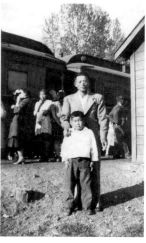

Lake. I could only recognize the camp's actual location by comparing the profiles of the mountains with the lower photograph on page 101. A modern ranch and a small resort occupy the land now. Apparently the remains of the vegetable gardens are still evident if one knows where to look.

Much changed today, Slocan City has few of the boomtown buildings that made it suitable for an internment camp. Joy Kogawa's novel *Obasan* is set in Slocan City – her family rented an old cabin on the outskirts of town and spent the internment years there, before moving to Alberta to a beet farm (like the Domais). In her novel, there is a letter entry from May 14, 1942: "Aya, kids, Dad and I have decided to go to Slocan. We hear that's one of the best ghost towns."[1]

The Domai family photographs illustrate their time at Lemon Creek toward the end of the war. Many years later, Nobuo Domai said:

"In June 1945, Koji, a fat baby boy was born. August of the same year, the war against Japan was over. The Japanese Canadians were still not permitted to have their freedom. We were only allowed to go to Japan or beyond the Canadian Rockies. Most of our relatives departed for Japan, but we decided to remain in Canada. In 1946, our family of six moved to a beet farm in Taber, Alberta. During an extremely busy autumn Kiyo and Toshiko were taken out of school to help with the beet harvest. They were young, but toiled in the fields alongside us. At the end of November in 1950, we returned to British Columbia. We rented a house in Steveston comprising a kitchen and a large bedroom. The house which we had been living in before the war was inhabited by a new family. I wanted to purchase the house, so I ventured off to ask the owners about buying it back. To my amazement, the owner demanded $7,000 in cash. I was furious, for I knew that they had purchased the house for $1,000 from the government. I refused to pay such an exorbitant sum. I searched for employment as a gardener and was successful in finding a job in Vancouver. Grandma worked at the local fish cannery. Once again, we found ourselves on a hectic schedule. Grandma would work the night shift at the cannery while I remained at home with the children. Grandma returned home, then I would leave for work. Our time together as a family was limited. Luckily the children had each other. Occasionally, I returned to the area where our first home used to be. I remember the times before the war and how greatly it changed our lives."[2]

According to Diana Domai, Kiyo's wife: "All but one of the Domai children attended UBC and my husband and one of his sisters are now retired teachers. In the late 1960s my in-laws built a new house in Steveston. Nobuo put in a 'glorious garden.' Unfortunately, he died in January 2000. My husband and his brother now help to look after the garden for his mother. I think my husband will always help with that garden because his father made it a place where we all loved to gather."[3]

1 Kogawa, p. 105.
2 Nobuo Domai, January 1992, as told to his granddaughter Jessica.
3 Correspondence, 2002.

Sandon

. .

Of all the god-forsaken places to be interned, there was Sandon – colder and more isolated than the other ghost towns of the Kootenays and Boundary Country. Somehow, 933 Japanese Canadians were shoehorned into its dilapidated buildings for the duration of the war. Most were Buddhists, a sinister religious commentary on the general racist attitude that targeted Christian Japanese Canadians for the more commodious ghost towns. Although there were many wartime deaths in the town, there are no Japanese names in the Sandon cemetery, the deceased being cremated.

Prospectors Eli Carpenter and Jack Seaton staked the first claims in the area in 1891. Word of their fabulous silver strike soon got out, and by the following summer hundreds of fortune-seekers had converged on the valley, creating an instant city of tents and shacks. Investors got word of a 125-ton boulder of galena float found on Sandon Creek and began to develop mines and a proper townsite. "The capital of the Silvery Slocan" boomed all through the 1890s, incorporating in 1898 when its population had reached 5,000. There were 29 hotels, 28 saloons, 3 sawmills, 3 butcher shops, 2 breweries, a soft-drink plant, a sash and door company, 2 banks, bakeries, grocers and other shops, and 2 newspaper publishers packed into the narrow valley. Its red-light district was said to employ about 115 prostitutes in 50 buildings, servicing the scads of young, single men. Approximately 2,300 miners worked the claims and hardrock mines surrounding the town, although many of them were lured away to the Klondike in 1898. A 1900 fire destroyed much of the town; although it was soon rebuilt on a less elaborate scale, a combination of collapsing silver prices, the war, and Carpenter Creek's periodic flooding had bankrupted the city by 1920.

Reco Street is the now-empty roadway that runs through Sandon. In the boomtime, Carpenter Creek was channelled into a wooden flume, which was then decked over to create an additional street. Major floods, in 1925 and 1955, destroyed both flume and street and sent a torrent of debris downstream, wrecking much of what was in its path.

Sandon's big landowner, John Morgan Harris, stayed with the town until his death in 1953. The ruins were

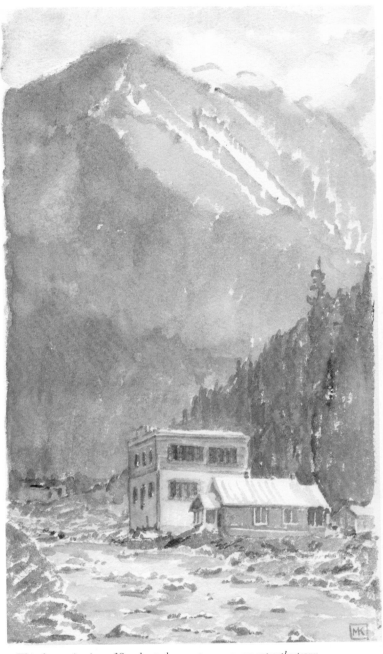

This dramatic view of Sandon today greets you as you enter the town by the only road. Carpenter Creek, strewn with boulders and broken timbers, runs down the middle of a narrow valley with the old city hall building inexplicably still standing, almost alone, on its bank. Surrounded on all sides by forested mountains and isolated in a deep, blue gloom during the winter months, it is a forlorn, fascinating place, with the snow settling earlier and staying later than in other nearby towns like New Denver and Kaslo. The narrow valley heading into the right distance indicates the presence of Sandon Creek, which joins Carpenter Creek in the middle of the old townsite. Mount Cody looms in the background.

scavenged and looted in the 1950s and 1960s, after which the Sandon Historical Society stepped in to restore and interpret the few surviving buildings. One of the more interesting relics is the Silversmith Powerhouse on Sandon Creek, which is the oldest continually operating hydroelectric plant in western Canada.[1]

Wartime brought a group of coastal people, salt-water people used to the freedom of the ocean, to the tight, mountain-ringed valley. Typical of the internees was Kyujiro Domai, born on May 14, 1881, in Wakayama Prefecture, Japan. A fisherman who emigrated to British Columbia in 1901, he became a naturalized Canadian citizen three years later in order to get a fishing licence (although he still could not vote). He left his wife and two daughters behind in Mio Village, Wakayama, Japan. Based in Steveston, he bought a salmon trawler and fished in the Gulf Islands, sending money home to his family. When his daughter Hisae, aged 18, came to Canada in 1933 to live, she came to a parent she did not know because he had been living and working in Canada for so long. According to Diana Domai, "His fish trawler, which was his home as well as his livelihood, was confiscated at the outbreak of the war. He had slept, eaten and worked on his boat. It was a terrible shock for him to be taken away from the coast and interned in the ghost town of Sandon, B.C. He died in Sandon at the age of 61 years, not long after the Canadian Government sent him there along with Hisae and grandson Kyosuke (Kiyo). His son-in-law, Nobuo was sent to a road camp near Jasper, Alberta in 1942 but was in Sandon in 1943 when his father-in-law Kyujiro died of rheumatic fever."[2] Subsequently, the family moved to Lemon Creek.

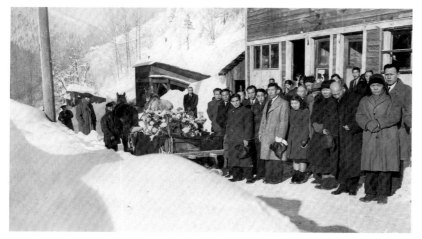

Domai family album, part 2:
TOP *Sandon softball team 1943. Nobuo Domai is in the front row, far right. Baseball was always a big part of Japanese-Canadian culture, with the Asahi team in Vancouver becoming one of the stars of the city's semipro league.*
MIDDLE *First winter of internment, 1942-3, at Sandon.*
BOTTOM *Correspondence from Diana Domai: "This is a photo taken at the funeral of my husband's grandfather, in Sandon on January 23, 1943, temperature -29°F. He was only 61 years of age when he died. My husband's mother always said she felt he died of a broken heart. Everything was taken from him when the internment took place." Photos by Nobuo Domai.*
DIANA DOMAI

1 Information from Sandon Historical Society.
2 Correspondence, 2002.

Two of the remaining historic buildings on the narrow road (Reco Street) leading to Cody, just past the Kaslo & Sandon Railway crossing. The second building, with the "Cafe" sign, is the Tattrie house, built in 1895. It operates as Tin Cup Annie's in the summer.

Creston & Canal Flats

The grain elevator at Wynndel in the summer of 1995, a tiny piece of the prairies in mountainous southern British Columbia. On April 14, 1961, it was damaged by a bomb set by Sons of Freedom terrorists; the conviction of Mike Bayoff led to further arrests and the eventual end to the bombings and arson in the Kootenays.[1]

After the steep, dramatic traverse of the Salmo-Creston highway, the east-bound traveller emerges through the folds of mountains onto a flat plain, divided like patchwork and dotted with barns and silos like an orphaned corner of the prairies. In the distance on the high ground, a line of grain elevators marks the railyards on the outskirts of Creston. This unexpected granary is linked historically with one of the most ambitious public works projects attempted in the nineteenth century: W.A. Baillie-Grohman's scheme to divert water from the Kootenay River into the Columbia River at Canal Flats, reclaim (and sell) the lowlands at the southern end of Kootenay Lake, and end the seasonal flooding of the Kootenay itself.

Partly because Baillie-Grohman's scheme, and later ones by BC Hydro to increase the power potential of the Columbia River, was thwarted, and in spite of land-reclamation activities in 1940, the Creston area today is sufficiently in its natural state to attract a notable migratory bird population. Perhaps only Axel Wenner-Gren, who proposed the economic development of the Peace River and the Rocky Mountain Trench in the 1950s, dreamed bigger than Baillie-Grohman.

Canal Flats, about 300 kilometres north of Creston, is part of a true geographical curiosity: a two-kilometre-wide berm of land in the valley between the Purcell Mountains to the west and the Rocky Mountains to the east, separating the headwaters of the northward-flowing Columbia River (in fact, Columbia Lake) and the Kootenay River, which flows south into the USA before returning to Canada near Creston. Indicative of its role for Natives and fur traders, the place was named McGillivray's Portage by explorer David Thompson, who passed through the area in 1808. Eight decades later, English-Austrian entrepreneur William Adolph Baillie-Grohman completed a canal between the two river systems, intending to lower the level of Kootenay Lake to reclaim the 48,000-acre rich alluvial plain in the Creston area and open up a north-south navigational system from Golden to Montana. The scheme was abandoned under pressure from the Canadian Pacific Railway and from farmers further north in the Columbia Valley who feared that new high-water levels would threaten their fields and bridges. Only two ships ever passed through his canal. Undaunted, he built a store

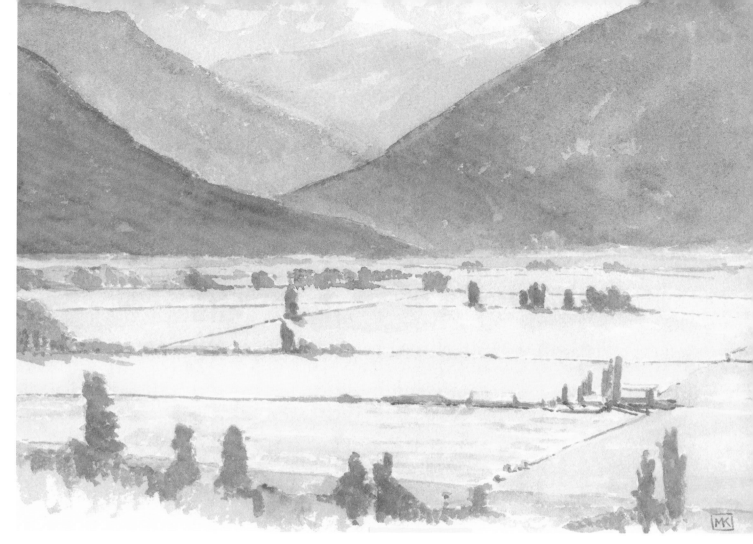

The view from Creston, looking back across the flats through which the Kootenay River flows and toward the cleft in the mountains that is the route of the Salmo-Creston Highway. A formal checkerboard superimposed on the random terrain of the province's Interior, it is one of the few grain-growing areas of the province other than, of course, the Pouce Coupe prairie near the Alberta border.

and a post office, then opened the first steam sawmill in the valley, the start of a lumber industry that, until the recreational boom of golf courses and resorts now transforming communities like Invermere and Windermere, kept the area on the map.

The Canadian Pacific Railway's Crow's Nest line built maintenance shops at Sirdar, although the trains went further north to Kootenay Landing (page 91). The word Sirdar was an honorific applied to the British commander of the Egyptian army, in the case of this village Lord Kitchener. A feature of the village is the stone terracing of the orchards above the road, built by Italian pioneers, two of whom were Santo Pascuzzo and Peter Cherbo. As for Wynndel, "O.J. Wigen, the father of Wynndel, first set foot there in 1893 in his mining pursuits. When the mining petered out, interests turned to logging and sawmilling. In 1901, Mr. Wigen cleared the first orchard and gave Wynndel its start as a strawberry-growing centre. Tree fruits did not gain prominence until more recent years."[2]

1 Simma Holt, *Terror in the Name of God,* p. 179.
2 *Creston Review,* 1958 centennial edition.

W.A. Baillie-Grohman, sportsman and visionary entrepreneur, at his home, Schloss Matzen, in the 1880s. Photographer unknown.

Yahk

.

A hamlet on the CPR's Crow's Nest Pass route in the extreme southeast of the province, Yahk has a few old "main street" buildings including the hotel with its Horny Owl saloon, a couple of log homes in good repair, some streets of trailers and small houses, and the building to the right, standing in the tall grass next to the hotel, which looked worse than my September 2000 painting of it. A railway manager's house? A provincial government building, perhaps? Its quality indicated the pen of an architect.

It turned out to be the BC Provincial Police post and residence built in 1919 as the "Yahk lock-up,"[1] with additions done in 1927.[2] Jones and Doris of Cranbrook built the 1919 section for a total price of $3,000, the contract specifying that the builder was to include "the collecting of two double steel cells from the railway siding at Yahk." The 1927 plans show the addition of an extra gable to the right of the 1919 building to create accommodation for the Provincial Police officer and his family. The addition, by Doris Construction Co. of Windermere, cost $1,856.[3] This appears to be the only survivor of a design of village police post that perhaps once dotted the province; the Burns Lake outpost, from the same period, is illustrated on page 20.

The British Columbia Provincial Police Force was established 15 years before the much more famous Royal North West Mounted Police. With the arrival in British Columbia in 1858 of rowdy miners from California, the Colonial Office recognized the need for a locally controlled police force that would be less expensive to maintain than the Royal Engineers. Chartres Brew, a veteran of the Royal Ulster Constabulary, was commissioned in London and sent to Vancouver Island, but after he failed to show up on time Douglas presumed him lost, and appointed Augustus Pemberton instead. When Brew finally arrived, Douglas sent him to the mainland to establish the force there once the separate mainland colony – British Columbia – was established in November 1858. Brew's brother Tomkins became town constable in Granville, *aka* Gastown, in 1870.

The Provincial Police had a long and colourful history, reflected in its own magazine, the *Shoulder Strap*, which was published for many years. Its reputation became sullied in the 1940s during the administration of John Hart, due to allegations against its quartermaster. Attorney general Gordon Wismer finally moved to disband the force in 1950, with the RCMP taking over provincial policing duties that August.

Yahk's main street, photographed in the 1940s by "Lithgoe." This is the building that, stripped of its porch and cornice, is the current hotel. The view of the Provincial Police building on the far side is blocked by the hotel. The buildings in the distance have all been demolished and the forest has crept back in to the roadside.
BC ARCHIVES E-05365

1 BC Archives GR-0054, box 50, file 641.
2 BC Archives GR-0054, box 6, file 96.
3 Don Wilson put me in touch with Rita Dickson, author of *The Unforgettable Memories of Yahk*; Nicola Finch, webmaster of Yahk on Line was my original source of the plans, a copy of which belonged to Stan Junglas.

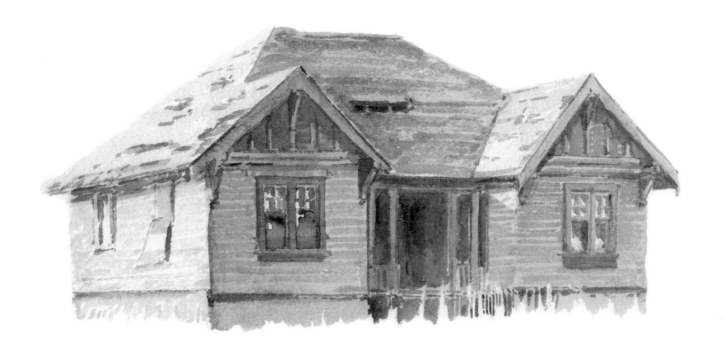

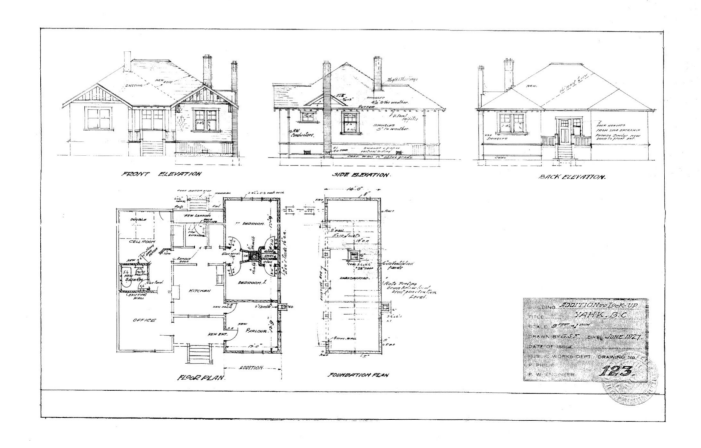

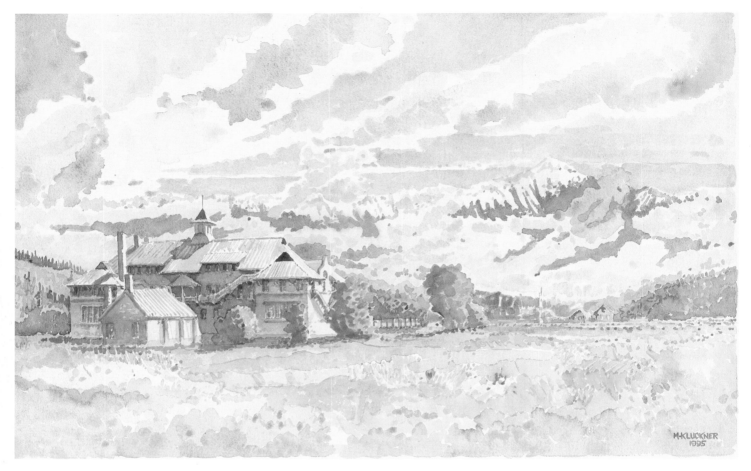

1 Information from Tom Annandale of Toby, Russell, Buckwell and Partners, the project team that worked to incorporate this building into the resort development. Historical information from an undated brochure published by the St. Mary's Indian Band.
2 Dana H. Johnson, "Indian Affairs," in Donald Luxton, ed., *Building the West*, p. 73.

I first saw St. Eugene's Mission and the St. Mary's Reserve north of Cranbrook in 1995, and was struck by the beauty of the massive old residential school and its dramatic siting with the Rocky Mountains in the distance. The other notable building on the reserve is the St. Eugene's Church, one of two (the other being at Moyie) built with the proceeds of a galena mine discovered by a Ktunaxa man named Pierre, assisted by the resident missionary of the Oblates of Mary Immaculate, Father Coccola. The church was completed in 1897. After a lengthy process that occupied the last half of the 1990s, the school is now rehabilitated and incorporated into the St. Eugene's Mission golf course and resort.[1] Like "St. Mike's" at Alert Bay, it has been retained and reused, the profits from the business operation helping the Ktunaxa First Nation toward self-sufficiency. I recall hearing a local woman there at the time saying, "This is where they tried to take my culture away, so it is fitting that it will now help me get my culture back."

This is an unusual residential school for the period in that it did not use standard plans developed by Indian Affairs departmental architect Robert M. Ogilvie. A private Ottawa architect, Allan Keefer, designed it in 1912 in the fashionable Mission Revival style, identifiable by the curved "key" on the extreme right of the facade, the tiled hipped roofs and brackets.[2]

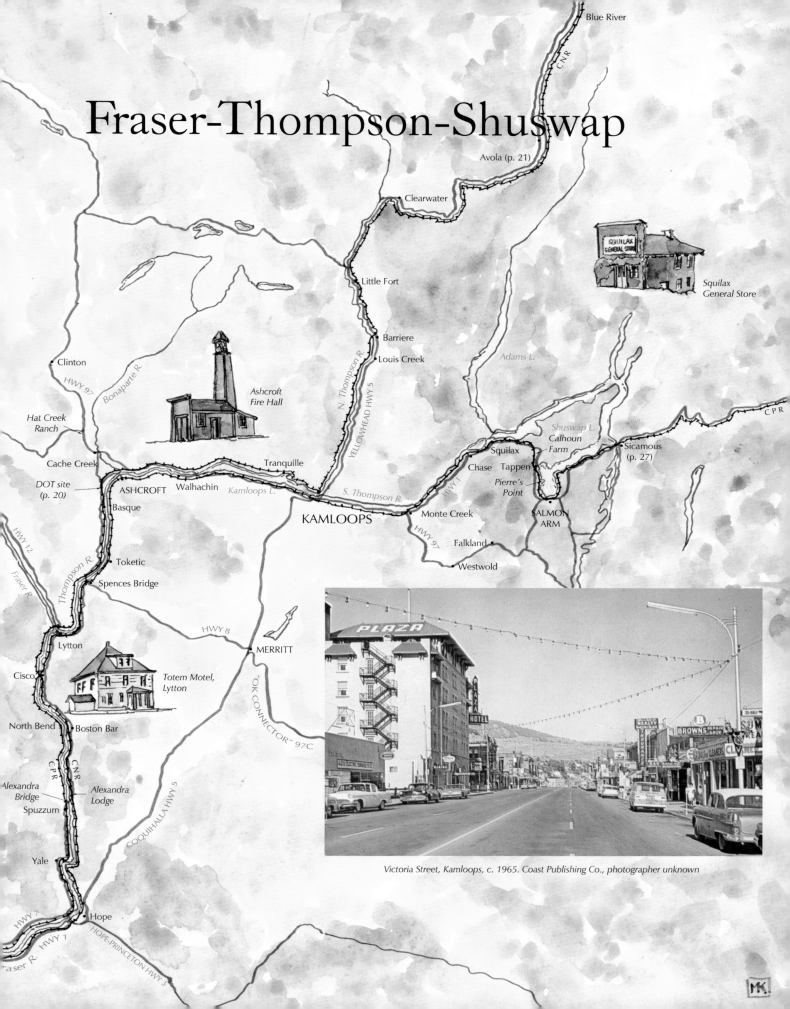

Fraser-Thompson-Shuswap

Blue River

C N R

Avola (p. 21)

Clearwater

SQUILAX GENERAL STORE

Squilax General Store

Little Fort

Barriere

Louis Creek

Adams L.

Clinton

HWY 97

Bonaparte R.

Hat Creek Ranch

Cache Creek

DOT site (p. 20)

ASHCROFT

Walhachin

Basque

Kamloops L.

Tranquille

N. Thompson R.

YELLOWHEAD HWY 5

S. Thompson R.

KAMLOOPS

Ashcroft Fire Hall

Squilax

Chase

Tappen

Pierre's Point

Calhoun Farm

Shuswap L.

C P R

Sicamous (p. 27)

HWY 1

SALMON ARM

Monte Creek

HWY 97

Falkland

Westwold

HWY 12

Fraser R.

Thompson R.

Toketic

Spences Bridge

HWY 8

MERRITT

"OK CONNECTOR" 97C

Lytton

Cisco

Totem Motel, Lytton

North Bend

Boston Bar

C P R

C N R

Alexandra Bridge

Alexandra Lodge

Spuzzum

COQUIHALLA HWY 5

Yale

HWY 7

Hope

Fraser R. HWY 7

HOPE-PRINCETON HWY 3

PLAZA

HOTEL

BROWNS

Victoria Street, Kamloops, c. 1965. Coast Publishing Co., photographer unknown

MK

Fraser Canyon

As the head of navigation on the Fraser River, Yale rapidly overtook Fort Hope in importance once gold was discovered in the Cariboo. Its heyday of a little more than 20 years, taking in the construction of the Cariboo Road, the gold rush, and the construction of the Canadian Pacific Railway in the 1880s which effectively destroyed the road, was followed by an equally precipitous decline. Contractor Andrew Onderdonk's fine house, for example, became an Anglican girls' boarding school called All Hallows[1]; the name (spelled "All Hallowes") survives on a trailer park just south of town.

Tourism began in the mid-1920s with the reopening of the Cariboo Highway. In the 1970s, the province purchased a number of properties with the idea of making Yale a historic town like Barkerville, but there was little local support. Only St. John the Divine Church and a house converted into a museum were restored.[2] Some historic buildings, including the On-Lee house from Yale's Chinatown, burned down several years ago. However, just across

LEFT *The first Alexandra Bridge – a faux nighttime scene by John Valentine & Sons mailed a decade after the bridge deck washed out in the 1894 floods.*
YALE & DISTRICT HISTORICAL SOCIETY
RIGHT ABOVE *All Hallows' school in Yale, c. 1900, a John Valentine & Sons card. Note the gardener pushing the lawnmower.*
RIGHT BELOW *The 1926 Alexandra Bridge, a Gowen-Sutton postcard from c. 1930.*

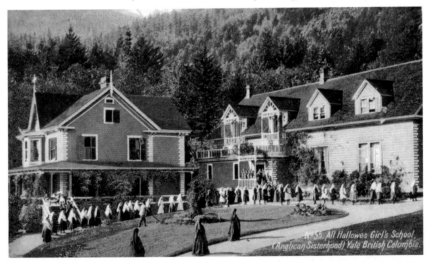

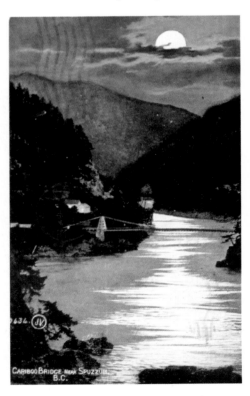

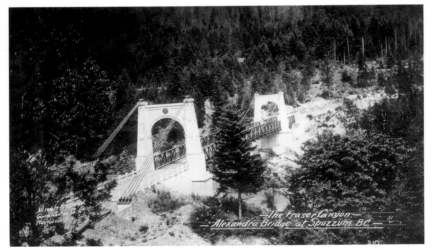

the tracks from the church, diguised by asbestos shingling, is one of the oldest houses in the province. Built about 1863 for Johnny Ward, a Nova Scotian and teamster with the famed BX (Barnard's Express), it was purchased around 1992 by the provincial government and is used as the home for the museum curator.[3]

Essential to the completion of the Cariboo Road, the first Alexandra Bridge was begun in June 1862 and completed September 1, 1863. Sergeant McColl of the Royal Engineers surveyed the site at the narrows between Spuzzum and Chapman's Bar. Joseph Trutch, a civil engineer who had been in the colony since 1859, obtained the contract to build the structure and sections of the road itself. At Confederation he became the province's first lieutenant governor; his actions in reducing the size of reserves which Governor Douglas had settled on the province's First Nations fomented distrust and left unsettled the land claims that dog modern British Columbia. Politically, he was identified with neither the British nor the Canadian factions, and infamously advised Prime Minister Macdonald that the new province would not hold Ottawa to the letter of the railway clause, which promised completion within a decade of a transcontinental railway all the way to Victoria. BC almost seceded from Canada in the late 1870s over the issue.[4]

Trutch's bridge fell into disuse following the completion of the CPR and was badly damaged in the flood of 1894. In 1912 the local road supervisor cut the suspension cables because of the danger of accidents to those few pedestrians who continued to use it. But, with increasing use of the automobile after the First World War, the government decided to reopen the Fraser Canyon road, and in 1926 A.L. Carruthers supervised the construction of a new bridge. The 1863 abutments served as its foundations, and a toll booth with resident collector was established at Spuzzum. The toll was one dollar, an astonishing sum for the late 1920s, equivalent to two hours' work for a skilled tradesman or about $40 in today's currency.

This second Alexandra Bridge, unused by vehicles since 1964, provides the earliest physical evidence of the scale of highways and bridges in the Fraser Canyon in the automobile age. Accessible by a path, in fact the old highway, that winds down the hillside from the modern highway just east of the new Alexandra Bridge, the bridge is alarmingly narrow and, with its open-weave metal decking, not an experience for anyone prone to vertigo. The concrete in the towers is badly spalled and the cables are rusty but so far adequate. It will probably fall down soon and be declared unsafe, perhaps in that order.

The second general store and Esso station on the Trans Canada Highway at Spuzzum burned to the ground several years ago, making it even easier to drive past Spuzzum and, as the saying goes, "blink and miss it." But the original general store, on the section of the old highway that wound down

The Ward house in Yale, built c.1863, hints at its great age due to its side gables and the narrow hipped-roof porch. The CPR main line crosses in the foreground, close enough to shake the house.

1 Laforet and York, *Spuzzum: Fraser Canyon Histories, 1808-1939*, p. 160.
2 Heritage Society of BC newsletter, Fall 2003, p. 5.
3 Bruce Mason, Yale and District Historical Society.
4 Margaret Ormsby, ed., *A Pioneer Gentlewoman in British Columbia*, pp. 136 and 142.

ABOVE *Japanese Canadians on the front steps of the Spuzzum Hotel on New Year's Day, 1948. The building's hipped roof is easily visible from the Trans Canada Highway.*
BELOW *The Spuzzum General Store, cafe and Esso station, a c.1950 postcard by J.C. Walker. The store building still exists, minus its porch, on the dead-end road below the railway tracks.*
CHARLOTTE GYOBA

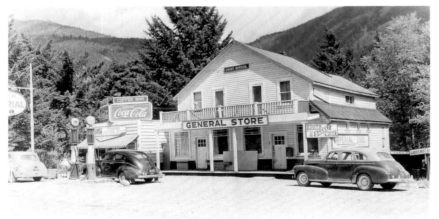

1 Joe Butler, current owner, located the dated cornerstone.
2 Co-author of the book *Spuzzum: Fraser Canyon Histories, 1808-1939.*
3 Correspondence, 2003.
4 Interview with Charlotte Gyoba, 2002.

the hill toward the 1926 Alexandra Bridge, still stands, converted into a home with a bed of flowers occupying the space in front where the gas pumps once stood. Another surviving building, now used as a private residence, was for many years the Spuzzum Hotel. It stood across the street (that is, the old highway) from the Spuzzum railway station and was built in 1923.[1] After the war, it was occupied entirely by Japanese Canadians released from the internment camps but still restricted from moving to the coast.

One couple, the Gyobas, were both interned in 1942 at New Denver, where their daughter Charlotte was born. Gyoba was a faller who lived near Cumberland; his wife, married to him in Japan, had joined him in 1933. Early in 1942, the RCMP arrested him at home at gunpoint, and ordered his wife with her three small children – one a newborn – to report to Hastings Park in Vancouver. Later in the war they moved to Tashme, where another son was born. They were planning to go back to Japan as part of the repatriation that started on May 31, 1946, but decided instead, along with several other Japanese-Canadian families, to move to Spuzzum where jobs were available at a sawmill. Some lived in the hotel, where the Gyobas, with their five children, had two rooms. A large group of men occupied the parlour. The families erected a bathhouse beside the hotel and a number of cabins, all now demolished. Other families lived in a row of at least a dozen tarpaper cabins erected by Mr. Neville, the owner of the sawmill. After the government removed the remaining settlement restrictions, most of the families left. Those who remained, after some initial coolness, were accepted into the community. The Gyobas became friendly with Spuzzum's most celebrated resident, the Nlaka'pamux woman Annie York,[2] often giving her a ride into Hope for shopping.

Around 1950 the lumber company closed and Mr. Gyoba went to work for the CPR. The family eventually grew to seven children, all of whom attended the elementary school that still stands at the corner of First Avenue. Charlotte's older sisters worked through their high-school and university years in the coffee bar at the general store. Terumi Oikawa Leinow, then called Dulce, was a classmate. "It is interesting for me, who married an American and now lives in sunny California, that my past somehow erases itself behind me! Tashme, where I was born, no longer exists and Spuzzum where I spent part of my early childhood is slowly vanishing ... I have fond memories of the Spuzzum days, where all the families gathered at the bathhouse near the hotel and my father would piggyback me on his back as we returned to our cabin under the night stars."[3]

The experience of her husband's arrest in 1942 left Mrs. Gyoba with a life-long fear of the police. Once, flying into Honolulu, she heard the captain announce that Pearl Harbor was visible out the window. It sent a shiver through her. "Pearl Harbor" meant total upheaval.[4]

Alexandra Lodge

There has been a roadhouse or lodge at Chapman's Bar in the Fraser Canyon since 1858, four years before the Cariboo Road opened and Joseph Trutch's workers completed the Alexandra Bridge nearby. For many years it was believed that some portion of the current Alexandra Lodge was a goldrush era roadhouse, which would have made it among the most historic buildings in BC. The provincial government gave it a heritage designation in the early 1970s, but withdrew it a decade later when a subsequent review revealed that the building dated only from the 1920s – the highway era when auto tourism and long distance trucking began and the Cariboo Highway reopened as a toll road. In the early 1980s, a Heritage Branch report dismissed the lodge as "only of local significance"[1] – something of a death sentence when combined with the loss of tourist traffic through Fraser Canyon since the opening in 1986 of the Coquihalla Highway.

The 1858 gold rush created as many opportunities for entrepreneurs as it did for miners. The slow pace of travel, especially for supply teams, and the large number of prospective miners created a demand for roadhouses or

The familiar first view of Alexandra Lodge, as it looked to me in September 2001 as I travelled east on the Trans Canada Highway. The old gas station that used to stand next to it collapsed following a heavy snowfall in the mid-1990s and was later razed. There are still a few cabins from its tourist heyday dotted about in the woods behind.

1 *Lillooet-Fraser Heritage Resource Study*, vol. 1, Heritage Conservation Branch, Province of BC, 1980.

stopping places along the major routes, initially in the Fraser Canyon and on the Harrison Route from Port Douglas to Lillooet. By 1864, two years after the Cariboo Road and Alexandra Bridge opened, innkeeper William Alexander went into partnership with Louis Waigland, who had purchased 32 acres beside the Cariboo Road above Chapman's Bar.[1] They built a large, two-storey frame roadhouse there, an 1867 photograph of which (by Frederick Dally) survives in the BC Provincial Archives.[2]

Old photographs confirm that the present building had "emerged" by the 1930s. The roofline and main floor of the front elevation's left-hand side (minus a proposed dormer) reflect the 1926-7 plans drawn by Vancouver architect Willliam Frederick Gardiner for Cariboo Hotels Ltd.[3] But the rest of the building differs substantially, and perhaps was assembled from other buildings, some portion of which may be the roadhouse from the gold-rush era. In the watercolour, the strong vertical shadow below the peak of the gable reflects the difference in size between the front half and the rear half of the building – the former is a few feet longer. The porch structure is also very different. Possibly the entire W.F. Gardiner plan was built in the late 1920s, but a fire may have destroyed the right-hand side of the architect's front elevation soon after its completion.

The ownership history was equally complex. Following the gold-rush era, the property passed into the hands of the McGirr family, who entered into a 10-year lease on December 2, 1926, with John Hind and James Simm Day – $6,000 at $50 per month. Six weeks later, Hind and Day assigned the lease to Mrs. Claire Hind and Cariboo Hotels Ltd. The company renewed the lease 10 years later in the middle of the Depression at $35 a month. In October 1947, on the death of shareholder Kathleen Clegg, the company tried to sell the lodge, but the following February, having been unsuccessful, turned the keys over to Miss Hope McGirr. The McGirrs hung onto the property for a time, evidently because of the small family graveyard nearby (close to where I sat to paint the watercolour reproduced on the previous page). Later owners,

LEFT *The front elevation of the proposed hotel from 1926 blueprints by Vancouver architect William Frederick Gardiner.* BELOW LEFT *Alexandra Lodge Union Gasoline, the service station that stood beside the lodge.* RIGHT *The lodge in the 1930s, a postcard by an unknown photographer, showing the rental cabins dotted about behind. I stayed in one in 1992, narrowly avoiding being eaten by fleas that had colonized the ancient shag carpet.*

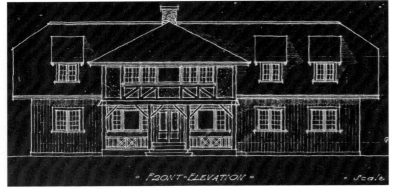

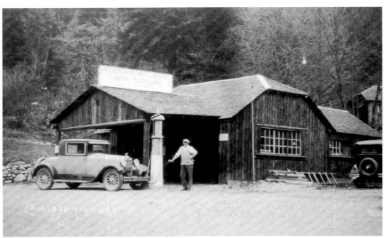

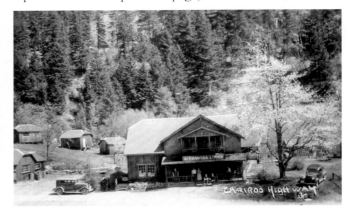

including Dorine Hooper who had a well-deserved reputation for her cinnamon buns, struggled to keep the lodge going until she closed it finally around 1995.

In the lodge's heyday, its first two decades of operation, it apparently was run by the Barrett family in a very elegant style. Correspondent Doris Tuohey, who first travelled up the Fraser Canyon in 1929 and spent a lot of time in the 1930s and 1940s gold panning and vacationing in the area, recalled white linen cloths on the tables and filet mignon on the menu. The proprietress had straight-cut hair, an Irish brogue and smoked a pipe; her husband was a "well-educated Englishman." Prajadhipok, the king of Siam, stayed or stopped there with his entourage during his tour of BC in September 1931.

The niece of the owners, Joan Barrett, first stayed at the lodge for two weeks in 1927 when she was 14 and her father was operating the garage part of the business for his relatives. Evidently she subsequently managed it, noting that, "I should add when I moved out of Alexandra Lodge [in 1947] I left the hotel register behind – which was the custom – whether Miss McGirr rescued it I do not know."[4]

The long-abandoned Alexandra Lodge, together with significant property between the highway and the river, was for sale for many years and could not be easily reopened as a historic inn on its exact site, due to its proximity to the noisy, truck-choked highway and the lapse of its restaurant permits. It sold in 2004, but the new owner merely upgraded it somewhat, then put it back on the market. One glimmer of hope for its future lies in its location near the Alexandra Bridge and a historic network of trails increasingly used by back-country horsemen and hikers.

The remains of the Anderson brigade trail of 1848, used briefly by the Hudson's Bay Company, ascend the ridge behind the lodge. The trail began at Fort Yale, crossed the river at the narrows at Spuzzum and continued to Fort Kamloops via the Merritt area. It was the first attempt post-contact to establish a route through the canyon. Above the Alexandra Lodge site, the trail climbed a steep hill to what was called Lake House and also connected to an Indian pack trail from Boston Bar to the Merritt area. The route was superseded after the 1849 season by the Hope to Tulameen brigade trail, but it was used again to reach Fort Kamloops in 1858 and in 1882 (due to CPR construction destroying the Cariboo Road) and became a route to Boston Bar. The site of Lake House has not been found.[5]

Much of the forest along the trail has been logged over the years, but the first seven kilometres, starting near Alexandra Lodge, is more or less untouched. Charlie Hou, a Burnaby secondary school history teacher who had been taking his Grade 10 students on an overnight hike along the trail for several years, attempted in the late 1990s to have the trail designated by the provincial Archaeology Branch. Mr. Hou proposed provincial park status for the trail, but his efforts were not acted upon before the change of provincial government in 2001. However, the trail is recorded under a "map reserve" status according to a memorandum of understanding between the Archaeology Branch and the Ministry of Forests; this could mean the preservation of a strip 100 metres wide on either side of the trail.[6]

Henry Bertram Clegg (1888-1942) and Kathleen Lilliam Clegg (1893-1947) were directors of Cariboo Hotels Ltd. She died in North Bend at the same age, 54, as her husband.
YALE & DISTRICT HISTORICAL SOCIETY

1 Branwen Patenaude, *Trails to Gold,* pp. 30-2.
2 www.bcarchives.gov.bc.ca, image number A-03865.
3 Biography in Luxton, ed., *Building the West,* pp. 306-9.
4 Letter by Joan Barrett, Dec. 18, 1990, Yale and District Historical Society collection.
5 *Lillooet-Fraser Heritage Resource Study,* 1980.
6 Heritage Society of BC newsletter, Summer 1999.

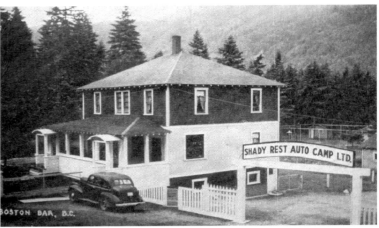

Although most of them are in ruins, the auto courts and motels of the Fraser Canyon are a window onto an early era of tourism and travel that seems almost laughably modest and rustic by contemporary standards. C.P. Lyons, in his 1950 tour book *Milestones on the Mighty Fraser,* gives an estimated travel time from Vancouver to Boston Bar of four hours; today, via the Coquihalla, it takes four hours to get all the way to the Okanagan.

Correspondent "Diana" sent a copy of her great-grandmother's obituary of January 1948: "Mrs. Christian came to British Columbia 67 years ago, travelling from her home at Ludington, Mich., via San Francisco, to Victoria and from there to Yale by paddlesteamer. From Yale to Savona she travelled by stage coach over the historic Fraser Canyon Road. The coach was driven by Fred Tingley, brother of the famous 'Whip' Steve Tingley. From this point she left for Tranquille by lake boat. Then again she went by stage to the Greenhow and O'Keefe homesteads. Here the month-long journey was broken for a few days' rest. Mrs. Christian, then Emma Genia, was joined at this point by her fiancé. The journey was completed to Okanagan Mission by team and wagon."

By comparison, according to Grace Darney: "I recall my dad saying that during the 1920s and 30s they travelled down from Williams Lake to go to ballgames 'At The Coast' (I always pictured these words capitalized). He said they travelled at night so that they could see another vehicle's headlights blinking through the bushes. One of the vehicles would pull over in the first place available, to let the other go by. Thinking about it now, I don't know how it was determined which car had to find a spot to pull over."

Like many of the Fraser Canyon's motels and homes, the abandoned motel just north of the Boston Bar airstrip had a wonderful collection of weeping willows – enormous yellowy-green trees swaying gracefully in the hot wind. Its long-time owners, Bill and Marianne Walker, both of whom died recently at venerable ages, bought it in the mid- to late 1970s from a man named Couteau who had been running it as an antiques shop, and never themselves ran it as a motel. Bill Walker picked up scrap metal along the high-

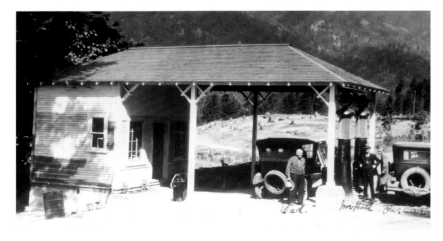

way for a living, and managed to accumulate a vast amount of it by the time he and his wife had to move from the property. They were among the last of a generation of eccentric country folks who somehow eked a living from the fringes of the modern BC economy. Both were well known up and down the canyon, especially at Alexandra Lodge, where they often ate dinner and where Bill would entertain guests with his accordion.[1] With their passing and the eventual demolition of such places, only the exotic trees like the willows and acacias will remain to indicate a human presence.

A t Cisco, below Lytton, the bridges of the two great national railways cross the Fraser River. On the bench just above stand the ruins of a resort known as Siska Lodge (Siska being the name of the Indian village a kilometre or so further downstream). These days, only the deep green patch of the acacia grove – so different from the bleached olive and black tones of the pines that typically dot the hillsides – tells of its existence.

Siska Lodge was known in the 1930s and thereafter as a good vacation spot, with opportunities for hiking and gold panning available for recreation. Correspondent Doris Tuohey recalled its several acres with fruit trees and cabins, a "good colonial house with a good restaurant." In the 1960s it was owned and managed by Fred and Florence Lindsay.

Born in 1903, Frederick William Lindsay was a classic BC character, a

ABOVE *The "Willows Motel."*
BELOW *Bill Walker at the Jade Springs Cafe in Lytton in 1998.*
SHARLEINE HAYCOCK

1 Correspondence with niece Grace Darney and daughter Sharleine Haycock, 2002-3.

ABOVE *One of Fred Lindsay's books.*

JIM WOLF

BELOW *Siska Lodge in the Fraser Canyon, a 1949 photo by an anonymous provincial government employee.*

BC ARCHIVES I-30042

1 *Vancouver Sun*, August 10, 1971, p. 6.
2 *Province*, July 20, 1973, p. 9. Basil Stuart-Stubbs located the biographical information.

roustabout who revelled in the roughness of a life just barely advanced from frontier days. Journalist Barry Broadfoot admired Lindsay's two-fisted yarning and dubbed him "the British Columbian." In an interview with him two years before he died, Broadfoot wrote of an afternoon spent in his kitchen, with Fred talking, "free-wheeling and straight-shooting. We kill a crock or two, and his good wife Florence keeps offering us sandwiches and cake on the theory that food absorbs alcohol." Lindsay was "a stocky, tough, profane old bird" who had lost some of his agility with the loss of a leg a few years earlier. "He's done everything, from blacksmithing to selling shoes to farming to running a store to hustling with his own outdoor advertising outfit to almost every kind of logging, interior and coastal, to owning a tourist resort to packing mining supplies in winter over the Monashee Pass to writing and publishing books on colorful Cariboo history to timber cruising to watchman on a forestry tower to cooking in camps and city hotels. And he has panned gold on the creeks and run a successful don't-give-a-hoot weekly newspaper in Quesnel and slugged it out on tugboats and seiners and walked the length and breadth of the province during the depression hunting work and braked on the railways and messed a bit with bootleggers in the rum-running trade and done a bit of trucking and had organic gardens when nobody knew what they were and he's helped a lot of poor Indians and cursed every government in and out of office for 50 years."[1]

Lindsay wrote and published *Cariboo Story* (1958), *Cariboo Yarns* (1962), *Outlaws* (1963) and *Cariboo Dream* (1972) – rollicking tales of the gold-rush days. With Florence as illustrator, he wrote a children's book called *Mouse Mountain*. His obituary noted that he had not only published a weekly newspaper in Quesnel but served as an alderman there, where he made "a few enemies and a hell of a lot of friends."[2]

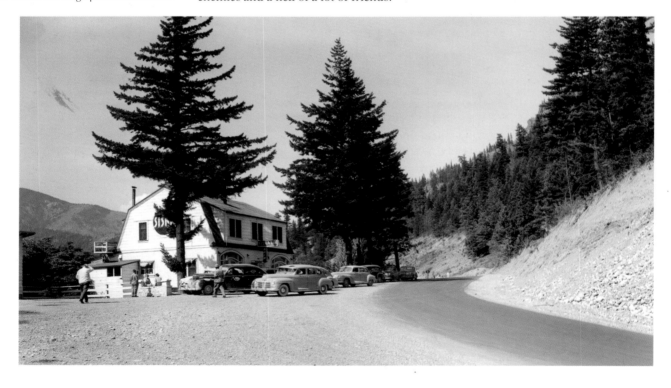

VANISHING BRITISH COLUMBIA

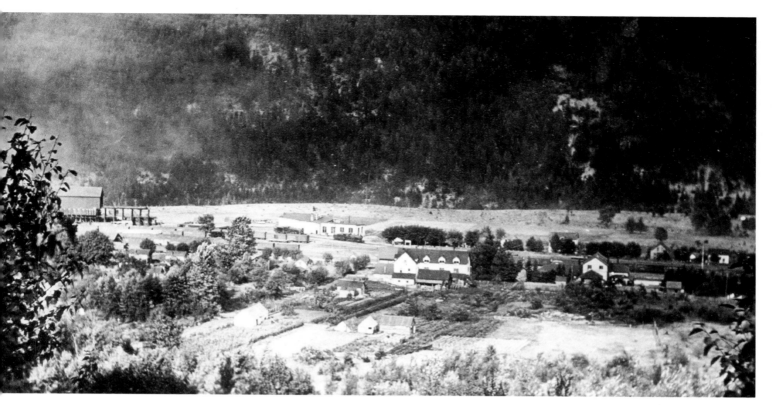

North Bend

N orth Bend now exists more in the memories of its "old-timers," and in their photographic collections, than in reality. A divisional point for the Canadian Pacific Railway, it was established in the mid-1880s. The raison d'être for the original CPR Fraser Canyon House was the railway's inability to haul heavy dining cars up the hill from Hope; in 1901, the railway changed its policy and attached a dining car to eastbound trains at Agassiz.[1] The town was isolated from the province's developing road system (except for a single-car aerial tram that crossed the Fraser River) until the government completed a bridge in 1986, linking it conveniently with the bustling stores along the highway in Boston Bar. Within a decade, North Bend's store (latterly its cafe) had closed and burned and other old houses and buildings had disappeared. The two towns held a reunion in the spring of 2003, and visitors were greeted by the news that the North Bend school was to be closed as a cost-cutting measure. Only two of the eight Highline Houses (page 127) still exist, along with a handful of other historic buildings, including the old Mountain Hotel.

North Benders' memories, as revealed by the quotations below, recall the railwaymen and townspeople who ran the hotels and cafes.

"My Dad was the night foreman at the CPR shops. He worked a 12-hour shift six days a week with Thursday off, if there was no emergency. If there was, he worked the seventh day at no extra pay because he was an official and a salaried employee. Hard to believe in this day and age. The cafe that you mention was originally the main store in town, owned by Mr. and Mrs. Elmer Carlson ... We lived in North Bend until 1951 when the federal government introduced the 40-hour week that summer and the CPR brought in the diesel engines. North Bend was a vibrant community and we were always busy, what

North Bend about 1910, photographed by Aida Abray. The roundhouse is visible in the centre distance (with the pen mark); the Mountain Hotel has three white dormers, and the CPR's Fraser Canyon House is on its right. Harry Lee's house (p. 126) is just out of sight on the right, and the Highline Houses' location (p. 127) is just out of the picture on the left. The store site is just to the left of the Mountain Hotel.
ARLANA NICKEL

1 *Province*, November 4, 1901.

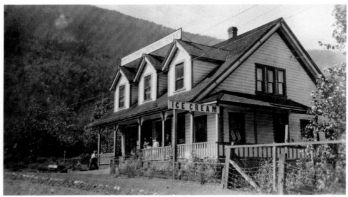

LEFT *The Mountain Hotel, about 1910, Aida Abray in the white apron. The "wines-liquors" sign dates the photograph to before Prohibition was enacted in 1917.*
ARLANA NICKEL

RIGHT *The North Bend store, which stood across Station Street from the Mountain Hotel until its razing in the mid-1990s. When I first saw it in 1992 it was an abandoned cafe.¹ It apparently started life on the opposite side of the tracks and was moved to its final location about 1920. William Edward Ford ran the store from 1921 to 1928.*
LINDA REID

BELOW *The original CPR hotel in North Bend, about 1890, when it was run by Miss Jean Mollison (later proprietor of the elegant Hotel Glencoe in Vancouver). It burned down in 1927 and was replaced by a new hotel that was demolished in the 1980s.*
GREG SAHAYDAK

1 Reproduced in my self-published *British Columbia in Watercolour,* 1993, p. 79.

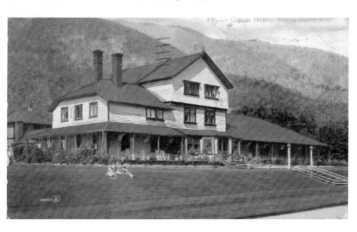

with Dave Weinmaster's North Bend brass band and the never ending 'plays' that we were constantly putting on at the town hall. The town hall burned down in the 1960s, I believe. We had one public phone in town located at the Lunch Counter so if one had to make a long distance call everyone in town knew about it. There was no booth and no other phone in town as they hadn't yet brought phone service into the town other than that one line." – Clarke Peters

"My Dad worked for the CPR in North Bend from the late 40s to the early 60s. My parents lived in the house on the right in your painting [of the Highline Houses] in 1949, when I was born. My Mom was the only RN in North Bend for many years, and was called out when babies were being born, people were injured and people died. [A woman brought her baby] to Mom, who told her that from his symptoms he had a bowel condition that could be fatal and urged her to get to the doctor asap. We had to take the train for five hours to get to the doctor in Vancouver. Apparently the baby was treated and recovered ... We used to go to the movie every Thursday night, the children went to the first show for ten cents, and the parents went to the second show. When the kids got home, we'd all get on the phone, as we had party lines and had three or four people on each line – so we could have about six kids talking on the phone at once. That was our entertainment, as there was no TV in those days." – Wendy Sahaydak

"I understand that the Mountain Hotel is still standing in North Bend, although abandoned. My greatgrandfather took over that hotel, called the 'Pig's Ear' by the locals, much to my grandmother's dismay. He was Jackson T. Abray, and was the first police constable of Vancouver after the fire of 1886. Abray is one of the officers in the City Hall tent picture [taken on the Carrall Street wharf immediately after the fire]. Jackson Abray came to Vancouver in 1885 after helping build water towers during the building of the CPR across Canada. His butcher shop burned to the ground in the great fire. He married Abigail Maude Martin in Vancouver in 1888 and his daughter Aida was born August 3, 1890 in Vancouver. He ran the Mountain Hotel in North Bend starting about 1908. He then went on to run the general store at Boston Bar and lived on a little farm there. Abray's daughter Aida M. Snowden and son-in-law William R. Snowden (my grandparents) helped Abray from time to time with the Mountain Hotel until they moved to Kamloops in 1923." – Arlana Nickel

Three of the Snowdens' five children were born in North Bend, with "Ma" Richmond as midwife. Daughter

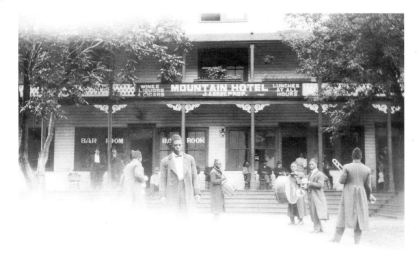

Snowden family album: CLOCKWISE FROM ABOVE *A brass band playing in front of the Mountain Hotel. Jackson and Maude Abray, with son George (l.) and son-in-law Bill Snowden with daughter Bonnie. Aida Abray in the orchard behind the CPR hotel. Bonnie and Pearl Snowden about 1916 with Caroline, a young Native woman hired to be the Snowdens' "mother's helper"; according to a family story, the North Bend policeman and jailer, named Wyatt, crawled through her bedroom window one night and impregnated her; in the ensuing scandal, Bill Snowden was initially blamed, and the Provincial Police moved Wyatt, a married man, to another posting, while Caroline was let go, returning presumably to her family. The Snowden family home, long since razed, about 1914; a simple frame cottage, it was much less substantial than contemporary CPR-built dwellings like the Highline Houses overleaf.*

ARLANA NICKEL

Pearl, aged five, was the town's first May Queen in 1919, crowned with mock-orange blossoms. Before her marriage to CPR engineer Bill Snowden, Aida Abray developed a small business taking postcard photographs using printed-on-the-back Kodak postcard stock for her pictures. According to family legend, she developed the film underneath a blanket in her bedroom, then printed it in the bathroom with a red lightbulb screwed into the socket.

"Ma" Richmond, the celebrated Fraser Canyon midwife, was born Sarah Annie Little in south Wales in 1882. Her husband, Harry Herbert Richmond, came to Canada in 1911, followed a year later by her and her four sons, supplemented by two more once they settled in North Bend. His grandchildren, including future MLA Claude Richmond, took him his lunch at the roundhouse every day during the summer holidays. "Ma" lived on until 1977, spending many years productively with the Pythian Sisters Lodge in North Bend and Kamloops.

(Correspondence and interviews with Clarke Peters, Wendy Sahaydak, Brian Avery, Ellen Fagan, Ernie Clelland, Syd Strange, Arlana Nickel, Pearl Snowden, Linda Reid, Charlotte Granewall, Cliff and Irene Fisher, Kay Henderson, Joan Blake-borough, Leslie Rowe, Jack Cosar, Claude Richmond and Jo-Anne Colby at CPR Archives, Montreal.)

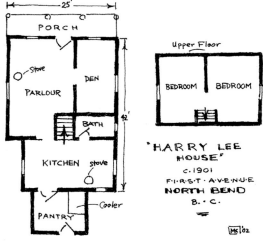

PORCH

Stove
PARLOUR
DEN

BATH
KITCHEN stove

PANTRY — Cooler

Upper Floor

BEDROOM BEDROOM

"HARRY LEE
HOUSE"
c.1901
F·I·R·S·T·A·V·E·N·U·E
NORTH BEND
B·C.

MK'02

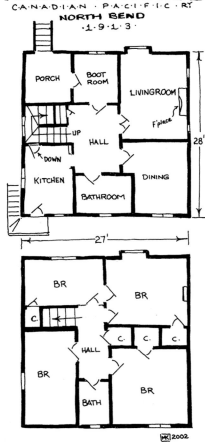

'HIGHLINE HOUSE'
C·A·N·A·D·I·A·N · P·A·C·I·F·I·C· R·Y
NORTH BEND
·1·9·1·3·

PORCH
BOOT ROOM
LIVINGROOM
F'place
UP
HALL
DOWN
KITCHEN
BATHROOM
DINING

BR
BR
c.
c. c. c.
HALL
BR
BR
BATH

MK 2002

ABOVE *Reputedly the oldest building in North Bend, the house occupied by Harry Lee until his recent death at age 101 stands on First Street on the opposite side of the main line from the site of the CPR hotel – land still owned by the CPR. Harry Lee, who lived in the house for as long as anyone can remember, was the son of pioneers at Keefers, upstream on the same side of the river, where there is still an Upper Lee and a Lower Lee. His father, an Englishman, was a farmer who supplied milk to the railway. The house retains vestiges of Lee's personality – for example, the metal cooler (vented to the outside like a meat safe) is plastered with old Irish Sweepstakes tickets.*

LEFT *Harry Lee, legendary locomotive engineer, at his 100th birthday party, North Bend, 1995.* CLIFF FISHER

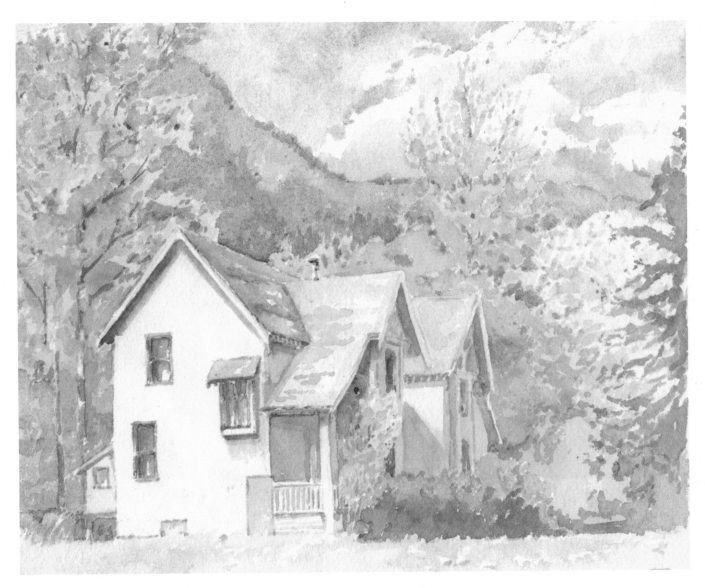

The two survivors of eight Highline Houses, all built in 1913[1] on the street just north of North Bend's centre across the street from the modern swimming pool, in 2002. Although they shared the same efficient floor plan, they appeared in three facade designs: four were like the two above, two had a projecting gable above the stoop, while the remaining two had a bay window set into the lower storey of the main gable.[2]

I had contemplated breaking into one of the boarded-up houses in order to see the inside, certain that they would soon be torched or demolished, but found that the plywood panel over the back door of one of them was already partially ripped out. The house had been squatted in, as there was semi-pornographic, political graffiti scrawled on the walls in one of the upstairs bedrooms and other evidence of subhuman habitation. In 2002 the unheated houses were deteriorating very quickly, with plaster coming down from the inside walls, but the floors were true and solid and the roofs did not leak. The houses were very modern for their time: bathrooms on both floors, a boot room as an adaptation to the winter climate, and good closet space – different from the houses of a decade earlier, where people typically used armoires for storage.

1 Property Value Sheet, CPR Archives, Montreal.
2 *Lillooet-Fraser Heritage Resource Study*, Heritage Conservation Branch, Victoria, 1980.

Toketic, Pokhaist & Basque

The Anderson ranch at Toketic and the Anglican church, St. Aidan's, at Pokhaist Village, both places in the dry country along the Thompson River north of Spences Bridge, were united by their connection with the Timothy family of the local Indian band. Pokhaist Village stands at the mouth of Pukaist (or Pokhaist) Creek.

Correspondence from Coyla Stewart, 2002: "My great grandfather was Chief Shumahatsa of the Pokhaist. Our band burial ground is there, close to the Pokhaist church. My mother, sister and many others are buried there. My father is from the Shulus Band near Merritt and my mother was from the Cook's Ferry band now in Spences Bridge. I've been told that her actual Band was the Pokhaist to which her mother belonged, but it was broken up for one reason or another, mostly political with the land distributed to their descendants. My Grandmother's maiden name was Lucy Timothy. The Timothy name is associated with Chief Shumahatsa through marriage. My people were actually there before the Andersons ... A sister of my grandmother adopted Jacob Anderson who later became the rancher and builder of that red ranch house on the hill. They farmed and raised cattle. By adopted, I mean as a

LEFT *An old log barn on a cattle ranch at Basque.*
RIGHT *St. Aidan's Anglican Church at Pokhaist Village, its steeple a minuscule exclamation mark below a slide-ravaged mountainside, visible from the Trans Canada Highway. Erecting a church beneath such a denuded rockface can only be described as an act of faith, especially given that the original St. Michael and All Angels' Church (page 29), and its Indian village, were destroyed in the great Spences Bridge slide of 1905.*

ABOVE *The Anderson ranch at Toketic, with the long blue shadows of an early morning in August 1994, that promised to be a scorcher. The farmhouse, a storey-and-a-half tall with side gables and a single shed-roofed dormer on the front, was a red dot on an irrigated patch of grazing land in the middle of the desert — a bench above the Thompson River several kilometres north of Spences Bridge.*

RIGHT *A detail of the 1914 edition of British Columbia Department of Lands map, New Westminster and Yale districts. It shows the Canadian Pacific Railway on the east bank and the still-incomplete Canadian Northern Pacific Railway (now Canadian National) on the west bank. At Basque, on January 23, 1915, with war raging in Europe, dignitaries drove the last spike on the soon-to-be bankrupt CNPR.*

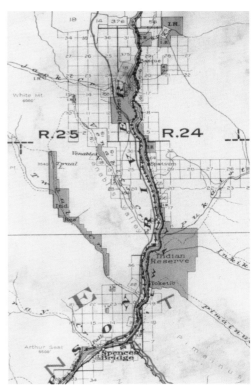

son, I don't know about the legalities and all, but for all practical purposes he became a member of both the Band and our family. I may be wrong about the person being my grandmother's sister though, because I recall my mother calling him Uncle Jacob. He was like an Uncle to her, in fact as a child we used to visit at that ranch house and I would spend the summers there. My Grandmother Lucy died in 1956 and we buried her there at the Band graveyard in Toketic, and held a service for her at the Pokhaist church. My mother attended a boarding school north of Lytton until she graduated from the eighth grade."

Correspondence from Aaron Sam, 2002: "Mary and Jacob Anderson were my grandparents. Their children were Marie, Lorna, Judy, Grace, Bernice, David, Aiona (my mother) and Trudine." The house apparently burned down by accident, when a fire lit to drive away rats got out of control.

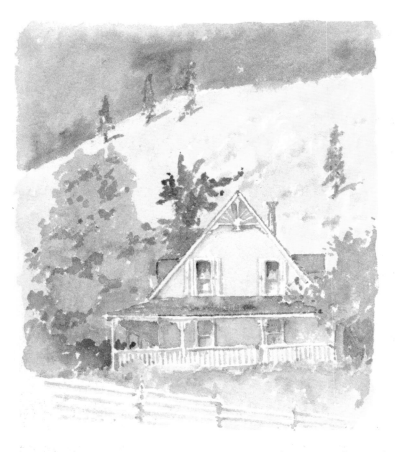

The Morens-Teit home, now the house at Hilltop Gardens a few kilometres north of Spences Bridge.

1 John Veillette and Gary White (UBC Press, 1977).

2 Anglican Diocese of Cariboo Archives.

3 Allan Ferguson Regional Consulting Ltd., *Cariboo Road Heritage Conservation and Tourism Development Study,* vol. 2, 1989.

4 Jessie Ann Smith, *Widow Smith of Spences Bridge,* p. 71.

5 Smith, p. 23.

6 "Lucy Antko" on her marriage certificate, "Lucy Susannah A." on her death certificate.

7 Don Bunyan, "James Teit: Pioneer Anthropologist," originally published in *Midden,* republished in *Heritage West,* Fall 1981, pp. 21-2.

8 Historic Sites and Monuments Board of Canada agenda paper 1994-49, p. 3.

9 Smith, p. 67.

10 Smith, p. 104.

11 Thanks to Steve Rice of Hilltop Gardens for access to the property.

12 Bunyan, p. 22.

13 Information and photo access from Dr. Wendy Wickwire.

Photographs of St. Aidan's Church appear in Donovan Clemson's *Old Wooden Buildings* and in *Early Indian Village Churches*, whose authors were unable to determine a date of construction or any other information about it.[1] The Pokhaist-Toketic congregation and the one at St. John at the Latin Gate Church, in Cornwall, have been part of the St. Alban's congregation since the 1970s.[2]

Hilltop Gardens is the biggest of the surviving fruit stands along the Thompson River, across from Toketic several kilometres north of Spences Bridge on the Trans Canada Highway. The quality of the produce sold there is indicative of the summer sun's heat in the Thompson Canyon and the plentiful water from the river. Most of the other fruit stands in the vicinity, such as the one attached to the orchard illustrated on page 9, have closed, in part due to the decline of tourist traffic through the area since the opening of the Coquihalla Highway in 1986.

The house on the property is somewhat run down but despite a covering of grey stucco still reveals its nineteenth-century lineage in a wraparound porch with carved brackets and an interesting stick-built sunburst in the main gable. It is very historic, situated on an 1873 preemption by Pierre Morens: Lot 22, visible on the map on the previous page, surveyed the same year by Edgar Dewdney. In 1880, surveyor John Jane staked out Lot 379, on the bench immediately below the highway (at that time the Cariboo Road) for Morens, at which time he noted the house.[3] It is unquestionably one of the oldest buildings in this part of the Interior. The Morenses were related to the Guichons,[4] whose cattle empire included vast grasslands around Quilchena near Merritt, through Morens's marriage to Françoise Rey in Victoria in 1878 – apparently both were from the Savoie.

In 1904, Morens's daughter Leonie Josephine married widower James Teit, a Shetlander of Norse ancestry who had come to Spences Bridge in 1884. Teit had left Liverpool bound for New York that February, accompanying John and Jessie Ann Smith. Teit was heading to Spences Bridge to work on the estate of his uncle, John Murray, which John Smith managed.[5] Teit married Antko, a 25-year-old Native woman from the Nlaka'pamux Nation, in 1892;[6] they were childless, and she died, apparently of pneumonia or tuberculosis, in 1899.[7] During the time of this marriage, Teit began his life's work as an ethnographer, encouraged by Franz Boas, the New York-based anthropologist who travelled through the area in 1894 and urged him to record the oral traditions, language and mythology of the local people. Later in his career, Teit travelled through the Dene and Kootenay areas, making a significant contribution toward preserving the Aboriginal world view for posterity. In addition, he became an activist for Native rights and organized the First Nations into an association.[8] Many of his studies were published

posthumously. He is commemorated in a National Historic Site plaque at the Five Nations Campground in Spences Bridge; regrettably, neither the plaque nor the background research paper make the connection to the Smith or Morens families, this house or "Widow Smith's" in Spences Bridge.

John and Jessie Ann Smith bought the estate of Teit's uncle, John Murray, in 1896, following the latter's death.[9] Murray's Morton House, a local hotel, was managed by Archibald Clemes, one of the first fruit growers in the Thompson Canyon who went on to own much of Spences Bridge (and, incidentally, built the first Pantages Theatre in Vancouver, still extant on East Hastings Street west of Main). John Smith himself died in April 1905, from the consequences of a prospecting accident and overwork, leaving "Widow Smith" in charge of their extensive orchards. She and the orchards became internationally famous for their Grimes Golden apples, winning gold medals in 1909 and 1910 at Royal Horticultural Society exhibitions in London and, apparently, attracting the attention of King Edward VII.[10] Mrs. Smith's advice on fruit growing in the desert was much sought after, including by proponents of the Walhachin scheme. She was able to convince the Canadian Northern Pacific Railway to move its main line, which would have bisected her orchards (regardless now bisected by the Trans Canada Highway), although the new route necessitated the demolition of Morton House. In 1910-1 Widow Smith built a new house, on the site of John Murray's original cottage (where Teit had stayed); it survives today in good condition next to the Chief Whistemnitsa Community Complex. She died on February 7, 1946, in her 93rd year, her memoirs being published 43 years later by her descendants.

James and Josephine Teit had five children: Erik (1905), Inga (1907), Magnus (1909), Sigurd (1915) and Thor (1919), in addition to an unnamed infant. On the bench above the house, a small graveyard, overgrown with iris amidst the sagebrush, records the family saga: "Pierre Morens, died May 2, 1897, aged 64; Wife Françoise Rey, died December 7, 1915, aged 71; Baby boy Teit, died March 25, 1912; Inga Teit Perkin, born here, 1907-1993; Pauline Morens, born here, 1883-1919; Teit Erik Leon, born here, 1905-1977; Leon F.A. Morens, born here, 1879-1939."[11]

James Teit himself died after a lengthy illness due to a bladder infection, aged only 58, in 1922; his widow Josephine, supported in part by a pension established by her late husband's colleagues, survived until 1948.[12]

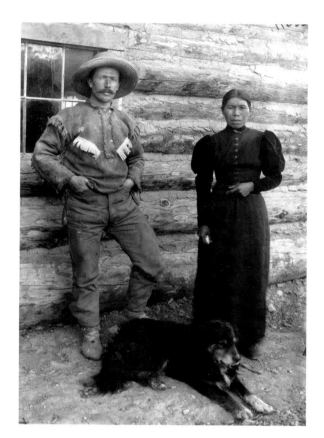

ABOVE *James and Antko Teit, photographed by Harlan Smith in 1897 when Franz Boas and Livingston Farrand launched the first phase of the Jesup North Pacific Expedition, at Teit's cabin in the Twaal Valley behind the Morenses' property.*[13] AMERICAN MUSEUM OF NATURAL HISTORY 11686

BELOW *James Teit at the time of his marriage to Leonie Josephine Morens, photographed at an unknown studio in Vancouver in 1904.*

WENDY WICKWIRE VIA SIGURD TEIT

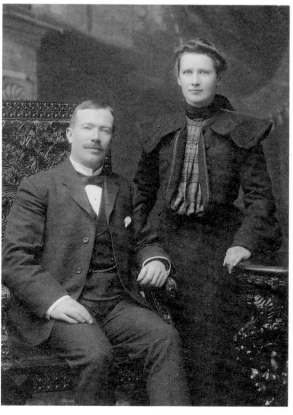

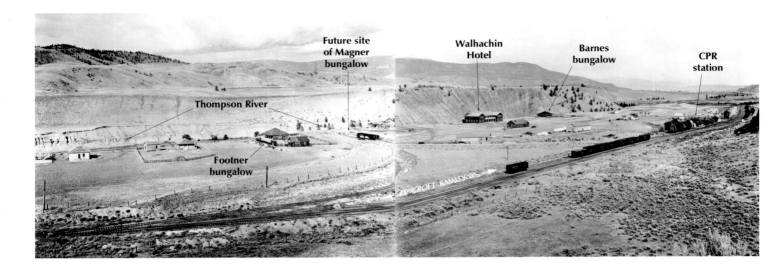

Future site of Magner bungalow

Thompson River

Walhachin Hotel

Barnes bungalow

CPR station

Footner bungalow

ASHCROFT · KAMLOOPS

Walhachin

ABOVE *Walhachin in 1910, adjoining images by an unknown photographer. The Walhachin Hotel and the CPR station are long since demolished. Charles Barnes was an American surveyor who was manager of the British Columbia Horticultural Estates Company (BCHEC) – his house still exists.*

BC ARCHIVES D-8175 AND D-8176

BELOW *The house at Magner and Riverview Drive, a classic bungalow with a pyramid roof and wraparound porch. The third chimney for a fireplace in what was obviously a recreation or billiards room indicates the house's original owners were different folk from typical BC settlers. The house stands on the edge of the village, looking out onto what is now a verdant alfalfa field.*[2]

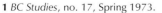

The saga of Walhachin is one of the most compelling and enduring in the history of settlement in BC. The story has oft been told: a colonization company based in London attracted English aristocracy, in this case the marquis of Anglesey, to anchor a new community that was successfully marketed to well-born Englishmen, many of them remittance men and their families. They worked hard and were initially successful at that "most gentlemanly of occupations" – orcharding – and played hard at pursuits including fox hunting, using local coyotes as stand-ins. For a generation, the story had only a romantic ending, exemplified in the breathless prose of the government of BC stop-of-interest sign from the late 1950s, which still exists at a viewpoint on the side of the Trans Canada Highway: "Ghost of Walhachin: Here bloomed a 'Garden of Eden'! The sagebrush desert changed to orchards due to the imagination and industry of English settlers during 1907-14. Then the men left to fight – and die – for King and Country. A storm ripped out the vital irrigation flume. Now only ghosts of flume, trees and homes remain to mock the once-thriving settlement."

The real story emerged in a master's thesis by Nelson Riis, "The Walhachin Myth: A Study in Settlement Abandonment."[1] He demonstrated that a number of factors, most notably the poor choice of a site for the colony and fatal flaws in the design and construction of the irrigation system, doomed it to failure. For example, subsequent soil studies by the provincial government confirmed that only 160 acres of the site had soil suitable for fruit trees or vegetables. The upheaval of

1 *BC Studies*, no. 17, Spring 1973.
2 Current owners Dave and Arlene Taylor showed me the interior.

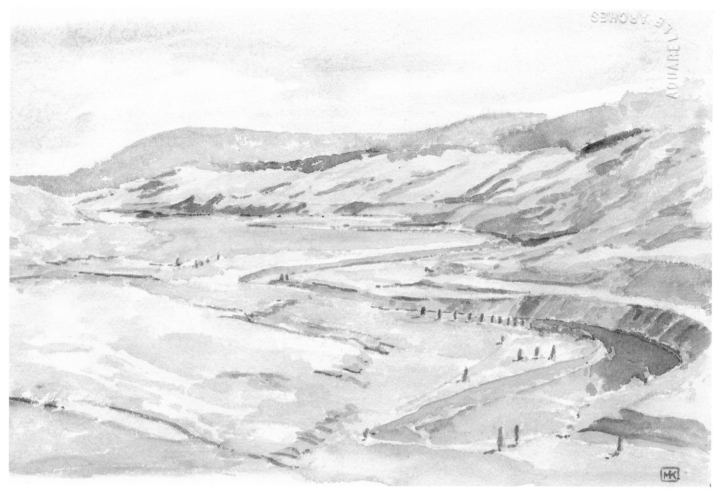

the First World War, during which many Walhachin settlers served in British regiments and indeed perished, was only the straw that broke the proverbial camel's back. The prewar depression also contributed to the colony's demise. Riis's story was retold with additional information in *Walhachin: Catastrophe or Camelot?*, by Joan Weir.[1]

Brochures for the venture, mainly distributed in England by the BCHEC's parent company, the British Columbia Development Association, advertised that settlers could purchase houses ready for occupancy upon their arrival; a four-room house, painted and with a bath, could be had for $1,100, with larger houses available at an extra cost of $125 per room. Orchard land itself cost a minimum of $3,000 for 10 acres of bare land, although it could be had planted for another $500.[2]

Befitting the venture's British roots, the promoters chose to build in the colonial bungalow idiom that had evolved from indigenous Indian architecture and become the standard country house in England's hot-climate colonies, especially Australia. A high hipped roof (sometimes built as a true pyramid) provided a natural insulator to keep the main-floor rooms cool. Windows were set to catch views and breezes. Porches, sometimes open and wrapping around the house, other times screened, provided extra heat shelter.[3] An itinerant engineer was hired to design and build them.

Bert Footner was born in England in 1880. He served in the Boer War, then stayed on in Africa where, according to his son, he built railways in the Sudan. Around 1908 or 1909, he became engaged to Norah Edith Briden, a

The panoramic view from the Trans Canada Highway to Walhachin, across the arid, sagebrush-studded landscape of the Thompson River. Walhachin sits in the left distance, on a small bench in front of what appear to be two pyramids — in fact, the remnants of a single hillside, the centre of which has been mined out for gravel. Modern pumps have no trouble supplying water to irrigate the alfalfa field occupying the former orchard land that was the community's raison d'etre. I painted it late on a September afternoon, with the low sun shading the hillsides into soft hollows.

1 Hancock House, 1984.
2 Weir, p. 16.
3 The standard work on the subject is Anthony King, *The Bungalow: The Production of a Global Culture.* Guisachan House in Kelowna is the purest example of the style in Canada (page 68).

The Footner bungalow as it appeared before renovations a generation ago. The front porch was screened, as was the sleeping porch above. The upstairs dormer had a hipped roof, now changed to a gable; the roof itself was covered in cedar shakes – there is now a separate rafter system with metal roofing over it.[5] The X board detailing on the dormer, which has since been removed, appeared in a poor-quality photo of the house from 1976.[6]

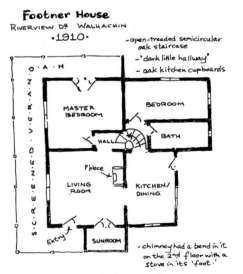

Footner House
RIVERVIEW DR WALHACHIN
·1910·

- open-treaded semicircular oak staircase
- "dark little hallway"
- oak kitchen cupboards

- chimney had a bend in it on the 2nd floor with a stove in its 'foot·'

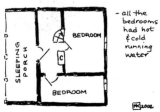

- all the bedrooms had hot & cold running water

woman the same age as he, who had grown up in comfortable circumstances. Her doctors apparently told Footner that she would not survive the African heat, so he set out for Canada in search of opportunities. He apparently lacked the qualifications necessary to practise as an engineer in Canada, but heard of Walhachin and moved west in 1909. Late in 1910, he returned to England to marry, and arrived back with his bride in December. They moved into his stone house, one of the first dozen buildings completed in the townsite. Soon after his return, he participated in a debate (arguing the affirmative) that women should get the vote.[1]

At least in his own house, which is the most imposing of the surviving buildings, Footner used the cavity-wall system – a double outside stone wall with an air space – that had been pioneered in Australian brick houses in the 1880s.[2] The rest of the Walhachin houses were probably simple platform-framed wooden structures. He also included up-to-date conveniences, especially hot and cold running water, in each house. His own home had sinks in every bedroom, but in the style of the time there was only one bathroom, on the main floor, with chamber pots doubtless still in use upstairs. Each house had carbide pressure lamps for lighting, probably on an internal gas system with pipes running through the house from a central acetylene generator.

He had 13 houses completed by Christmas 1910, with four nearing completion. New arrivals awaiting their finished houses lived in the Walhachin Hotel, built that spring.

During the First World War the Footners stayed at Walhachin; their children Mollie and Vern were born during those years. He had little tolerance for most of his neighbours – a mix of men who usually had failed or had behavioural problems in school, the military or the civil service, or had had legal or personal scandals and had been "encouraged" to manage their families' investments at Walhachin. Riis quoted him in 1969 stating that "Walhachin was a catch-all for rejects."[3]

With no construction work left, he leased property six miles west of Walhachin on the railway line, but failed as a farmer. Partly because his wife Norah disliked the quality of life in rural Canada, they moved on. He obtained work as a builder elsewhere in BC and in California, returned to Canada so the children could avoid an American education, and eventually settled in Victoria. Both lived on into their nineties, he dying in 1972 and she in 1976.[4]

There are still a few pieces of the old flume system visible on the hillsides, and a handful of old buildings in the townsite. The concrete swimming pool is all that survives of the Anglesey estate a few kilometres downstream from the village. Its post office closed for good on October 13, 2004, with the retirement of the postmaster.

1 Weir, p. 66.
2 J.M. Freeland, *Architecture in Australia*, p. 134.
3 Riis, p. 18.
4 Interview with Vern Footner, Victoria, 2002.
5 Gwen and Cliff Vossler provided me access to their house's interior. Thanks also to Val Carey for general Walhachin information.
6 Unpublished research document by Edward Gibson, written for the Canada Council, in the Heritage Branch library, Victoria.

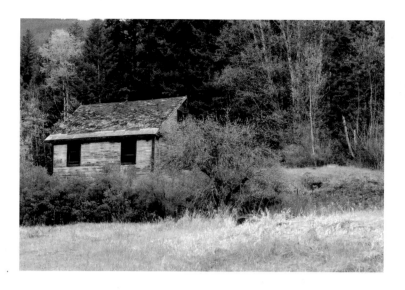

Calhoun Farm

Although there were no internment camps or officially sanctioned "self-sustaining villages" in the Shuswap, a number of Japanese-Canadian families exiled themselves into the valleys between Chase and Tappen for the duration of the Second World War. A few Japanese Canadians had settled before the war in the Silvery Beach area on the Shuswap River east of Chase, and Charlie Nakamura, an entrepreneurial man who had been living at Telegraph Cove at the northern end of Vancouver Island, moved to Salmon Arm just before the war and started a tie mill. But once the Pacific War started and the BC Security Commission rounded up all the coastal people of Japanese ancestry into Hastings Park, families scrambled to find a decent place where they could survive.

The frantic, uncertain quality of those times is well-captured in Joy Kogawa's autobiographical novel *Obasan*. It describes the options people were exploring, how they were desperately trying to obtain extensions to stay in their houses in Vancouver in order to arrange the rental of a property somewhere in the Interior. May 1: "The Commission put out a notice – everyone has to be ready for 24-hour notice ... We're trying to get into a farm or house around Salmon Arm or Chase or some other decent town in the Interior – anywhere that is decent and will let us in." May 4: "There's another prospect. McGillivray Falls, twenty miles from Lillooet. Going there would eat up our savings since that's all we'd have to live on but at least it's close to Vancouver and just a few hours to get back."[1]

Salmon Arm's populace was no more tolerant or welcoming than those elsewhere. At one town meeting, it was reported that "30 Japanese are now living in the community having moved from the coast district," and participants demanded there be no business licences, a curfew, no subleases, and "no more Japs."[2] Nevertheless, some families managed to rent old farmhouses; Mieko Kawase's, for example, rented a big white two-storey place called the Sanderson house. All of them have apparently been demolished, fallen victim to the passing of the decades since the war years, and there appears to be no one surviving who can recall clearly which houses were rented by whom.

ABOVE *The Calhoun farmhouse, since demolished, as it was in 1995.* SIAN UPTON
BELOW *The Japanese-Canadian community on the Calhoun farm near Carlin in the 1940s.*

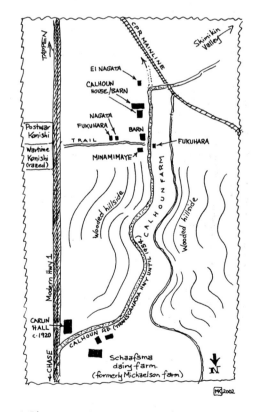

1 *Obasan*, pp. 102-4.
2 "Salmon Arm Asks Japanese Removal," *Province*, March 31, 1942.

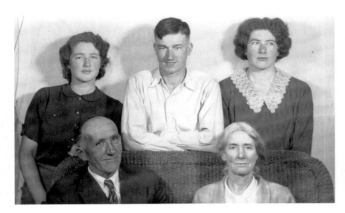

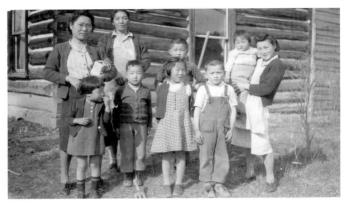

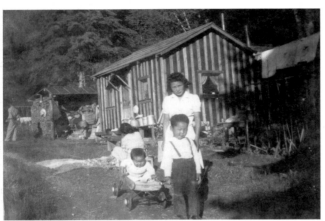

TOP LEFT *The Calhoun family, about 1940. Henry and Hilda seated; their children Alice, Harold and Joyce standing.* ABOVE *Fumiko Fukuhara with two of her children on the Calhoun farm, c. 1943. Photograph by George Fukuhara.*
KATHY UPTON

TOP RIGHT *The Konishis in front of the log cabin they rented from 1943-6, photographed by Kumajiro Konishi. Back, left to right: Mrs. E. Hayashi, Mrs. Chiyoko Konishi, Fiko Konishi, Mrs. Fumiko Fukuhara with her daughter Kathy. Front: Mie-chan Hayashi, David Fukuhara, Haruyo Hayashi and Jenji Konishi.*
KATHY UPTON

A long-surviving enclave was the cabins of a group of families, most related by marriage to the Nagata family of Mayne Island, who settled in the immediate vicinity of the Calhoun farm along what was the Trans Canada Highway (now Calhoun Road) within two kilometres of the Carlin Community Hall. The last of those cabins, and the Calhoun farm buildings themselves, were demolished in the 1990s. Indeed, there appears to be only one building, the cabin on the Konishi property on the Trans Canada Highway, that has survived since the internment time.

As described on pages 38-9 and 150-2, the Nagatas and Konishis, with two Fukuhara families related by marriage, banded together under the leadership of Kumazo Nagata (brother-in-law of Kumajiro Konishi) and obtained permission in June 1942 to head off by train from Vancouver to the Chase area. They were dropped off with all their possessions at the Squilax siding, near the Squilax General Store, a place where they could obtain offcuts for shelter building from a nearby sawmill. Kathy Fukuhara Upton, who was born at Skimikin later that year, recalls her parents saying there were 11 families on the train.

The Nagatas, Fukuharas, Hayashis, Konishis and Sumis all built tarpapered shacks in Skimikin Valley. "Those nights that the coyotes howled were nights to be remembered!" wrote Hatsue Konishi Yoshida. Early that summer, she recalled, they were in great demand as harvesters on the local farms; she described a family from Sorrento coming in a Model T to take them to work picking strawberries and raspberries. But as summer turned to fall and winter, and there was no employment, they were hungry and freezing. With his wife Fumiko having given birth to their second child, George Fukuhara set out on foot to visit every farm in the uplands between Squilax and Tappen, searching for work, and narrowly escaped permanent frostbite damage to his feet. Eventually, in a narrow valley along which the Trans Canada Highway ran between Carlin and Tappen, he found a farmer, Henry Calhoun, who was willing to help them.

Henry Calhoun's father had homesteaded the narrow, winding valley bottom – an old stream course – around 1895. By the 1930s, the Calhouns had a large wholesale vegetable operation, market gardening for nearby residents and growing produce for packing plants in the Okanagan and the Vernon army camp. His operation was apparently quite advanced for its time, with

machines for washing vegetables such as carrots; it was big enough that the Canadian Pacific Railway, whose main line crossed the end of the valley a few hundred metres from the Calhoun farmhouse, put in a siding where the vegetables could be easily loaded. By the winter of 1943, when he invited the Japanese families to disassemble their cabins and move them, using his wagon, to his property, his son Harold was taking over the operation of the farm. The Nagatas and Fukuharas clustered around a small barn just north of Calhoun's house, while nephew Ei Nagata and his wife lived further down the road. The Konishis rented a log house on the other side of the hill, connected to the others by a narrow path through the forest.

From 1943 until 1952 Hatsue Konishi worked on Calhoun's farm, while her younger sister Setsuko kept house for Henry and Hilda Calhoun during the summers. Kiyono and Kumazo Nagata stayed on in their cabin until about 1949, then moved into a new house they and son John built in Gleneden, where they lived until repatriating to Japan in 1953. John Nagata developed a sawmill of his own at White Lake, married Miyuki Yoshida of Chase and remained in Gleneden to raise his family. George and Fumiko Fukuhara moved to Grindrod after the war to work in the sawmill; later, he became the foreman at the Chase sawmill, renowned for his skill as a log scaler, then returned to the coast in the 1960s. As for the Calhouns, they continued

The Kumajiro Konishi cabin, on the Trans Canada Highway between Carlin and Tappen, looking west toward the Skimikin Valley in the fall of 2002. It is, I believe, the last of the buildings occupied by Japanese-Canadian families in the Shuswap area during the wartime and post-war years of internment and settlement restrictions.

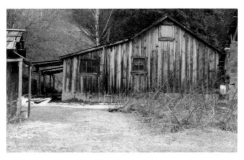

ABOVE *The Minamimaye cabin,*
the last wartime cabin to survive
on the Calhoun farm, in 1991.
ALLAN WILSON
BELOW *Minamimaye family*
portrait at the cabin in 1945.
Front, left to right: mother Sae,
grandmother Taru and father
Ryuichi. Back: children George
(Jogi), Rei, Jessie (Kimiye) and
Joe (Shoichi). GEORGE MINAMIMAYE

Sources: Correspondence and interviews
with Kathy Upton, Sian Reiko Upton, Fumiko
Fukuhara, Hatsue Yoshida, Fiko Konishi,
George Minamimaye, Ron Minami, Mieko
Kawase, Carol Schaafsma (who, with her
husband, has owned since the 1950s the
Mikkelson dairy farm at Calhoun Road and
the Trans Canada Highway), Dean Trenholme
(the farm north of the Schaafsmas), and lo-
cal historian Allan Wilson. A story about
George Fukuhara appeared in *A Town Called*
Chase, by Joyce Dunn, Theytus Books, 1986,
pp. 288-91. *Obasan*, by Joy Kogawa, was
published by Penguin in 1981. The Carlin
Community Hall has been moved across the
highway since I drew the map on page 135.

vegetable farming until at least the late 1950s, losing in 1954 the highway
traffic that used to go down their road when the alignment was straightened
to its current one directly from Carlin to Tappen. The other family on the
farm, the Minamimayes, arrived in 1944 and stayed there until returning to
Vancouver in 1950. Yoichi and Taru Minamimaye, long-time friends of the
Nagatas from Japan, before their immigration to Canada at the turn of the
20th century, were evacuated with a number of other families to Notch Hill,
near Tappen, in 1942, taking with them their granddaughter Rei. Their son
Ryuichi and the balance of his family spent 1942-4 on beet farms in Alberta
before obtaining permission to move to Notch Hill.

The Konishis came closest to repeating their Mayne Island experience.
From 1943 to 1946 they stayed in the log house east of Calhoun's, then moved
onto the next property south. Soon, they were growing 6½ acres of
strawberries and had built greenhouses for tomatoes. In the 1950s or early
1960s, they were able to build a modest modern bungalow, stucco above pink
horizontal board siding, in front of the cabin they occupied in 1947, which is
now home to their son Fiko. His cousin's granddaughter described it as "a
small, nondescript kind of house surrounded by trees and garden, but its
smallness and obscurity just underlines the Nikkei wish to blend in." Fiko
spent his career with Clearwater Timber Products, then retired about 10 years
ago to the family property. The greenhouses are long-since demolished. His
older sisters Hatsue and Setsuko live in Kamloops.

Sian Reiko Upton, daughter of Kathy Fukuhara, described visiting the last
two cabins with her grandmother and mother in 1996, shortly before they were
demolished. "Entering the cabins on a hot muggy day, my mother teared up,
while my grandmother chattered excitedly in Japanese about the various things
she found on the site: the old root cellar where she and Granny Nagata made
root beer and sake; pieces of old Vancouver *Sun* and Japanese newspapers
stuffed into cracks; the windows and nails which they'd brought on the train
from Vancouver. 'Remember this ... oh!' she cried at each find, and a story
would unfold. On the floor of the Minamimayes' house she picked up a piece
of cardboard and wood with the family name written in Japanese and English:
Minamimaye." After alluding to the reticence that hovered over Nikkei
families, an atmosphere well-captured in *Obasan*, she continues, "many old
Nikkei families remain close through informal support networks,
intermarriage, visits and so on – this was illustrated last year when my
grandfather died. I think this will end with my generation: we children of
Trudeau's multicultural society do not remember the difficulties of living in
wartime-postwar white Canada. We do not view life in terms of restrictions,
and tend to look outwards rather than inwards ... hence our globetrotting!"

One positive aspect of the story is how they all survived. The Nikkei,
according to Sian Reiko Upton, "were already experienced migrants. They
were peasants, too – hardy types. They did really extraordinarily well during
the war, something that portrayals of them as victims obscures – most kids
ended up with tertiary education, and a decent grounding in their own culture
and language. My Mum and I probably know more about making Japanese
food from scratch than most native Japanese today." Sian is an anthropologist;
her mother Kathy is a high school art teacher.

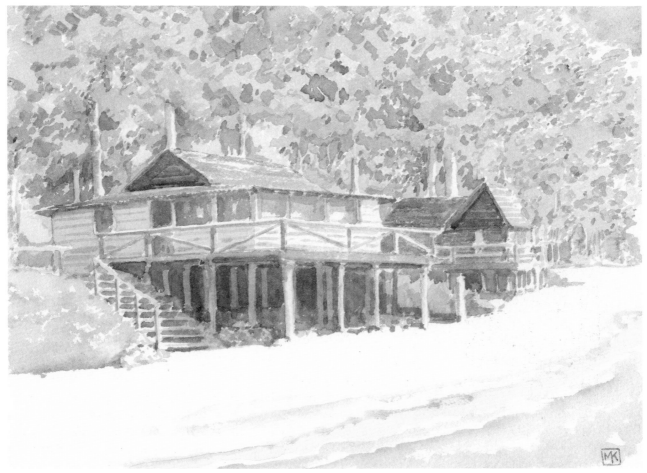

A different sort of cabin: two of the last surviving "originals" on Shuswap Lake, at Pierre's Point about 10 kilometres west of Salmon Arm on the Trans Canada Highway. In the 1950s and 1960s, there was a long row of cabins including these, nearly all of them on stilts, along the shoreline. In June, at the height of the spring melt, the cabins were often standing in a metre or more of water, but by the end of summer they stood on the edge of 100 metres of beach. No electricity, no running water, no worries – this was "cottaging" in an era when people had more leisure than money. In the 1950s, a family could buy a cabin on a piece of beautiful beach for $425 and retain it year after year for a leasing fee of $50, made possible by the compliance (oppression) of the local Indian band, whose land it stood on.

My family's cabin, which we had until I was 16, was just like one of these – and was the farthest one south on the beach.[1] It was boarded up by the early 1980s and burned soon after. When I went back in the fall of 2000, I found very few of the old places still standing and had difficulty orienting myself. In the 35 years since we left, trees had grown old and died, cabins had been demolished and replaced by new, plush year-round homes and, most significantly, a couple of years of freakishly high water had destroyed a number of places and altered the shoreline. And the band had taken control of their land, erecting new homes for themselves and a community building in the midst of the leasehold houses.

1 See "Shuswap Summers," *Cottage Magazine*, July/August 2000.

Tranquille is the old King Edward VII tuberculosis sanatorium on the north side of Kamloops Lake west of Kamloops. It is a fascinating collection of buildings, established about 1908 by the provincial government – the same McBride government, with Henry Esson Young as minister of health, that created the mental hospital Essondale, now known as Riverview, in Coquitlam. It was very much a self-contained agrarian community, with its own power-generating system, until recently. The dozens of buildings dotted around it are in the styles typical of government architecture from the 1910s through the 1950s. The sanatorium has been closed since 1985 and the property has been sold, as it is considered superfluous to the role of government in the twenty-first century; like that of Riverview, its fate is uncertain. In 2003, the owner was investigating resort-redevelopment options under the name Tranquille-on-the-Lake.

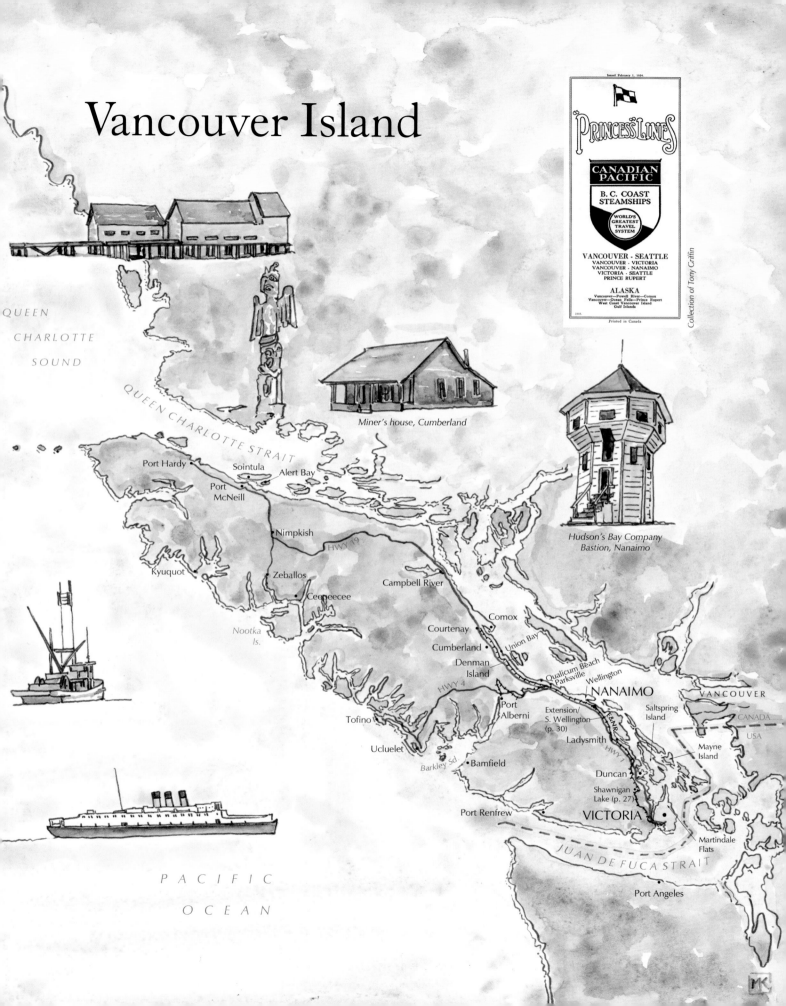

Vancouver Island

Issued February 1, 1934.

PRINCESS LINES

CANADIAN PACIFIC

B. C. COAST STEAMSHIPS

WORLD'S GREATEST TRAVEL SYSTEM

VANCOUVER - SEATTLE
VANCOUVER - VICTORIA
VANCOUVER - NANAIMO
VICTORIA - SEATTLE
PRINCE RUPERT

ALASKA

Vancouver—Powell River—Comox
Vancouver—Ocean Falls—Prince Rupert
West Coast Vancouver Island
Gulf Islands

Printed in Canada

Miner's house, Cumberland

Hudson's Bay Company
Bastion, Nanaimo

QUEEN
CHARLOTTE
SOUND

QUEEN CHARLOTTE STRAIT

Port Hardy

Sointula

Alert Bay

Port
McNeill

Nimpkish

HWY 19

Kyuquot

Zeballos

Ceepeecee

Campbell River

*Nootka
Is.*

Comox

Courtenay

Cumberland

Denman
Island

Union Bay

Qualicum Beach
Parksville

Wellington

NANAIMO

VANCOUVER

CANADA

USA

HWY 4

Port
Alberni

Extension/
S. Wellington
(p. 30)

E.&N.R.R.

Saltspring
Island

Tofino

Ladysmith

HWY 1

Mayne
Island

Ucluelet

Barkley Sd.

Bamfield

Duncan

Shawnigan
Lake (p. 27)

Port Renfrew

VICTORIA

Martindale
Flats

JUAN DE FUCA STRAIT

P A C I F I C

O C E A N

Port Angeles

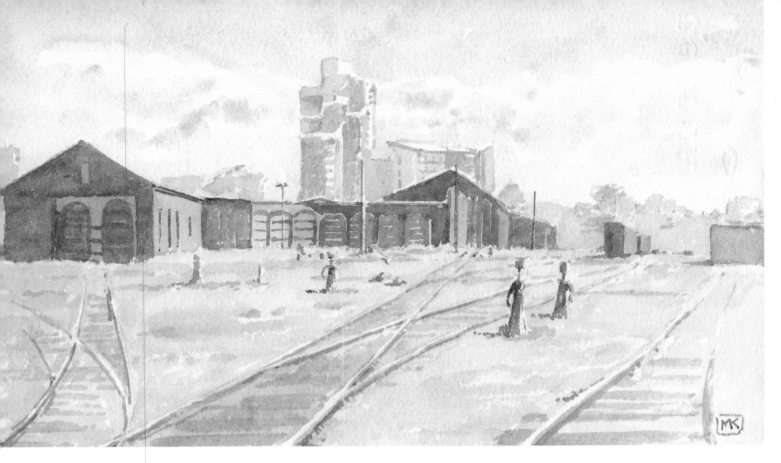

The E&N Railway

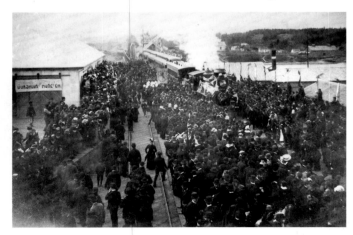

The inaccurately named Esquimalt & Nanaimo Railway connects Victoria with Courtenay and survives into the twenty-first century in a kind of time warp, with a VIA Rail Budd car providing a ghostly daily passenger service – the faintest possible echo of the dreams that brought the colony of British Columbia into confederation with Canada in 1871. The freight service on the line is now owned by RailAmerica, the world's largest short line and regional freight operator, headquartered in Florida.

Even after the passage of a century, the political and financial chicanery that created the E&NR leaves a bad taste in the mouth, dwarfing recent government scandals and making other railway deals of the era seem, in retrospect, to have been entirely in the public interest. The railway's promoters, coal magnate Robert Dunsmuir controlling a syndicate with, as minor partners, three of the famed "robber barons" from the Southern Pacific Railway – Charles Crocker, Leland Stanford and Collis Huntington – received a grant of $750,000 cash and about one-fifth of Vancouver Island (the southeastern corner, on a line roughly from Sooke through Port Alberni to Campbell River) from the provincial government headed by William Smithe. (The other "giveaway" of the time, of much of the site of Vancouver to the Canadian Pacific Railway, at least created a city marked by orderly planning, notably neighbourhoods on the west side such as Shaughnessy Heights.)

Even its completion was an afterthought: Sir John A. Macdonald had inveigled the voters of Esquimalt to choose him in a by-election in 1878 after he had lost in his own Kingston riding, had dutifully promised that Esquimalt would be the transcontinental railway terminus, had reneged soon thereafter, and then visited Vancouver Island in August 1886, on his only visit ever to BC, to drive the last spike of the E&NR soon after he had ridden a train into Port Moody from eastern Canada. The new line was indeed an orphan, for Vancouver, newly incorporated, was growing at an astonishing rate. But, for the E&NR's principal owner, the profitability of his coal mines was the only real issue, and when his son and successor James Dunsmuir added a ferry link between Ladysmith and the mainland he was able to interest the CPR in the railway's potential.

The CPR acquired the E&NR and its lands in 1905 and before the First World War expanded it north to Courtenay and west to Port Alberni. Nanaimo's docks and railyards became the hub of the Vancouver Island rail link with Vancouver's waterfronts, the CPR barges and ferries a familiar part of coastal traffic until the 1990s. In a handful of communities along the east side of the island, notably at Qualicum Beach, the passenger part of the railway still has a presence.

The E&NR roundhouse in Victoria West is one of the last historically significant structures in the region not to have been scooped into Victoria's net of benign heritage policies and relatively sympathetic owners. It sits in a rather derelict state on its overgrown railyard, on the edge of the disappointing cluster of condominiums and highrises developed in the 1980s on what was known as the Songhees Lands,[1] servicing only the VIA dayliner. Although the roundhouse is both a National Historic Site and a muncipally designated heritage structure, the CPR has shown little interest in restoring it as, for example, a community centre like the former round-house in Vancouver's Yaletown.[2]

The railway's original passenger terminus at the time of the driving of the last spike was at Russell's Station at Catherine Street and Esquimalt Road, just a block away from the roundhouse. The downtown Store Street station, completed following the erection of the first Johnson Street Bridge in 1887, survived until 1972 when it was demolished to improve automobile access to the bridge. The Janion Hotel, built next door to it in 1891, is one of the few empty hulks on the edge of Victoria's beautifully restored downtown.

The contrast between old industrial and modern residential Nanaimo: the railyards, with the weighscale operator's shack, located near the Esplanade. The splendid trees of Robins' Gardens (page 153) are directly across the Esplanade from this building.

1 Now known as the Lekwammen, the Songhees were a group of Natives who congregated near Fort Victoria from 1844 until they moved in 1911; see Kluckner, *Victoria the Way It Was*, pp. 28-9; Francis, *Encyclopedia of BC*, p. 407.
2 Correspondence from Steve Barber, Victoria heritage planner.

1 For example, "The CPR boobed when it attempted to cut off the lower part of Vancouver Island, wanting to funnel all travel through Nanaimo." James K. Nesbitt, "Capital Comment," *Vancouver Sun,* December 5, 1961, p. 6.
2 David Mitchell, *W.A.C.*, pp. 270-1; Kluckner, *Victoria the Way It Was*, pp. 78-9; Francis, *Encyclopedia of BC*, p. 58.
(Thanks to Stephanie Gould for background information on the Martindale Flats.)

A sketch of the Martindale Flats in Central Saanich, looking east toward the Strait of Georgia. Often it is sunny, but banks of clouds pushed to the east in the Fraser Valley block the view of Mount Baker. The flats between Martindale and Island View roads are the only really rural panorama of the Saanich Peninsula visible from the "Pat Bay highway." They are sandwiched between the ugliness creeping north from Victoria and south from Sidney, an algae bloom of suburbia traceable to the building of the highway connecting Victoria with the Swartz Bay ferry terminal.

The provincial government's decision of 1958 to enter the car-ferry business probably "saved" the southern end of Vancouver Island. In the 1950s, privately owned CPR and Black Ball ferries divided the island traffic between them, increasingly focusing on Nanaimo as the island's transportation centre. In the tourist doldrums of the 1950s both companies invested little money in southern BC routes, the CPR citing a steady decline of patronage on its Vancouver-Victoria steamship route.[1] A strike in the spring of 1958 by the Seafarers International Union and Merchant Service Guild prompted Premier W.A.C. Bennett to create the BC Ferry Corporation, initiating the era of modern tourism and travel in southwestern BC. Service began between Swartz Bay and Tsawwassen on June 9, 1960, with cars charged $5 one way, passengers $2.[2]

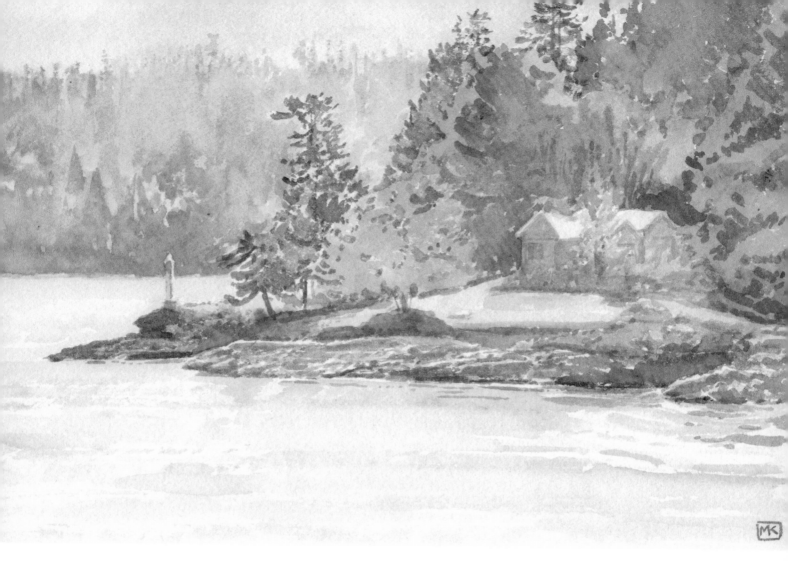

A characteristic Galiano Island cottage on a patch of well-tended, sunlit grass at Mary Anne Point in Active Pass – the route taken by the ferries connecting Tsawwassen with the Saanich Peninsula and Victoria. This is the Scoones house, built in stages beginning in 1885 by a carpenter named Cullison. It was initially owned by the Burrill brothers, before being bought by seaman Alec Scoones in 1897. The painter Betty Steward, who was a Scoones by birth, was born in the house. It has been added to many times over the years, but no addition has completely erased the historic character of the old place.[1] The Mary Anne Point light sits on the water at the end of the yard and is well-known to local boaters and passengers on the BC Ferries vessels travelling between the islands.

The southern Gulf Islands, including Galiano and Saltspring, loom large in the Canadian consciousness due to the numbers of writers and artists – people like humorist Arthur Black and painter-naturalist Robert Bateman on Saltspring, and novelist Jane Rule and bookseller Celia Duthie (who established a literary retreat) on Galiano – who have settled there, drawn by its gentle, relatively dry and sunny climate (certainly by Canadian standards). Denman and Hornby islands, being somewhat more remote, have a counter-cultural cachet but their reputation, like that of Savary Island, is more regional than national.

1 Thomas K. Ovanin, *Island Heritage Buildings,* p. 102.

Saltspring Island

. .

Like Mayne and Denman islands, Saltspring has a long, interesting agricultural history, supplemented in recent decades by the infrastructure of a regional service centre, including a hospital, making it the capital of the southern Gulf Islands. In spite of recent population growth and development, it is hanging on to its status as a refuge from the rat race.

The balancing act between property rights on the one hand and preservation of an island, or rural, way of life on the other has been an issue since the 1960s. Responding to the spate of development on the islands (12 major ones and more than 450 smaller ones) which lack the local governmental structure of incorporated communities, the provincial government under Premier Dave Barrett established the Islands Trust in 1974, the year after it established the Agricultural Land Reserve to manage and plan farmland throughout the province. Originally a planning agency, since 1990 the Trust has been an autonomous local government and has moderated the impact of change in what was formerly cottaging and farming country.

Increasingly, the big islands like Saltspring and Bowen attract year-round residents, who bring urban expectations of convenience and house size with them and often find them met by developers whose planned communities have the cookie-cutter look of Fraser Valley subdivisions, or by builders working from stock suburban house plans. When combined with the inevitable ministrations of traffic engineers, the result is wide roads, curbs, turning lanes, mercury-vapour streetlights and other forms of "management" that clash with the rustic character of the ideal island. Ganges, the main community on Saltspring Island, is rapidly losing its charm.

Perhaps only romantic painters care.

Because of such aesthetic preferences, I found myself drawn to the area around Fulford Harbour and the Burgoyne Valley, the locale of the Travellers' Rest. It is the most open and pastoral landscape on the entire Gulf Islands. The dramatic, rocky shorelines elsewhere provide picturesque building sites but make access difficult to the water itself, and reflect recreational or retirement habits that are not part of a "Vanishing British Columbia." Fulford Harbour, the village from which the ferry connects with Vancouver Island, is reminiscent of the Gulf Islands a generation ago, and a visit to it is a journey into the recent past. Little stores sell organic muffins and cups of herbal tea; colourful headbands and shawls abound, and rusty, beaten-up Volkswagen buses, many apparently with burnt exhaust valves or blown head gaskets, provide a noisy background chorus.

Until its demolition in 2003, the most important threatened building on Saltspring Island was the Travellers' Rest, the 1865 home of market gardener and innkeeper Joseph Akerman Sr. It was the oldest building on the Gulf Islands; there are only a handful of older buildings extant elsewhere in British Columbia. Built of hand-hewn squared timbers, the house was covered in shingles in the 1920s and was operated for many years as a store and as Travellers' Rest, the first inn on Saltspring Island. After a half century of ownership outside of the family, Akerman descendants repurchased the property in 1974. The official 1987 heritage inventory for the Gulf Islands noted that it was "presently unoccupied and becoming somewhat overgrown, but is still structurally sound and continues to have good potential for restoration."[1] Fifteen years later the house had become a pergola for an enormous tangle of blackberry bushes and ivies. Unfortunately, no collective will emerged to challenge the neglect; indeed, according to architect and long-time resident Jonathan Yardley, there appeared to be little official interest in island heritage at all.[2]

On a more positive note, one of the extraordinary sites on Saltspring Island, equal to the sort of historic tableaux preserved by National Trusts in

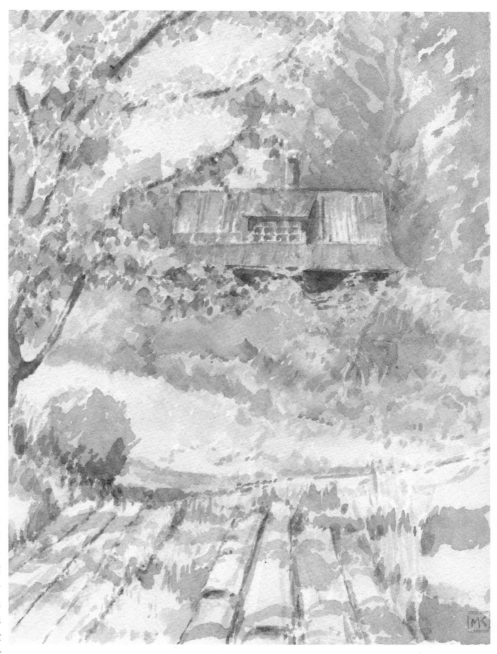

The Travellers' Rest, historic inn nonpareil, as it appeared in 2001. Rampant vines swarmed over its parts, and sections of its rusted metal roof were twisted and bent by winter windstorms. A log bridge crossed a rill, overhung by alder branches, just off the main road through the Burgoyne Valley that connects Fulford Harbour with Ganges.

1 Ovanin, *Island Heritage Buildings*, p. 78.
2 Interview, 2004.

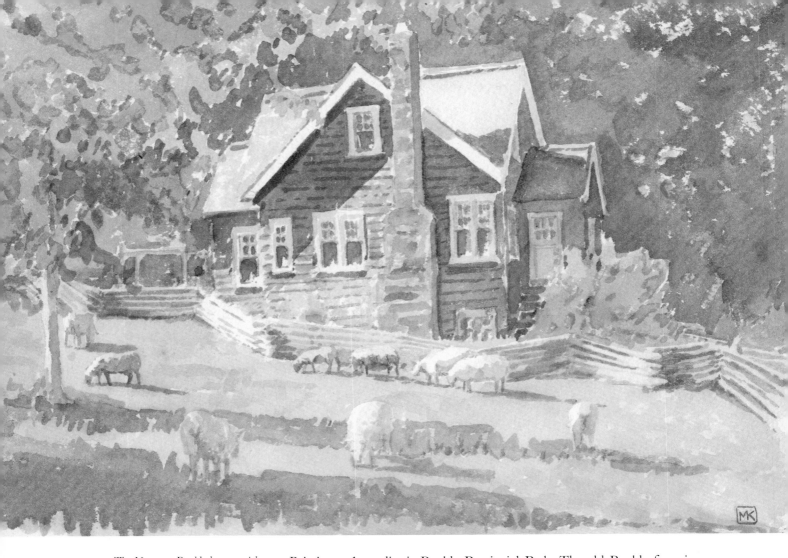

The Norman Ruckle house, with sheep grazing on the rich grass in an adjoining paddock, could be the essential Saltspring Island view (island lamb being acclaimed in BC's gourmet restaurants). The snake fence is adequate to contain livestock on an island that lacks predators like coyotes or cougars, but the arrival on the island of bored suburban dogs created a spate of sheep-killings that was much in the local news at the turn of the century.

Britain or Australia, is Ruckle Provincial Park. The old Ruckle farm is a combination of restoration, contemporary recreational access and working farm that is run by the BC Parks Service – not, ironically, by the BC Heritage Branch which, until "devolution" began in 2002, managed the provincially owned heritage sites in the province. Ruckle Park provides a window onto an idyllic Gulf Islands history: Henry Ruckle preempted his first 160-acre parcel at Beaver Point in 1872, the year after British Columbia confederated with Canada, and built his home about 1876. Other family members added their own homes to the property over the years. The entire Ruckle farm, then consisting of 1,196 acres, was bought by the provincial government in 1974 for the creation of Ruckle Provincial Park. The "tenancy for life" agreement, which allows members of the family to continue to live in their homes and work the land, is similar to the agreements by which the National Trust in England acquired country homes and created a large part of the modern British tourist industry. Alas, there are no similar agreements elsewhere.

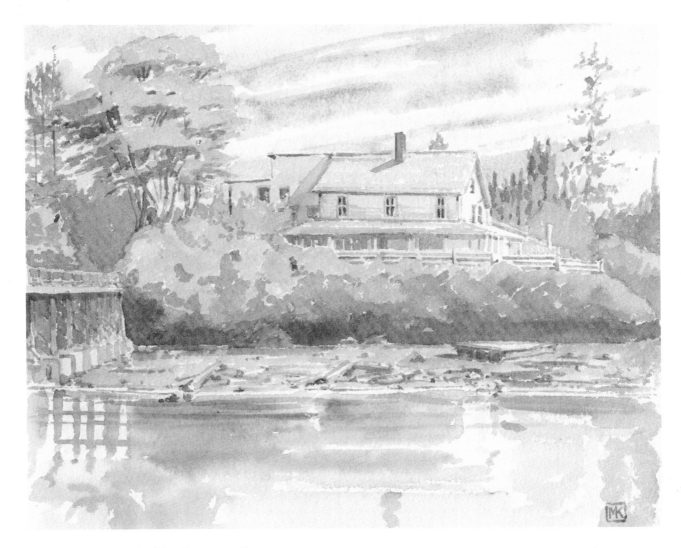

Mayne Island

Springwater Lodge at Miners Bay on Mayne Island still evokes a long-past era of tourists arriving by steamship. It stands at the foot of the Miners Bay wharf, with the village's business street extending beyond it and a large playing field-cum-picnic ground behind it. As many as 700 day trippers, often sponsored by Spencer's or Woodward's Department stores or by churches, would disembark here from the Canadian Pacific steamers – the *Charmer, Motor Princess* or *Princess Mary* – to spend Sundays picnicking, swimming and drinking tea on the hotel's verandah. Today, the Miners Bay wharf caters to recreational boaters, but the ferry docks a couple of kilometres to the west at Village Bay, disgorging a cargo of vehicles that disappear quickly o'er hill and dale to all points of the compass.

The original building, a one-and-a-half-storey house built in 1890 by Tom Collinson, still exists behind the false front. Collinson had a large family but was soon taking in boarders to supplement the family income, a practice continued until 1960 by later owners, all descendants of the original family. At that point it became known as Springwater Lodge. The proprietors kept costs down by provisioning the lodge's table from their own small farm, and developed such a good reputation that they were able to add indoor plumbing,

Springwater Lodge, one of the fine old buildings forming the village of Miners Bay on Mayne Island.

electric lights and a walk-in refrigerator together with a diesel generator to run them, in spite of the economic depression of the 1930s. In 1935 they charged $14.00 single or $12.50 double per week, meals included.[1]

Nearby is another historic building with a less venerable pedigree as an inn: the Mayne Mast Restaurant on Village Bay Road, a good place for a quick beer, its eccentric interior decor worth a visit before joining the ferry lineup. Its real history lies in its associations with the Japanese-Canadian community on the island before the Second World War.

The house dates from about 1910, erected by an unknown builder. Kumazo Nagata bought it in 1921 and enlarged it in 1937.[2] The Nagata family was one of a group of Japanese-Canadian tomato growers and fishermen on Mayne Island in the 1930s. Kumazo Nagata developed the Active Pass Growers Association after freight-rate increases had made poultry farming unprofitable, around 1930. He grew hothouse tomatoes in the Campbell Bay area and founded the cooperative which grew and packed "Island Brand Tomatoes and Cucumbers," a large firm once located on Georgina Point Road. The family was also heavily involved in the herring fishery, with salteries located on Mayne, North Pender and North Galiano. About half of Mayne Island's commerce was in the hands of Japanese-Canadian businesses, who constituted just one-third of the population. The CPR steamer *Princess Mary* carried about five tons of tomatoes from the island twice a week at the peak of the season.[5]

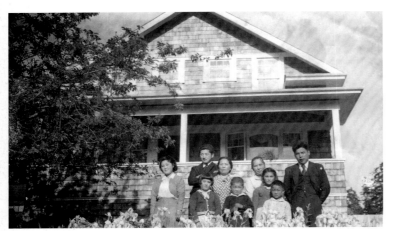

ABOVE *Members of the Mayne Island Japanese-Canadian community at the Kumazo Nagata house near Miners Bay, photographed by Kumajiro Konishi in the spring of 1942, just before the evacuation. The adults in the back row are Margaret, John and Kiyono Nagata, Grandma Sumi and Ei Nagata. The children in front are Masako Sumi, Fiko Konishi, Setsuko Konishi Iwasaki, and Tommy Sumi.[3]*

KATHY UPTON

RIGHT *The house is now the Mayne Mast Restaurant, located on Village Bay Road near the Mayne Street Mall. A 1930s photograph from John Nagata's collection[4] shows large greenhouses occupying the land on which the newer house sits. Sadly the Nagata house is in shabby condition, with tufts of grass growing enthusiastically in the gutters and on the deteriorated roof shingles.*

Along with all the other Japanese Canadians within 100 miles of the coast, the families were forced into Hastings Park, leaving on the *Princess Mary* on April 21, 1942. Kumazo Nagata wrote a letter to the community about his non-Japanese employees: "At this time may we convey to you our opinion that those already in employment now be permitted to remain so while possible for them, as we do not wish to have their source of income deprived from them while the greenhouses are being operated by our successors. These persons, though not Japanese, have been our assistants for many years." In 1943, the Soldiers' Settlement Board disposed of much of the Japanese-Canadian property at discounted rates; after the war, the white residents of Mayne Island resisted the resettlement of their former neighbours, and the agricultural community never re-established itself.[6] The Konishis restarted their business near Tappen (page 137).

The other Japanese-Canadian enclave on Mayne Island was at Horton Bay on the southern shore of the island. The surviving house there was built about 1920 for the Kadonaga family. Together with a number of other families they farmed in the area, concentrating in the 1920s on chickens but also becoming part of the Active Pass Growers Association and erecting greenhouses for growing tomatoes and cucumbers. In addition, the Kadonagas kept dairy cattle and shipped their cream to the Salt Spring Island Creamery. There was a sawmill nearby which made the lumber for packing crates.[7]

The Mayne Island pioneer was Gontarô Kadonaga, who left the village of Agarimichi (today part of Sakaiminato City) in western Japan in 1900. "The people from that region spoke a very distinct dialect of Japanese, which in the first decade or two of the last century naturally drew them together for mutual comfort and support in this new land," wrote Victor Kadonaga, whose paternal grandfather Kanematsu Kadonaga left Agarimichi the same year and probably settled near Horton Bay.[8]

The Horton Bay community's diaspora began on December 9, 1941, when the RCMP arrested the heads of several families. They were initially shipped off to detention in Petawawa, and then worked on a road-camp project at Schreiber in northern Ontario. Gontarô Kadonaga's first son Tôru and his family, including six children, worked on a sugar-beet farm in McGrath,

The Kadonaga house on Horton Bay, in the spring of 2003, seen from the Horton Bay dock. Horton Bay is well-protected from the southeasterly storm winds by Curlew Island. The house is further sheltered in a tiny cove, which looks out onto the main bay, where the breeze lays hand-shaped patterns of ripples onto the calm water.

1 Thomas K. Ovanin, *Island Heritage Buildings*, p. 107; and Marie Elliott, *Heritage West*, Summer 1983, p. 5.
2 Ovanin, p. 106.
3 Identification by Hatsue Konishi Yoshida.
4 Reproduced in Ovanin, p. 106.
5 Elliott, op. cit.
6 Marie Elliott, *B.C. Historical News*, Fall 1990, p. 16.
7 Ovanin, p. 115.
8 Correspondence, 2003.

For thousands of years Natives used Active Pass as an efficient route between the Fraser River fishing grounds and Vancouver Island, but the pass, with its seven-knot tides, defeated early explorers and navigators. The Georgina Shoals off the northeast coast of Mayne Island could also be treacherous, so a lighthouse with attached living quarters was built at Georgina Point in 1885. The current tower dates from 1969. Correspondence from Lynne Nagata: "My father used to polish the reflector in the lighthouse in the late 1920s, his weekend chore as a schoolboy."

1 Correspondence with Victor Kadonaga, Hamilton, 2003.

Alberta. Shintaro Sasaki (a nephew of Gontarô) and family spent the war years in Slocan, then opted to move east, first to Brampton and later to Toronto and Scarborough. The family of Kôji Saga went to a sugar-beet farm in Alberta, then also moved to Brampton and subsequently Toronto. After Yûzô Teramoto was reunited with his family, they moved to Huttonville, just west of Toronto, where three of his children still live. And the family of Toshikazu Koyama, like the Konishis and Nagatas, took the "self-supporting" option and went to the Kamloops-Shuswap area.[1]

Correspondence from Dennis Emmett, current owner of the property: "There were two large double greenhouses that were used for tomatoes. I have seen pictures showing the northern shore along Robson Channel bare of trees that had been used to fire the furnaces in the greenhouses to start the tomatoes early. We have found a few artifacts but there was very little remaining other than the buildings when my grandfather arrived in 1948. There is a gravesite on the hill to the left of the boathouse. Members of the Kadonaga family return to visit and tend the graves at least every couple of years ... The property has been in my family since 1948. My grandfather left it to his two daughters and it is presently owned by myself, four cousins and my mother. We are now into the fifth generation using the property."

An apparently final chapter of the island's reconciliation with its past came with the completion of a Japanese Memorial Garden at Dinner Bay, dedicated by the lieutenant governor in May 2002. It came in time that a number of the former residents, those old enough to recall their last journey on the *Princess Mary*, were able to attend.

Island Motoring

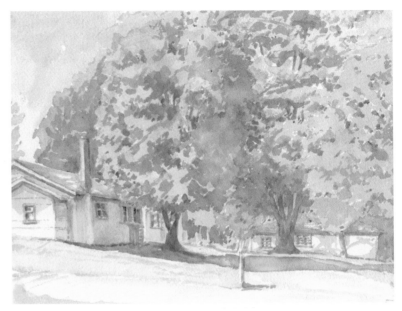

The towns of Vancouver Island's east side, from Victoria north through Duncan, Nanaimo, Parksville, Qualicum Beach, to Courtenay and Comox are linked by the Island Highway and dotted with tourist cottages and motels. Excellent beaches and summer sun bring families back year after year, partaking in that most democratic of vacations, the driving holiday, successor to the popularly priced railway excursions that took Victoria residents by the E&NR to Shawnigan Lake, and by BC Electric Railway Company interurbans to Deep Bay on the Saanich Peninsula. In 1911, early in the automobile era, the scenic 16-kilometre stretch of wagon road over the Malahat, between Goldstream Provincial Park and the Mill Bay area north of Victoria, was paved. No sooner had the automobile become reliable and popular than builders began to shape spaces for motorists.

A block of cottages arranged beneath some magnificent mature trees, the Evergreen Auto Court, the last of at least six auto courts built in Nanaimo in the 1930s, sits in an area of old working-class homes in Nanaimo's Southend Neighbourhood Area, across the street from the plaque on the site of the Number One Esplanade Mine. Workings extended far out beneath Nanaimo Harbour and yielded 18 million tons of coal, exacting a price that included the lives of 153 miners killed in an 1887 explosion. Yet, before 1900 this area was the upscale part of town and included many of Nanaimo's most elegant homes. The auto court block was known as Robins' Gardens, named for Samuel Robins, the Vancouver Coal Company mine superintendent from 1884 to 1903 and owner of the property. Robins was an avid gardener who collected plant specimens from around the world. His 18-room home and grounds, complete with gazebo, fishpond and rose garden, had disappeared by 1930, although several fine specimen trees remain.[1]

Union Bay, the rail port for the coal from Cumberland shipped by the Dunsmuirs' Union Colliery Company, survives today as a row of buildings along the waterfront, with the pilings and railbed of the long-vanished coal port stretching out into the bay. The Union Bay Historical Society bought and restored the 1912 post office in 1989, then moved the old jail and a church next to it. The roadside relic from the early era of motoring, in these times of Mr. Lube, Canadian Tire and Speedy Muffler, is the independently owned Union Bay Station.

ABOVE *The Evergreen Auto Court from Milton Street – the Esplanade and the railyards are to the right, Fry Street up the gentle hill to the left – in Nanaimo's Southend neighbourhood.*
BELOW *Union Bay Station, along the Old Island Highway.*

1 "Nanaimo's Southend Heritage Walk," Nanaimo Heritage Commission.

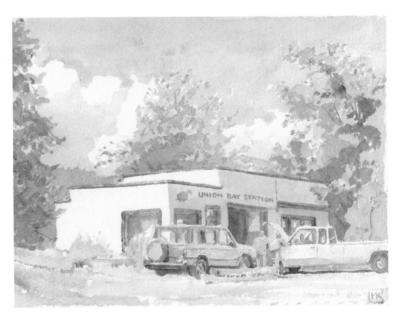

Qualicum Beach

Qualicum Beach has been a watering place for "old money" and has maintained its English seaside atmosphere for the better part of a century. It is not hard to see why – a beautiful beach, some fine buildings, a sense of history, and a convenient and compact town centre, with no invasion by the perfidious malls and big-box retailers that line the highways into Nanaimo. Examples of its early style included the Qualicum Beach Hotel, built in 1913 and since demolished, and the Qualicum College Inn (originally an English-style private school) on College Road, both by architect K.B. Spurgin;[1] and the James Lowery summer house at 320 East Crescent Road.[2] The British connection has continued with Milner Gardens, the estate of Ray Milner, a lawyer and philanthropist. His second wife Veronica, a relative of Sir Winston Churchill and Diana, the Princess of Wales, developed a notable garden and again brought royal visitors to the area, continuing the tradition of A.D. McRae's Eaglecrest estate nearby; since 1996, Milner Gardens has been operated by Malaspina University-College. Qualicum Beach is so popular with retirees that it has the highest proportion of senior citizens of any community in BC, with 35 percent of its population over 65 years of age.[3]

On a more modest scale, another British immigrant designed a number of homes in Qualicum Beach. Simon Mure Little (1877-1966), a naval architect from Lanark, Scotland, started work on the Clyde at 17, but while still a young man fell ill and endured a leg amputation. In 1913, seeking a different kind of life, he followed a brother to Hillier, on Vancouver Island, with the idea that poultry farming would better suit him. Soon, he moved to Qualicum Beach and, except for World War I service at the Burrard Shipyards in Vancouver, he remained there all his life.

In 1928 he started designing houses locally for friends and later branched out into schools, retail stores and churches, eventually building as far afield as Courtenay, Nanaimo, Port Alberni and Kitimat. But his main legacy is St. Andrew's Lodge and Glen Cottages along the beach, whose intrinsic charm is unmatched by any vacation place in British Columbia.

Two postcards of old inns at Qualicum Beach:
LEFT *The Log Cabin Inn was built in 1925 by Alec Fraser for General Noel Money, managing director of the golf club and the Qualicum Beach Hotel, allegedly so that his daughter could have a respectable place to dance. It has been demolished (photographer unknown).*
RIGHT *The Morgan Hotel, with rock gardens and views of the sea; a postcard by J. Fred Spalding of the Camera Products Company, Vancouver, c.1935.*

1 Jennifer Nell Barr, in Luxton, ed., *Building the West*, pp. 392-3.
2 Luxton, *Building the West*, p. 309.
3 Francis, *Encyclopedia of BC*, p. 585.

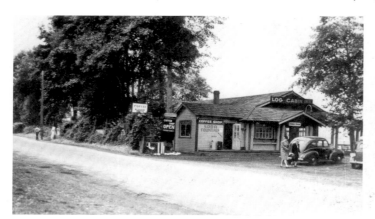

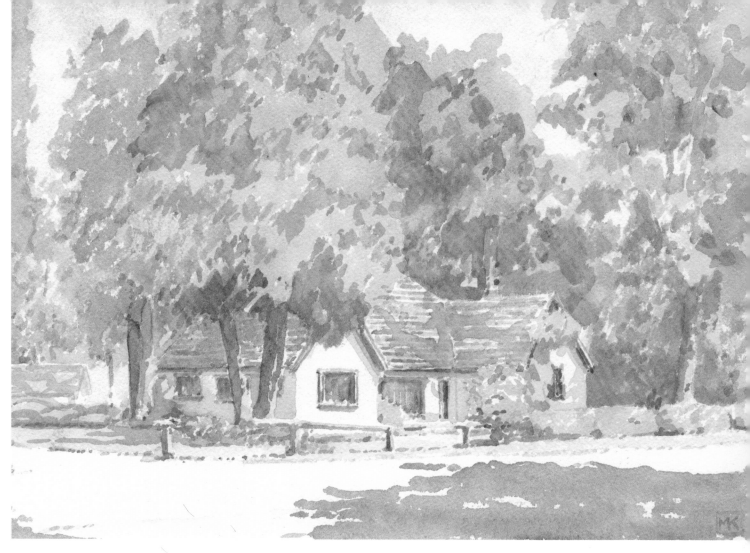

A plaque on the door of the lodge reads: "Opened August 1, 1938 by Simon, Dora, Robert & Elizabeth Little. Operated by Elizabeth Little, August 1, 1998." It retains the character of holidays a generation ago and the eccentricity of an English seaside boarding house, with small sleeping rooms and a common living area cluttered with the souvenirs of a lifetime. The cottages are similarly unpretentious, with few of the sybaritic trappings favoured by modern resorts. In August 2003, Elizabeth Little again welcomed North Vancouverites Bruce and Jeanne Box, who have stayed in the cottages every year since 1943, perhaps a record worthy of Guinness.[1]

ABOVE *St. Andrew's Lodge in the summer of 2002.*
BELOW LEFT *The Glen Cottages, between the lodge and the beach, around 1950 – a watercolour by artist Edward Goodall, a favourite on Vancouver Island who divided his time between Qualicum Beach and Victoria for many years. He published much of his work as postcards, and also rendered pencil illustrations for C.P. Lyons's 1958* Milestones on Vancouver Island.[2]
BELOW RIGHT *Edward Goodall, photographer unknown.*

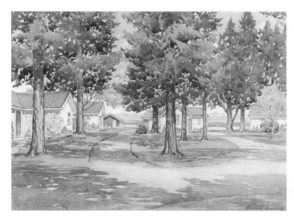

1 Interviews with Elizabeth Little and Bruce Box.
2 See footnote 4 on page 10.

Eaglecrest

. .

O f all the estates at fashionable Qualicum Beach, Eaglecrest was prob-
ably the most lavish, a sprawling model farm on beautiful meadows
above the Strait of Georgia, with a view toward islands and mountains reced-
ing into an infinity of pastel blue layers. The main house, designed in 1935 by
Vancouver architect C.B.K. Van Norman, followed the lead of an earlier
Qualicum Beach mansion – Major Lowery's summer house built of peeled
cedar logs in 1929-30 (*its* architect, W.F. Gardiner, designed the rustic
Alexandra Lodge, page 117, a few years earlier). The log vernacular style of
Eaglecrest continued in barns and other modest buildings, a few of which sur-
vive on the edge of the nearby golf course of the same name and at the inter-
esting servants' compound on the bluff above the shore nearby.

Eaglecrest was the country estate of Major General Alexander Duncan
McRae and his wife Blanche, who by the 1930s were tiring of their city home,
Hycroft, in Vancouver's Shaughnessy Heights. During the Second World
War, McRae turned the latter over to the Canadian government for use as an
annex to Shaughnessy Hospital; since 1962, it has been home to the
University Women's Club.

Such munificence, at least when it came to his country in wartime, was
typical of him. His primary business in his early days was land colonization on
the Canadian prairies, so profitable that he came to Vancouver in 1907 with an
enormous $9 million fortune. McRae served as quartermaster general for the

ABOVE *Alexander Duncan
McRae, usually referred to as
"General" in spite of becoming a
senator.*
WHO'S WHO AND WHY, 1921, P. 593
RIGHT *The main house on the
Eaglecrest estate at Qualicum
Beach, by an unknown BC
government photographer, 1948.*
BC ARCHIVES I-28382

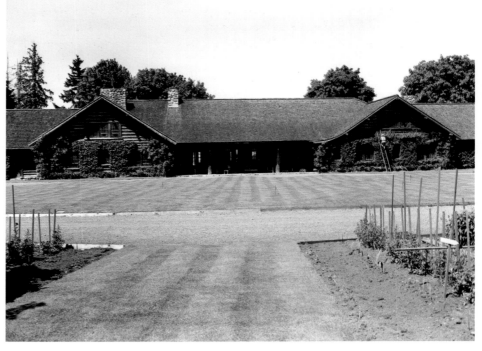

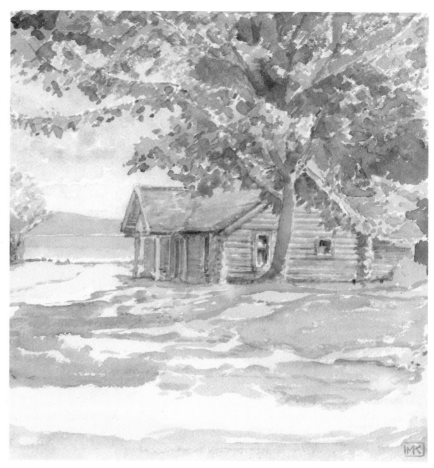

Canadian army during the First World War and had extensive interests in fishing and lumbering. His investments at Millside near New Westminster in 1909, in the wake of the 1907 anti-Oriental riots in Vancouver, led to the hiring of 150 Quebec workers and the creation of the community of Maillardville, now part of Coquitlam. He was also active in politics, including an abortive attempt in the mid-1920s to lead a conservative "reform" movement called the Provincial Party. He subsequently became a senator, a sinecure for his organizational role in R.B. Bennett's campaign to become prime minister, although he was only once successful himself at getting elected federally, for the Conservatives in 1926.

Under the direction of Qualicum contractor A.N. Fraser, workers cut all the cedar logs "within 10 days at the season when the pitch was going up the tree. This will prevent the logs from discolouring with age. Floors are of oak laid like deck-planking on a boat."[1]

The ceiling was a colossal 27'6" high; the fireplace could burn 7'6" logs. A boon to the depressed area, the project employed about 150 men for a year building and clearing, including a half mile of beach in front of the lodge. To stock the farm, the McRaes arranged while in England for the coronation in the summer of 1937 the purchase and shipping of 71 Dorset horn sheep, eight Lincolnshire Red cattle and four Yorkshire pigs.[2] Through the early 1940s, Vancouver newspaper articles dutifully recorded the farm's fine crop of spring lambs.

But their health failed them. Blanche died in her suite at the Hotel Vancouver in November 1942. The "General" remarried within the year to a Texas widow, but died himself in Ottawa in June 1946. That October, entertainer Bing Crosby was reportedly interested in paying $320,000 for the house and 320 acres.[3] However, the following month, realtor Leonard Boultbee bought the entire 3,700 acres, including its livestock, at the estate sale, then sold the cultivated property and woodlands the following summer to industrialist H.R. Macmillan.

Eaglecrest reopened in June 1948, as a very exclusive "holiday estate," under the watchful eye of hostess Mrs. Dallas Irvine, with accommodation for 22 guests; among the first were Mr. and Mrs. C.B.K. Van Norman. Its apotheosis occurred from October 16-9, 1951, when Princess Elizabeth, her husband the duke and entourage occupied the entire lodge. Five years later Eaglecrest was home to a more straitened version of royalty: Prince Vladimir Czetwertynski, the assistant manager.[4] A cinder on the cedar roof destroyed the lodge in the spring of 1969.[5]

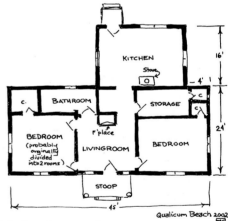

The Hornby, originally the gardener's cottage in the servants' compound at Eaglecrest.

1 *Vancouver Sun,* April 18, 1936.
2 *Sun,* July 27, 1937.
3 "Crosby Wants McRae Estate," *Sun,* October 7, 1946.
4 Edith McConnell Murray, "Eaglecrest Sits on Quiet Road, Restfully Elegant," *Sun,* September 22, 1956.
5 "Built-to-last Lodge Goes Up in Smoke," *Sun,* March 24, 1969.
Thanks to Diane MacKie, who lives in the Hornby and showed me inside.

Alert Bay & Sointula

The villages of Alert Bay and Sointula, on neighbouring Cormorant and Malcolm islands respectively, present an interesting visual contrast that reflects their history. Alert Bay is a company and government town: the agencies of the state, including the church, the residential school, the hospital and the Big Employer, are all arranged prominently along the shore, or at least were until the BC Packers plant (frontispiece) was demolished in 2003. There is also a fourth "state agency" – the 'Namgis, part of the Kwakwaka'wakw First Nation with its U'mista Cultural Centre and totem poles, including the tallest one in the world. On the hill behind the residential school is the Alert Bay Big House, a traditional post-and-beam structure with its planked facade painted in traditional Kwakwaka'wakw designs. By comparison, at democratic, proletarian Sointula, not even a church steeple punctuates the rooflines of the modest houses, and the largest building is the co-op store.

Cormorant Island is divided between the Village of Alert Bay, about 100 hectares in extent, and the Alert Bay Indian Reserve which occupies the balance. Its population is about 600. According to a Department of Fisheries and Oceans report, *Fishing for Direction*, Alert Bay ranked third among communities most affected by the fisheries collapse.[1] An informal survey indicated that business revenues had declined 60 percent since the mid-1990s.[2] In response, the village and the 'Namgis First Nation began collaboration through an Accord of Cooperation to develop mutually beneficial tourism initiatives based on history and Aboriginal culture, focused around the U'mista Cultural Centre, which celebrates the history of the potlatch. The summertime transit through the Inside Passage of cruise ships bound for Alaska offers a potentially profitable tourism source. At the time, the possibility of using the old cannery as a meeting/conference facility or a high-end fishing resort was also discussed.

By comparison, Sointula is trying to reinvent itself through low-key, resource-based initiatives such as the Malcolm Island Shellfish Cooperative, an enterprise that includes organic abalone farming, and the Wild Island Food Cooperative. Home to about 650 people, it was rated fourth among coastal communities affected by the fishing collapse, according to *Fishing for Direction*.

The BC Packers complex at Alert Bay was one of the last operating canneries in what had been in effect a company town.[3] The corporate predecessor to BC Packers began operation at Alert Bay in 1881, 11 years after the first store and saltery were established there. The complex was completed by the Second World War years. The cannery

ABOVE *Detail from a 1925 provincial government Ministry of Lands and Forests map. Port McNeill, the modern administrative centre and ferry base for the islands, was not established until 1937.*

BELOW *The Alert Bay waterfront about 1900, photographer unknown. Nothing of this scene except the church survives, and the modern Native houses are standard Department of Indian Affairs bungalows.*

BC ARCHIVES E-07873

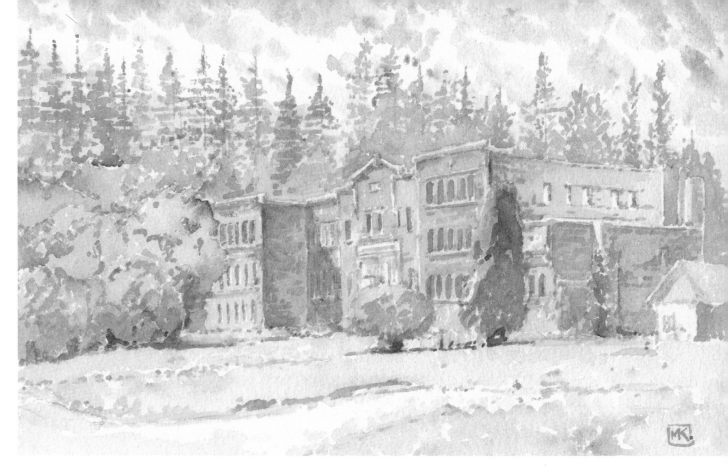

"St. Mike's," the Anglican residential school at Alert Bay now called 'Namgis House. It is much as it was when built in 1929, except that the large wooden portico is gone from the front facade.

store also served as the post office after 1890, helping to establish consistent government services in the remote town.

The first cannery in BC opened for business in 1870 in Annieville, on the south arm of the Fraser River downstream from New Westminster. Soon, with the wide acceptance of tinned salmon and increasing international trade, canneries spread up and down the coast, with entrepreneurs such as Henry O. Bell-Irving, R.V. Winch, Henry Doyle and Robert Tatlow quickly making fortunes leveraging English and American capital. Although in the early days canneries bought from independent fishermen, they soon developed their own fishing fleets. This tendency toward corporate concentration is exemplified by the story of BC Packers. As technology, notably refrigeration and automation, improved and boats became larger and more reliable, canneries also grew and became the economic linchpins of coastal towns such as Alert Bay. Until 1911 sockeye was the only species used for canning; subsequently, almost every species of salmon was accepted by canneries at one time or another. Even dogfish, whose liver oil became an important product especially during the Second World War, was processed.

Another advantage at Alert Bay was the proximity of a large workforce of Native women. Chinese men were also popular as cannery workers (there being very few Chinese women in BC before the Second World War, due to head taxes and exclusionary legislation). The canning season was typically June through September, and workers were paid for piecework. Significant technological improvements that reduced the need for labourers included prefabricated cans and the Smith Butchering Machine, introduced to canneries in the first decade of the twentieth century, which bore the extraordinary nickname Iron Chink.

1 G.S. Gislason & Associates Ltd., *Fishing for Direction: Transition Support for BC Fishermen and Their Communities.* Prepared for DFO, September 1998.
2 "The Barometer, Economic and Labour Market Review," May 2000, p. 3.
3 Surviving cannery museums elsewhere in BC are the North Pacific Cannery at Port Edward, south of Prince Rupert, and the Gulf of Georgia Cannery museum at Steveston on the south arm of the Fraser River.

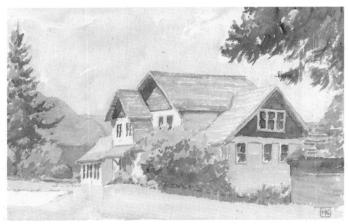

ABOVE *The nurses' residence at St. George's Hospital, Alert Bay, in the summer of 2002. It was still boarded up and empty in 2004. The two-storey part was built in 1925 while the lower structure beyond was added in 1941.*

BELOW *The Anderson boathouse at Sointula, originally used for shipbuilding and currently used for ship repair. The Anderson family still operates it.*

The corporate successor to BC Packers, owned by Toronto conglomerate George Weston Foods Ltd., pulled out of Alert Bay, as it did from Steveston in the Lower Mainland, leaving the buildings empty; it floated a number of proposals to redevelop the site, optionally including the buildings, as a fishing resort or a conference centre. By the summer of 2002, however, Alert Bay Council was tiring of dealing with the company, stating that "we are no longer interested in saving the building as B.C. Packers has failed to provide or be responsible for the clean up. B.C. Packers hired environmental engineers but refused to disclose the report. We would like them to tear it down and do proper reparation."[1]

In February 2003, businessman Colin Ritchie threatened to chain himself to the cannery to stop the demolition of 30,000 square feet of "perfectly usable space." Mayor Gilbert Popovich argued that "insurance, taxes and upkeep of the buildings would cost $50,000 annually," and Chief Bill Cranmer faulted the provincial government. " 'After the current government was elected, all plans were put on hold,' recalls Cranmer. 'BC Packers wanted a decision made.' "[2] The reduction of support for heritage business revitalizations, which began in the early 1990s with the NDP government, continued into the twenty-first century.

One of the other Alert Bay landmarks, "St. Mike's" residential school, fared better. Built in 1929, it was one of a large number of residential schools in British Columbia (indeed, across western Canada) intended by the federal government and the churches to provide Native children with a basic education as well as a complete reprogramming from their parents' culture. Many of the residential schools were run by the Roman Catholic Church, while others, including this one, were Anglican. Its style of architecture, brick colour and size cause it still to dominate the town – it almost jumps off the landscape. It is set away from the commercial heart of the town, the part of the waterfront with ferry wharf, the fish-packing plant site, town hall and hospital, and until its closure in the early 1970s was more or less self-contained, with gardens, a dairy and an electrical generating plant.

Late in February 2003, just as crews were preparing to start the demolition of the fish-packing plant, a group of dignitaries, including Lieutenant Governor Iona Campagnolo, Bishop Barry Jenks from the Anglican Diocese of Victoria and Mayor Gilbert Popovich joined with Chief Bill Cranmer and Kwakwaka'wakw elders to perform a cleansing ceremony of the old residential school, which they renamed 'Namgis House. The intention is that the refurbished building house the Kwakiutl Territorial Fisheries Commission, the Musgamagw Tsawataineuk Tribal Council, a language centre, a carving shop and possibly a permanent exhibit to honour and respect the people who attended the school.[3]

In a further transfer of Alert Bay's governmental infrastructure away from the old non-Native town, the new Cormorant Island Health Centre

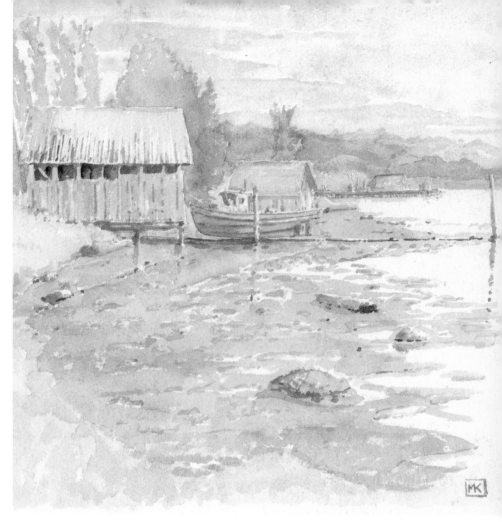

opened next to "St. Mike's" and the old St. George's Hospital was closed down. In what was primarily an Anglican town, the first St. George's Hospital opened in 1909 and burned down in 1923. The hospital buildings still extant in the summer of 2002 were low flat-roofed structures with horizontal board siding and large multipaned wooden windows – a style reflecting their parentage as an RCAF hospital from the Second World War, originally located in Port Hardy and floated over.[4] From the water, the hospital buildings were concealed behind the nurses' residence.

Sointula, meaning "harmony" in Finnish, is the town on Malcolm Island. About 2,000 people were attracted there at the turn of the twentieth century, inspired by the writings of socialist utopian Matti Kurikka to seek an alternative to the exploitive employment conditions many had found in industrial settings like the Wellington coal mines near Nanaimo. The provincial government granted the island to the Finns' Kalevan Kansa Colonization Company. The more practical members of the colony's leadership quickly clashed with Kurikka, and by 1905, three years after the bulk of the population arrived, the socialist experiment effectively ended.[5]

As a profoundly atheistic, socialist colony Sointula makes an interesting contrast with the profoundly *religious*, socialist Doukhobor villages of the Christian Community of Universal Brotherhood (pages 82-8). Both had charismatic leaders, and internal dissension broke them apart even before changing social attitudes could do it.

In spite of the collapse of the fishing industry, the waterfront is still dominated by working rather than pleasure boats. Toward the east end of the island, near Mitchell Bay, the forest has been pushed back behind a more settled rural landscape, with some fine new houses built to attract summer tourists and urban refugees. But it is still very much a working island, with small logging operations such as the one at Mitchell Bay (page 213) continuing the "improvements" begun by the Finnish colonists a century ago. The portion of the 1925 BC government map reproduced on page 158 implies that sheep raising might offer gainful employment.

One of the last authentic, unaltered Finnish settlers' cottages on Malcolm Island stands at 175 Kaleva Road not far from the community of Sointula. The swag of fishing floats between the fenceposts attests to owner Victor Wirkki's

Rough Bay, Sointula, with the tide going out on a summer evening and the mountains of Vancouver Island in the distance – a picturesque, quintessentially west-coast scene of boat sheds, small gillnetters, wharves and shanties in muted colours softened by moss and rain.

1 Minutes of the Council of the Village of Alert Bay, July 23, 2002.
2 Chrissy Johnny, *North Island Gazette*, Port Hardy, February 5, 2003 (Mark Allan, publisher and editor).
3 Chrissy Johnny, *North Island Gazette*, February 28, 2003. In a later story, published March 12, former students described abuse and hunger they experienced at the school.
4 Insight Consultants, *North Island Heritage Inventory and Evaluation*, 1984.
5 The standard work is Paula Wild, *Sointula: Island Utopia*.

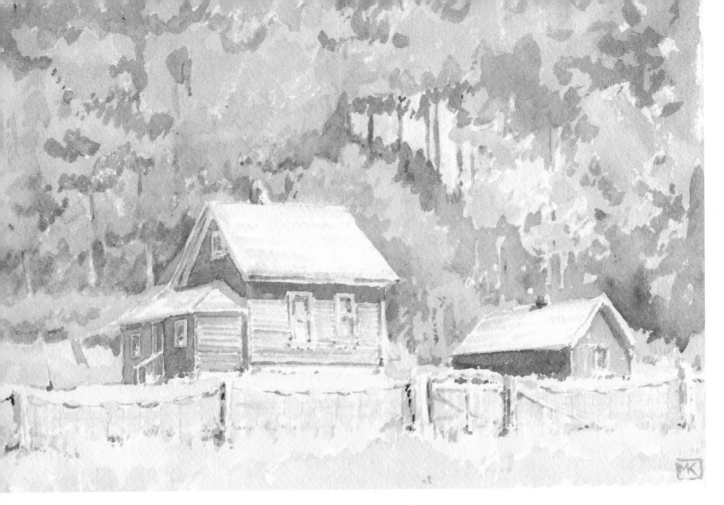

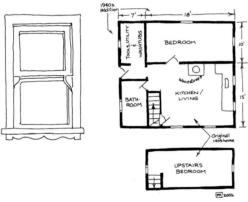

The Aho cottage, across the road from a flat shingle beach on Malcolm Island.

1 Wild, p. 206. Correspondents Tom Roper and Marnie Crowe of the Sointula Museum suggest there may have been another Aho on the island in the early years, but Antti Aho is the only person of that surname in the Sointula cemetery.
2 Interview, August 2002.

life-long occupation. Born a quarter mile away in a log home, he spent about 45 years on "the boats," mostly in small gillnetters, later on seiners.

Wirkki bought the cottage from Andy Aho in 1943 and added to it, as shown on the floor plans I drew in the summer of 2002. "Andy" Aho was probably Antti K. Aho (1864-1945) who appears as "Andrew Aho" on the board of directors for the Kalevan Kansa Colonization Company at Sointula in June 1902.[1] In Aho's day the place was "just like a little farm" – Aho had cleared the land, much of which has grown back since, and kept an ox and a cow whose calf he used for meat. At age 82, Victor Wirkki claimed his longevity was due to his never having married. "If you want to live a long life, you'll stay away from the women," he told me.[2]

In its original form, with an outside privy, the Aho home was a typical frontier bachelor's cabin, except for the care taken with the windows and the inclusion of an upstairs bedroom. The windows are double-hung, with the top sash blocked with decorative pieces, and the window skirts are decoratively carved, reminiscent of rural Finnish architecture. The house was originally red with white trim, also in Finland tradition, but most of the paint has worn off. I did not see many other examples of this paint scheme and decoration, referred to by earlier writers, and wonder how much the island has changed in the past 20 years or so. It appears that the vinyl-siding and aluminum-window salesmen have been busy, as there are very few brightly painted houses left and the good-quality new architecture tends to be in the log-rustic browns and ochres seen elsewhere in BC.

Denman Island

· ·

The Denman Island General Store was built in 1908 by storekeeper P.J. Doheny. Strategically located at the top of the hill above the ferry slip, it is the most "village-like" building in the Denman Island village, a blip of activity in what is otherwise a very quiet place. Typically of the Gulf Islands, there is a rush of traffic following the arrival of ferries at either the Vancouver Island side opposite Buckley Bay or the Hornby Island side near Orkney Farm, then a great calmness, interrupted only by the occasional dog crossing the road and the carolling of the crows in the Douglas firs. Everyone else disappears into the forest to their personal heavens. The store is one of the best examples of a boomtown-fronted building in the province, made even better by its extensions over the years, the additions of the porches and the side sheds.

Denman Island has good agricultural land and was a thriving farming community for the first half of the twentieth century. Nearby markets included the coal-mining towns strung along the east coast of Vancouver Island, Union Bay being especially close. By the 1950s and 1960s, population was declining as old farmers retired and there were few new ones interested in attempting to make a living where transportation put such a premium on anything bought and sold. Then came the hippie era, with urbanites from Canada and the US dropping out and purchasing the old properties, in some cases collectively. Over the years many have cut their hair and commuted to jobs on Vancouver Island, but their laid-back pace and hobbit-house rural architecture is a lasting legacy. Now there are the young people, the "bush babies," who are dropping out in the midst of the older dropouts, camping in the

Early evidence of nonconformist behaviour: "The Last May Queen, 1938," by an unknown photographer. BC ARCHIVES A-09398

woods or crashing in unoccupied buildings, hanging out, louche and footloose, around the store in the summertime. Nevertheless Denman is, to my eye, a more authentic place, a working island, than heavily treed Hornby with its high-art and resort atmosphere.

Of the historic places, Orkney Farm evokes the pastoral west coast – a paradise of mild bright winters and dry summers – as well as any surviving landscape. Besides the barn, outbuildings, hedgerows, old shade trees and hay meadows, there is an orchard of old-fashioned fruit trees including Bosc pears and apples such as Cox's Orange Pippin and Gravenstein. Today it is a working farm of 76 acres, operated by stewards Marlena and Dale Merrick, still bearing an air of self-sufficiency typical of early British Columbia homesteads.

Tom Chalmers came from the Orkney Islands in 1897 to homestead the land and spent the next three years building the house, completing it in time for the arrival of his fiancée. His brother Jack bought the property to the south and built a similar house and barn, still extant but renovated more than Tom's. Two brothers bought the two houses in 1929; Jack Isbister bought Tom's while Tom Isbister bought Jack's. The father of Tom Isbister's wife, William Baikie, had arrived on Denman in 1888 and like Tom Chalmers bought part of the early preemption of Charles McFarlan. Isbister logged, established an apple orchard, and continued shipping milk and cream to Comox until the 1960s, when he switched to beef.[1]

For the past 30 years, the properties have been co-owned by three families: the Clarks, the Boothroyds and the Elliots. "The three families that own the Farm continue to support the farming operations in every respect (including of course financially), and I can assure you that there is no foreseeable danger of Orkney Farm becoming a profit-earning property. My mother Zella Clark has lived on Orkney Farm for about 20 years, and my father died there a few years ago and his ashes are spread about the Farm. The other two owner families both spend a considerable amount of time on the Farm and both have lived on the Farm off and on since 1972."[2]

THIS PAGE *Tom Chalmers's house, begun in 1897.*

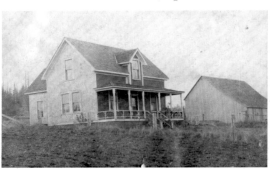

ABOVE *The familiar view of Orkney Farm to anyone who has travelled along Denman Road and turned onto East Road, typically the route taken by people speeding from the Denman ferry to Gravelly Bay for the Hornby ferry.*
BELOW LEFT *Maggie (Mrs. Tom Chalmers), with crew and Lynn the horse, at the barn.*
BELOW RIGHT *Jack Chalmers's farmhouse.*

1 Thomas Ovanin, *Island Heritage Buildings*, p. 17.
2 Correspondence from Keith Clark, 2003. Thanks to the Merricks for showing me their home. All photographs from Tom Chalmers's granddaughter Carolle Lynn Price; Keith Clark acted as intermediary.

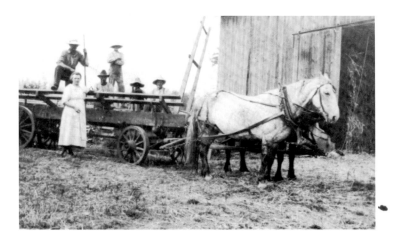

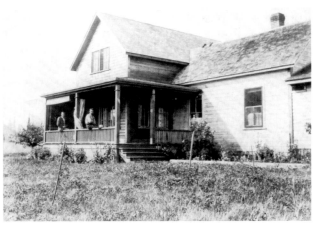

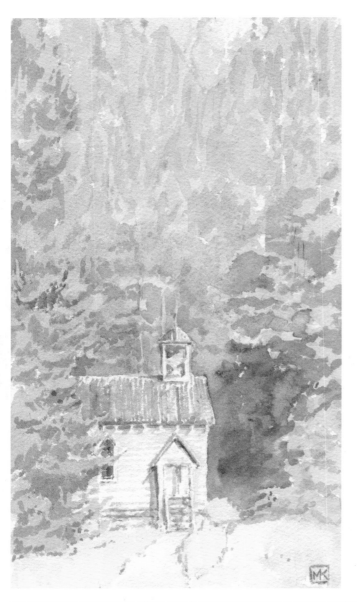

Zeballos

. .

Zeballos is something of an anomaly among Vancouver Island resource towns, being more like a Cariboo boomtown than the heavily capitalized coal- or lumber- or pulp-based communities that are the island's mainstays. It was an outport until 25 years after its mining heyday ended, and so connects with the era of long-vanished, ship-dependent company towns like nearby Ceepeecee at the head of Esperanza Inlet.[1] In 1970 the Tahsis Company moved its Fair Harbour logging camp to Zeballos and began its second incarnation as a forestry town with a road connection to Woss.

According to one story, a Kyuquot fisherman named Tom Marks found the first traces of gold on the Zeballos beach in 1908, but the first working mines, the Tagore and the King Midas, began operation on a modest scale in the 1920s. With the onset of the Great Depression, and the shipping of two tons of hand-dug ore from the Tagore, many unemployed men took the provincial government's prospecting course and flocked to the area to stake claims. In the late 1930s, more than 400 men laboured in more than 30 mines on a patchwork of claims scattered across the steep terrain, and quickly a townsite

ABOVE *St. Anthony's Catholic Church, on the edge of town, occupying a rise of land against the steep hillside. Built in 1939 by a Benedictine missionary, Father Anthony Terhaar; it is now abandoned and boarded up, and suffered a fire in 2002.*
BELOW *The cottage near the waterfront of Adolf Aichmeier, the manager of the Privateer Mine, the most profitable and long-lasting of the local claims. When the Privateer closed in 1948 the town's population dropped from 1,500 to 35; the boomboat is of the type once used to take groceries and passengers out to the CPR steamships that were lifelines to the outside world, and sometimes had to make the long run down Tahsis Inlet to Ceepeecee, where there was a permanent store.*

developed at the mouth of the Zeballos River. It turned out that the most profitable claims were along Spud Creek, which drains into the Zeballos River not far from its mouth.

Zeballos – named for Spanish navigator Lieutenant Ciriaco Cevallos, a member of Alejandro Malaspina's 1791 expedition charged with charting and exploring the northern reaches of Nootka Sound – is the last of the gold-rush towns from an era of small claims and grizzled prospectors. (Two other golden girls of the Dirty Thirties, Bralorne and Wells, were well-financed corporate mines with company towns attached.) Labour shortages and the difficult terrain, as well as the fixed price ($35 an ounce) made it difficult to keep the mines open as the war progressed. A later discovery of high-grade iron ore led to the opening of Zeballos Iron Ore Mines, exporting to Japan, which operated from 1959 to 1969.[2]

One of the early arrivals was a sturdy young man in his late twenties named Jack Crosson, who had grown up in Victoria and gone to sea while still in his teens. At the outset of the Depression, he got summer work on the federal Hydrographic Survey ships that were then charting the west coast of Vancouver Island. In 1936, smitten by gold fever, he moved to Zeballos to live in one of the first four shacks built along the beach – on the west side of the river, the wharf and town eventually being built on the east side. Over the next few years, he divided his time between prospecting and working as a carpenter, including a stint building an ore-sorting shed for Privateer where he insisted (after a couple of experiences working for fly-by-nighters) on being paid in

Maquinna Avenue, Zeballos, looking toward the inlet, with the Zeballos Hotel, built in 1938 and originally called the Pioneer, in the foreground. The two-storey building beyond housed one of the town's brothels on the upper floor during the gold rush. According to local legend, a ladder at the back helped shy but agile customers preserve their respectability. The boomtown-fronted building was the drug store.

1 Ceepeecee, standing for Canadian Packing Co., was one of 15 reduction plants along the coast; built in 1926, it became one of the major service centres of the area. As well as the fish plant, it had a first aid station, post office and general store. It was destroyed by fire in 1954.
2 Roland Shanks, www.zeballos.com.

cash rather than shares. In his memoirs, he notes that had he taken the shares and cashed out at the peak, he could have realized a small fortune of about $60,000.[1]

The memoirs reveal Crosson's incredible memory for the detail of prospecting, gold mining and roughing it on the west coast in the era before telephones and roads. All the camps, whether mining or fishing, were completely dependent on the *Princess Maquinna* for supplies, and on Vancouver for provisioning and financing. And it rained all the time, except when it was tinder dry in the brief summer drought. "Victoria" appears as a regulatory body – surveying, conducting inquests when miners blew themselves up. He recalled the round of life on the edge of the wilderness: "boat day," "grocery orders" and "mail"; staking claims, documenting the information and mailing it to the mining recorder in Port Alberni; shipping ore samples to Vancouver for analysis and ore itself to the smelter at Tacoma; slippery financiers from Vancouver; working with geology graduates from UBC and their city-bred wives; prospecting like goats over the steep ground; trips to Ceepeecee for extra supplies; off-loading groceries from the *Maquinna* into rowboats; before the ocean wharf was built, carrying new arrivals on his back to dry land across the tidal flats when the tide was too low for the skiffs to get to shore; setting springboards into cedar trees before sawing them down, and splitting shakes to make shacks that would stay dry in the monsoon; hand-smelting ore in the kitchen stove; Sloan's Liniment – essential for keeping packers' knees in condition for the steep climbs carrying heavy loads to the mining camps; men sharing tents, shacks, bunkhouses and meals; and his partner going to Vancouver on business and ending up on a multimonth drunk on Skid Row. In spite of its frontier ambience, Zeballos was a law-abiding place, where miners left chunks of high-quality ore on the windowsills of their shacks, and, as in much of BC's history, few claims were jumped.

Unsuccessful as a miner, and deeply patriotic, Jack Crosson enlisted at the outbreak of the war, which he spent as a naval inspector of merchant ships. After demobilization, he returned briefly with his wife to Zeballos and Kyuquot to the north before chucking it in and spending the rest of his working life at HMCS Dockyard in Victoria, where he became captain of the ammunition lighter until his retirement in 1972.

Zeballos is one of those places engendering considerable loyalty from anybody who used to or still does live there. There was a reunion in the town in August 2002; as in the Peace, most of its modern-era history has taken place within the memories of people still living.[2]

ABOVE *Jack Crosson, his wife Anne and daughter Charlotte about 1946, waiting for the* Princess Maquinna.
BELOW *Zeballos waterfront, 1946. "Jack's shack" is the one on the right.*
CHARLOTTE CROSSON GRANEWALL

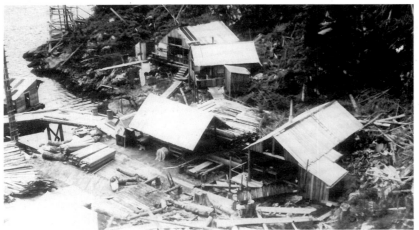

1 *Jack's Shack: Memories from the West Coast of Vancouver Island.* According to his daughter, Charlotte Crosson Granewall, he died in 2000 just as his book was being printed.
2 Thanks to Roland Shanks for general information and clarification.

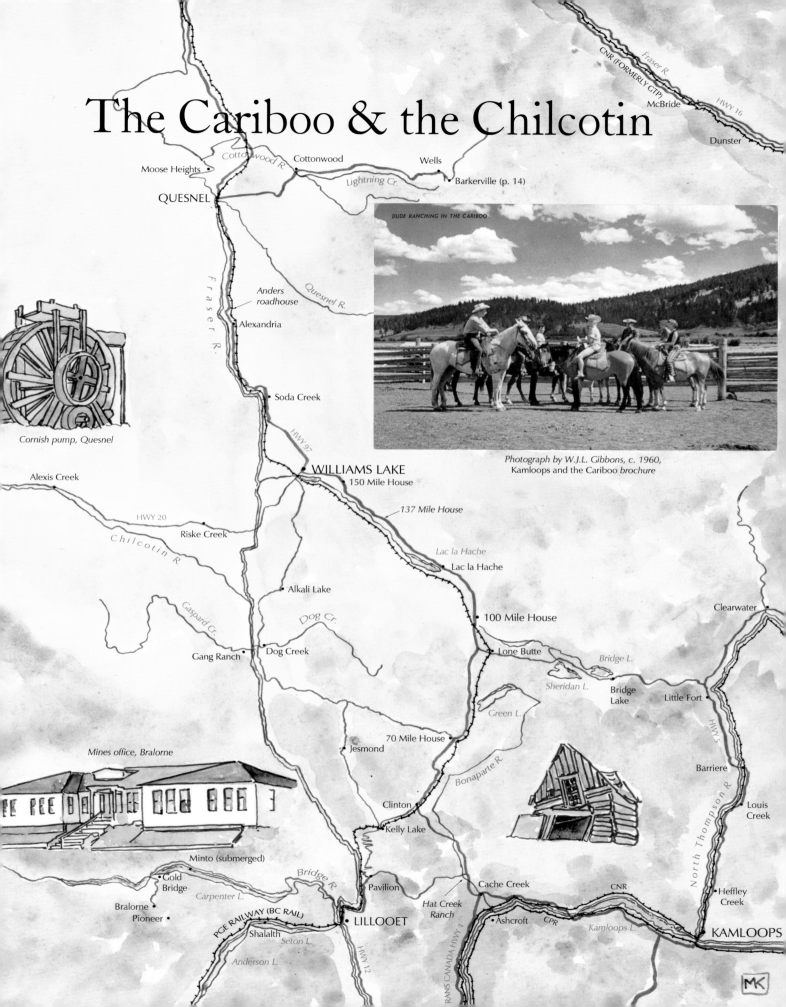

The Cariboo & the Chilcotin

Cottonwood R.

Fraser R.

CNR (FORMERLY GTP)

Fraser R.

HWY 16

McBride

Dunster

Moose Heights

Cottonwood

Wells

Lightning Cr.

Barkerville (p. 14)

QUESNEL

Quesnel R.

Anders roadhouse

Alexandria

Fraser R.

Soda Creek

DUDE RANCHING IN THE CARIBOO

*Photograph by W.J.L. Gibbons, c. 1960,
Kamloops and the Cariboo brochure*

HWY 97

Cornish pump, Quesnel

Alexis Creek

WILLIAMS LAKE

150 Mile House

137 Mile House

HWY 20

Chilcotin R.

Riske Creek

Lac la Hache

Lac la Hache

Clearwater

Gaspard Cr.

Alkali Lake

Dog Cr.

100 Mile House

Gang Ranch

Dog Creek

Lone Butte

Bridge L.

Sheridan L.

Bridge Lake

Little Fort

Green L.

70 Mile House

HWY 5

Mines office, Bralorne

Jesmond

Bonaparte R.

Barriere

North Thompson R.

Clinton

Louis Creek

Kelly Lake

Minto (submerged)

Bridge R.

CNR

Gold Bridge

Carpenter L.

Pavilion

Cache Creek

Heffley Creek

Bralorne

Pioneer

PGE RAILWAY (BC RAIL)

Hat Creek Ranch

Ashcroft

CPR

Kamloops L.

KAMLOOPS

Shalalth

Seton L.

LILLOOET

TRANS CANADA HWY 1

Anderson L.

HWY 12

MK

Lillooet

. .

Ringed by stony, rugged mountains dotted with tenacious pines and bi-sected by the Fraser River, Lillooet is an unexpected oasis in the arid Interior, Mile 0 of the original Cariboo Road for miners who had used the trail from Harrison Lake to Pemberton on their way to the goldfields. Its history before contact is most evident a few miles north of town, at the confluence of the Bridge River and the Fraser where, on the benches and rocks, Natives still net salmon and dry it on wooden racks displayed to the hot sun and wind. Like Lytton further downstream, Lillooet is a gusty place with the distinction of hottest spot in Canada.[1] It was equally heated journalistically, and known far beyond its region for the Liberal fulminations of "Ma" Murray, who, with her husband George, founded the *Bridge River-Lillooet News* in 1933; her heyday was the W.A.C. Bennett era of the 1950s and 1960s.

One of the surviving historic buildings in town is an early 1890s house standing on a narrow lane immediately behind the main street. For many years it was presented historically as the home of Casper and Cerise Phair, he having been the first government agent, a gold commissioner, teacher and merchant who walked to Lillooet from Yale to settle in 1877, his descendants becoming storekeepers in Lillooet for the next two generations. Officially it was called Longford House after Cerise Phair's family house in county Galway. Recently, a second chapter was added to the house's story, chronicling the life of Dr. Masajiro Miyazaki, who

RIGHT *Dr. Masajiro Miyazaki.*
DISTRICT OF LILLOOET
LEFT *The Miyazaki house in downtown Lillooet. With its mansard roof, the house is a rare BC example of the Second Empire style, fashionable throughout the Western world around 1870.*

was subject himself to wartime evacuation from the coast, and went to the Lillooet area in 1942 to care for the Japanese Canadians there. Following the war he bought the house, and although the Japanese-Canadian community had largely dispersed by the early 1950s, he stayed on and over the next three decades distinguished himself in public service to Lillooet and the surrounding area. He donated the house to the town in 1984, and after a period of use as a studio-gallery it opened as a museum of his life and times.

There were no internment camps in the area, but rather "self-supporting villages." One was the abandoned gold-mining town of Minto, now submerged by Carpenter Lake, the reservoir for the Bridge River dam, where about 25 families spent the war, with many of the men finding employment in logging. During their tenure, the town blossomed with gardens for the only time in its existence.[2] The other, much larger camp was in East Lillooet, on the flat occupying both sides of the Lillooet-Lytton Highway. The site is now (on the river side of the road) a commercial garden growing vegetables for the local market. According to a map drawn by Taka Tsuyuki and T. Yamashita, and presented to the Lillooet Museum in 1991, the "Self Supporting Evacuation Village 1942" was home to about 345 people living in 62 cabins, "12' x 12' and up." In the main part of the community, the houses were lined up neatly in two rows across from the commercial tomato field and vegetable garden. Their tomato-canning plant continued in business for a number of years, but no trace of it, or the village, remains today.

COUNTERCLOCKWISE FROM TOP *Schoolgirls in traditional costume, 1947. The East Lillooet Japanese-Canadian village during wartime. The tomato-canning plant in 1947.* LILLOOET MUSEUM *Lillooet's main street about 1960, photographer unknown. The old Lillooet Hotel, on the right, was built about 1897 and initially called the Victoria; it burned down in the early 1980s but was rebuilt to more or less the same shape and size, and reopened under its original 1897 name.*

1 On July 16, 1941, temperatures reached 44.4°C. Francis, *Encyclopedia of BC,* p. 413.
2 Lewis Green, *The Great Years: Gold Mining in the Bridge River Valley,* p. 196.

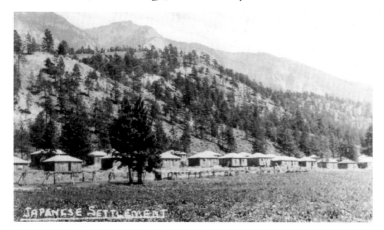

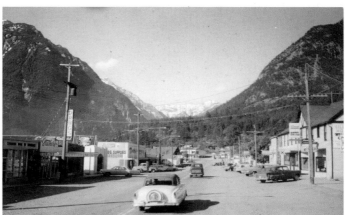

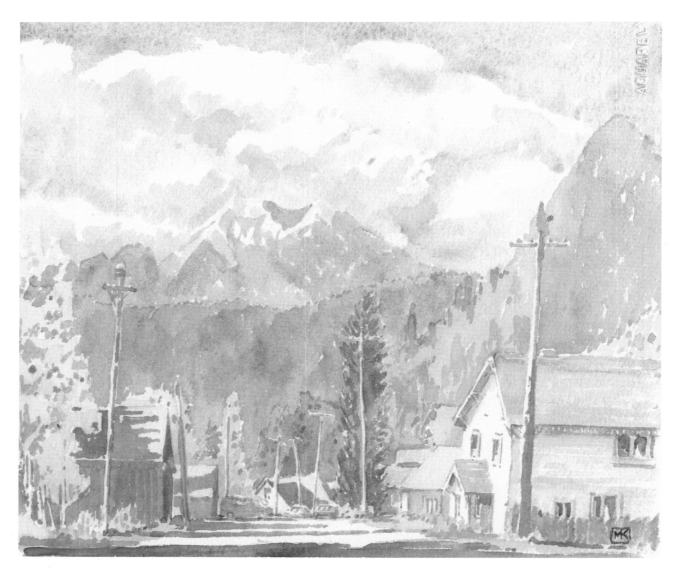

Bralorne
· ·

Townsite 1, Bralorne, a jumble of buildings spilling down the hill above the mine works. The building on the right, according to a faded sign on its facade, was once the Bralorne Inn.

Bralorne is the most intact mining company town in the province from the interwar years. Unlike Zeballos from the same period, Bralorne's Townsite 2 was a planned community, with curving streets and cottages that were state-of-the-art suburban design. This sort of company town re-emerged after the Second World War, most strikingly at Kitimat. Townsite 1 has much more of the sort of organic layout usually associated with a mining town, like that of Barkerville from a lifetime earlier.

Controlled by Vancouver-based financier Austin Taylor, Bralorne's gold was one of the few glittering spots in the dismal BC economy of the early 1930s.[1] On the profits from it and his other investments, including Home Gas, Taylor was able to entertain about 900 guests at a reception at the Hotel Vancouver early in 1936, and later that year buy the Rogers family's 10-acre Shannon estate at 57th and Granville for $105,600.[2]

Bralorne's Townsite 2 began construction in 1934 on a bench a kilometre to the southwest of Townsite 1. Eventually there were about 70 houses there,

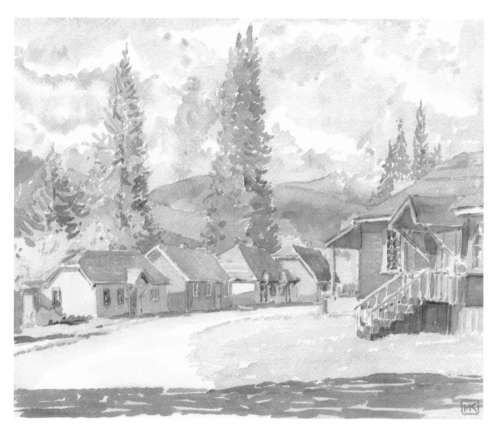

ABOVE *Vancouver financier Austin Taylor.*

ABOVE LEFT *Whiting Avenue, Townsite 2, Bralorne, in the fall of 2002. The brown house second along was vacant, with its door hanging open, so I entered to draw the floor plan below.*

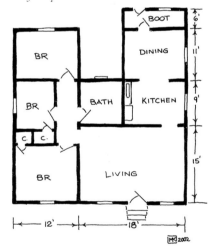

together with school buildings, park facilities, a hockey rink and a church, likely designed by Taylor's favourite architect, William Frederick Gardiner.[3] Although cheaply built, the three-bedroom bungalows in Townsite 2 are masterpieces of compact design in about 1,000 square feet above a dirt crawl space with a forced-air furnace, every room having windows for light and ventilation. The duplexes were less successful with their "blind" bedrooms against the common wall. Another design had two of the three bedrooms opening directly onto the living room. "When Bralorne's [manager] Bosustow asked a foreman's wife how she liked her house she summed it up neatly: 'Kitchen too small. Head in oven, arse out the back door.' "[4] But, for employees squatting in log cabins outside the townsite or living in bunkhouses and unable to bring their families to town, it would have seemed deluxe.

Correspondence from Teri Anderson, Portland: "I lived in Bralorne from 1978 through 1981 with my husband and brand new baby daughter. Bralorne was quite a place in those years. We had a hardware store and a grocery store. The Mines Hotel with its beautiful polished burl bar was in full operation. There was work around. I ran a cookhouse for the drillers that used to fly in there. There were lots of young people throughout the area with small children. When I lived there, the Whitings had actually purchased the town and were selling lots and houses and there was a lot of activity to recreate Bralorne. I see that did not really happen ... It is the place that has value – the lakes, hiking and of course the quiet. We lost a lot of the stars when they put in those pesky street lights. My ex got arrested one night trying to correct this crime against nature."

1 Lewis Green, *The Great Years: Gold Mining in the Bridge River Valley*, 2000.
2 Kluckner, ed., *M.I. Rogers 1869-1965*, p. 141.
3 Donald Luxton, ed., *Building the West*, p. 309.
4 Green, p. 94.

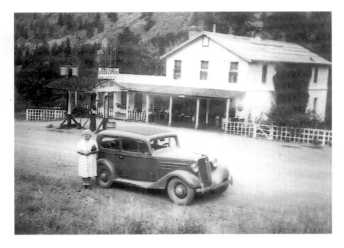

ABOVE *Adventurous motorists at the Pavilion Store in the late 1930s.*
LILLOOET MUSEUM
BELOW *The surviving chimney from the burnt-out store in 2002 with a 'Harison's Yellow' rose still growing in the gravel.*

Pavilion

Until January 2000, the self-described "oldest operating store in British Columbia" stood by the roadside near the Pavilion Indian village on the Lillooet-Hat Creek road. The successor to a business established about 1861, the store operated in a 1920s or 1930s structure which may have contained elements of an earlier roadhouse, perhaps the fine old stone-faced fireplace. I had last seen it late on a hot afternoon in the fall of 1999 and stopped for an ice cream, but as there were a number of people about and I had intended to get to Ashcroft that evening, I did not paint it. So I was astonished to go again along the road in June 2002, sketchbook and brushes at the ready, only to find just the chimney standing against the sky, with a jumble of rusted metal roofing, contorted by the heat of a fire, lying scattered about on the ground.

Correspondence from Bernard Schulmann: "[On a Saturday evening] Shirley Alec was at work and heard some odd cracking noises in one of the walls. She went and looked around and saw nothing. She closed the store and went home. At about 11 pm the building was seen to be on fire, the Pavilion Band Fire Department came and tried to put the fire out. The first truck of water and foam was getting the fire under control, but it was not enough.

Ronson Ned had to go back to get the truck refilled and by the time he got back the building was in full flame. It seems clear now that the 1920s wiring (with bakelite insulation) within the sawdust-insulated walls had caused a short and a fire. Over the previous five years there had been several problems with wiring, but the cost of renovating was too high given the value of the property. The Regional District had not zoned the property commercial and therefore the building was not in conformity with the zoning and the site was officially not acceptable to the Highways Department due to the access to the highway."

In earlier times, the main road from Lillooet went to Pavilion and then climbed north over the mountain. A diary entry in July 1899 by Mrs. B.T. Rogers, travelling with her husband (owner of the BC Sugar Refinery) and some fellow mining investors from Vancouver to see a gold mine north of 150 Mile House, recorded the journey: they took the CPR train to Ashcroft, then went by BX stagecoach via Hat Creek to Lillooet and overnighted there. "The road into Lillooet is grand but awful. The road is at the edge of a precipice, sheer down to the Frazer [sic], and some of the hills were terrifying. We passed a place where a Chicago man is hydraulicking; near Lillooet,

some Chinamen who rent the property from a N.W. Co. are very flourishing. They pay $350 rent and last year took out $13,000, besides raising fodder and vegetables, which they irrigate at night when not using the water in the flumes. Arrived Lillooet and went to the Pioneer, kept by Mrs. Allan, a funny old girl with a false front fastened to her net cap. She gave us a fine dinner – venison, peas and wild raspberries." The following day, they started at seven and retraced their steps to Pavilion: "The road to Clinton goes over the mountain. We ascended to 4,850 feet, and then in 3 miles dropped to 3,500 – it was awful, the sharp turns terrible. We had two trees behind to save the wheels and brake. Long before we arrived it was quite dark. Got into Clinton at 10:30, put up at the Dominion."[1]

Early in the automobile age, motorists were still tying trees behind their cars to save their brakes and slow their descent, and old-timers recall a pile of cut trees left by the roadside at the Kelly Lake end. Historian Branwen Patenaude described it as G.B. Wright's Road, constructed in 1862. "Just why G.B. Wright chose such a difficult route for this road has always been a subject for conjecture. A much easier grade would have been the route followed many years later by the Pacific Great Eastern Railway [now BC Rail] from west of Pavilion Mountain, north to Kelly Lake and east to Clinton."[2]

The mark of Zorro: a typical switchback road, a bulldozer-blade wide, climbing through the sagebrush and Ponderosa pines in the canyon above the Fraser River between Lillooet and Pavilion, heading for bunchgrass pasture on the uplands.

1 Kluckner, ed., *M.I. Rogers 1869-1965*, pp. 51-2.
2 Patenaude, *Trails to Gold*, p. 78.

The long purple shadows of late evening along Jesmond Road – June 2003.

Jesmond, north of Kelly Lake and west of Clinton, is one of those intriguing dots on the Cariboo map that turns out to be just a house, rather than a village. The Coldwell family from Jesmond, a suburb of Newcastle-upon-Tyne in northern England, settled here about 1914 and were able to secure the post office for the surrounding ranching area. The original log roadhouse, built across the road from the current house by American miner Philip Grinder, burned down in 1921.[1] The family rebuilt – in the Craftsman style that was still popular in the 1920s even in the cities – to include a post office (closed 1960) and store (closed 1970) which occupied the single-storey annex behind the main house. Today, a green multifamily post box sits on the side of the road, and Clinton is about 30-40 minutes away by well-graded gravel road, a mere blink of the eye in travelling time in the vast Cariboo-Chilcotin.

1 Branwen Patenaude, *Trails to Gold*, p. 60.

The Cariboo Road

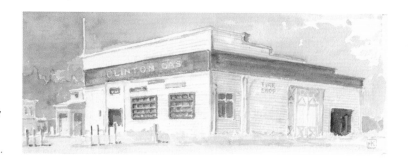

Cariboo towns like Clinton (47 Mile House in the early years) and 70 Mile House were created as way stations for travellers. The old gas stations and tire shops are modern replacements for the hay barns and stables that kept the wagons rolling in the gold-rush era. Unlike some Cariboo towns which have succumbed to highway-commercial blight, Clinton still has a mix of old and new buildings, a fine museum and a western ambience that is an appropriate teaser for the many guest or dude ranches in the area. Many businesses, such as the Cariboo Lodge, trade on the area's history with excellent displays of historic photographs throughout their lobbies and hallways.

Like the old Victoria Hotel in Lillooet, the venerable Clinton Hotel burned to the ground. Built in 1862, it was one of the significant buildings in the BC Interior. Erected by Watson and Co., it had a large barroom, a private sitting room, bedrooms with "Pulu" mattresses (a predecessor of kapok), free bunks for those who brought their own blankets, and good food. It survived for almost a century, with its billiards room becoming the scene of the annual ball. Ironically, it was in centennial year, after the ball in May 1958, that the hotel caught fire. All the guests got out except for a couple and their child who, although awakened by the manager, went back to sleep and were killed in the blaze.[1] The remains of the hotel's foundations are still visible on a vacant lot near the north end of downtown.

As a young man, Ken Sigfusson took his cameras with him on family driving trips from Vancouver to Prince George in the 1940s. The Fraser Canyon tunnel picture on page 120 was taken on one such vacation, as were the two photographs below, in 1946 (left) and 1950 (right). His parents had bought the Buick (in the photo) in 1944 from Mrs. B.T. Rogers; her chauffeur Hathway, who had previously had a Packard to drive, declined to wear his chauffeur's cap while driving the Buick.[2]

LEFT *Truck accident on the Cariboo Highway, 1946.*
RIGHT *The historic Clinton Hotel about 1950.*
PHOTOS BY KEN SIGFUSSON

1 Branwen Patenaude, *Trails to Gold*, p. 85.
2 Correspondence from Mrs. Rogers's granddaughter, Janey Gudewill.

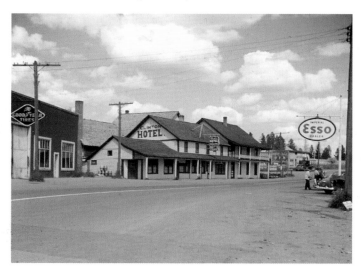

ABOVE *"On the way to Barkerville," a photo in Jessie Acorn's collection from a car trip in the late 1950s.*
RIGHT *The Anders roadhouse at 183 Mile, a small farm, store and change-stop for the BX stages, built in the late 1890s by W.J. "Buckshot" Anders, whose main occupation was threshing for farmers between Soda Creek and Quesnel.[1]*

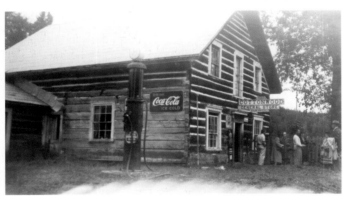

Life would be much simpler, and history less entertaining, if gold were more often discovered in convenient places. But, as has often been said with reference to the Klondike stampede, getting there was at least half the fun, and many of the prospective miners arrived, looked around, and then went home, either because they were too late, insufficiently smitten, or perhaps because they just wanted to be part of a great human migration.

It is difficult today to imagine being so afflicted by gold fever and to understand the hardships of the journey to the goldfields. Today's swift run over paved roads from the coast to Barkerville belies the reality of a river journey, the jouncing wagons and the roadhouses dotted along the Cariboo Road every 10 or 15 miles, packed with lice-ridden, smelly travellers and serving endless plates of bacon and beans washed down by two-bit shots of liquor as rough as the long day's road. Between Lillooet and 150 Mile House the roadhouses took the name of the nearest milepost, while between Yale and Clinton most were known by the name of the owner. As the road improved the inferior houses were demolished, or when they burned down (as frequently happened) they were not rebuilt. Two of the historic stopping places, Hat Creek Ranch near Cache Creek and Cottonwood House, are part of the provincial set of heritage sites developed since the BC centennial in 1958; the Cariboo Road's destination, Barkerville, is the largest of the set.

Cottonwood House, on the wagon road from Quesnel to Barkerville, opened in 1864, its general store and telegraph office a lifeline into the quiet area for many years thereafter. John Boyd's family ran it between 1874 and 1951. Since 1998, it has been run by Quesnel's School District 68, which took it on as part of its tourism training program; like Barkerville, Cottonwood House's long-term survival is crucial to the Cariboo's increasingly tourism-dependent economy, yet the provincial government's rapid devolution of responsibility onto local agencies, without any assurance of long-term funding, makes the future uncertain.[2] The recent addition of overnight accommodation, in the form of

1 "Bill Broughton's Story," in Old Age Pensioners' Organization, *A Tribute to the Past*, p. 115.
2 Rick Goodacre, "On the Gold Rush Trail," Heritage BC newsletter, Fall 2003, pp. 5-7.
3 Irene Stangoe, *Cariboo-Chilcotin Pioneer People and Places*, p. 78.

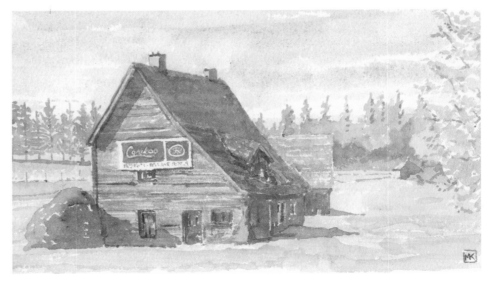

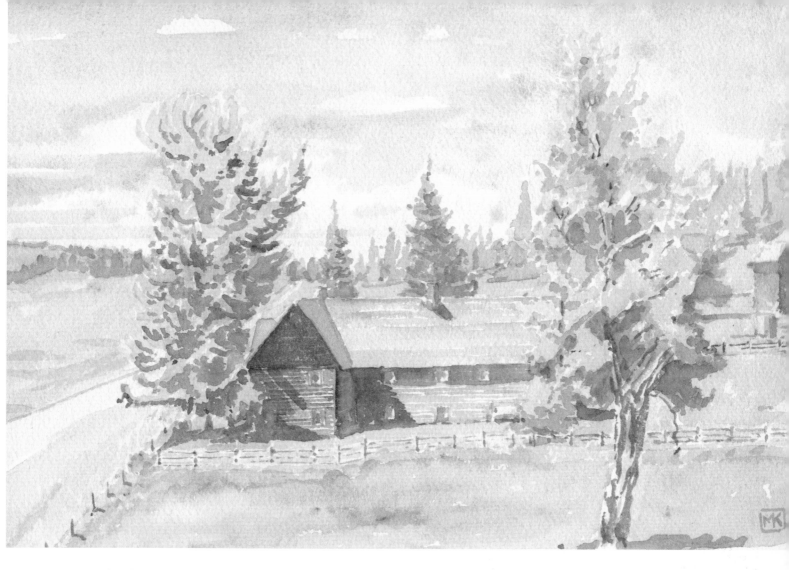

student-built rustic cabins, is intended to improve its bottom line.

The publicly owned sites are complemented by a handful of historic roadhouses left on private property. One is 137 Mile House, sitting back 100 feet or so from the modern Cariboo Highway and looking much as it must have in the days of teamsters and stagecoaches. It is the best surviving roadhouse "tableau" – the main house with a large addition forming a T at the rear, squared-log construction, a strategically planted cottonwood tree to shade it from the hot afternoon sun, paddocks divided with pole fencing, barns and other outbuildings – and is the oldest of the log roadhouses left along the modern highway. The original part of the property, a pyramid-roofed log building that was the first homestead, was built about 1862 by William Wright and his son John and is still used as a garage (it is on the far side of the house in the large picture). The main house, built by either the Wrights or the McCarthys, dates from a decade or so later and was not a stopping house, but rather a way station for teamsters.[3]

Another survivor, the Anders roadhouse, now serves as a billboard support for the Ford dealership in Quesnel. It is a classic "saltbox" with a flat front facade pierced by three windows on each of two levels, and a dormer, now collapsed, on the rear roof pitch. It stands with some other old barn buildings by the side of the highway about five kilometres north of the Fort Alexandria historic cairn.

137 Mile House, a classic Gothic Revival building with side gables and a central wall dormer, built in the Cariboo style of squared logs with dovetailed corners. Everything looks dry and weathered, bleached by the hard light, and the cottonwoods cast an open, flickering shade on the thin grass.

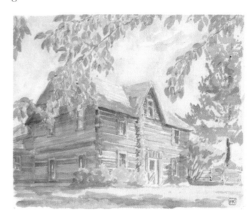

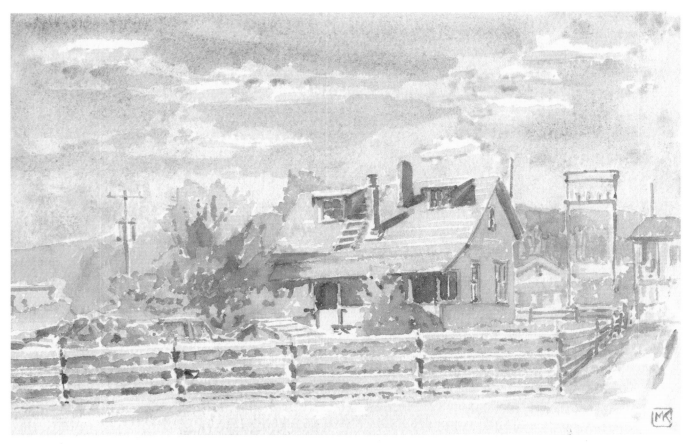

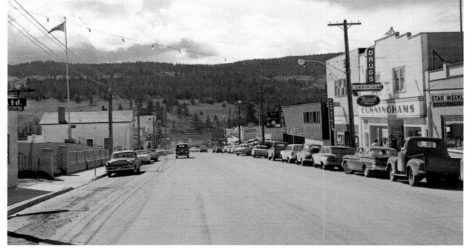

ABOVE *Alcina and Manuel's house on Borland Street, Williams Lake.*
BELOW *Downtown Williams Lake in the 1960s, looking toward the BC Rail station and railyards on Mackenzie Avenue. Photographer unknown.*

Williams Lake is a strategically located ranching and lumber town that calls itself "the hub of the Cariboo." Named for the Secwepemc Chief William who helped to keep the peace when his territory was invaded by (mainly) American miners, fresh from the killing fields of the California gold rush,[1] it became a thriving town only with the arrival of the Pacific Great Eastern Railway in 1919. The Cariboo Road missed it, forging east from 150 Mile House directly to Soda Creek in the 1860s.

Although a lot of the town's business has migrated to malls along the highway, Williams Lake's downtown still shows signs of life. One of its curiosities is a house on Borland Street, a block from the railway station. A downtown orphan, it backs onto commercial buildings, and new apartments dot the adjoining blocks. It would be easily missed except for its unusual garden, which is entirely potatoes on the back, side and front yards. Alcina and Manuel, an elderly couple, live there. The first time I saw it, in 1993, my wife Christine asked Alcina if she ever rotated her crop, to which she replied, "sometimes I plant red ones and sometimes I plant white ones." In 2003 their garden was still the same: tended by traditional people "putting food by" in spite of the agricultural plenty overflowing at the many local supermarkets.

The Chilcotin Highway, completed in 1953, runs west for hundreds of kilometres through the classic ranching landscape immortalized by Paul St. Pierre in books such as *Breaking Smith's Quarter Horse.* Through communities and dots on the map such as Riske Creek, Alexis Creek and Anahim Lake, the road runs between zigzags of snake fence and crosses innumerable cattle guards, passing through endless forests of lodgepole pines – the "hairy toothpicks" of the BC Interior – interspersed with bunchgrass plateaux and stunning vistas of distant blue mountains, before descending steeply through the coastal rainforest and arriving finally at the Bella Coola tidewater. Bella Coola was originally the community of the Nuxalk First Nation to which explorer and fur trader Alexander Mackenzie arrived overland in 1793. Later settlers from Norway established the farming community at Hagensborg nearby. The coastal communities seem so focused on the sea, the Chilcotin communities on the sky.

For miles around Williams Lake the landscape is dotted with small lakes beloved of fishermen and cabin owners. Rose Lake Lodge, a dude ranch and fishing camp nearby, drew my parents with their two small children for a memorable vacation in the mid-1950s. The former guest ranch at Beaverdam Lake, on the road west of Clinton on the way to Gang Ranch, captured something of the flavour of those rustic places: a line of shanties, with only a few conveniences, on the edge of a lake of the most astonishingly vivid turquoise. Pine forest stretching forever over low hills in one direction, with high mountains under a robin's-egg-blue sky in the other.

Abandoned guest ranch at Beaverdam Lake on an early June day in 2003. The cabins began life as Pollard's 3-Bar Guest Ranch on the main road, but were trucked up to the lake and re-established in the 1960s as the Beaverdam 3-Bar Guest Ranch.[2]

1 For example, "the genocidal gale that – in the Gold Rush years – blew the California Indians away." Larry McMurtry, "Mountain Men," *New York Review of Books,* October 9, 2003, p. 21.
2 Interview with former owner Mike Brundage, Clinton, who got out of the guest-ranch business due to the cost of liability insurance and the complexities of making his mounted guests sign waivers.

Wells

ABOVE *A typical miner's house at 4281 Sanders Street, with the side wall of the Wells Community Hall, designed in 1937 by Ed Richardson and built by Garvin Dezell, next to it. It was one of the second contract of houses, all two-storey, built for the Townsite Company by Gardner Construction in 1934. An earlier 1934 contract by Northey Construction built 24 small single-storey, four-room bungalows with hipped roofs. In the second set, the roofs were all gabled, probably due to the snow loads. In total, the Townsite Company built about 40 houses.*

Wells is one of the more interesting company towns from Depression-era BC – an intriguing contrast with Bralorne, Britannia Beach, and the freewheeling Zeballos. "Wells went well beyond Pioneer [Bralorne] in creating an 'open town,' and the townsite company seems to have been sincere in its efforts to create an independent community," wrote Jennifer Iredale. Pooley Street, for example, was not dominated by a company store in which everyone had to shop. Perhaps because of this liberal policy, the town has survived better than others in the decades since the Island Mountain Mines closed.

Prospector-miner Fred Wells and Vancouver doctor W.R. Burnett had formed the Cariboo Gold Quartz Mine Co. in 1926, and brought the mine into production on January 10, 1933. The company began dividend payments to shareholders in 1936, and paid out nearly $1.7 million over the next seven years. Eventually, as was the case with other hardrock gold mines, the fixed

BELOW *Map of downtown Wells, showing workers' and management's blocks separated by Pooley Street; "Edna in Wells," a photograph included in a pile of postcards I obtained many years ago from the estate of Jessie Acorn, an inveterate traveller who lived in Vancouver's Kerrisdale district. The Sunset Theatre, constructed by Olson & Pigeon in 1935, is the building on the right; the Deluxe Cafe building moved across the street in the late 1990s. The 1935 building in the middle, erected by carpenter Ira Mooney, was long known as the Good Eats Cafe.*

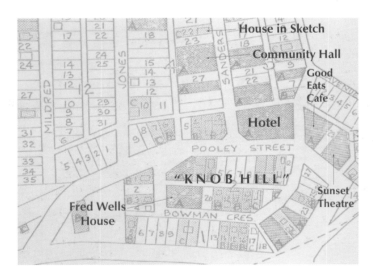

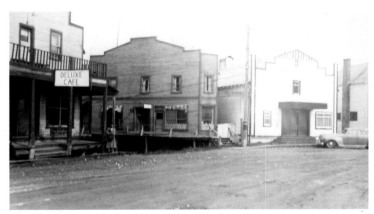

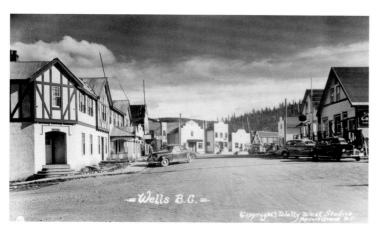 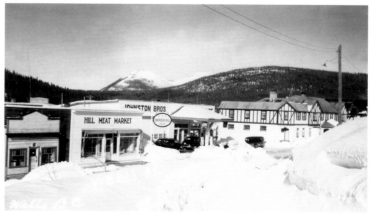

gold price killed the company. "Old Number One" shaft closed in 1959, with the balance of the operation surviving only until 1967.

For his townsite, Fred Wells bought DL 289, Blocks A and B, a total of 40 acres east of Jack of Clubs Lake, on which he intended to build a commercial centre, school, hospital, recreational facilities and housing for 450 people. This meant small houses on small lots, an advantage in an age when few miners owned cars and the proximity equalled neighbourliness and convenience in an otherwise rough and isolated part of the Cariboo. Wells hired Major Gook, apparently an old friend, to lay out the town, but the latter delegated the job to a young civil engineer, Ed Richardson, who worked with fellow graduate Ted Baynes.[1] Richardson went on to planning work with the Municipality of West Vancouver, including Park Royal and the British Properties; Baynes was the son of well-known Vancouver contractor Edgar Baynes of Baynes & Horie.[2]

They placed the commercial street, Pooley, and Bowman Crescent, the "high-end" residential street, on the driest, most solid land on the knoll, with the balance of the housing and buildings on the flats to the north. Wells survives today as a real period piece, in spite of the loss of a few of its major buildings, most notably the 1937 Jack of Clubs Hotel, which stood on Pooley Street beyond the Sunset Theatre until destroyed by fire in the 1990s. Cutbacks of government services, most notably plans to close the school, brought the town into the news shortly after the Liberal government was elected in 2001; more recently, the District of Wells refused to take on the management of nearby Barkerville, part of the government's devolution of heritage properties, arguing that the government's proposed heritage business model would bankrupt both Barkerville and its steward. The government proposal was "too much responsibility, too little money." The only potentially positive outcome was that local people, who had been running Barkerville for years, could make their own decisions rather than always having to defer to distant Victoria civil servants.[3] Regardless, as goes Barkerville (the largest heritage attraction in western North America with over 90,000 visitors a year) so goes Wells, and as they go, so goes the economy of this part of the Cariboo.

Like many of BC's beleaguered small towns, Wells has an irrepressible community spirit; the Sunset Theatre is being restored, the Jack o' Clubs dinner theatre and casino provides summer entertainment in a hybrid gold rush/art deco style, and the nearby Bowron Lakes are an outdoorsman's paradise.

LEFT *Pooley Street, 1950s. Much of the street is intact today, notably Paddy McDonnell's Wells Hotel (on the left), in the fashionable Tudor style, built in 1934 by Vancouver carpenters Bury and Johnson. Photographer Wally West, born in Vermilion, Alberta, in 1916, worked in Victoria for five years (including the 1939 royal visit) and Edmonton for a further five before moving to Prince George in 1946. The Fraser-Fort George Regional Museum has 56,000 of his negatives in its collection.*
© WALLY WEST STUDIOS
RIGHT *Pooley Street with the Wells Hotel in the distance, by an unknown photographer. Pooley Street was named for Charles Edward Pooley, a gold seeker who arrived in Victoria in 1862 and subsequently became Judge Begbie's registrar general, then a lawyer and executive with Dunsmuir-family interests including the Esquimalt & Nanaimo Railway. His son Harry was attorney general in the Tolmie government from 1928-33.*

1 Information unless otherwise cited from Jennifer Iredale, "Wells, B.C. A Proposal for Heritage Conservation," Master's Thesis, Graduate School of Architecture and Planning, Columbia University, 1984. Collection of Wells Museum – thanks to Carolynne Burkholder for locating it.
2 See Luxton, *Building the West*, pp. 453-4; Kluckner, *Vanishing Vancouver*, p. 23.
3 Rick Goodacre, "Up the Gold Rush Trail," Heritage BC newsletter, Fall 2003, p. 7.

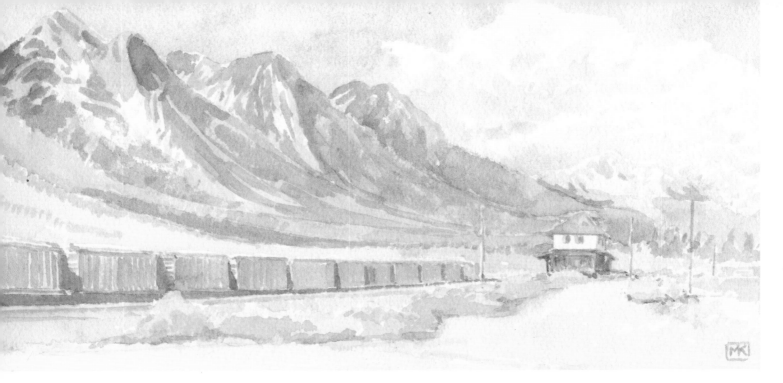

The GTP Railway

Although much of Smithers's business district is now focused along the highway, the old Grand Trunk Pacific station is well-restored with a functioning Beanery – the universal name for Canadian National canteens/ coffee shops along the line.

The string of communities across British Columbia's north – in reality, across its geographic centre line – follows the Bulkley and Skeena rivers toward the coast just south of the fated 54°40' north latitude, the bottom of the Alaska Panhandle which the Americans have controlled since purchasing Alaska from Russia in 1867. Recognizing it as an ideal northern railway route, as it could serve the "parklands" of the prairies and connect with an ice-free port much closer to the markets of the Far East than was Vancouver, the directors of the Grand Trunk Railway created a separate corporation, the Grand Trunk Pacific Railway, in 1903. Headed by Charles Melville Hays and backed by the well-entrenched Liberal government of Sir Wilfrid Laurier, it believed it could beat the Canadian Pacific Railway (long associated with the Conservative Party) at its own game – the high-speed movement of goods over long distances.

The GTP built west from Winnipeg, choosing Edmonton as its main divisional point and selecting Kaien Island as the terminus in August 1905. A contest the following year, with a $250 prize, decided on Prince Rupert for the new city's name. Surveyors laid out a spate of identical townsites

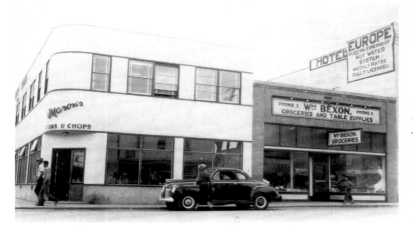

Prince George (here, Third Avenue in the 1950s, photographer unknown) is the most successful BC community to emerge from the GTP investment, due to its forestry and pulp mills and other industrial operations, and its location at the crossing of the BC Rail and CNR lines. Although it has all the services of a significant regional city, it has lost much of its downtown vitality to sprawling suburban development, including that of the University of Northern BC, opened in 1994, on its outskirts.

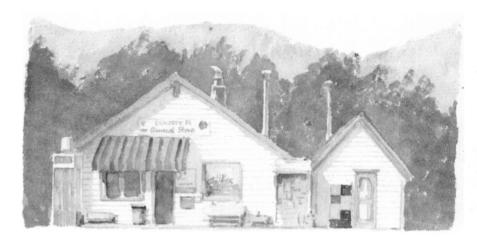

RIGHT *The Dunster store, a classic country emporium of human essentials and animal feeds.*

with standard-plan stations across the north, and breathless tracts extolled the possibilities of settlement, the fertility of the land and the excellent crops that could be expected from the long summer days. Work proceeded apace, and in spite of the GTP's nickname, "Grand Trafficker of Promises," the first through-train reached Prince Rupert in the spring of 1914. Six months later war began in Europe, immigration and colonization ceased and the British Columbia economy, already battered by the bust following its decade-long boom, was barely limping along. Even though its second rival, the Canadian Northern Pacific, was bankrupt by 1917, the GTP itself succumbed in 1919

BELOW *Arguably the prettiest station on the GTP, McBride's, recently restored with an excellent Beanery, is an absolute gem. The original McBride station burned in 1918 and was immediately replaced by this graceful structure.*[1]

1 Marilyn Wheeler, *The Robson Valley Story,* p. 132.

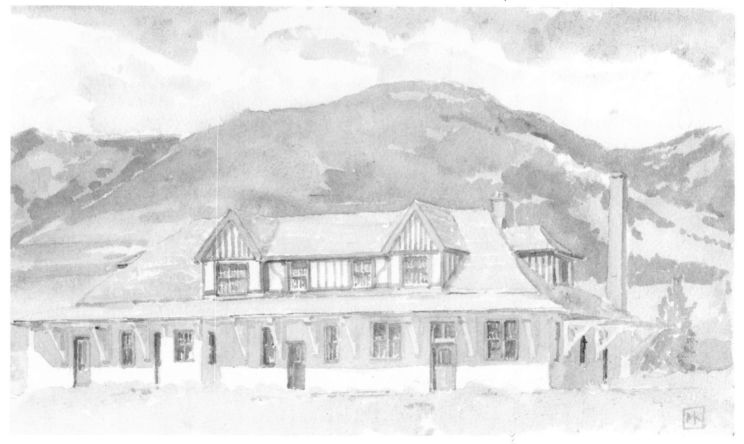

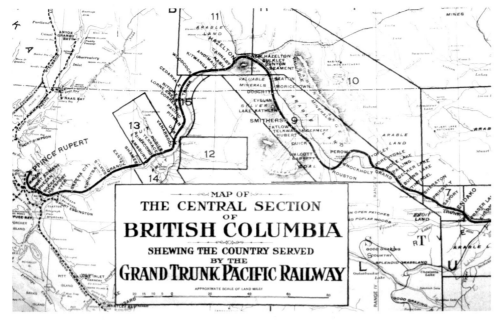

MAP OF
THE CENTRAL SECTION
OF
BRITISH COLUMBIA
SHEWING THE COUNTRY SERVED
BY THE
GRAND TRUNK PACIFIC RAILWAY
APPROXIMATE SCALE OF LAND MILES

LEFT *West of Prince George, some of the communities once served by the GTP no longer exist. Along today's Highway 16, only the road signs pointing the way to a "station road" identify their location.*
BULKLEY VALLEY MUSEUM
BELOW *The Kitwanga station, one of the once-common Type "E"s, survived until an arson fire in early 2003; it had been pulled away from the tracks, boarded up and set on blocks across the road from St. Paul's Church in Kitwanga Village, which is where I painted it in the winter of 1998.*

and was taken over by the Canadian government in 1920. Both lines became the Canadian National Railway in 1923.[1] Exactly 80 years later, CN's control of the north and its promise to reinvigorate the port at Prince Rupert gave it the upper hand in negotiations with the provincial government to take over BC Rail.

The identifiable GTP communities across the north range from tiny Dunster on the Upper Fraser River southeast of McBride to the divisional point named for Alfred Waldron Smithers, chair of the board from 1910 until the company collapsed. Once ubiquitous at villages and whistlestops across northern BC, the little Type "E" stations of the GTP provided a connection with the outside world. Almost all were placed on the north side of the track with the waiting-room end toward the east (probably so that the uninsulated buildings could take advantage of the morning sun).[2] Dunster has restored its station very close to the tracks, making it the least altered of the small stations in the province. There is a Type "E" station in Prince George at the Railway Museum, relocated from Penny, east of Prince George,[3] and another, the former Kwinitsa Station, restored on the Prince Rupert waterfront, not far from the terminus of the VIA Rail "Skeena" line, which uses the CN's tracks to cross British Columbia. Although the station at Prince Rupert was to have been designed by the legendary architect Francis M. Rattenbury and connected with a luxurious hotel in the midst of a thriving port and city, the modest, ramshackle building that emerged was the work of an anonymous CNR designer, supervised by General Manager A.E. Warren and Engineer H.A. Hixon of Winnipeg.[4] One other station, a size larger than the "E"s, is now, moved and modified with stucco siding and new windows in new positions, used as the Last Spike Pub in Fort Fraser.

1 A well-documented review of the GTP appears in George H. Buck, *From Summit to Sea*, pp. 66-89.
2 Kalman, *History of Canadian Architecture*, vol. 2, p. 483.
3 Correspondence from Kent Sedgewick. The Fraser Fort George Regional Museum website, www.settlerseffects.ca, has his photographs from the 1970s and 1980s of old GTP stations. Also see his work at web.unbc.ca/upperfraser/.
4 Thanks to Sue Rowse for research.

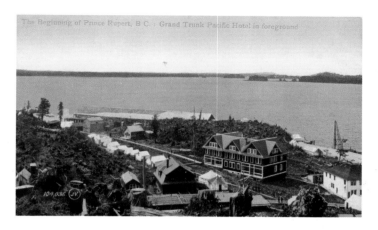

The Beginning of Prince Rupert, B.C.: Grand Trunk Pacific Hotel in foreground

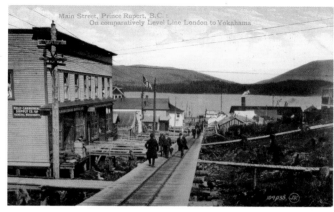

Main Street, Prince Rupert, B.C.:
On comparatively Level Line London to Yokahama

Squatters, Prince Rupert, B.C.

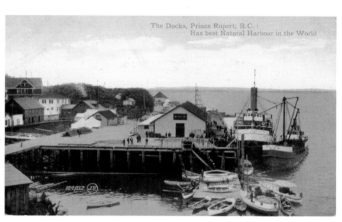

The Docks, Prince Rupert, B.C.:
Has best Natural Harbour in the World

Correspondence from John Rinaldi: "When we came to Canada in 1952 (I was five years old) we lived in that Kwinitsa station for a few days while my dad Richard Rinaldi was making arrangements to transfer to Telegraph Point, just a few miles from Kwinitsa. My dad worked for the CN for 35 years and for seven years of that we lived in Dunster. I have fond memories of living in that Grand Trunk station. We lived in about 10 different places on the CN system. The last was at Amsbury, just out of Terrace. We left there in 1963, when the CN had their big station shutdown. A sad time for many Class 'E' Grand Trunk stations. The station at Amsbury was burnt in 1963, along with many others."

The City of Prince Rupert is the BC equivalent of the prairie farmers' "next year country." Although the dreams of its promoters may have been unrealistic, its location ought to ensure eventual prosperity. It is still a transportation hub, with ferries to Alaska, Port Hardy and the Queen Charlotte Islands, and the 2003 privatization of government-owned BC Rail to CNR will perhaps result in investment and more traffic for its port. But fishing and the forest industry have fallen on hard times, causing the city's population to decline by more than 12 percent, to a little over 14,000 (less than one-sixth of Prince George's) from 1996 to 2001. The eventual fulfillment of its destiny may rest with oil and gas development, unimaginable to the railway and land promoters of a century ago.

ABOVE *Four John Valentine & Sons postcards, c. 1910, showing the beginnings of what was to be a northern metropolis – a port to rival Vancouver.*
BELOW *Prosperous Third Avenue West in downtown Prince Rupert during the 1960s – the heyday of the north's lumber- and fishing-based economy. Postcard for Wrathall Photofinishing by an unknown photographer.*

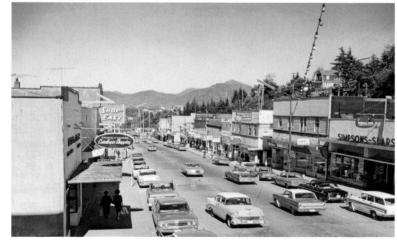

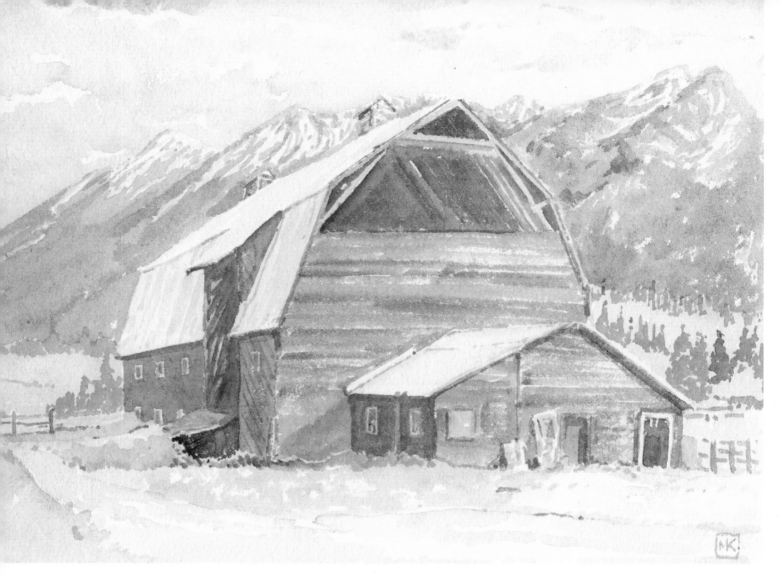

The Reitsma barn on the side of Highway 16 at Evelyn, in the spring of 2003.

L ush and green, the Bulkley Valley's promise of new, fertile land along the route of the GTP Railway brought farmers into the Smithers area a century ago. According to a 1914 booklet by local land promoters, the Japan current, "further moderated by the warm 'Chinook' or Chinese winds which blow in from the Pacific and reach the sheltered Bulkley Valley ... bring an abundance of rain for the maturing of crops and completely do away with the severe winter weather found in this latitude in other portions of the world. The long summer days, with eighteen hours of sunlight, and the temperate, well-balanced climate insure quick growth, while crop failure, woefully common in less favored sections of the North American Continent, is unknown here."[1]

The dot on the map called Quick, southeast of Smithers, is an agricultural community now attracting its share of artists and artisans. Quick Station Road is a loop from the highway that crosses a ridge and then winds down the hill, traversing a lush hay meadow to the bridge over the Bulkley River. Like most of the old bridges in the area, it is a single lane wide, with steel trusswork and a wooden deck. The old Quick store, now converted into a home, was run by Waldham Paddon for more than 50 years until it closed in the 1970s.[2] Quick's Anglican church, St. John the Divine, is in good repair on the western end of the Quick road, closer to where people live now that the focus has shifted across the river from the railway to the highway.

1 *Smithers,* republished in facsimile by the Bulkley Valley Historical and Museum Society, 1979.
2 Francis, *Encyclopedia of BC,* p. 588. Thanks to Rob Chaplin for background information.

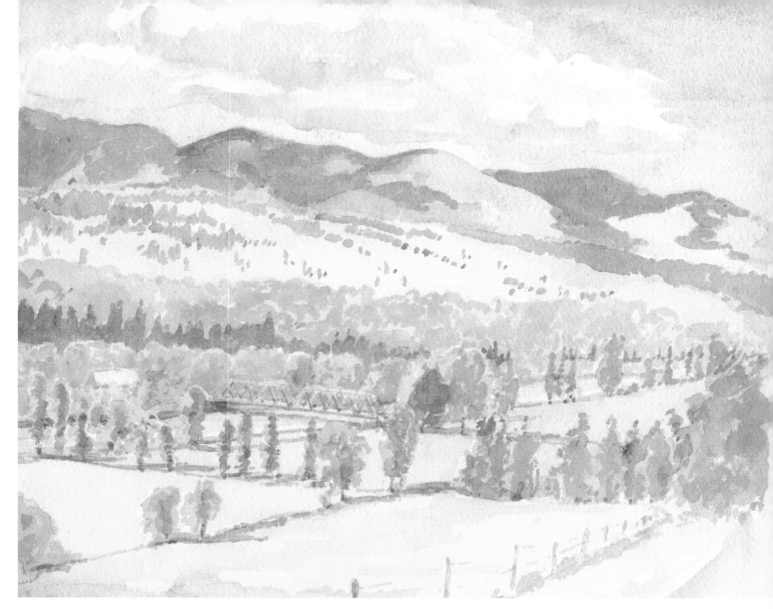

Another memorable farming landscape is at Evelyn, a grassy valley northwest of Smithers. The red barn is a roadside icon – unintentionally, as improvements to Highway 16 bisected the farm, leaving the barn on one side and the farmhouse on the other. It is architecturally interesting because it is a "bank barn," built on a slope, with the huge hayloft reached by a ramp and the cattle byre on the level below. This is the common style in Ontario and Quebec, but is rare in western Canada, where hay was usually loaded into the barn's loft using either a hook (in the loose-hay days) or a geared ramp for lifting bales driven by a tractor. The board siding on the long walls is nailed on diagonally to provide additional shear-bracing against storm winds. Regrettably, because of the ramp and the wide span over the byre, it is an impractical design for heavy modern tractors and 400-kilogram round haybales. Although the barn is quite an old-fashioned type of structure – a reinforced balloon frame – it was built in 1961 by farmer Jack Reitsma, a Dutch immigrant who moved to the area after arriving in Canada in 1950 and, like many of his countrymen, working for low wages for dairy farmers in the Fraser Valley. He soon moved north to work at a sawmill and in 1956 had saved enough to marry his Dutch fiancée. They bought the farm in 1960.[1]

Central Quick: the bridge crossing the Bulkley River, the roof of the former store visible above the trees at its far side.

1 Interview with Shirley Reitsma, 2004.

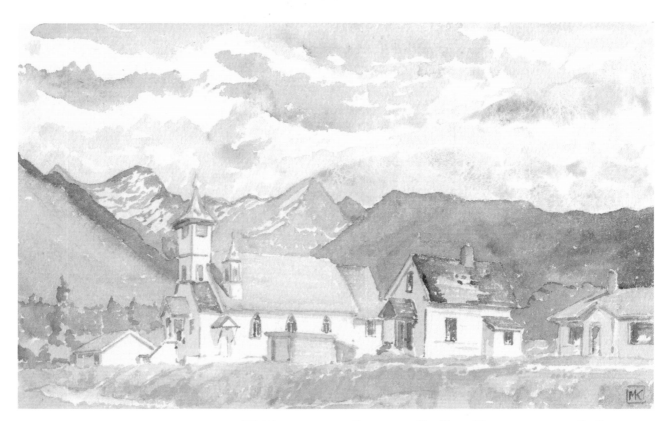

Hagwilget & Gitsegukla

ABOVE *Gitsegukla Village with its United church.*
BELOW *The second Hagwilget Bridge, and the village along the river. Photographs probably by Wilfrid Playfair.*[1]

VPL SPECIAL COLLECTIONS

1 *British Columbia Magazine*, October 1911, p. 1011.
2 See Barry Downs, *Sacred Places*, p. 153.

Gitsegukla is a Gitxsan village at the confluence of the Kitseguecla and Skeena rivers west of Hazelton, with a distinctive set of tall, slender totem poles. It also has an interesting old United church, originally Methodist, with sheet-metal spires, the main one of which has a "candle-flame" top. The setting is superb, with Mount Roche de Boule in the distance and a variety of village houses along the street. Perhaps only Hagwilget Village near Hazelton, with its Catholic church, St. Mary Magdalen, on the high ground, is as evocative of the missionaries and their once-dominant role in the villages along the Skeena. By comparison, the totem poles at Gitanyow and Kispiox dominate their villages.

Hagwilget, its church built by Father Morice in 1908, was the "outpost of Catholicism" in the Babine district; the villages to the west along the Skeena were divided between the Anglicans (such as Kitwanga with St. Paul's) and the Methodists at Kispiox and Gitsegukla.[2] Some people from the latter village who had become members of the Salvation Army founded the community of Glen Vowell near Kispiox in 1898; local carpenters there built a very handsome Victorian-style band administration office in the 1970s.

About 70 percent of the 10,000-strong Gitxsan Nation live on the traditional territories, most in five Gitxsan villages

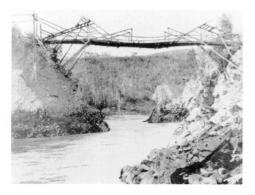

(Gitwangak, Gitsegukla, Gitanmaax, Glen Vowell and Kispiox) and two provincial municipalities (Hazelton and New Hazelton). The Gitxsan people make up about 80 percent of the total population living on the territories.[1]

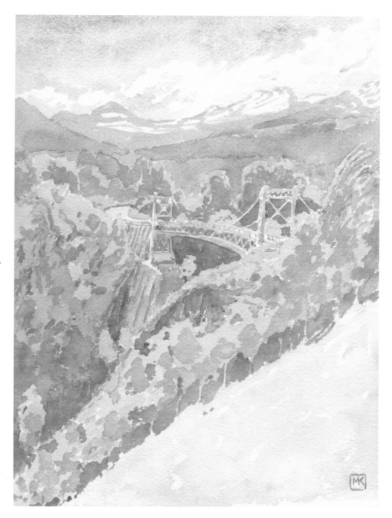

Although the 1930 Hagwilget highway bridge – one of the last single-lane bridges from the early years of auto travel – is a historic structure in its own right, it replaced an ingenious Aboriginal-built suspension bridge across the spectacular canyon of the Bulkley River near the old riverboat terminus of Hazelton in northwestern BC. The Natives at Hagwilget had devised a bridge of poles and rope generations before white settlement began in the 1860s. When the Collins Overland Telegraph (sometimes called the Siberia-Alaska Telegraph) was abandoned following the successful laying of the Atlantic cable in 1866, the Hagwilget reinforced their bridge with some of the cable left lying in the woods. The nearby Gitxsan village of Kispiox, renowned for its totem-pole carvers, is the site of the blockhouse that was the end of the operating section of the line. The telegraph line was later resurrected to provide a connection with Dawson City during the gold-rush years of c.1900.

Travel writer Wilfrid Playfair gave a sympathetic account of the bridge and its Native builders. "Hagwelget [sp. in original] will be one of the chief attractions for tourists in the country. Its outstanding feature from this point of view is a very ingenious bridge over the canyon ... while a rickety-looking structure, the bridge is very strong and does not trouble when you cross it. Undoubtedly some day the site of this will be used for a high-level bridge over the Bulkley, this fact also being a tribute to the engineering abilities of the Hagwelget Indians."[2]

Photographic evidence indicates that the current bridge is in fact the fourth across the canyon: the original a pure suspension bridge; the second a combination of cantilever and suspension (the one Playfair wrote about); the third, which appears to be a copy of the original Alexandra Bridge-type of suspension bridge built by the Royal Engineers in 1862 and which must have been built c. 1912-4 and removed c. 1930; and the extant bridge.[3]

The upgrading of the 140-metre-span bridge in 1990 by engineers Buckland & Taylor Ltd. increased its load capacity and won the firm an award of excellence from the Consulting Engineers Association of Canada. Five kilometres past the bridge, 'Ksan Historical Village today interprets traditional Native culture.

ABOVE *A view of the Hagwilget Bridge spanning the Bulkley River's dramatic canyon, in the traditional territory of the Gitxsan-Wet'suwet'en, in 2003.* BELOW *A painting on a Royal Grafton teacup, No. 62, c.1950, of the famous bridge.*

1 Chief's Page, www.gitxsan.com.
2 *British Columbia Magazine*, October 1911, p. 1011.
3 Photographs A-06048, A-04015, A-04014 at www.bcarchives.gov.bc.ca.

Two watercolours from Burns Lake, one of the prettier villages along Highway 16 west of Prince George. As the highway goes through the town, rather than bypassing it, there is no highway strip of commercial buildings such as those sucking the life out of Vanderhoof or Smithers, for example. ABOVE *The last "log house" in Burns Lake's downtown, at 22 Fifth Avenue on the corner of Government Street, was boarded up and for sale in the summer of 2003. The door on the right opens onto an enclosed outside staircase that ascends the far side of the building, providing access to an upstairs hall. Correspondence from Russ Brown, Toronto: "For most of my growing-up years (1970s, early 1980s), that was the home of the high school principal and his family. My dad advises that indeed it was at one time the local high school." For a time in the late 1940s, "when the high school had outgrown Andy Anderson's old home, one division had used the basement of the Anglican Church and the other two divisions remained in the old building."[1]*

BELOW *The old manse for St. John's Anglican Church on First Avenue at Centre Street, with the church on the slope below and the roofs of the downtown in the middle distance. The building is a very nice "pattern-book" Craftsman erected in 1922. Russ Brown: "In the church building itself, the windows were shipped from a Toronto parish (Church of the Messiah, at the corner of Avenue Rd. and Dupont), the stove came from a local hotel, and the church bell was donated by the CNR from one of its old trains." Correspondence from Michael Turkki, clerk of the village of Burns Lake: "The municipality purchased St. John's Anglican Church from the Diocese of Caledonia last year. The church is a municipal heritage building and will be preserved. We envision the church being available for rental (weddings, etc.)."*

1 Pat Turkki, *Burns Lake and District*, p. 121.

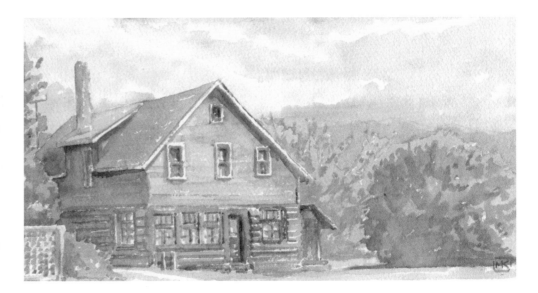

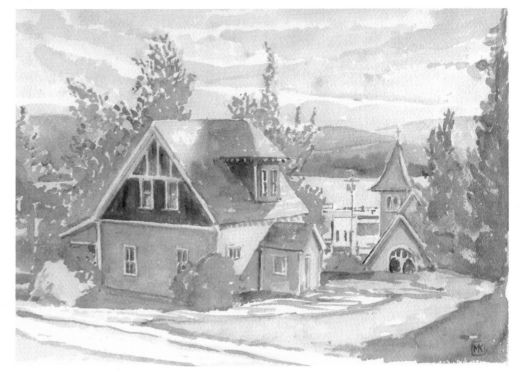

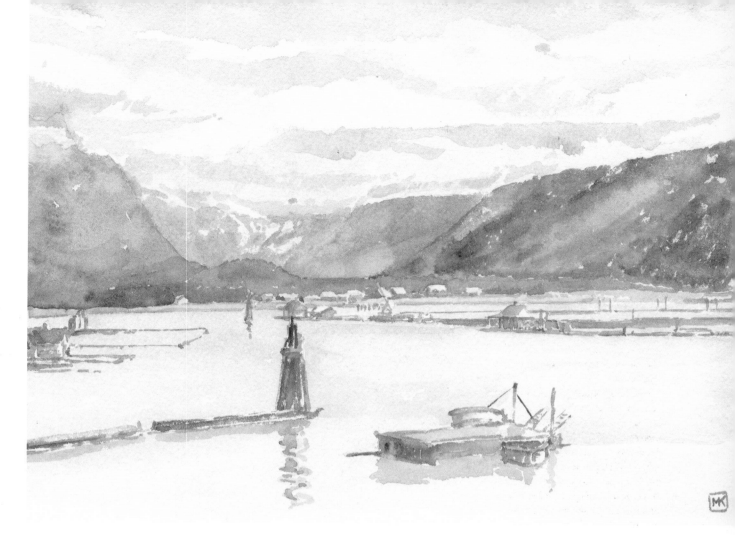

Stewart

. .

S tewart, at the head of the Portland Canal on the Canadian edge of the Alaska Panhandle, began as a supply centre for local mines but was rapidly boosted into the status of a northern metropolis, its location promising easy access to the untapped riches of northern BC and Alberta. An example of the lunacy of the times, comparable to the overexpansion of telecommunications and dot-com firms in the 1990s, was the commencement of work around 1910 by railway barons Mackenzie and Mann of the Canadian Northern Railway on the Canadian *Northeastern* Railway, with its terminus at Stewart and a proposed connection directly eastward with the Peace River wheatlands and Edmonton. Meanwhile its rival, the Grand Trunk Pacific, was furiously laying track to its own northern terminus not far south at Prince Rupert.

Although prospector Robert Stewart incorporated a land company in 1906 to promote his namesake townsite, the key to its brief boom appears to have been initial investments by Alvo von Alvensleben and partner E.P. Davis in a 160-acre townsite on its eastern side called Portland Canal. The pair sold its lands to the Canadian Northern Railway in August 1910. The 25 x 100-foot lots were placed on the market by the railway's Townsite Department; T.S. Darling, the manager in charge, sold them along with lots in Port Mann from the same office in Vancouver.[1] News that the Canadian Northeastern Railway

The town of Stewart at the head of Portland Canal, with the Bear River Valley stretching into the distance and a log pond with floathouses on the right. I sat on the wharf used for ore shipping from the local mines; behind where I sat, about 200 metres further down the road, is the international boundary (with customs only on the Canadian side) and the town of Hyder, Alaska.

1 "New Townsite of Portland Canal: Canadian Northern Lays It Out Adjoining Stewart, & Lots Are Now On Sale," *Province*, August 24, 1910, p. 7.

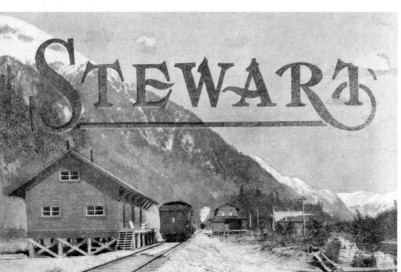

had commenced work in the spring of 1911, grading eastward up the Bear River Valley, confirmed in many minds the potential of Stewart as Canada's most northerly Pacific port. Thirteen miles of track were laid before the project was abandoned and today the grade forms part of the Stewart-Cassiar road.

The Canadian Northeastern was not the first attempt at a northerly railway by Mackenzie and Mann. In 1898, under the banner of the Canadian Yukon Railway Company, they signed a contract in Ottawa to lay track from Telegraph Creek to Teslin Lake, with a supplementary provincial agreement to construct south from the Stikine to an undesignated BC port, with the intention of creating better access to the Atlin area.[1]

Stewart promoter Alvo von Alvensleben was one of the most flamboyant speculators in BC before the First World War. He was born in Westphalia in 1879, a "second son" who was said to be a count. He arrived in Vancouver almost penniless in 1904 but had soon wheeled and dealed his way to success. He is said to have channelled millions of dollars of German investment into British Columbia in the first decade of the twentieth century, his projects including the Portland Canal development; the Dominion Trust building at Hastings and Cambie in downtown Vancouver and the Vancouver Docks proposal of 1909; Pacific Coast Fisheries, which erected a $300,000 cold storage, ice and reduction plant in 1909 at Pacofi Bay on the east side of Moresby Island in the Queen Charlottes;[2] and Wigwam Inn on Indian Arm, completed in 1910 for him and fellow developer Benjamin Dickens, and seized by the custodian of enemy property in 1914.[3]

Henry J. Boam recorded that Alvo von Alvensleben Ltd. "mainly operate[s] in 40-acre farms on Vancouver Island, situated not more than 10-15 miles from the railway."[4] A biographical sketch in *British Columbia Magazine* talks of his proposal to put the "idle lands" of the north to work as profitable grazing lands.[5] Thereafter, though, it being wartime, his motives were seen in a different light. In an undated and anonymous newspaper article entitled "Last of Alvensleben Party Now Being Interned," the writer claimed: "It is further stated that Alvensleben used money put up by members of the court circle to buy immense tracts of coal lands in the Ground Hog district [east of Stewart] and in his promotion here of an outpost of the Kaiser's empire he had also taken options on great areas of lands upon which he planned to place German settlers."[6] After spending the first years of the First World War in the USA, he was interned for the duration. Upon his release he resumed his activities on both sides of the border, eventually becoming an American citizen in 1939. He died in Seattle in 1963. His daughter Margaret, a journalist, "earned a living by her typewriter most of her life." She married the Canadian abstract artist William J.B. Newcombe, a member of the well-known Painters Eleven group, and lived with him for many years in Spain, England, and the Mexican artists' colony of San Miguel de Allende.[7]

War, depression and low metal prices drove most of the settlers and prospectors away from Stewart, but some began to return in the expansive 1920s. The town was on the regular run of CNR steamships including the SS *Prince Rupert*. The railway idea was revived in 1928 by Conservative MP Harry H. Stevens, the minister of trade and commerce in the Meighen administration of the early 1920s (and subsequently in the Bennett one). He and his London-based associates had "secured ample capital to take over all the railway and land interests of Sir Donald Mann in [the Stewart area], and we are proceeding as rapidly as the season will permit with reconditioning the existing line of railway."[8] But another round of depression and war intervened, and when mining again became profitable, under the banners of the Premier, the Big Four, and the Granduc Copper Mine, it required a relative handful of workers compared with the old days. The Ground Hog district remains quite inaccessible to this day.

Largely due to the efforts of architect-entrepreneur Frank Kamermans, Stewart's main street is splendidly restored. It is busy during the season with tourists, many of them Americans intent on seeing Hyder which, like Point Roberts near Vancouver, can be reached by land only from Canada.

1 V.R. Cox and A.G. McIntyre, *Yukon Railway Feasibility Final Reconnaissance Report*, Office of Engineer of Location and Construction, CNR, January 1969.
2 Dalzell, *Queen Charlotte Islands*, vol. 2, p. 235.
3 Luxton, *Building the West*, pp. 354-5.
4 *British Columbia*, pp. 207-8.
5 Vol. 7, pp. 1303-12, May 1914.
6 Matthews clippings, CVA, M 214. See also Kluckner, *Vancouver the Way It Was*, pp. 50-1.
7 Obituary published in *Seattle Times*, August 8, 2004. Thanks to Paul Crawford, Grand Forks Art Gallery, for further information.
8 *Stewart the Gateway City*, Stewart Advancement League, 1928, p. 23 (reprinted in facsimile by Bitter Creek Cafe).

ABOVE *The Empress Hotel, at the corner of Fourth Avenue and Brightwell in Stewart. Closed, but potentially restorable, it was built in 1908 as part of Alvo von Alvensleben's investments in the area, and was likely intended as a base for the Canadian Northeastern Railway. I could not resist painting the truck, a Ford Model 45, once operated by Lindsay's (1973) Ltd., travelling the route from Prince Rupert to Terrace and Stewart. It seemed a nostalgic reminder of the days before 18-wheelers came to dominate all long-distance trucking.*
RIGHT *Alvo von Alvensleben, about 1912.*
WHO'S WHO IN CANADA, 1913 EDITION
BELOW *Advertisement reproduced from* British Columbia Magazine, *July 1911.* VPL SPECIAL COLLECTIONS

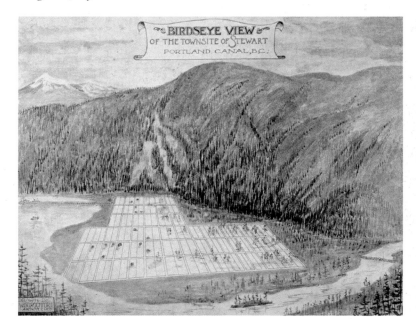

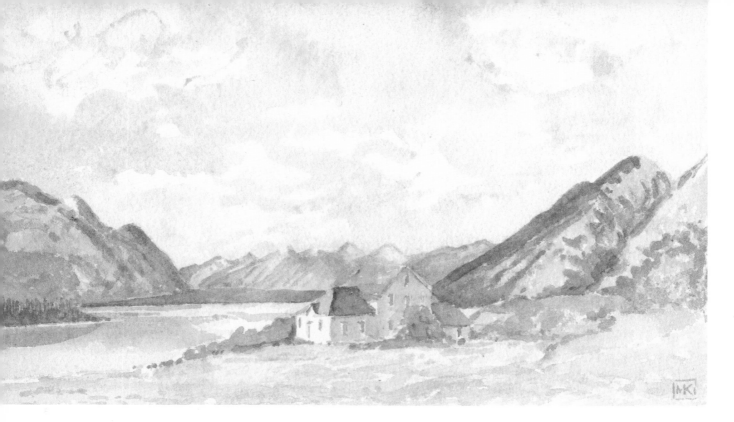

Atlin

.

Characteristically of Atlin, the former Atlin Hospital, now the Glaciological Institute, began life elsewhere – as one wing of the Atlin Inn, built in 1916 on the waterfront directly in front of the town. In 1942, six years after the hotel closed, this wing was dismantled and moved to the north end of town. In the 1950s it was a Red Cross Outpost Hospital under the control of Norah Roxborough Smith, R.N.[1] Sue Morhun, who lived and worked in Atlin in the early 1970s, recalled Nurse Smith talking about having to rig umbrellas over a patient's bed during spring breakup because the roof leaked so badly.

1 John Keay, Atlin inventory, file N-29 1987, Provincial Heritage Branch library.
2 Atlin Museum.
3 Bennett-Atlin Commission, 1899, BC Archives GR-0004; also journal at GR-0223.

Fritz Miller and Kenneth McLaren registered the first gold claims on Pine Creek near Atlin in July 1898, the summer when thousands of stampeders ascended the Chilkoot Pass, carrying a year's supply of provisions on their backs, en route to the distant Klondike. A number of prospective millionaires changed course and headed for "nearby" Atlin; joining them were many of the workers on the White Pass and Yukon Route, which had begun construction from Skagway in May, who took their picks and shovels, but not even their pay, with them as they rushed to get to Pine Creek ahead of the mob. By the end of August, more than 500 new claims had been registered; eventually, about 10,000 people lived in Atlin, Discovery and along the creeks.[2]

A number of miners had difficulty registering their claims, as they tried to do so in the Yukon, being unaware that Atlin is south of 60° north latitude and thus in British Columbia. Justice P.E. Irving headed a special inquiry to settle claim disputes caused by the geographic confusion.[3] Further complicating the process was the BC government's Alien Exclusion Act, denying free miners' licences to the many American miners in the area; following an uproar, including a protest letter from the US president, the Canadian government disallowed the BC legislation.

A glance at a map of the area shows long lakes filling mountain trenches and running more or less north to south toward the Alaska Panhandle. The same rail route that connected the outside world to the Klondike – from Skagway to Bennett, then northward along the lake to the Yukon River – allowed relatively easy access southward along Tagish Lake (the winter route went from Bennett; the summer steamboat route from Carcross). There was only a narrow strip of land that needed to be portaged between Taku on the east side of Tagish Lake and Scotia Bay on the west side of Atlin Lake; from

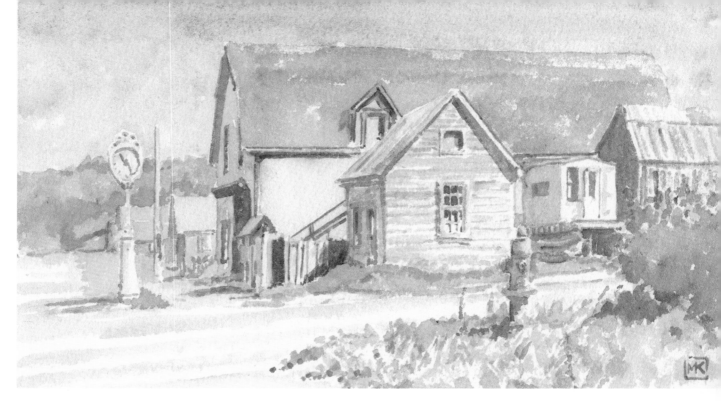

there, it was an easy trip across Atlin Lake to the mouth of Pine Creek, the goldfields, and Atlin Townsite itself.

Although the gold fever soon cooled, tourism increased, prompting the White Pass company to build a four-storey resort hotel called the Atlin Inn on the town's waterfront, and to launch the MV *Tarahne*, a gasoline-powered, propeller-driven lakeboat with an observation deck lined with wicker viewing chairs. The rustic hotel needed regular expansion to keep up with the demand, so that by 1928, with a third wing added, it dominated the Atlin waterfront. Guests played tennis and golf, walked, hiked, and visited the gold mines and the Warm Springs in McLaughlin-Buick touring cars. There were moonlight cruises and dancing to the Atlin orchestra.

However, by 1936, after several years of economic depression, tourism had declined to such a point that the White Pass company closed the inn and beached the *Tarahne* on the waterfront, where it remains today. Atlin slipped back into an isolation relieved only in 1949 by the spur road connecting it to the Alaska Highway. Today, the stores, supermarkets and airport of Whitehorse are about an hour and a half away; Atlin itself has a post office, cafe and a handful of other businesses.

The courthouse, built in 1900, was designed by stampeder and architect Edward Garden.[1] Its main floor has four rooms, two on each side of a central hallway. One side is judge's chambers and the court-room, the other was the mining recorder's office and gold commissioner's office (now used for the community library). Upstairs, the private residence of the gold commissioner was converted in 1988 and is now used by Northern Lights College. The courthouse was in use from 1900-56, at which time it was moved to its present location. Empty for a decade, it became a private residence and gallery from 1967-73, then was

ABOVE *The former Jules Eggert jewellery store, with the tiny former Discovery jail beside it. His clock has been on the street since 1921, and tells the correct time — twice a day at 10:20.*
BELOW *The former holistic health centre of Dr. Branigan, its pyramidal shape channelling cosmic energies to earth, with the Atlin courthouse further along the street.*

1 BC Archives GR-0054, box 28, file 442.

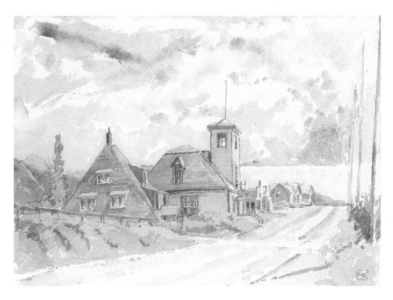

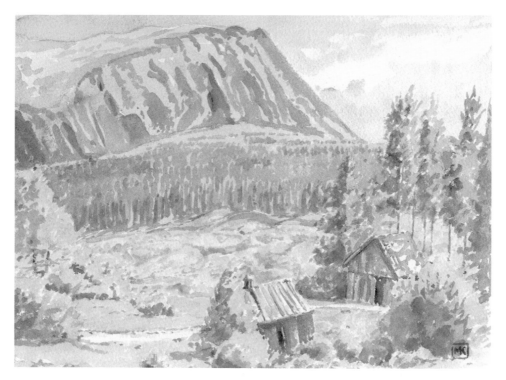

The remains of Discovery: these two dried-out shacks, the near one containing the jumbled possessions of a packrat and an ancient rusted bedstead, and two other squared-log cabins along Discovery Road, which continues for many miles into the hinterland toward new mining claims and timber leases. The former townsite is now the moonscape of dredge spoil in the middle distance.

restored by the Atlin Historical Society. Since 1976, a circuit court judge has visited Atlin several times a year and uses the historic courtroom.

Next door is a relatively new addition to the community: a building with a pyramid roof. It is the former holistic healing centre built by Dr. Donald Branigan in the 1970s. His obituary noted that he was a former staff member at Whitehorse General Hospital and was elected mayor of Whitehorse four times. Less conventionally, he once performed "psychic surgery" on national TV, and used "bio-energy therapy" at his Whitehorse clinic, together with alternative treatments for cancer, that earned him a reputation as either a visionary or a madman.[1] The Atlin holistic centre is mentioned once on the Internet by "Cindy" who was led to it in 1985 by a UFO.[2]

Atlin's government agency, in a low modern building, now occupies the original site of the courthouse. The latter, the 1902 school and St. Martin's Anglican Church (the only one of the three still on its original site) were on the edge of the town core, avoiding Atlin's catastrophic fires of 1901 and 1914. Jeweller Jules Eggert's 12-year-old building burned in the 1914 fire, leaving only its concrete vault standing (in which, legend says, his wife's butter survived without melting). His newer store, now Atlin's post office, has pressed-metal "stonework" on its facade, as has the building across the street, to give it a more substantial look than the board and shingle boomtown-fronted buildings elsewhere in town. The little cabin next to it is the two-cell Discovery jail, built in 1902 and deceptively solid, its walls consisting of 2 x 6s laid flat atop each other. Other old town buildings such as the Moose Hall and St. Joseph's Catholic Church were skidded the dozen kilometres from Discovery.

One discovers Discovery mainly because so many of Atlin's buildings were moved from there. Apparently, miners removed most of its buildings in order to dig and dredge through every bit of dirt and gravel near Pine Creek once the original placer claims were exhausted. Accordingly, there is almost nothing left of Discovery itself – just heaps of gravel with the creek running through the middle.

1 *Canadian Medical Association Journal*, October 19, 1999.
2 www.ufobc.ca/yukon/gianttagish.htm.
Sue Morhun and Kate Fisher added further information. Thanks to Brent Slobodin for taking me from Whitehorse to Atlin.

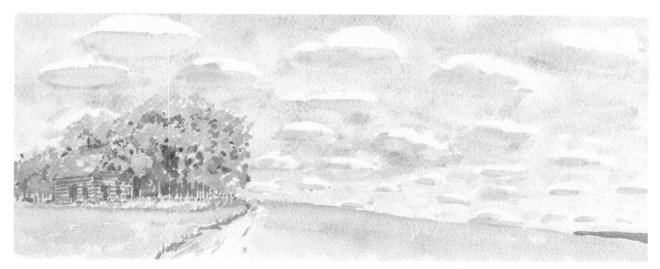

The Peace

The "Last West" captivated the imaginations of adventurers and home-steaders from the time of the first railway surveys in the 1870s until its modern era commenced with the construction of the Alaska Highway during the Second World War. Indeed it is still a compelling frontier, in the modern sense of the word, due to the ongoing oil and gas boom – jobs and prosperity for young families as sweet as the promises of land and freedom were to earlier generations. And still the aura of adventure, the fur trade and the untrammelled wilderness clings to it in spite of paved roads, cell phones and the other necessities of modern life.

The Peace first entered the written record through the journals of Alexander Mackenzie, whose overland trip to the Pacific in 1793 on behalf of the North West Company triggered an era of trading with the Natives. Either he or his associate John Finlay founded Rocky Mountain House at the confluence of the Peace and Moberly rivers about 1793-4 – the first permanent non-Native settlement in what became British Columbia.[1] Successor Simon Fraser established Rocky Mountain Portage House in 1805 on the south bank of the Peace River across from the modern site of Hudson's Hope, "portage" referring to the land route around the spectacular Peace Canyon. Later that year, Fraser established a trading post at McLeod Lake, then the following year Fort St. James and Fort Fraser. In 1807 he built Fort George, now Prince George, and the following year descended his namesake river to its mouth.

The Parsnip and Finlay rivers meet and become the Peace River in the Rocky Mountain Trench, the Peace then flowing in an easterly direction into Alberta; upstream from the Peace Canyon near Hudson's Hope, due to the construction in the 1960s of the W.A.C. Bennett Dam, the rivers have become the Lake Williston Reservoir. The "Peace Country," a rolling westward extension of the prairies, becomes part of British Columbia at the 120th meridian. "If it had not been for the discovery of gold in 1861 and 1862 along the banks of the Peace and the Parsnip rivers by Bill Cust and Ed Carey ... the Rocky Mountains and not the 120th meridian would have formed the northern half of the interprovincial boundary," wrote Gordon Bowes.[2] During that era, the land to the east was British territory under the nominal control of

The old log homestead on the Darnall farm just north of Fort St. John – a beautiful property off Rose Prairie Road north of Fish Creek with long views over the rolling prairie. Ross Darnall and his wife Margaret came to Fort St. John in 1928 in a covered truck from the USA via Edmonton and Grand Prairie, loaded down with stoves, agricultural gear and their four children. They stopped on the side of the dirt track when it rained, pitched their tent and resumed their trek when it dried out.[3]

1 Fort St. John museum.
2 Gordon E. Bowes, ed., *Peace River Chronicles*, p. 12.
3 Davies and Ventress, *Fort St. John Pioneer Profiles*, p. 71.

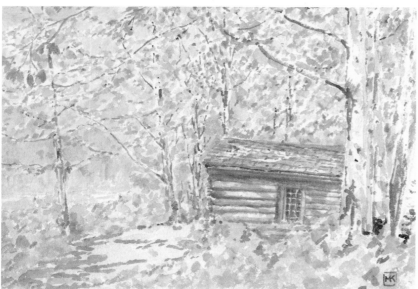

the Hudson's Bay Company, so the British Columbia colonial administration quietly moved the boundary eastward to be certain of sovereignty over all the known gold-producing areas.

The area entered the public consciousness due to surveys for the Canadian Pacific Railway in the 1870s. That of surveyor Charles Horetzky and botanist John Macoun in 1872 hinted at the area's agricultural promise and noted its easy grades to salt water: a climate "almost as warm as Belleville in Ontario" and the potential of an ocean terminus at Kitimat. More significantly, Horetzky argued that a line to a terminus at Burrard Inlet would run "for 600 miles through an irreclaimable wilderness" – the mountains of southern BC. Regardless, following an 1881 decision of its directors, the Canadian Pacific Railway pushed west across the southern prairies and BC to Burrard Inlet. Debate continued for years about the Peace's climate, until the introduction of early maturing Marquis wheat in 1909 ended any doubt about the area's agricultural value.

With much of the American plains and Manitoba broken to the plough, the new frontier captured the public's interest. The first and most significant chronicler was William F. Butler, a British army captain who first visited the North West in 1870 (the year the Hudson's Bay Company sold its trading monopoly interests to the Canadian government). His books, especially *The Great Lone Land*, published in 1872, not only stimulated readers' imaginations, but promoted better treatment for the Natives and the establishment of the North West Mounted Police. Other adventurous authors, including Hubert Footner, Hugh Savage, Philip H. Godsell and Paul Haworth, wrote travel books extolling the wilderness, hunting and trapping – even then a romanticized, outdated way of life.

"Deadly" or "Dudley" Shaw, more properly Reginald Withers Shaw, is one of the many characters in the Peace area whose exploits became the fodder of literature. As a 23-year-old in 1903, he boarded a ship from England to Canada and met a man going out to join the Barr colonists in the Lloydminster area. Shaw drifted farther west into northern British Columbia where he worked on survey crews and learned to trap. His nickname arose because of his frequent use of the word "deadly," usually referring to the quality of camp food. He homesteaded near Hudson's Hope in 1912, one of the early permanent non-Native residents near the village's Hudson's Bay trading post. A classic eccentric, he was said to have gone "out" only twice: the first time to Edmonton to attempt unsuccessfully to sign up for the army at the beginning of the First World War, the second in 1926 to Fort St. John. Nevertheless, he became widely known, partly due to his weekly news column written for the *Alaska Highway News*. Missionary Eva Hasell and a companion stopped by in 1928: "He gave us tea in his spotless shack, where he lived all

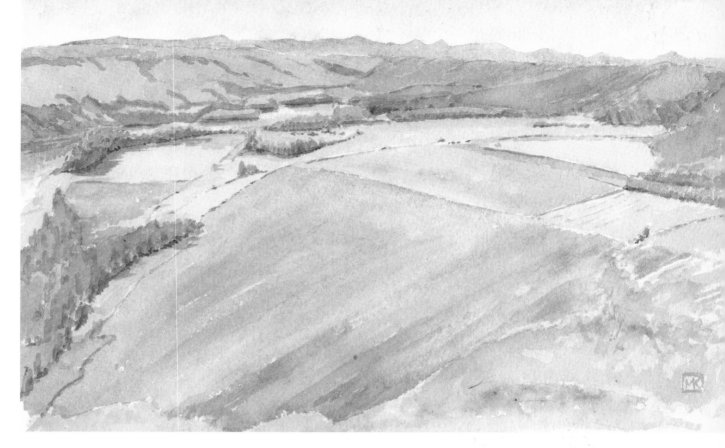

alone with his yellow cat, for whose convenience a hole was made in the door
... He thought there were far too many new people coming in; he would have
to build a new cabin further in the forest."[1]

In the 1950s, writer Bradford Angier used Hudson's Hope, and his
friendship with trappers and characters including Shaw (in *At Home in the
Woods* and *Wilderness Neighbors*), as the basis for a series of books on wilderness
living that caught the "back-to-the-land" wave. Until his death in 1965, Shaw
received fan mail and the occasional visit. A disciple of Henry David Thoreau,
Angier had moved from Boston to Hudson's Hope in 1947, leaving behind a
career in advertising, and soon became a guru of wilderness survival skills and
simplified living. Angier and his wife Vena bought Shaw's cabin in 1969 and
lived in it for the next few years, continuing to write their popular back-to-the-
land books. Another writer, John Onslow, kept the colonial dream alive in
England with his 1962 novel
Bowler-Hatted Cowboy.

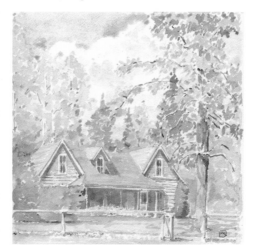

The expense caused to the
Dominion by the "irreclaimable
wilderness" of BC's southern
Interior forced British Colum-
bia in 1883 to agree to give it
3.5 million acres of "unalien-
ated arable land" in the Peace
River District as compensation.
The commitment to this "Peace
River Block" kept settlers out
of the area for 25 years. Finally,
in 1907, federal government

ABOVE *The old Tompkins ranch at
the Halfway River on the Peace,
midway between Hudson's Hope
and Fort St. John, looking west to
the Rockies. On the September
morning while I was painting,
coyotes or wolves were howling
and socializing on the far side of
the river. The dot on the map
there is Attachie, the name chosen
for a post office at the mouth of the
Halfway River. Attachie was one
of the signatories of the Beaver
Indian Treaty 8 in 1899; his
eldest daughter, Bella Yahey
(c.1858-1976), was reputedly
the longest-lived woman in
Canada.*
LEFT *The Ardill ranch house, an
unusual and very fine squared-log
home along the Peace River. Jack
Ardill visited the area as a
surveyor before the First World
War and returned to settle in
1919.*

1 Quoted in Bowes, p. 422.

surveyors selected land centred roughly on Fort St. John which, after adjustments, extended from the Alberta border westward for about 120 kilometres to a point just west of Hudson's Hope, and about 116 kilometres from north to south. Homesteaders began to take up land and the government began to promote it with printed material, the first being A.M. Bezanson's 1907 report entitled *Canada's Fertile Northland* (wherein the term "The Last West" was used), to smooth the rutted track for potential settlers. The 1913 depression, the subsequent war and the lack of a railway connection greatly slowed the influx of settlers which, although it resumed following the war with placements by the Soldiers' Settlement Board, did not begin to achieve its potential until the completion of the Northern Alberta Railway line into Dawson Creek in 1931. In 1930, the federal government turned back control of the Block to the province.

The ultimate Peace Country adventurer was Charles Bedaux. A successful businessman who gloried in publicity and what would subsequently be labelled a jet-set lifestyle (including a close friendship with the Prince of Wales and Mrs. Simpson), he launched in 1934 the "Bedaux Sub-Arctic Expedition" with the intention of travelling by Citroën half-track cross country from Fort St. John to the Alaska Panhandle. A boon to the Depression-ravaged area, worth perhaps $250,000, the disastrously unsuccessful expedition comprised about 50 people, including Mme Bedaux, her companion Mme Chiesa and her Spanish maid Josephine, 130 horses, 1 of which carried only women's shoes and another French novels, and a throng of filmmakers, local roustabouts and cowboys.[1]

More prosaic perhaps, but considerably more useful, were the efforts made in the 1930s by bush pilots including Grant McConachie (founder of Canadian Pacific Airlines) to establish a series of airstrips between Edmonton and Alaska via Fort St. John. With the beginning of the Pacific War and the Japanese threat to Alaska, the American army decided in 1942 to build the Alaska Highway following this Northwest Staging Route. The airstrips and thus the road were too far east to be in danger from carrier-based Japanese bombers, for otherwise the road (or railway, as was mooted) might have headed northward further west along the Rocky Mountain Trench. For the Peace it meant a wartime boom – the exact opposite effect of World War I.

Other Bedaux-like characters who streaked across the Peace's firmament like comets included Major General Francis Arthur ("One-Arm") Sutton, a colourful promoter whose fortune resulted from his work as a munitions and military expert to Chinese warlord Marshall Chang-Tso-Lin. With the sometime assistance of flamboyant Vancouver lawyer and MP Gerry McGeer,

ABOVE *A "flooded farmhouse" on Sweetwater Road – the yellow grain flows over the land, turning copses of aspen into islands and marooning abandoned farmhouses, their roofs the only things visible above the waving sea.*
RIGHT *The former Grand Haven dance hall, now the clubhouse of the Fort St. John Moosemen Rugby Club and Fort St. John Flag Football, at Forster Field, on 269 Road south of the Alaska Highway. An interesting hexagonal log building with moose-antler decoration.*

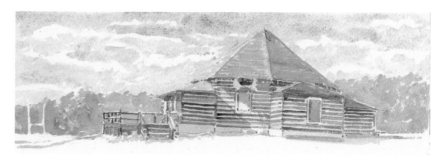

he promoted in 1927-8 a railway line from Quesnel, which at the time was end-of-track for the provincially owned "Prince George Eventually" (officially the Pacific Great Eastern, more recently BC Rail), to Prince George and thence through the Peace.[2] Thirty years later a kindred spirit, the Swedish industrialist Dr. Axel Wenner-Gren (controversial, like Bedaux, for his alleged "trading with the enemy" as part of an international munitions cartel during the Second World War), entranced BC premier W.A.C. Bennett with proposals for development in the Rocky Mountain Trench.[3]

The transportation issues which Sutton and Wenner-Gren attempted to address most affected the grain farmers on the prairie between Pouce Coupe and Rolla, a hamlet to the north about 10 kilometres west of the Alberta border. It is on the checkerboard of roads and grainfields that extends the standard prairie grid into BC, and was the first part of the Peace River Block settled after the First World War. Today, with farmers and oil workers ranging easily over its paved roads, it is hard to imagine how difficult life was before the Northern Alberta Railway arrived in Dawson Creek in 1931. "It was a standing joke among the settlers that the Victoria officials had never even heard of Rolla or Pouce Coupe," wrote Gordon Bowes.[4] Victoria was expected to provide roads, schools, police and other services. It did provide a government liquor store in Pouce Coupe – the only one in the entire district – but it failed to build a hospital, leaving that chore to the Alberta Red Cross, which opened an outpost hospital at Pouce Coupe in 1921. Australian-born

The Rolla Pub, at the corner of the Sweetwater Road and the Rolla Road. Pouce Coupe is 25 kilometres due south – that is, over the hill in the distance. Proximity to the stores at Dawson Creek has caused much of Rolla's business to close. In 1927, journalist E.H. Lukin Johnston called it "the metropolis of the northern part of this splendid farming area. We found it a little town of about 50 inhabitants with two hotels, stores and implement dealers, and the usual appurtenances of a small farming town."[5]

1 See George Ungar's 1996 film *The Champagne Safari.*
2 David Ricardo Williams, *Mayor Gerry*, pp. 75-8. His autobiography is *One-Arm Sutton*, Macmillan, 1933.
3 David Mitchell, *W.A.C.*, pp. 286-90.
4 Bowes, p. 349.
5 Quoted in Bowes, p. 411.

Ida Crook was its second matron, staying from 1923-35. She noted laconically that "the 30 or 40 mile drive home in sleighs with new babies, when the weather is 20 or 30 below zero, is a panicky thought if you're not used to it, but the pioneer parents seemed to know how to do it the right way."[1]

The journalist E.H. Lukin Johnston, who travelled through the area in 1927, wrote vividly about the problems it was having in fulfilling its destiny. The farmers around Pouce Coupe and Rolla had to haul their grain to the NAR railhead at Spirit River, Alberta. "Fifty-two below zero, a biting wind from the northeast. Five o'clock in mid-January and darkness already dims the road ahead. An endless line of heavy-laden sleighs creeps slowly onward along the tree-bordered trail from the west where Pouce Coupe and Rolla lie. The drivers, muffled to the ears in heavy furs but too cold to sit atop their loads, trudge along behind their sleighs."[2] On the end of the second day the teamsters were 40 miles from home, with 20 to go; they stopped at a huge barn, unhitched their teams and led them inside to be fed, then retired to a bunkhouse where they thawed their evening meal. By this age-old method they hauled 300,000 bushels along a roadway that was effectively the roadbed for the incomplete railway.

The Peace's first links to the rest of BC came about due to public investment. The John Hart Highway, named for the Second World War premier, was completed from Prince George in 1952. Six years later, the PGE Railway linked Fort St. John and Dawson Creek with the population and shipping centres in the south. Other industrial watersheds included the completion in 1957 of Westcoast Transmission Company's natural gas line from Taylor to the USA, Western Pacific Products' crude oil pipeline to Kamloops in 1961, and the aforementioned hydroelectic project — since supplemented by a second dam downstream — at the Peace Canyon in the late 1960s.

1 Quoted in Bowes, p. 388.
2 Quoted in Bowes, p. 412.
Eliza and Edward Stanford provided advice and help with research.

"Pollution is the smell of money," part three. A misty morning on the Peace River, about 9:00 AM on a September day promising to become fine, with smoke and steam from the gasworks at Taylor mixing with the ground fog rising from the fields. The yellow flares, hydrogen sulphide burning off as part of the "sweetening process" of the natural gas, eerily punctuate the blue-grey murk. Here, in 1957, at the crossing point of the Peace River on the Alaska Highway south of Fort St. John, Westcoast Transmission Company completed its natural gas line from the Peace to the USA and established its main processing plant. Duke Energy now owns the site.

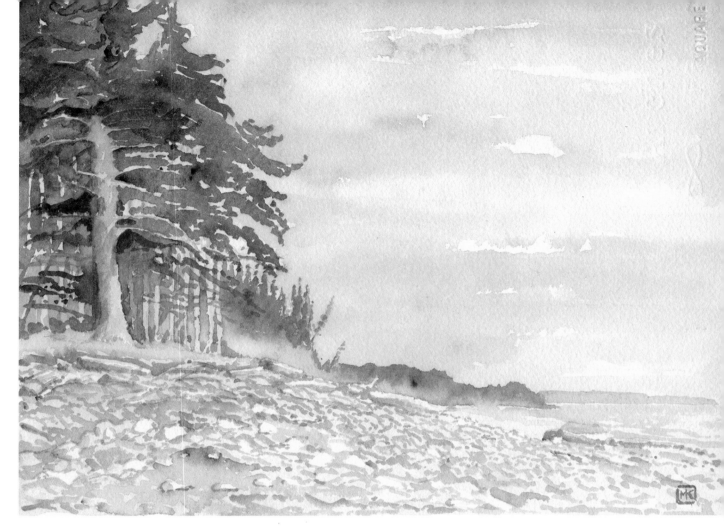

The Queen Charlottes

An inverted triangle of islands in the Pacific Ocean, far enough away from the mainland to seem, on all but the clearest days, to be a world unto itself. A place that missed the ice age, with a slightly different botany from the mainland.

Much of the reputation of the Queen Charlotte Islands arises from its natural beauty, but an equal part rests on its being also Haida Gwaii, home to a brilliant Native culture, whose elaborate social system and famous artwork were supported by the superabundance of foods and materials for shelter and clothing. The skilled hunters could hunt while, unlike in subsistence tribes in less verdant surroundings, people with artistic ability were free to create and carve. Yet the modern Charlottes/Haida Gwaii is not so different from much of rural BC: resource industries and population in decline (the Skeena-Queen Charlotte Regional District lost 12 percent of its population between 1996 and 2001), tourism ascendant, sharp contrasts between resorts catering to wealthy visitors and the typical housing of the residents, and disputes, some of them interracial, over land tenure, parks and conservation. However, the islanders seem to be further down the path to an "Atlantean" consciousness than the rest of de-industrializing British Columbia. Art, lifestyle and environment (including salmon) draw visitors and sustain residents, while a few gritty spots like Queen Charlotte City (population down about 15 percent over the past

Beach near Tlell, east coast of Graham Island, on a stormy October day. I was struck by the visual similarities between the seashore and the traditional Haida villages, as pictured in nineteenth-century photographs: in the former, a low understorey of young trees is topped by the tall verticals of mature forest, an arrangement that is repeated in the relationship of houses to totem poles. A similar transition – from the underworld of the sea to the earth and the skyworld – occurs in Haida cosmography.

five years) continue to process logs and make modern commerce flow. If the
Peace represents a traditional BC frontier of economic opportunity, the Queen
Charlottes is a new frontier of spiritual rebirth. I found I painted more pure
landscape on the islands, that seeming to be closer to the essence of the place,
than I did elsewhere in the province.

The Haida prospered in the fur-trade era but began to lose their
independence at the dawn of the gold-rush era. Governor Blanshard of the
colony of Vancouver Island reported to authorities in England in 1850 that the
Haida had shown some good samples of gold ore to the Hudson's Bay
Company trading post at Fort Simpson across Hecate Strait. The Haida, with
the collusion of the HBC, wanted to maintain control over their resource and
exclude American gold seekers, in one case holding the occupants of a
captured boat to ransom. In 1852, partly to forestall the possibility of an
American takeover, Blanshard's successor, James Douglas, established ad-
ministrative authority over the islands, which remained as a separate colony
until 1858 when it became part of the newly formed British Columbia.[1]

A combination of factors, including smallpox (some brought by Haida
returning from extended trading and working trips to Victoria in the 1850s
and 1860s) and the desire to trade with the newly arrived colonists and so
accumulate wealth, caused the Haida to abandon the "outports," including the
renowned southern villages of Tanu, Skedans and Ninstints (the UNESCO
World Heritage site), within a generation. The survivors migrated to
Skidegate, the documentation of their ghost towns painstakingly recorded by
explorers and adventurers using the newly invented camera. It was a
momentous juxtaposition of historical events, probably the first time (but
certainly not the last) in which an Aboriginal culture endured catastrophic
change more or less in front of the camera lens.[2] From the northern outports,
the Haida congregated into what became known as Old Masset.

Today's Old Masset is often referred to as Haida or Haida Village, an
attempt to distinguish it from the adjoining, largely non-Native town.
Promoters of the Graham City townsite, named in 1909 after Benjamin
Graham of the Graham Steamship, Coal & Lumber Company, coveted the
post office at Masset Indian Village and managed to steal its name, registering
its townsite plan as Masset and successfully confusing the distant provincial
and federal authorities. Similarly, Queen Charlotte City, immediately adjacent
to the oilery at Skidegate Landing, overtook Skidegate in importance during
the 1890s due to the promotional efforts of newspaperman Daniel R. "Windy"

1 Barman, *West beyond the West*, p. 63.
2 George F. McDonald, *Haida Monumental
Art*, provides an overview of Haida cosmol-
ogy, culture and art, using primarily 100-year-
old images.

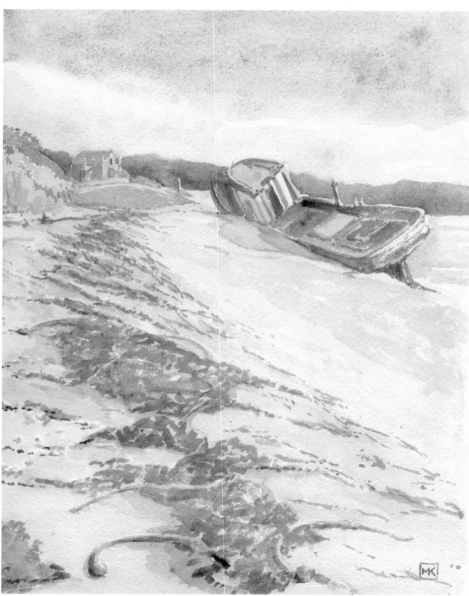

ABOVE *Adjoining Masset on the south side is Delkatla Slough, which opens onto Masset Sound — one of the most picturesque fishing harbours on the coast. The small townsite of Delkatla was a 1911 promotion by Charles Wilson on the site of an old Haida settlement.*[1]

BELOW *Wrecked fishing boat on the beach at Old Masset; nearby, a modern totem pole is visible above the dunes.*

1 Kathleen Dalzell, *Queen Charlotte Islands*, vol. 2, p. 384.

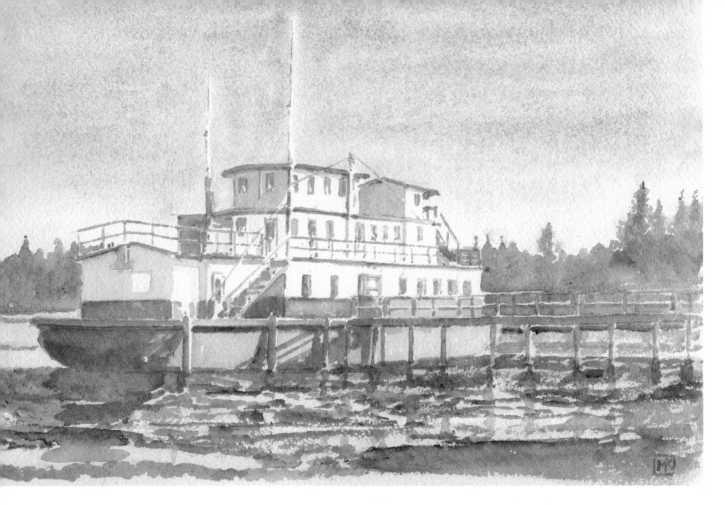

The old Samson IV *dredge from the Fraser River, now moored at Kumdis River Lodge near Port Clements after an odyssey worthy of the Grateful Dead's lyric, "What a long strange trip it's been." In the low sun of a late October morning, the rusty-coloured kelp along the shore of Masset Inlet glows like terracotta; coated with frost, it crunches underfoot.*

Young, and in 1910 obtained its post office.[1] For the Haida in both Skidegate and Masset, there was a sudden and dramatic lifestyle change in the 1880s, prompted by the influx of missionaries and settlers and the ending of customs like slavery. Writing about Skidegate, George F. McDonald noted the impact of Methodist missionary George Robinson on the community: "Within a year, traditional plank houses were abandoned or demolished, to be replaced with single-family dwellings of frame construction. The settlement pattern of the village also changed to streets on a grid pattern in which the church became the major focus of community life. There is no evidence of any forced destruction of totem poles instigated by the missionaries as there was at Masset." Most tellingly, he continued, "the few remaining master carvers and builders received no new commissions after 1883. The people of Skidegate had decided to adopt the ways of the white man."[2] The same grid pattern and frame houses are evident at Old Masset; today, though, no church dominates either town. Recently in both communities, supplementing the Department of Indian Affairs bungalows, some new houses reflect the Haida tradition of post-and-beam, plank-sided cedar construction, with new totem poles adorning many front yards.

Other communities include Sandspit, on Moresby Island, which looks like a military town with its neat, unadorned houses, while Port Clements has a charming, ramshackle quality befitting its logging heritage. The Sitka spruce on the islands was coveted early in the aviation age for its light weight and great strength. Provincial forester H.R. MacMillan, working during the First World War years for the Imperial Munitions Board, engaged future industrialist Austin Taylor to help with the procurement of this "airplane

1 Dalzell, vol. 2, pp. 305 and 312.
2 McDonald, p. 41; see also Downs, *Sacred Places*, p. 163.

Bridge Cottage at the Tlell River is one of the significant "roadside landmarks" on Graham Island. Local homesteader Lawrence Dyson (known as Bob) built it in 1928 at the end of the plank road he laid from his home at Port Clements. The Dysons maintained "typically English" rituals, according to neighbour Betty Dalzell, including afternoon tea with all the trappings, in spite of living in a logging town on the edge of the wilderness. Bridge Cottage is currently owned by author James Houston and his wife Alice and is, according to his memoir Hideaway, coveted for its proximity to the Tlell River's excellent fly fishing.

An oak tree at Port Clements, possibly a seedling of the great oak planted nearby at the Dyson homestead,[1] is dramatically golden in the October sunlight and, in a curious twist (as it is not a native tree), reminiscent of the famous golden spruce tree a few miles away – a botanical freak cut down in 1997 in an astonishing act of vandalism intended, it is said, to draw attention to the damage done to Haida Gwaii by commercial exploitation. I spent considerable time admiring the oak in part because of an auto repair place across the street, which was fixing the tire I had blown on the gravel road to Juskatla. The young man who did the work told me that, if he had stayed in the Lower Mainland, he might have gotten into trouble with the law, so he was glad he had moved even though there wasn't a whole lot to do in "Port." If he stuck it out, he would soon be qualified as a mechanic, he told me.

spruce." Its most famous military use came during the Second World War with the light, fast, twin-engined DeHavilland Mosquito fighter bomber, the "Wooden Wonder" or "Termite's Dream," the original stealth fighter of the radar era.

And then there is Tlell, the loose collection of houses and stores along the east coast of Graham Island midway between Skidegate and Masset, where one experiences the kind of time travel usually associated with Hornby Island or New Denver. If Port Clements is for loggers, Tlell is for hippies. Painted sunbursts and rainbows adorn some of the whimsically modified wooden buildings, artisans abound, and the Edge of the World Music Festival[2] is a summertime magnet for the counterculture. The landscape is an interconnected series of cleared meadows, with the particular long, rank grass and looming forest of the archipelago, and grazing cattle, sheep and horses on some of the properties. Tlell entered the written historical record in the person of an appropriately colourful character named William Thomas "Mexican Tom" Hodges, who homesteaded there in the first decade of the twentieth century.[3] More recent arrivals, at the picturesque Bridge Cottage at Tlell River, are James and Alice Houston, who bought it from a fellow fly fisherman in the 1970s, after trying to rent it as a writing retreat. The author of many books, including the autobiographical *Confessions of an Igloo Dweller, Zigzag,* and *Hideaway: Life on the Queen Charlotte Islands,* James Houston is considered to be the prime force in the development of Inuit art. Like an increasing number of island devotees, they overwinter elsewhere – in their case in Connecticut.[4]

The pristine environment and rich marine life throughout the archipelago attract, on the one hand, eco-campers and kayakers, and on the other sport fishers. The latter patronize a number of exclusive resorts accessible only by air or water; typically they arrive at Sandspit or Masset airport and leave immediately by chartered float plane or helicopter, seeing little of island towns as they are guided through an idealized west-coast experience. Typical resort buildings are west-coast post-and-beam log architecture.

At Kumdis River Lodge near Port Clements, a wandering relic from the Fraser River, the former *Samson IV,* served as an interim lodge – a transition between the rustic and the luxurious. Built by Edward Mercer in New Westminster and launched in 1924, *Samson IV* was a dredge like her predecessor *Samson*s, but also engaged in icebreaking, dragging for boulders, piledriving, towing scows and taking tidal gauge readings on the Fraser River until she was sold in 1937.[5] After a second lifetime in the commercial fishing industry, she was renamed *Langara I* and used in the 1980s as the lodge at Langara Island off the northwest coast of Graham Island. Later she became the dining facility and crew quarters for the new Langara Lodge, but every year until 2001 she was moored for the winter in the sheltered waters at Kumdis. She is now there permanently, still used for staff accommodation.[6]

1 Interview with Kathleen ("Betty") Dalzell, 2004.
2 www.edgecivilization.com.
3 Dalzell, vol. 1, pp. 231-4.
4 Interview with Alice Houston, 2003.
5 Samson V Maritime Museum web page at www.nwheritage.org.
6 Correspondence from Bob Turnbull, Langara Lodge.

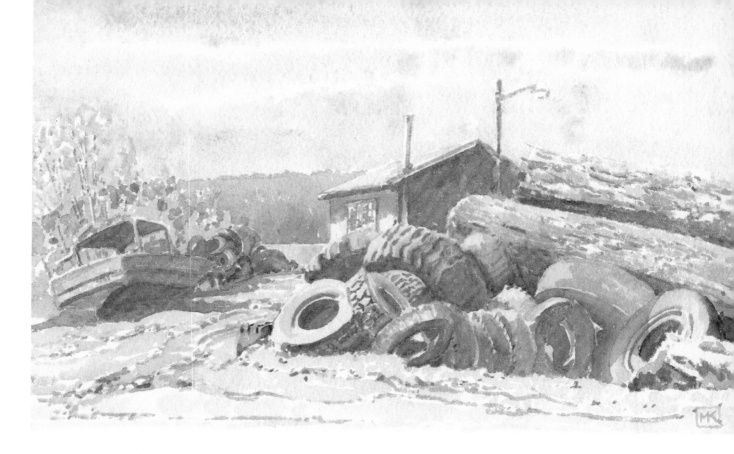

The Future

An oft-repeated cliché about Vancouver goes something like this: "it doesn't matter what you do to it because it will always have its beautiful natural setting." The same could arguably be said about British Columbia's historic places, the dots on my roadside map that I have watched deteriorate and disappear for the past 40 years. The province is still a beautiful place, so what's the problem? The public mind is focused on natural splendours and endangered species and habitats, all of which are skilfully defended by some of the most militant environmentalists anywhere in the world. British Columbia is, after all, the birthplace of Greenpeace.

I wonder whether, as "roadside memories" vanish, new images are emerging that reflect people's roots and define their values. Other than, perhaps, the skylines of major cities, are there modern icons that are replacing the tried-and-true fishing docks and lonesome cabins of the romantic past? Compare western Canada with Australia, one of the most urbanized countries in the world, which has embraced few representational scenes other than some Matisse-like semiabstracts of Sydney Harbour. In spite of all the changes there, the sunburnt homestead with a few gum trees still seems to tug at their national heartstrings. In Canada, most popular images are pure landscape containing no evidence of people at all, in itself a telling comment on our national image.

The province's prosperous cities, especially Victoria but also Vancouver and New Westminster, and a number of towns including Ladysmith, Nanaimo, Nelson and Revelstoke, have made heroic efforts to reuse and restore their historic buildings. But the impoverished small towns, with dwindling tax base

An independent logging operation at the eastern end of Malcolm Island, one of the few I came across in years of travelling and painting. A couple of boomboats scuttled around the log pond in the bay, and a single skidder worked to sort out the piles of cut trees. Elsewhere, large logging companies dominate the landscape, run by a handful of workers compared with a generation ago; industrial employment has all but disappeared, exacerbated by the collapse of the fishing industry which has taken a major toll on communities like Sointula and Alert Bay. The new construction on islands like this is invariably recreational — tourist lodges and retirement or summer cottages.

and expertise, have floundered, and most regional districts have not even gotten to first base with heritage *inventories*.

The contrast between urban and rural or small-town BC is a new version of Hugh MacLennan's "two solitudes" which, a half century ago, expressed the cultural divide between French and English Canadians.[1] Those left behind in this cultural shift are, in the main, Jean-Henri Fabre's "common people" who are "persecuted by the present."[2] As in Emily Carr's Indian villages, "the heartlands"[3] are succumbing to changes beyond the control of anyone there (although the buoyant spirit of the people themselves seems to be indomitable). Sawmills and canneries close; the government "rationalizes" services; local stores close because people can easily drive to the next town where there's a big-box discounter or large supermarket. Families move on, leaving few traces. In the Fraser Canyon, for example, only the "exotic" trees – willows and acacias – mark the sites of motels they were planted to shade (page 121).

Not surprisingly in such an environment, our architectural culture has lost its craft, preferring instead the inexpensive, the machine-made and the mass-produced. The Singlewide mobile or manufactured home is the most ubiquitous form of shelter. The rich colours, ample porches and fine detailing of even the modest houses of earlier generations stand out so strongly, to my eye so pleasingly, amongst contemporary buildings. The new suburbs and the commercial strips on the outskirts of towns could be literally anywhere in North America – a bitter disappointment when the old towns were so distinctive and well-built and the natural backdrops so dramatic.

To be realistic, though, however important roadside memory may be historically, no government could put together preservation policies to save it. It is too scattered, modest and vernacular. Like the buildings of ordinary people elsewhere in the world, it is not great architecture, and only the landmarks by great architects inevitably open the public purse. That said, governments in British Columbia have rarely led by example and have recently shown little interest in the province's old buildings and historic places. A cynic would say it is because buildings cannot vote, but it shows a short-sightedness typical of the West – in a North American sense – but also distinctly Canadian, where only the Quebec and Nova Scotia governments have consistently supported built-heritage preservation. On a world scale, Canada ranks somewhere in the middle, far behind Europe but ahead of rapidly modernizing Asian countries such as Singapore, China or Japan.[4]

Under the Canadian constitution, the federal government has no ability to legislate matters concerning land, it being a provincial responsibility. But unlike other federal states such as the USA and Australia, the federal government has failed to create a National Trust. Efforts were made in the early 1970s in the afterglow of the centennial love-in to develop a National Register of Historic Building, but it was never adopted. Recent initiatives[5] promise to create a proper historic register, implement tax incentives for heritage buildings, and create a National Trust for Canada, the role intended for the Heritage Canada Foundation when it was created in 1973.[6]

The provincial government became engaged in 1977 with the creation of the BC Heritage Trust, a crown corporation which used lottery funds to support an amazing number of projects throughout the province. Commercial

1 From the novel *Two Solitudes*, first published by Collins, Toronto, in 1945.

2 From Jean-Henri Fabre (1823-1915), *The Passionate Observer: Writings from the World of Nature*, Chronicle Books, 1998, pp. 38-9: "The common people have no history: persecuted by the present, they cannot think of preserving the memory of the past. And yet what surpassingly instructive records, comforting too and pious, would be the family papers that should tell us who our forebears were and speak to us of their patient struggles with harsh fate, their stubborn efforts to build up, atom by atom, what we are today. No story would come up with that for individual interest. But, by the very force of things, the home is abandoned; and, when the brood has flown, the nest is no longer recognized."

3 Historically called the "Interior" and the "Island" (Vancouver Island excluding the Capital Regional District), in recent years sometimes called "Region 250" after the area code, and rebranded by the provincial government in 2003 as the "Heartlands." The "B.C. Heartlands Economic Strategy," the first time the term was used publicly, was announced in the Throne Speech on February 11, 2003. Pundits quickly renamed it the "hurtlands."

4 See, for example, "AsiaWorld," by Ian Buruma, *New York Review of Books*, June 12, 2003, pp. 54-7.

5 Government of Canada Launches Historic Places Conservation Initiative, "Tomorrow Starts Today," press release, June 8, 2001. The "HPI," as it is usually called, crystallized around the creation of a national register of historic places and, in 2004, was still moving its way slowly through municipal and provincial administrations, receiving modest but consistent funding.

6 Steven Thorne, "Policies for Preservation: The Heritage Canada Foundation 1973-1993," Waterloo: Research Group on Leisure and Cultural Development, University of Waterloo, 1994.

streetscapes and historic houses were restored by non-profit community organizations, histories were written and inventories compiled. The Trust lost favour with the NDP regime of 1991-2001, which cut more than 80 percent of its budget. In 2001, the newly elected Liberal government began a process of devolving provincially owned historic sites to private and non-profit managers; two years later, it provided core endowment funds for a new private heritage trust called the Heritage Legacy Fund of British Columbia, formed through a partnership involving the Land Conservancy of BC and the Heritage Society of BC, to take over the work formerly done by the earlier Trust. Unlike in the United States, there is no great Canadian tradition of support for private endowments, but with luck that will change. Meanwhile, the devolution process has proceeded too quickly, causing a crisis at the largest sites, especially Barkerville, after 45 years of government investment.

One of the arguments repeated by former Canadian Heritage Minister Sheila Copps, in justification of the Historic Places Initiative, is that 20 percent of the country's stock of heritage buildings has been demolished in the past 30 years.[1] In my experience in the west, and especially in rural areas, that proportion is much higher.

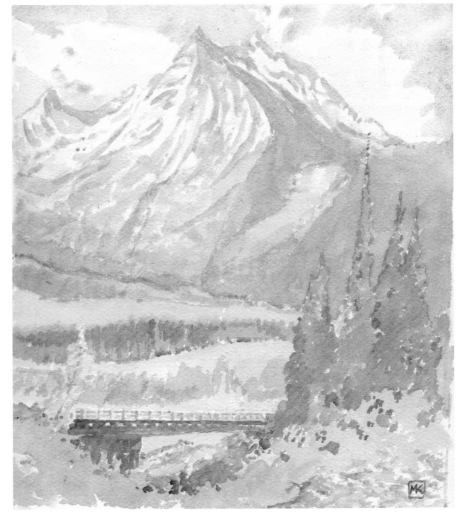

Access to the contested wilderness: a logging bridge on the Bone Creek Road about six kilometres north of Blue River.

Vanishing British Columbia demonstrates that people want to hang their family stories onto specific buildings and places. In the main, they have created new, rich lives for themselves in new homes (usually in cities), but their correspondence implies that, if they are unable to pinpoint their memories in the landscape, their pasts become like dust in the wind.

Although many admit to a sense of personal loss when their roadside memories disappear, they feel powerless to stop the change, being unwilling to meddle in others' affairs, others' private property. Stewardship remains an individual commitment, and in the face of all the changes and the lack of collective will to conserve, it is remarkable that I was able to find as many interesting sites as I did. Regardless, it is disheartening that so many have been lost. I may be merely nostalgic in thinking these places should somehow be saved or cared for, but the province is diminished each time one of them disappears and another cultural record is erased.

1 Backgrounder, "Tomorrow Starts Today."

Painting Notes

While still in my teens, I was inspired by the *sumi-e* (brush and ink) sketchbooks of the Japanese master Hokusai. Then, at the age of 20, I visited the Louvre and was enthralled by the watercolour sketchbooks Eugène Delacroix created on his trip through Morocco in 1832. Ever since I have carried a sketchbook while travelling.

Do paintings "document" as well as photographs? I don't paint because I'm a poor photographer, or because I'm incapable of admiring some photographs of the types of landscapes I painted over the years of travelling in British Columbia. Donovan Clemson's black-and-white photographs in his book *Old Wooden Buildings* (Hancock House, 1978), for example, capture the loneliness of his subjects as well as any Edward Hopper painting. And the carefully selected photographs that became postcards are in some cases marvellous period pieces, in others – for example, when hand-tinted – beautiful works of art.

But most photographs colour the sky and the wind like Kodak moments everywhere, whereas a painting is a selected, simplified view, useful when the subjects can be so cluttered. Paintings do not necessarily present a romanticized turn of mind; rather they are a pared-down, edited image that suggests reality more evocatively than the mechanical lens and shutter could. When left somewhat unfinished, they leave room for the viewer's imagination. Painters record only what the mind's eye sees, just as skilled photographers frame only those scenes where reality itself is an attractive composition. Everyone has had the experience of looking at photographs taken on a trip and thinking, "Why did I take that?" Although the mind's eye saw an appealing, *selected* scene, the camera recorded everything, or altered the sense of space, destroying the composition that was so inspiring.

All of the watercolours in *Vanishing British Columbia* were begun out-of-doors on site and were then finished back at the studio, with better brushes and more controllable conditions. The pre-1999 handful of watercolours in this book were painted on pieces of paper about 14 x 20 inches – that is, not in a sketchbook.

When I began to travel and paint in earnest, I reduced the size of the images to about 9 x 12 inches in a hand-made sketchbook of 140 lb. Arches cold-pressed paper, and on the road used a small Winsor & Newton travel paintbox and a "squirrel mop" Isabey travel brush. My 12 essential colours for BC are cerulean blue, manganese blue, ultramarine light, Payne's grey, cadmium yellow deep, yellow ochre, olive green, viridian, burnt sienna, burnt umber, sepia and Indian red. Ultramarine light is a typical underpainting/shadow colour for much of the province; in the drier regions, washes of yellow ochre and cadmium yellow deep capture the grassland tones. Skies are cerulean and manganese blue, or washes of Payne's grey in the clouds. The greens of the forests are viridian mixed with burnt umber or olive green, unless they are Ponderosa pines, which are olive green dulled with black. The distant light is always blue when it isn't grey.

I kept the watercolours so small because I needed to paint quickly while on the road; also, I wanted the watercolours to fit onto a standard scanner so I could get good-quality reproductions of them on the Internet. It is one of the ironies of modern technology that an old-fashioned, conservative medium like watercolour reproduces so well on the Internet, and on paper in books, losing less of its essence than the thick impastos of fashionable oils and acrylics.

Additional Notes & Acknowledgements

The notes below expand on the footnotes in the main part of the book.

BC ARCHIVES is the provincial archives located in Victoria.

VPL SPECIAL COLLECTIONS is the Vancouver Public Library division formerly known as the Northwest History Collection. Its collection includes *British Columbia Magazine* and the Okanagan Historical Society reports referenced throughout.

CVA is City of Vancouver Archives.

The various heritage inventories and reports by, for example, Robert Hobson and Associates, were for the most part commissioned by the BC Heritage Trust, the provincial government agency established in 1977 which used lottery money to support a myriad of research projects and building restorations throughout the province. The Trust was dissolved by the government in 2003, and the Heritage Branch library, which occupied a room in an office building on Johnson Street in Victoria, was closed. I was fortunate to have been able to use it in 2002, and thank Romi Casper, the former librarian, for her assistance and advice.

All images not specifically otherwise identified are in my own collection. Over the past 20 years, I have gathered many postcards but received many more: for example, several boxes of cards collected between the 1920s and 1960s by Jessie Acorn, who lived at 2015 West Forty-eighth in Vancouver and who apparently bought every card she came across in her extensive travels, sometimes buying them more than once. I have made every attempt to trace artists, photographers and card publishers, being successful at connecting with Edward Goodall (pages 10 and 155), Robert Donaldson (page 22), Hugo Redivo (page 33) and Wally West (page 183).

Correspondents, unless otherwise noted, became involved in the project by finding the Vanishing BC section of my website: www.michaelkluckner.com. Typically they were using search engines to find specific place or family names (such as Samuel Swann Fearn, page 11) or information on objects (the Salish baskets bought by the Abrays in North Bend, page 123). Much of the interest in the Internet is genealogical; *Vanishing British Columbia* is genealogy tied to specific historic places.

I am indebted to my old friend and patron Janey Gudewill, who supported this project as she has many others since I worked with her to edit and publish the diaries of her grandmother, M.I. Rogers, in the 1980s.

Rick Goodacre, executive director of the Heritage Society of BC, has a vast knowledge of the province and was unfailingly willing to share information and contacts. Donald Luxton, heritage consultant and principal author and editor of *Building the West: The Early Architects of British Columbia*, invariably provided prompt and useful information on buildings, construction techniques and architects.

This project would have been impossible without the support and advice (as well as company on some of the trips) of my beloved wife Christine Allen.

10: Richard Goodall, the son of artist Edward Goodall, maintains the family website and gave permission for the reproduction of the images on pages 10 and 155.

10: Through province-wide broadcasts on CBC's *BC Almanac,* made possible by Mark Forsythe, I made contact with Lisa Mori (page 25), Sian Reiko Upton (page 38), Doreen Armstrong (page 44), Tom Hodgson (page 55) and Glynnis Tidball (page 62).

12: Kim Shannon wrote about the George Ferguson house on Washington Street in Rossland.

15: The "protracted controversy" involving Spotted Lake was documented by *Osoyoos Times* reporter Wendy Johnson, and on the *BC Almanac* program by Mark Forsythe. The events were summarized in the *Living Landscapes Newsletter,* vol. 6. no 2, January 2002 (royal.okanagan.bc.ca/newsletr/index.html).

20: Beverley Campbell provided the original contact information for the DOT site.

22: Lois Shelton and W.B. Yeo added information about the Sanca glass house.

32: Brenda Anderson used her contacts from her early life in Pouce Coupe to find information about the Cree Met Drive-Inn and the Hillcrest Motel, and also wrote an article for the *Langley Times* on "Vanishing BC," which was republished in sister newspapers throughout the BC Interior, leading to further contacts and correspondence.

36: Thanks to Robert Ledingham for access to his office and his view of the McLennan house.

37: Colin Quinney of Toronto added details to the record of his ancestor, James Luke Quiney. A photograph of the two bungalows, with masonry porch posts as they were when built, is image number CVA 7-45 on the Vancouver archives website. The Finn Slough evaluation worksheet is available at

www.city.richmond.bc.ca/planning/Heritage-Inventory, ID number 167.

40: Thanks to Val Billesberger, Mission Community Archives.

44: Doreen Armstrong gave me copies of unpublished family stories about the early days of Gower Point. I received additional correspondence from Cathy and Rob Romans, William Sinclair and Ed Chessor. Thanks to Judith Reeve for local accommodation. I have a personal interest in the Wilson story as I was baptized by Canon Wilson at St. Michael's Church, where my great-aunt Kate Atkins (a grandmother of Don Atkins of the Vancouver printing firm Benwell-Atkins) was an active member of the congregation. According to my cousin Bob Stewart, Halford Wilson dated his mother in the early 1930s before she met her future husband, so we might have become relatives.

50: Peter Armstrong made it possible for me to visit and stay in comfort on Savary Island. Tony and Jane Griffin shared a lifetime of island stories, and showed me inspired Savary Island artwork in their collection by Helen Griffin and Ruth Massey.

55: Betty Pelley, in a telephone conversation, described the cattle drives over the Hope Trail. I received further confirmation of Bill Robinson's existence in notes from Peter Flynn and from Len McIver, who as a boy visited Camp Defiance with his father and retains a Foundation Mine share certificate belonging to the latter; he told me that photographs of Robinson and the cabin appeared in *Forging a New Hope,* published by the Hope Historical Society in 1984.

56: Neil Roughley made the first suggestion about the old GNR bridge near Keremeos. His website www.vanc.igs.net/~roughley/ contains excellent maps and text on the GNR in British Columbia.

64: Betty Kales, who lived in the Prairie Valley area from 1940-4 and went to grade 1 and 2 at MacDonald Elementary, corresponded about Summerland.

66: Ken Husveg provided information about the Naramata Inn and Spa.

72: The Beaverdell Hotel was for sale early in 2004 for $329,000, offering me a possible career change.

74: Penny Dell's original email led me to the Harfmans, who knew that Bunny Cox lived with her daughter in Greenwood.

77: Joan Weed in Grand Forks pointed me toward the Bubars in Midway.

84: Thanks to Edward Gibson for permission to reproduce his 1976 drawing.

96: Rosemarie and Milton Parent of the Arrow Lakes Historical Society provided suggestions and information about the Kootenay and Lardeau districts.

108: Michelle Fuchs of Kimberley corresponded with details about geography and buildings in the east Kootenays. I first became aware of the bomb attack on the Wynndel grain elevator while watching *Spirit Wrestlers* (see www.movingimages.bc.ca/catalogue for work by Jim Hamm Productions) on television in 2004. Kathleen Hart also wrote about the grain elevator there.

112: News reports in early 2004 stated that the St. Eugene's Mission resort was near bankruptcy, with $36 million in debts.

115: A number of people have told me about the one dollar toll over the years (notably when I've spoken about the project at seniors' homes like Crofton Manor in Vancouver), but I could not confirm it from public records.

116: Sian Reiko Upton put me in touch with Charlotte Gyoba.

117: I received a tremendous amount of information over the years about Alexandra Lodge, including correspondence from Sheri Ash, Bob Farrell, Mark Perry and Tyler Shepherd.

120: I tracked down Ken Sigfusson after seeing a photograph he had taken of the gas station at Ashcroft Manor, posted in Ashcroft Manor.

121: Cheryl and Ed Lea bought the old "Willows Motel." "We are in the process of cleaning it up and making it liveable," she wrote in 2004. It is now an antique store.

123: It was Clarke Peters's response to a 1998 watercolour of the Highline Houses which I had posted in the "travel" section of my website that gave me the idea of setting up Vanishing BC as an on-line historical research project. His memories, and the family photo albums of people including Arlana Nickel, Linda Reid and Claude Richmond, unlocked much of the community's past. I received additional correspondence from Lee Mason and Sherri Corrie. Linda Reid provided the page 124 photo of the store, and wrote: "The W.E. Ford is William Edward – he was my mother-in-law's father." Another of her photographs showed the store with a "J&E Lyons" sign; one of William Edward's siblings, Louisa, apparently married a Lyons.

126: Ernie Clelland and Syd Strange gave me access to the Harry Lee house and introduced me to Cliff and Irene Fisher, long-time North Benders (Cliff Fisher ran the aerial tram across the Fraser River).

129: Michael Klee, whose grandmother, mother and aunt lived in a house near Toketic, also wrote about the Andersons and their ranch house. He is a great-grandson of Chief Shumahatsa of the Pokhaist. Jan Brown also wrote about Pokhaist Village.

130: I received information from Doreen Stephens at the Anglican archives. Lucien Campeau sent close-up photos of St. Aidan's Church. Dr. Wendy Wickwire of the University of Victoria contributed information about James Teit, the subject of a biography she is writing: web.uvic.ca/history/faculty/wickwire.html.

132: Gillian Rodie of Nova Scotia wrote about her husband's grandparents, Edward and Edith Windsor, who, according to family legend, went to Walhachin to become orchardists. "They were talked into it by someone in England. They married in Shropshire in 1910 and apparently immigrated to Canada ... From then on we know little except that they lost all their money and, in October 1912, were in Port Alberni where their first child was born ... In January 1915 their second son was born in Vancouver. [That May] Edward Windsor died of heart disease leaving his widow and two babies." Theresa Kishkan corresponded about the Footner family, whom she knew in Victoria.

136: Allan Wilson told me that Rob Rutten of Country Store Antiques in Louis Creek had bought a filing cabinet at the Calhoun estate sale in Kamloops years ago, and had kept some of the relevant papers, as there were no Calhoun descendants to pass them to. I went to Louis Creek in June 2003, sought out Rob Rutten and had him dig out the picture of the Calhouns, which I bought. A month later the store, and much of the community, was destroyed by a forest fire. John B. O'Leary wrote about a section of the former Calhoun farm which he owns.

139: Wanda Leinweber corresponded about the Glen Echo and Pierre's Point areas. Grant Stuart Gardiner wrote about similar experiences at Gardiner Point, just west of Anglemont.

140: Kristina Nielsen first suggested I visit and paint at Tranquille.

145: Jean Wilson and Sarah Good sent information about the Scoones cottage.

151: The publication of the Kadonaga house watercolour in the article "Vanishing British Columbia" in *Canadian Geographic* magazine, November-December 2003, exposed it to descendants of the Mayne Island Japanese-Canadian community living in eastern Canada, resulting in correspondence from Victor Kadonaga and Glen Teramoto which illuminated the fates of the families.

166: Photographer Grace Darney sent background information on Zeballos, including the story of her parents' arrival on the *Princess Maquinna* in 1940, their marriage by a travelling preacher at midnight, and her brother's birth in the hospital, now the motor hotel on the edge of town, on a night in July 1940, when part of the town was on fire.

170: Kathy Young, director of finance, District of Lillooet, sent the picture of Dr. Miyazaki. Museum coordinator Susan Bell found the pictures on pages 171 and 174.

174: Bernard and Catherine Schulmann of Lillooet gave me a lot of information on the problems BC's small towns are having with economic woes and government service reductions.

176: Mike Brundage helped with directions and history in the Clinton area. Pat Coldwell gave me background information on Jesmond. Kristy Whitehurst wrote, "My dad and I are two of the many who've almost run over the Coldwells' infamous border collie numerous times."

177: Correspondence from Ken Sigfusson: "I would have used two cameras on this trip. The favourite one was an Ansco Pioneer camera in which I would have used 620 Verichrome film. The other was of course the old reliable Kodak box camera and again using Verichrome film (120). The Clinton Hotel picture was shot with a Yashica A Twin Reflex camera using 120 Kodak Ektachrome film. The black and white prints and film I processed. The Ektachrome film was processed by Munshaw of Vancouver."

179: Cliff and Jo Hinche own 137 Mile House. Her father, Bill Downie, owned it in the 1950s and 1960s.

187: Lelani Arris gave me information about Dunster and its general store.

189: Wrathall Photofinishing's collection of negatives has been donated to the Prince Rupert City and Regional Archives.

191: Carla Beerens wrote: "I lived in 'old' Quick from 1958 until 1964 when we moved next to the Quick School. I lived in the CN shack next to the railroad, left of Padden's store by a half kilometre. My dad, Rolf Beerens, was section foreman at the time. Mr. Padden was quite a character; he decided the road in front of his store should be called Padden Avenue, even though Quick had no streets! Mr. Padden's wife was a nurse, so when I got together with their grandkids and managed to drink creosote, she knew what to do."

192: Frances Simpson told me about the building of the band administration office.

198: Carol Studer at the Atlin post office provided information about her community. Judy Vaughan corresponded about her childhood there.

202: Lisa Hildebrandt of the Hudson's Hope Museum gave me good directions to Dudley Shaw's cabin.

204: Earl Brown of the *Milepost* magazine made many helpful suggestions.

Bibliography

Barman, Jean. *The West beyond the West: A History of British Columbia.* Toronto: University of Toronto Press, 1991.

Boam, Henry J. *British Columbia.* London: Gresham Press, 1912.

Bowes, Gordon E., ed. *Peace River Chronicles.* Vancouver: Prescott Publishing Company, 1963.

Buck, George H. *From Summit to Sea.* Calgary: Fifth House Ltd., 1997.

Carlson, Keith Thor, ed. *A Stó:lō Coast Salish Historical Atlas.* Vancouver: Douglas and McIntyre, 2001.

Carr, Emily. *Klee Wyck.* Toronto: Clarke, Irwin and Co., 1941, 1971.

Crosson, Jack. *Jack's Shack: Memories from the West Coast of Vancouver Island.* Victoria: Whistlepunk Books, 2000.

Dalzell, Kathleen E. *The Queen Charlotte Islands, 1774-1966.* Vol. 1. Prince Rupert, BC: Cove Press, 1968; Madeira Park, BC: Harbour Publishing, 1989.

—. *The Queen Charlotte Islands, Of Places and Names.* Vol. 2. Prince Rupert, BC: Cove Press, 1973; Madeira Park, BC: Harbour Publishing, 1989.

Davies, Marguerite, and Cora Ventress. *Fort St. John Pioneer Profiles.* Fort St. John, BC: Fort St. John Centennial Committee, 1973.

Denhez, Mark. *The Canadian Home.* Toronto: Dundurn Press, 1994.

Downs, Barry. *Sacred Places.* Vancouver: Douglas and McIntyre, 1980.

Fabre, Jean-Henri. *The Passionate Observer: Writings from the World of Nature.* San Francisco: Chronicle Books, 1998.

Francis, Daniel, ed. *Encyclopedia of British Columbia.* Madeira Park, BC: Harbour Publishing, 2000.

Fraser Jones, Jo, ed. *Hobnobbing with a Countess and Other Okanagan Adventures: The Diaries of Alice Barrett Parke, 1891-2000.* Vancouver: UBC Press, 2001.

Freeland, John Maxwell. *Architecture in Australia.* Melbourne: Penguin, 1968.

Green, Lewis. *The Great Years: Gold Mining in the Bridge River Valley.* Vancouver: Tricouni Press, 2000.

Harris, R.C. *Old Pack Trails in the Cascade Wilderness.* Summerland, BC: Okanagan Similkameen Parks Society, 1982.

Hart, E.J. *The Selling of Canada: The CPR and the Beginnings of Canadian Tourism.* Banff: Altitude Publishing, 1983.

Holt, Simma. *Terror in the Name of God: The Story of the Sons of Freedom Doukhobors.* Toronto: McClelland and Stewart, 1964.

Houston, James. *Hideaway.* Toronto: McClelland and Stewart, 1999.

Kalman, Harold. *A History of Canadian Architecture.* 2 vols. Toronto: Oxford University Press, 1994.

Kalman, Harold, Ron Phillips, and Robin Ward. *Exploring Vancouver 3.* Vancouver: UBC Press, 1993.

Kennedy, Ian. *Sunny Sandy Savary.* Vancouver: Kennell Publishing, 1992.

King, Anthony D. *The Bungalow: The Production of a Global Culture.* Oxford: Oxford University Press, 2nd edition, 1995.

Kluckner, Michael. *Vancouver the Way It Was.* North Vancouver: Whitecap Books, 1984.

—. *Vanishing Vancouver.* North Vancouver: Whitecap Books, 1990.

—. *Victoria the Way It Was.* North Vancouver: Whitecap Books, 1986.

Kluckner, Michael, ed. *M.I. Rogers 1869-1965.* Privately published, 1987.

Kogawa, Joy. *Obasan.* Toronto: Penguin, 1981.

Koroscil, Paul M. *British Columbia: Settlement History.* Burnaby, BC: Department of Geography, SFU, 2000.

Laforet, Andrea, and Annie York. *Spuzzum: Fraser Canyon Histories 1808-1939.* Vancouver: UBC Press, 1998.

Luxton, Donald, ed. *Building the West: The Early Architects of British Columbia.* Vancouver: Talonbooks, 2003.

Lyons, C.P. *Milestones on the Mighty Fraser*. Toronto: Dent, 1950.

McAlester, Virginia, and Lee McAlester. *A Field Guide to American Houses*. New York: Alfred A. Knopf, 1988.

McDonald, George F. *Haida Monumental Art*. Vancouver: UBC Press, 1983.

Miki, Roy and Cassandra Kobayashi. *Justice in Our Time: The Japanese Canadian Redress Settlement*. Vancouver: Talonbooks, 1990.

Mitchell, David. *W.A.C. Bennett and the Rise of British Columbia*. Vancouver: Douglas and McIntyre, 1983.

Neering, Rosemary. *Traveller's Guide to Historic BC*. North Vancouver: Whitecap Books, 1993.

Old Age Pensioners' Organization. *A Tribute to the Past*. Quesnel, BC: Old Age Pensioners' Organization, 1985.

Ormsby, Margaret. *A Pioneer Gentlewoman in British Columbia: The Recollections of Susan Allison*. Vancouver: UBC Press, 1976.

Ovanin, Thomas K. *Island Heritage Buildings*. Victoria: Islands Trust, 1987.

Patenaude, Branwen. *Trails to Gold*. Victoria: Horsdal and Schubart Publishers, 1995.

Perrault, E.G. *Tong: The Story of Tong Louie, Vancouver's Quiet Titan*. Madeira Park, BC: Harbour Publishing, 2002.

Sanford, Barry. *McCulloch's Wonder: The Story of the Kettle Valley Railway*. North Vancouver: Whitecap Books, 1978.

Shadbolt, Doris. *Emily Carr*. Vancouver: Douglas and McIntyre, 1990.

Smith, Jessie Ann. *Widow Smith of Spences Bridge*. Merritt, BC: Sonotek Publishing, 1989.

Smithers. 1914. Reprint, Smithers, BC: Bulkley Valley Historical and Museum Society, 1979.

Smuin, Joe. *Kettle Valley Railway Mileboards: A Historical Field Guide to the KVR*. Winnipeg: North Kildonan Publications, 2003.

Spilsbury, Jim. *Spilsbury's Album*. Madeira Park, BC: Harbour Publishing, 1990.

Stangoe, Irene. *Cariboo-Chilcotin Pioneer People and Places*. Surrey, BC: Heritage House, 1994.

Stewart Advancement League. *Stewart, the Gateway City*. Stewart, BC: Stewart Advancement League, 1928.

Surtees, Ursula. *Sunshine and Butterflies: A Short History of Early Fruit Ranching in Kelowna*. Kelowna, BC: Regatta City, 1979.

Tanaka, Tosh. *Hands across the Pacific: Japan in British Columbia 1889-1989*. Vancouver: Consulate General of Japan, 1990.

Thirkell, Fred, and Bob Scullion. *Frank Gowen's Vancouver, 1914-1931*. Surrey, BC: Heritage House, 2001.

Turkki, Pat. *Burns Lake and District*. Burns Lake, BC: Burns Lake Historical Society, 1973.

Turner, Robert D. *The SS Moyie: Memories of the Oldest Sternwheeler*. Victoria: Sono Nis Press, 1991.

Veillette, John, and Gary White. *Early Indian Village Churches*. Vancouver: UBC Press, 1977.

Walker, Lester. *American Shelter*. Woodstock: Overlook Press, 1981.

Weir, Joan. *Walhachin: Catastrophe or Camelot?* Surrey, BC: Hancock House, 1984.

Wheeler, Marilyn. *The Robson Valley Story*. McBride, BC: McBride-Robson Valley Story Group, 1979.

Wild, Paula. *Sointula: Island Utopia*. Madeira Park, BC: Harbour Publishing, 1995.

Williams, David R. *Mayor Gerry: The Remarkable Gerald Grattan McGeer*. Vancouver: Douglas and McIntyre, 1986.

Woodall, Ronald. *Magnificent Derelicts*. Vancouver: J.J. Douglas, 1975.

Wynn, Graeme, and Timothy Oke, eds. *Vancouver and Its Region*. Vancouver: UBC Press, 1992.

Index